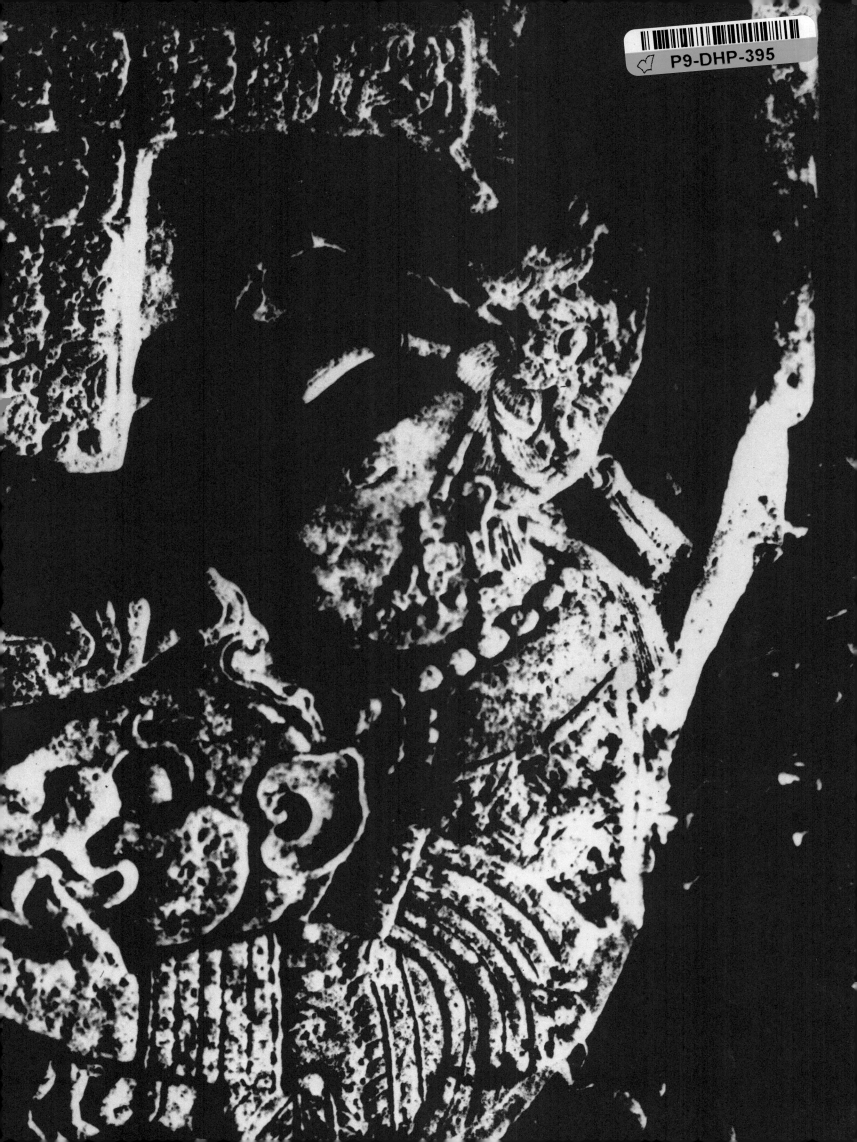

Art of the Maya

Ferdinand Anton

Art of the Maya

with 365 illustrations, 37 in colour

Distributed in Latin America by Librería Británica S.A.,
Villalongin 32, México 5, D.F.

Thames and Hudson · London

Translated from the German
Kunst der Maya
by Mary Whittall

Copyright by VEB E. A. Seemann Buch- und Kunstverlag, Leipzig 1968
This edition © 1970 by Thames and Hudson Ltd, London

Printed in Germany by Druckerei Fortschritt Erfurt
500 23129 x

Contents

In Memoriam Frans Blom

1 Maya country

Three times a week a small mailplane flies over the green sea of jungle which covers the greater part of the Mexican states of Tabasco and Chiapas. There is no visible sign of the sites where the civilizations of the Maya once flourished. The taciturn Mestizo at the controls suddenly speaks: '*Aquí está Ciudad Pemex*'. Mexico's newest city lies below us, in a square clearing. Oil tanks and tin huts, laid out in a geometrical pattern as sober, matter-of-fact and functional as the city's name, Petróleo Mexicano, reflect the tropical sun from hundreds of sheets of brash aluminium. From the air it is nothing more than a neat depository, finished but incomplete, inhabited but lifeless, planned down to the last detail on a drawing-board hundreds of miles away; soulless and with no history, a city of the future.

The model town vanishes into the forest as quickly as it appeared and we continue our flight. Very soon, the picture changes once again and the ancient Maya ceremonial centre *pl. 107* of Palenque lies beneath us. In less than fifteen minutes we have travelled back through fifteen centuries. The rays of the sun are reflected here from the matt white walls of temples and palaces which for centuries have withstood the rain and the sun as well as the encroachments of the greedy jungle, from which archaeologists extricated them only a few years ago.

To the pilot, ruins are ruins, but I, who have come here from the Old World, experience the same thrill as others who have thus unexpectedly come face to face with monuments of a civilization that has long since come to an end. Palenque was built for gods who are long dead, but it is immortal; its heart still beats, ruined and yet perfect, uninhabited but full of life.

When the first Europeans set foot on the ancient soil of the 'New World', most of the ceremonial centres of the Maya had already been swallowed up by the jungle, and only the very tallest buildings still towered up out of vegetation which rose to 150 feet and more. The purpose of the *conquistadores*, as one of them blandly admitted, was 'to serve God and His Majesty and to bring light to those that were in darkness, but also to acquire those riches that men are accustomed to seek'. They failed to notice any of the signs of the past splendour and magnitude of Maya civilization. Cortés, the conqueror of Mexico, passed only a few miles from Palenque and Copán on his punitive expedition to Honduras, without seeing or hearing anything of them. The chronicles of Spanish soldiers and monks, which furnish much valuable information on the Inca and Aztec civilizations, never mention the fabulous centres of the Classic civilization of the Maya.

One of the first to investigate the isolated rumours of lost cities in the jungle was John Lloyd Stephens, a New York lawyer, and a fanatical explorer. He threw up his practice and,

accompanied by an Englishman, Frederick Catherwood, a talented and painstaking artist, he journeyed the length and breadth of Maya territory in south-eastern Mexico. Both men had visited archaeological sites in the Near East and Egypt; and they were so fascinated by what they found here that they spent years in remote areas of damp, unhealthy country, undeterred by the grudging welcome they received from the scattered population. In the years 1839 and 1840 they discovered a large number of old sites. This is how Stephens describes their sensations on first coming to Copán:

> We sat down on the very edge of the wall, and strove in vain to penetrate the mystery by which we were surrounded. Who were the people that built this city? In the ruined cities of Egypt, even in the long-lost Petra, the stranger knows the story of the people whose vestiges he finds around him. America, say historians, was peopled by savages; but savages never reared these structures, savages never carved these stones. We asked the Indians who made them, and their dull answer was '¿Quién sabe? (Who knows?)'.

With the help of Catherwood's clear and accurate drawings, Stephens' vivid evocation of this strange and fabulously beautiful country and its imposing, mysterious ruins distracted public attention for a time from Egypt, Greece and Mesopotamia. But with the conquest of Arizona, New Mexico and California in the New World, the revolutions of 1848 in Europe, and the sensational spread of railways in the following years, the civilization of the Maya was once more forgotten. Their temples decayed in the green, humid jungles, and only the natives' '¿Quién sabe?', the invariable answer to all enquiries, remained unaffected by time.

It was the craze for chewing-gum which ended the sleep of the ancient palaces and temples. *Chicleros*, seeking the sapodilla trees from which the *chicle* gum is extracted, came across an amazing number of sites, and this gave a new incentive to archaeologists from many nations. The chief among these was an Englishman, Alfred P. Maudslay, who spent fourteen years, from 1881 to 1894, traversing the jungle. He made plaster casts of many stone monuments, and took a large quantity of original works back to London; there they caused a sensation. His collection is now one of the glories of the British Museum.

pls 161, 163–5

Maudslay's work marks the beginning of the scientific study of the Maya. To a great extent this has been financed by private patrons, particularly in the United States; the work has been done by trained archaeologists from American universities. Every discovery, however small, has been catalogued, disparate sites and dates have been compared with each other, hypotheses subjected to critical scrutiny. There is no place among today's professionals for romantic eccentrics like Viscount Kingsborough who, between 1831 and 1848, published a nine-volume work entitled *The Antiquities of Mexico*, in which he attempted to prove that the Indians were one of the ten lost tribes of Israel.

At the present time, approximately two million Maya still live in the region where the most brilliant of all early American cultures flourished over a period of fifteen centuries. There are about twenty tribes, whose homeland falls into three geographical zones.

The earliest to be settled was probably the highland region of Guatemala and western El Salvador. This 'land of eternal spring', as the tourist brochures call it, enjoys an exceptionally pleasant climate and is still the most densely populated of the three zones. Across

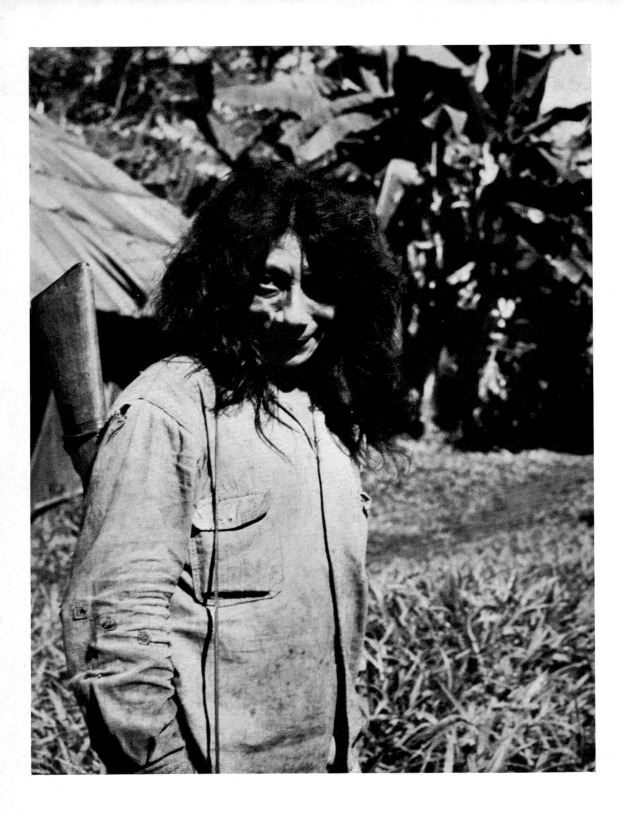

2　Yacum, a Lacandón Maya
3　The Usumacinta near Yaxchilán

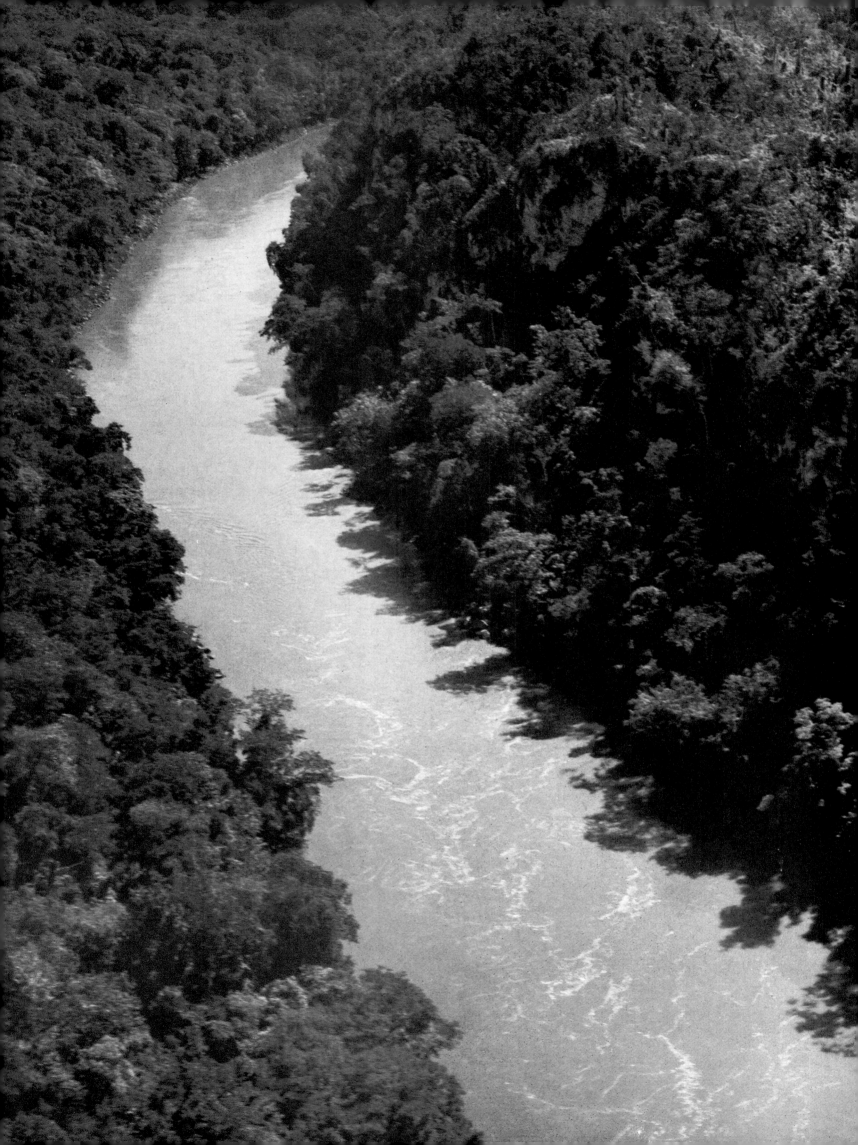

4 Two Lacandón girls beside the Lacanjá
5 Maya boy from the village of Zinacatán
 in the Chiapas highlands

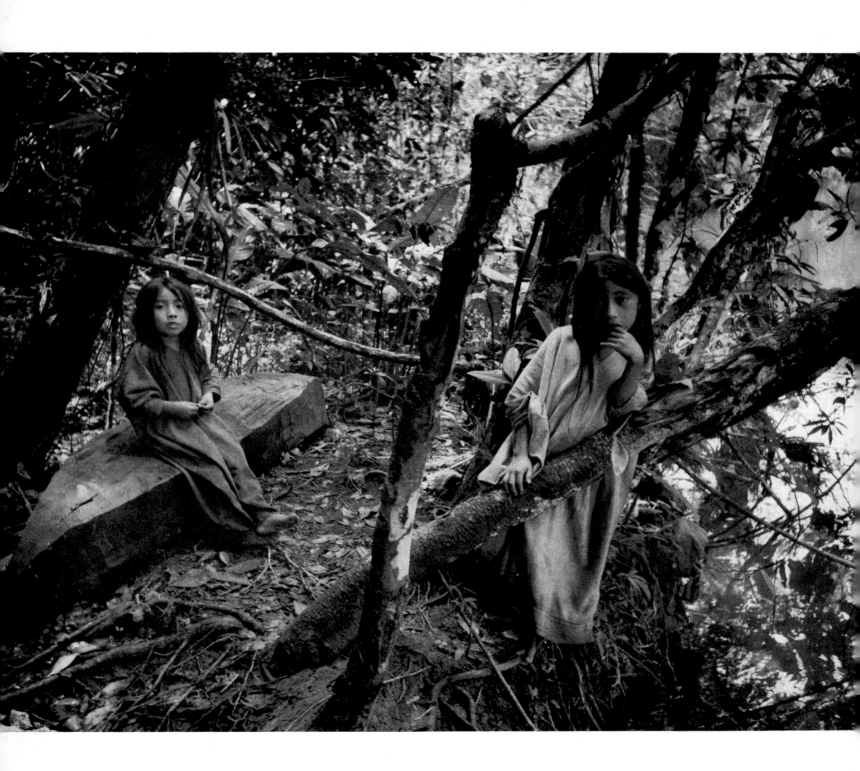

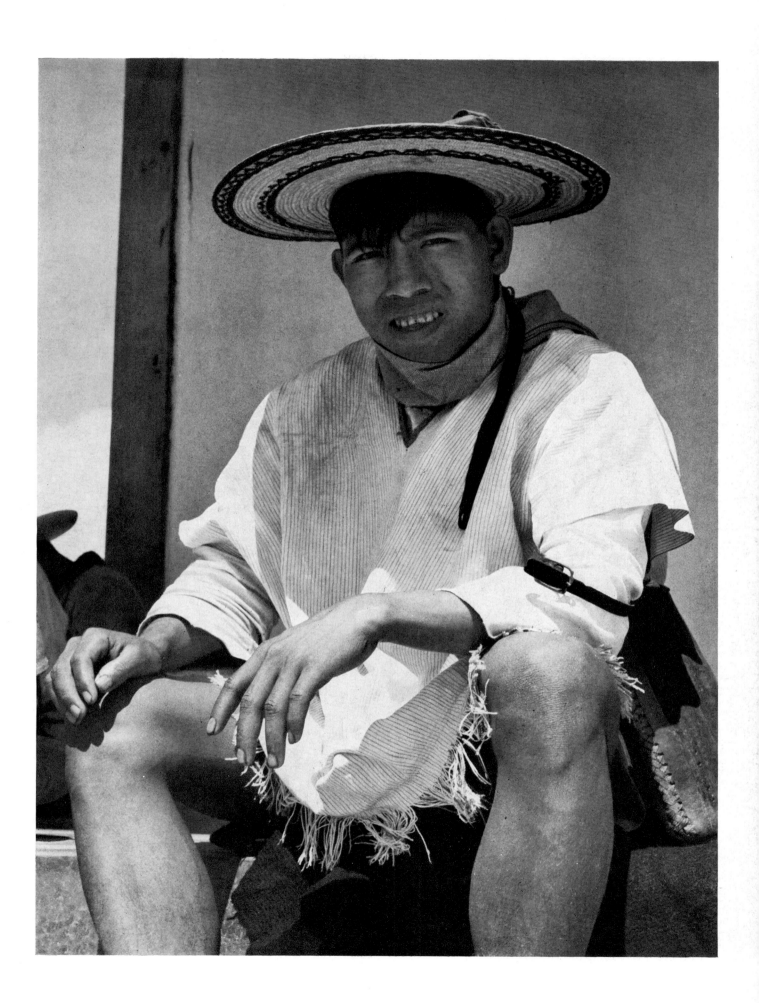

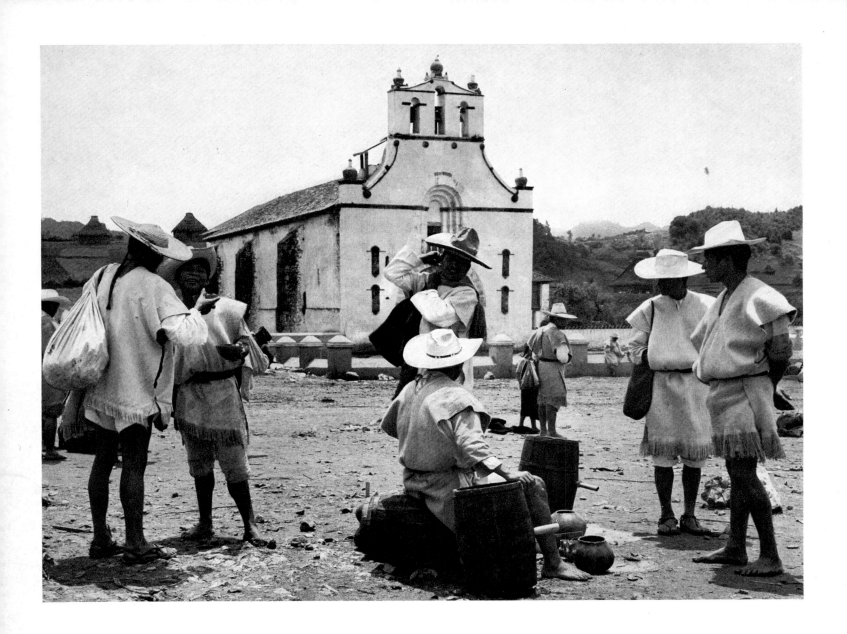

6 Market day in Chamula, a village in the Chiapas highlands
7 A Tzeltal Maya woman selling her produce in a village market
 in the Chiapas highlands

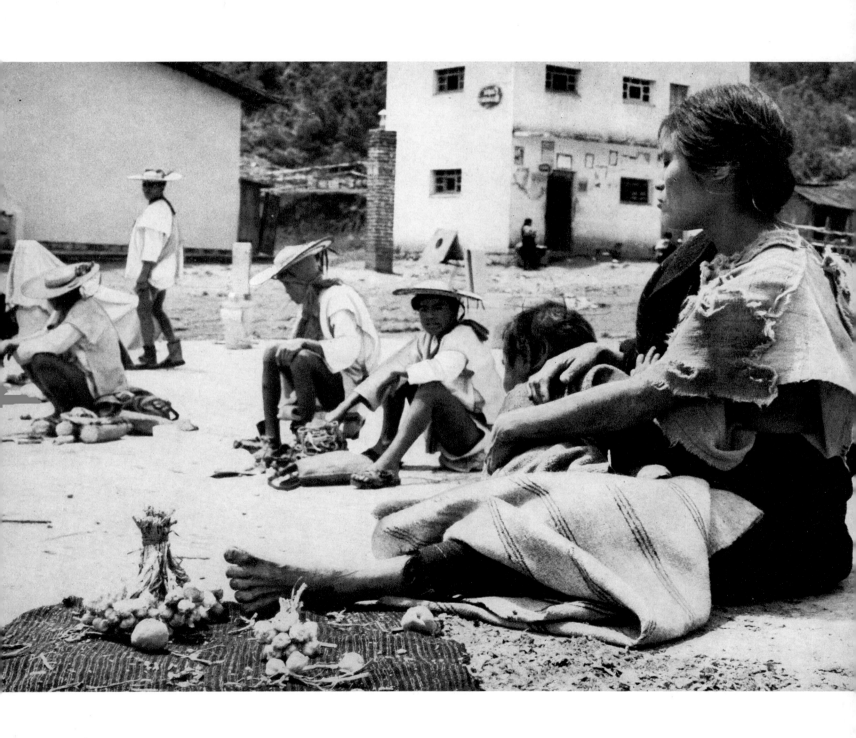

8 The main street of a village on the Yucatán peninsula

the broad plateaux and through the canyons of this mountain range ran the primeval routes which linked South and North America. It is only in this region that the influence of Proto-Classic Mexican culture can be traced.

It was almost certainly from the Guatemala highlands that the agricultural system, based on the cultivation of maize, spread into the adjoining regions in about the third millennium BC. This staple crop will flourish in almost any climate. 'If we consider it well, we will find that everything they [the Indians] do and everything they say is bound up with maize. Truly it provides almost all their needs, and they have made a god of it.' This statement, from a sixteenth-century manuscript, is still as true as ever it was. The highlands offer better conditions for living than the other two zones, where the dense vegetation is one of man's worst enemies. It is therefore surprising that the greatest monuments of Maya culture were not built there, but in the jungles of the lowlands.

figs 1, 3 The centre of Maya civilization lay in the second zone, the low-lying and now almost uninhabited forests of northern Guatemala, western Honduras, British Honduras (Belize) and parts of the Mexican states of Tabasco and Chiapas. The unhealthiness of the climate here is equalled, in the Americas, only in French Guiana and on the banks of the Amazon. Even the technology of the twentieth century has never furnished this vast region with a rudimentary network of roads and railways, the prerequisites of any further advances. And yet in these impassable forests, in the midst of rank vegetation and dangerous animals, Maya culture reached its highest level: the architecture of this region is the purest, the artistic expression the most personal. The presence of a particularly large number of inscribed stelae makes it possible to date the period of this extraordinary cultural flowering, the so-called Classic period, between about AD 600 and AD 1000.

The boundary between the central and northern Maya zones corresponds more or less exactly to the line along which the tropical rain forest gives way to the lower, but even denser bush which covers almost the whole of the Yucatán peninsula. Here, apart from one small range of hills, the whole land is flat. The ground is porous limestone, and the topsoil is seldom more than a few inches deep. Rivers are few and far between; water collects in channels four or five yards below the ground, and runs into the Atlantic without ever coming to the surface. Even today, human settlement is only possible in the vicinity of the *cenotes*, deep waterholes which have been opened up by the subsidence of the rock. The difficulty of the terrain has meant that communities have always been very isolated. Inscriptions of the Classic period are very rare, although the land was certainly inhabited by then; in the subsequent Postclassic period it replaced the central zone as the centre of Maya civilization.

The chief justification we have for recognizing the Maya Indians of today as the descendants of the people who created the civilization of the past is their physical resemblance to the figures depicted on the ancient sculpture and ceramics, and described by the earliest Spanish historians. Comparison of bones found in early graves with skeletons of the more recent past gives further substantiation. The visiting foreigner frequently sees a face in the *figs 6–7* street or the market-place which recalls one which, only a short time before, he saw on a stela, among the ruins or in a museum.

The Maya are not particularly tall, but they have long arms and legs. They are inclined

to be rather stout, and their skulls are among the broadest of any race. Their dark, somewhat slanting, almond-shaped eyes, and their high, wide cheekbones, display their kinship to the Mongoloid races more clearly than is the case with other American Indians. The colour of their skins ranges from *café au lait* to copper. Baldness is virtually unknown, but beard growth is rather feeble.

The Maya are farmers, largely cut off from foreign influences, and have therefore been able to preserve their characteristic way of life through the ages. In remote areas it has hardly altered at all in the last thousand years; even Christianity has brought no changes. The usual age for marriage is seventeen for girls and twenty-one for men. The average number of children a woman bears is eight, but nearly seventy per cent of all children die before the age of five. As with other Indian races, this high rate of infant mortality is the result of malnutrition; but the fecundity of the Maya women makes it unlikely that the race will die out.

An exception to this is found among the only tribe not to have been converted to Christianity, the Lacandón,[1] who still live in the Maya heartland, in the tropical rain forests. Sickness, inbreeding and the dangers peculiar to their uncomfortable habitat have reduced the tribe to fewer than a hundred people, who roam about in an area of some 4,500 square miles. The Lacandón are a peaceful, hospitable and cheerful people, who live in small family units and hunt and fish with the same implements that their ancestors used before Columbus. They play the same musical instruments, and worship the old gods. Religious practices and ceremonies are handed down orally from father to son. The Lacandón visit the ruined temples of their ancestors on specific festivals and sacrifice to the gods. The whereabouts of many of these temples is known only to them. There has been only one instance of their revealing the location of a temple to a stranger; this was when one of them guided an American photographer to the site of Bonampak.

figs 2, 4

The people of Yucatán are generous and hospitable, pressing food upon anyone who enters their houses. They are also extremely clean, which is not always the case with American Indians; they bathe at least once a day, and their white clothing is always spotless.

fig. 8

There are eighteen different Maya languages, bearing much the same relationship to each other as the Romance languages of Europe. As might be expected, we find the closest affinities between those spoken in territories adjacent to each other, the exception being Huaxtec, which is encountered both in the northern part of the state of Vera Cruz and in parts of San Luis Potosí, more than three hundred miles to the north-west. Archaeologists and linguists have established that the Huaxtecs are a Maya tribe who broke away from the main body of their race in prehistoric times. They did not participate in the development of the Maya hieroglyphic script, or of astronomy, and the characteristic corbelled vault does not occur in their buildings. The Aztecs, who began to exact tribute from them in the fifteenth century and tried to incorporate them in their empire, described them as naked barbarians, as lazy, drunken cowards, and as powerful magicians. Apart from the interest of their own independent artistic achievements, the chief interest of the Huaxtecs to the student of the Maya lies in the proof that, in the third or second millennium BC at least, the land inhabited by the Maya did not correspond to the region where their civilization was to develop and where they still live today.

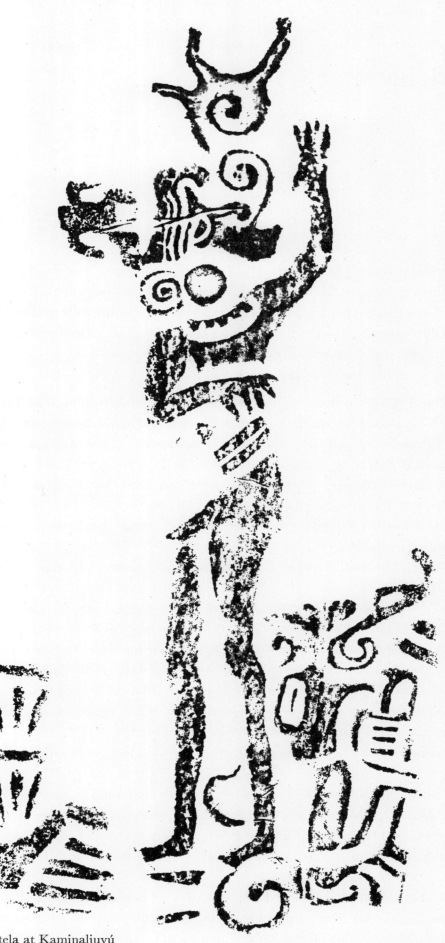

9 Rubbing from a stela at Kaminaljuyú

2 Mythical origins

The most complete version of the Maya account of the creation is in the *Popol Vuh*, the holy book of the Quiché, who live in the highlands of Guatemala. It is one of the few works of Maya literature to have survived, having been handed down orally for generations before it was finally written down. Its many repetitions have more than a rhythmic function; they also serve to impress the incidents upon the listener. The style of the epic, in its written version, is over-ornate, like the elaborate stone sculptures of the Classic era.

This is the true account, when all was vague, all was silence, without motion and the sky was still empty. This is the first account, the first narrative. There was neither man nor beast, no bird, fish nor crab, no trees, rocks, caves nor canyons, no plants and no shrubs. Only the sky was there.

The face of the earth had not yet appeared. There were only the silent sea and the sky above it.

There was nothing formed, nothing that made a noise, nor anything that moved, lived or caused a sound in the sky.

There was nothing but the silent waters, the peaceful sea, alone and calm. There was nothing there.

There was only the stillness, the silence of darkness and night. Only the creators and the givers of form, Tepeu, Gucumatz, the mother and the father, were in the waters. He was clothed in light and sheathed in green and blue feathers, and therefore was he called Gucumatz.[2] They were great thinkers and possessed great wisdom.

Then came the word. Tepeu and Gucumatz came together in the darkness, in the night; and Tepeu and Gucumatz spoke with one another. They spoke thoughtfully and were in agreement. Their thoughts and words were wedded.

And as they spoke together, they realized that when the dawn came, man must appear.

Then they planned the creation. The growing of trees and plants; the birth of life; the creation of man. That was decided in the darkness, in the night by the 'Heart of the Sky', which is [also] Huracán; [for] the first is called Caculhá Huracán, the second Chipi Caculhá, the third is Raxa Caculhá, and these three are the 'Heart of the Sky'.[3]

'Let it be done! Let the void be filled! Let the waters withdraw and make way! Let the earth be manifested and take shape! Let it be done!' they said. 'Let there be light and let it shine in the sky and on the earth. There will be neither fame nor hon-

our for what we have made and created until the race of man has been made, until man is created,' they said.

And then the world was made by them. Truly, this is how it was, this is how they created the world: 'Earth,' they said, and instantly it was there.

Like mist, like a cloud, like a cloud of dust was the creation, as the mountains rose up out of the waters.

Only a miracle, only magic power could bring the mountains and valleys into being and at the same time cover the face of the earth with cypresses and pine forests.

And therefore Gucumatz rejoiced and cried: 'Your coming was good, "Heart of the Sky", Huracán, Chipi Caculhá, Raxa Caculhá.' 'Our work, our creation shall be completed', they replied.

At first the earth was made, the hills and the valleys, then the waters were divided. The streams ran freely between the hills, and thus the water was separated [from the earth] when the high mountains appeared.

This is how the earth came to be, when it was created by the 'Heart of the Sky', the 'Heart of the Earth', as they also called themselves [after] they had made it fertile, when the sky was a vagueness and the earth was submerged beneath the water.

Then follows the creation of the beasts; and, since there was 'silence under the trees and no sound among the creepers', the gods gave the beasts voices: 'Let your speech be heard, everyone in his own manner and according to his kind. Speak our names, call upon us and praise us!' However, the animals are only able to cackle, grunt and hiss. The gods therefore degrade them and condemn them to be slaughtered and their flesh to be eaten.

'Let us try once again, for the time for sowing is near, let us make man, who will feed and sustain us. What shall we do that we may be called upon, that we shall not be forgotten upon the earth? We have already tried with our first creations, with our first creatures. But we could not bring them to honour and praise us. So let us try to make obedient, humble creatures, who will sustain and feed us,' said the gods.

Then was the creation and forming. They made the flesh [of man] of clay and earth. But they saw that he was not good. He melted, he was soft, he could not move, he had no strength and could not stand up. He was clumsy and could not turn his head, his face sagged sideways, his sight was poor and he could not look behind him. He had speech but no intelligence. He was quickly dissolved and swept away in water. And the creator and giver of form said: 'Let us try again, since our creatures neither walk nor multiply. Let us ponder this,' they said. Then they destroyed their work.

The gods make a third attempt to create beings to feed and sustain them. This time they use wood, but once more the attempt is unsuccessful. Again the gods decide to destroy them.

Suddenly the wooden figures[4] were annihilated, destroyed, broken and slain...

Because they did not think, nor spoke to their creators... for this reason the face of the earth darkened and a black rain fell by day and by night.

Then came the small beasts and the large beasts, the sticks and the stones, they all struck [men] in the face and all raised their voices: the earthenware jugs, their

dishes, their plates, their grindstones, they all rose up and struck them in the face.

'You have hurt us, you have eaten us, and now we shall kill you,' said the dogs and the turkeys.

And the grindstones said: 'We have been tormented by you, day in, day out, at night and in the light of dawn. For your sake, our bodies have cried out unceasingly, in the dark and in daylight, "*Holi holi, huqui huqui*". That was the sacrifice we made; but now you are no longer men. You shall feel our strength. We shall grind your flesh and tear you to pieces,' said the grindstones.

And then their dogs spoke: 'Why did you not give us food to eat? When you so much as saw us, you chased us and drove us away. While you were eating your meals you kept a stick ready to hand, to beat us with. That was how you treated us and we could not speak. You did not treat us kindly. Shall we not kill you now?

'Why did you not foresee this? Why did you not think of your own good? Now it is our duty to destroy you. Now you shall feel the teeth in our jaws. We shall eat you,' said the dogs and destroyed their faces.

At the same time, the hearthstones and cooking-pots said: 'You caused us pain and anguish. Our bodies were blackened with soot, we were forever being placed in the fire as if we were insensible to pain. Now you shall see: we are going to burn you,' said the pots, and they destroyed the faces [of the wooden men].

Resolutely, the hearthstones rose up from the fireplaces and hurled themselves in their faces, to destroy them. Desperate, [the men] ran as fast as they could. They climbed up on the roofs of their houses, but the houses collapsed and they fell to the ground. They tried to climb trees, but the trees shook them off. They ran to caves but the caves closed their entrances against them.

This was how the men that were created and formed were destroyed. They were made to be destroyed and annihilated; their mouths and faces. Everything in which they were wanting.

But it is said that the monkeys, which now live in the forests, are their descendants, for their flesh [too] was made of wood by the creator, and that is why the monkey so resembles man, and is the example of the race of men that were created and made and [yet] were nothing but wooden figures.

The fourth and last attempt by the gods to create beings to feed and sustain them is successful. This time man is made from maize, brought by the animals from beyond the mountains.

First, so the story goes, the gods formed four men out of maize dough.[5] But the creatures were too perfect. They could see to the furthest corner of the earth and were too like the gods. The gods would not tolerate creatures like themselves, and therefore veiled the men's eyes with a slight mist. The four men were greatly saddened by this. To cheer them up again the gods gave them four women. Thereupon, the first men were happy with what they could see, and from then on they paid their gods and creators proper respect.

The descendants of these men are the Quiché Maya, who live in the mountains of Guatemala. One of them wrote down the ancient oral tradition, the *Popol Vuh*, in the seventeenth century, in his own language but using the Latin alphabet.[6]

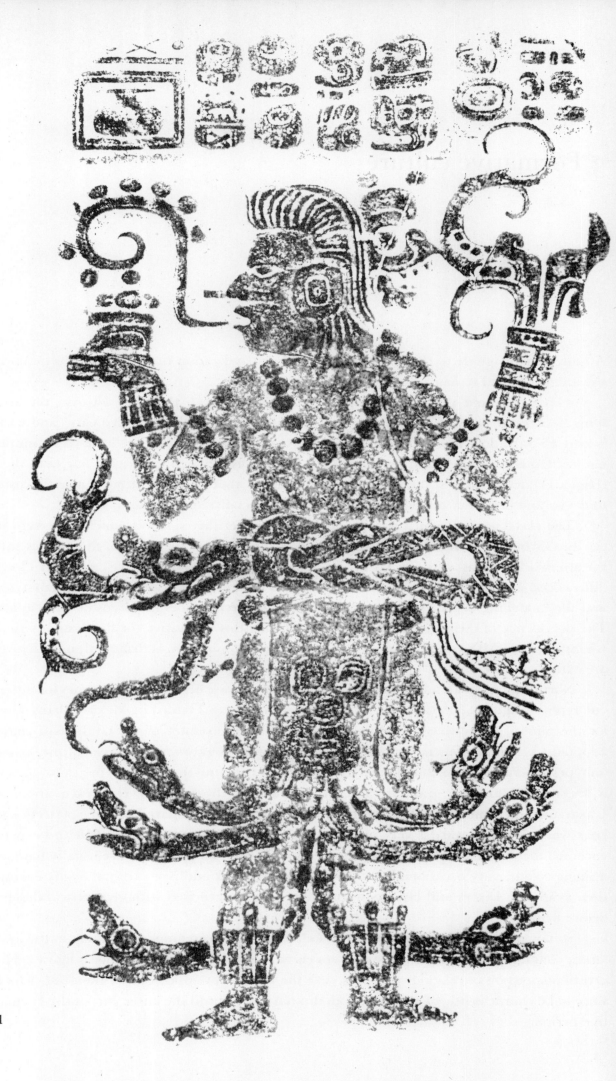

10 Rubbing from a stela at Seibal

3 Formative culture

A more reliable guide to the development of Maya civilization than the myths is found in the archaeological remains.

Three thousand years ago living conditions were much the same all over the area lying between the city of Teotihuacán (thirty miles to the north of Mexico City) and what is now El Salvador: where the soil and other conditions were suitable, little communities had settled and cleared land for cultivation in the forest. Their gods were few, and their religious concepts were still very vague. It is unlikely that they had either a priestly caste, to devise and carry out religious ceremonies, or a specialist artisan class.

The clay figurines which date from this period, fertility symbols which were kept in the huts or buried in the fields, or effigies made to accompany the dead on the journey into the afterworld, are all very similar in appearance. Only the practised eye can discern local differences. The little female effigies are all naked or clad in loincloths: only the hairstyles, and the modelling of the eyes, distinguish figures made in places hundreds of miles apart. The prevalence of these figures suggests that, during this Formative (or Preclassic) period, communities in Mexico and Maya territory were predominantly matriarchal; male figures are extremely rare.

North American archaeologists (who have coined some breezy but apt names for different types of figures: 'pretty lady' for the female figures of Tlatilco in Mexico, 'baby-face' for the plump, infantile types prevalent in the 'Olmec' country of the Gulf Coast) have adopted a system of nomenclature for the various phases of Formative Maya culture, based on types of ceramic ware, and named from the *Popol Vuh;* thus the earliest type (1500–300BC) is known as Mamom ('grandmother'). It is found at the lowest level of excavations at Uaxactún, and some has recently been discovered at Tikal. Compared with the perfection of later work, Mamom ware is very primitive, betraying the potters' lack of skill and experience. All the pieces found to date are broken sherds. The simple vessels are usually painted a single colour, very occasionally two. Red, orange, black and ivory were the only colours then available. Dishes and beakers were painted red and incised with geometrical designs before firing.

So far, not a single grave of the Mamom phase has been found, anywhere in the lowlands, containing more than a few clay vessels or deliberately broken ('killed') figures. The artistic expression of religious concepts, and the highly developed cult of the dead, which were to be characteristic of a later period, did not evolve until the latter part of the Formative period.

The highlands appear to have achieved a higher level of civilization in the Formative period than the lowlands (in the Classic era, the balance was to be reversed). The highlands, where the soil was fertile and the climate agreeable, supported a considerable population. Gradually an élite began to emerge, exercising a power that was primarily religious in origin. As early as the Formative period, a great religious centre, which may also have been a seat of secular power, arose on a site on the outskirts of the modern capital of Guatemala. Its name, Kaminaljuyú, means, in the language of the Quiché Maya, 'Hill of the Dead'. One of the pyramids of *adobe* (sun-dried brick) on the site measures approximately 230 × 300 feet at the base. So large a structure dating from so early a period came as a surprise to the archaeologists; an even more startling find was the contents of two graves at Kaminaljuyú, in which two men of high rank had been buried with their wives (or sacrificed slaves), and with 345 objects of various kinds in one grave and 200 in the other. These grave goods comprised clay figurines, pots, numerous bone and obsidian utensils, ornaments made of jade and seashell, and some of the curious stone carvings known as 'mushroom stones'. It is not known what purpose these carved stones, peculiar to the Formative period and confined to the highlands, originally served.[7]

pls 5, 6

The Formative period seems to have lasted much longer in the highlands than in the heartland of the Classic Maya civilization, the tropical rain forests of the Petén in northern Guatemala. No evidence of the custom of recording dates on monuments, which presupposes a calendar and a script, has been found at Formative sites in the highlands. These, at least the later ones, reveal systems of fortification built around temples, which were raised on pyramidal stone bases. The temple buildings themselves were of perishable materials, and none has survived. The style of architecture is fairly uniform throughout the highland region, and altered very little right up to the Spanish conquest. While the function of Maya buildings in the lowlands was predominantly religious, the greater proportion in the highlands were of a secular nature. Excavations made up to the present time give the impression that religion did not play a dominant role in the life of the highland Maya.

The next phase, chronologically, in the Formative development of Maya civilization is found in the lowlands, where Mamom ceramic ware was succeeded by the Chicanel type. The word means 'the concealer' and no more apt name could be found for a style whose origins are so obscure. As with Mamom, the most important finds of Chicanel ware have been made at Uaxactún. It was produced during a period of transition and experiment, which led to many new forms and a fundamental improvement of firing techniques. The production of

figurines went out of fashion during the Chicanel phase, but the good state of preservation of many of the finds partly makes up for this.

It was during this phase that Maya religious concepts lost their vagueness; religion now came to be organized to serve the interests of a ruling élite which determined the forms and ceremonies of worship. This is proved conclusively by a single building which, for all the precision of its construction, is quite without technical or stylistic prototypes anywhere in the Maya homeland. Found beneath Building VII of group E in Uaxactún, it is a richly decorated, layered pyramid, known prosaically as 'E-VII-sub'. The superimposition of a later pyramid preserved its plaster facing. The temple on top of E-VII-sub, to which flights of steps led up on all four sides, was built of wood and has not survived.

The most astonishing feature of the pyramid is the sequence of jaguar masks, carved from stone and faced with plaster, which line the flights of steps; these faces are quite foreign to the Maya. The only objects bearing any relationship to the jaguar masks of Uaxactún are relics of the Olmec civilization whose centres lie on the southern Gulf Coast at La Venta, Tres Zapotes and Cerro de las Mesas. The influence of this early civilization can be detected in both Mexican and Maya art through its trade-mark, the so-called 'were-jaguar' facial type, in which elements of jaguar and human baby are mingled in varying proportions.[8]

On my desk there is the clay head of a child, only an inch or so high. It may hold, like the many other objects found in Olmec graves, the clue to the mystery that surrounds the origins of Classic Maya civilization. This mute witness to a great Indian past has the plump cheeks of a Bavarian baroque angel. It is not at all the face that one would expect to find at the starting point of Mesoamerican civilization.

La Venta, the centre of Olmec civilization, is no longer archaeological *terra nova*, thanks to the colossal monolithic heads and other stone monuments, some weighing tons, whose raw materials must have been fetched from quarries over fifty miles away. Because of their size, they were never completely buried or overgrown even during the ensuing two thousand years. American and Mexican archaeologists have now built up a fascinating picture of this culture. Their researches have established that the ancient Olmecs ('people from the land of rubber', from the Aztec word for rubber, *olli*) determined the traits of many of the central Mexican and Maya religions, developed the calendar, and laid the foundations of the hieroglyphic script. A stone monument from another Olmec site, at Tres Zapotes, is inscribed with a date corresponding to 31 BC by our reckoning, and the date on an Olmec jade sculpture found at San Andrés Tuxtla shows it to have been made in AD 162. These are the earliest recorded dates of the New World.[9]

fig. 26

Little clay heads like the ones I collected at La Venta (they were buried so deep that they escaped the archaeologists' spades altogether, only to be churned up by the bulldozers of the oil companies) tell us as much as great stone monuments, yards high. Experience has shown that nothing was made without a reason, that everything had some magic or religious significance, and these effigies are believed to be those of sacrificial victims. It is an illuminating interpretation. It is highly probable that this inventive race, who seem to have developed the calendar and hieroglyphic script, who built pyramid platforms and dated stone monuments, also instituted the rite of human sacrifice, which was later common through-

out Mesoamerica. Everything found at La Venta and similar sites suggests a sophisticated religion. The great, square, earth pyramid at La Venta is several centuries older than the earliest Maya construction. On the north side there is a huge plaza, 165 × 205 feet, where the people used to congregate for religious ceremonies. The finds made in the burial grounds leave no doubt that a cult of the dead was practised. In Cerro de las Mesas no fewer than 782 jade figurines were found in one grave.

Olmec art and the society it reflects flourished for centuries before the beginning of the Christian era. Its expressive power and technical expertise are the fruit of a longstanding tradition. At its height its influence extended from the highlands of Mexico and Oaxaca to the coast of Honduras and into the mountains of Guatemala and western El Salvador; jaguar or 'baby-face' representations in art are distributed all over this area. These distinctive features of the Olmec 'mother culture' (as Covarrubias aptly calls it) disappeared again as independent local cultures evolved. The frequent depiction of warriors on Olmec monuments suggests that the spread of Olmec culture went hand in hand with military conquest.

We do not know where the Olmec people came from, nor do we know the reason for the abrupt end of their civilization. But it was from that civilization that the Maya tribes[10] in particular took what appealed to them and what they needed: the technique of jade carving, the construction of pyramids and broad plazas and the erection of stone monuments with dates incised on them. They adopted and improved the hieroglyphic script and brought the calendar to a pitch of accuracy that far surpassed not merely the comparable projects of other American tribes but also all the calendars devised in the Old World up to the end of the Middle Ages.

12 Rubbing from a lintel at Yaxchilán,
depicting two priest-kings in ceremonial dress

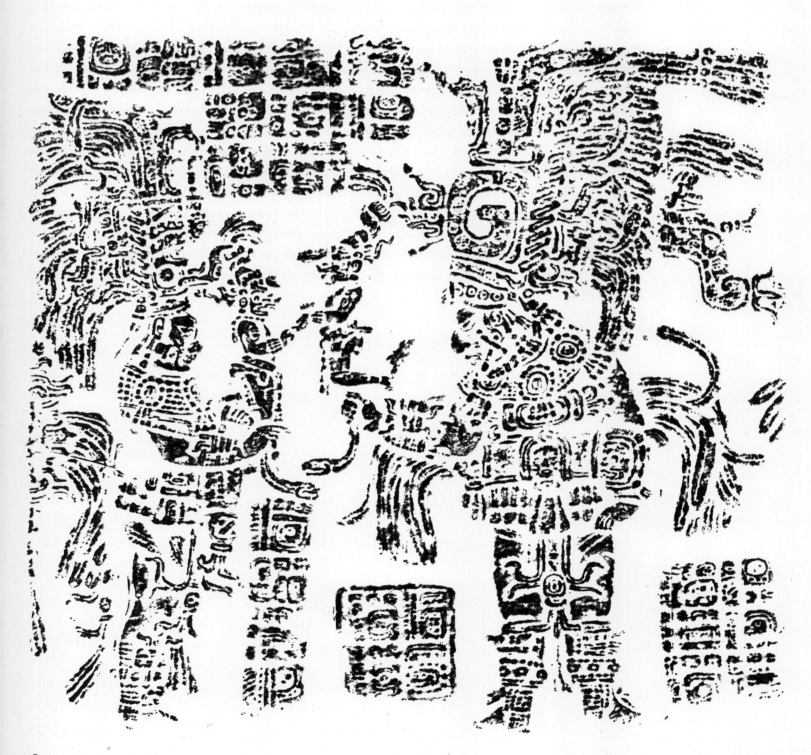

4 Classic culture

Maya civilization moves from the realm of legend into history at the beginning of the Early Classic period, in the second century AD.[11] Of the centres which arose all over the region settled at this time, the earliest, and greatest, was Tikal. Surrounded on all sides by the impenetrable rain forest, Tikal was both the geographical and spiritual centre from which the new civilization spread westwards to Palenque and Comalcalco, eastwards to Quiriguá and Copán, north into the heart of the bush country of Quintana Roo and south as far as the foothills of the Andes. The social structure of the Classic Maya civilization was based on a broad stratum of village communities, bound together by religious, social and economic factors and ruled by priest-kings, who lived in the temple-cities.

The Early Classic period is marked, in architecture, by the invention of the corbel vault, which enabled massive buildings with thick walls to be constructed. The ceramics of this period are as different from earlier ware as the shimmering colours of a tropical butterfly are from the greys and browns of a moth. Even in the absence of the buildings and stone monuments, the pottery alone would be sufficient evidence of the beginnings and development of an advanced civilization.

Thanks to the Maya astronomers, we possess an almost unbroken sequence of calendar inscriptions from the Early Classic period onwards. Richly decorated and dated stelae were erected in the great religious centres at regular intervals, at first at the end of each *katun* (a period lasting approximately 19 years, 7 months), then at every half-*katun* (9 years, 8 months) and eventually at every quarter-*katun* (4 years, 9 months). The sculptors must have spent years working on the massive stelae (free-standing carved pillars) with their stone tools. A stela discovered at Tikal in 1959, bearing a date corresponding to AD 292, is the earliest component of a chronological record in stone which continues up to AD 909. At the present time, only about one-third of the symbols which occur on the Maya stelae have been deciphered, and those are for the most part calendar and date symbols; it is not yet known for certain whether the rest of the inscriptions are of an historical or a religious nature. The state of our knowledge has hardly progressed since Tozzer pointed out in 1921 that, on the one hand, we do not yet know in which of the many Maya languages the inscriptions were written, and, on the other, these languages themselves have changed since Classic times.[12]

The root of this civilization was the calendar devised by the priests. It gave them a power over men and nature which is perhaps not immediately apparent to members of a modern mechanized society, living in a temperate zone. In Mesoamerica, the tropical sun, the sea

pl. 16

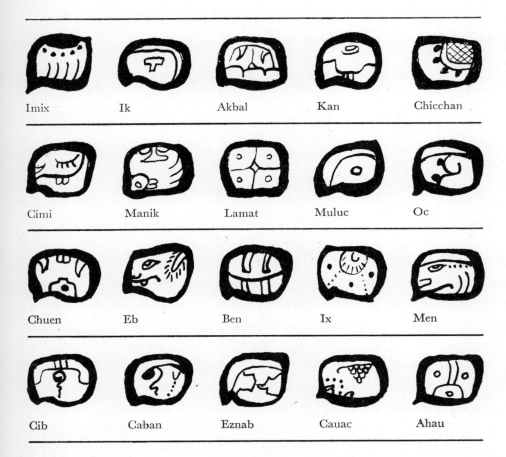

Imix	Ik	Akbal	Kan	Chicchan
Cimi	Manik	Lamat	Muluc	Oc
Chuen	Eb	Ben	Ix	Men
Cib	Caban	Eznab	Cauac	Ahau

13 Day glyphs, from the *Codex Dresdensis*

and the mountains work together to produce an unvarying rhythm of wet and dry seasons. The priests, keeping a close watch on the heavens and the march of time according to the stars, must have become aware of this at a very early stage. They used their knowledge to tell the peasants when to start clearing land in the forest, in August, while the rainy season was still on. The peasants worked in groups of ten or fifteen, using stone implements to hack down the centuries-old vegetation. When they had made their clearing they sacrificed to the gods, again by order of the priests. During the whole of the dry season, a period of nearly five months, they were employed in public works, the construction of temples and palaces, roads and plazas, while the newly felled trees and the stalks and shoots left over from the last harvest dried in the fields. The precise moment for burning all this was a matter of the greatest importance. If the order from the priests came too late and the rains set in, there would be famine for a whole year, until burning was possible again. The soil of the tropical forests is far less fertile than that of temperate zones: it takes about a third of a square mile of jungle soil to support a single person. As the Maya knew nothing of manures,[13] the soil was quickly exhausted, yields being reduced by a third in the second year of cultivation and by well over two-thirds of the original crop in the fourth year. New fields had then to be cleared by the same 'slash-and-burn' method. The Indian peasants bowed to their fate, sacrificed to the gods, built temples for them and subjected themselves to the priests.

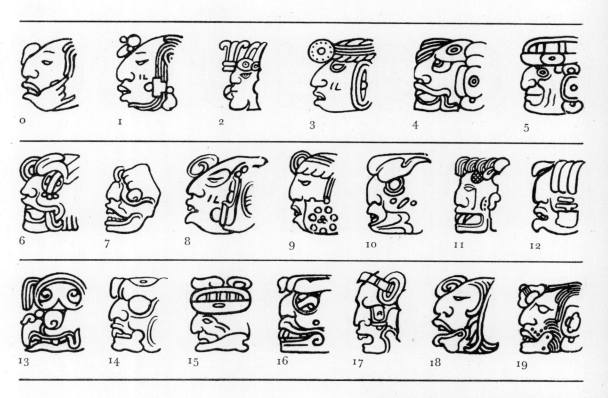

14 Head-variant numerals from 0 to 19

The Maya calendar, the greatest scientific achievement of pre-Columbian America, is the creation of a race of men who had to pit all their intellectual and physical energies against their merciless tropical environment. To the different units of the calendar was ascribed the patronage of individual deities. The few, indeterminate gods of the Formative period being no longer sufficient, many more were called into existence, but although their hieroglyphs are preserved, only a small number have been identified. The calendar thus came to have a profound religious significance, while serving a politico-economic function. The gods and time were one and indivisible for the Maya, who continued to personify the units of time long after the Spanish conquest.

The oldest dated monuments of the Olmec civilization show that the basic concept of a calendar antedated the Classic Maya civilization by many centuries, but the mastery of mathematics displayed by the Maya astronomers in perfecting the calendar should not be underrated. On the contrary, if we assume that the Mesoamerican calendar was the invention of the Olmecs, as seems most probable at the present stage of archaeological research, and bear in mind that their influence was extended over a number of tribes, it is the more astonishing that the Maya were the only race to develop it further. The Zapotec, Toltec, Mixtec and Aztec cultures all failed to realize that time is a manifestation of the movement of the universe. Only the Maya understood that time is a physical, not an abstract, phenomenon, whose mysteries could be revealed by constant observation of the stars. This

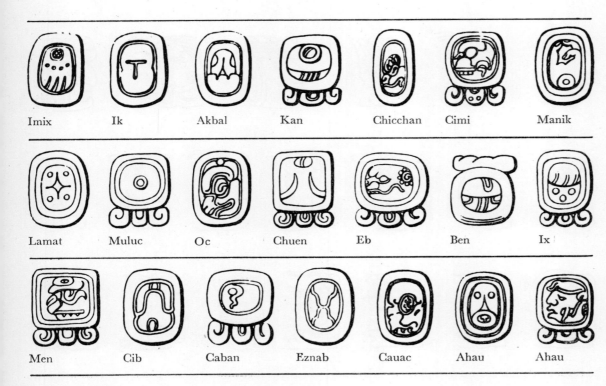

Imix	Ik	Akbal	Kan	Chicchan	Cimi	Manik
Lamat	Muluc	Oc	Chuen	Eb	Ben	Ix
Men	Cib	Caban	Eznab	Cauac	Ahau	Ahau

15 Day glyphs

comprehension of the rhythm that governs the motion of the sun, moon and stars dispelled the superstitious fear of time as a daemonic power and allowed the Maya priests to regard the forces of nature in a completely different way. By contrast, the Aztecs, whose civilization rose to its height in the centuries following the decline of the Maya, believed that at the end of each cycle of 52 years, or 18,980 days, the world was liable to come to an end. All fires had to be extinguished, all household goods smashed, and countless sacrifices – vegetable, animal and human – made to persuade the gods to grant a reprieve for another 52 years.

In the Maya calendar there was in theory no day, past or future, which did not have its own, unique date. Their estimate of the length of the solar year – and this is perhaps the most astonishing feature of this essentially 'Stone Age' culture – differed from the modern measurement by no more than 0.0002 per cent! Such accuracy could be achieved only by constant observation over a very long period.

It is not known precisely when their calendar reached the definitive form prevalent in the Classic culture, since the earliest inscriptions have not survived. The many stone stelae without inscriptions are generally taken to have preceded the inscribed ones, and it is assumed that they were originally faced with plaster and bore painted inscriptions and dates.

A prerequisite of the consistent reckoning of time is a fixed starting-point. In the Old World, Christians base their calendar on the year of the birth of Christ and Mohammedans on the year of Mohammed's flight from Mecca in AD 622. The Greeks counted from the year of the first Olympiad (776 BC), the Romans from the foundation of their city (753 BC),

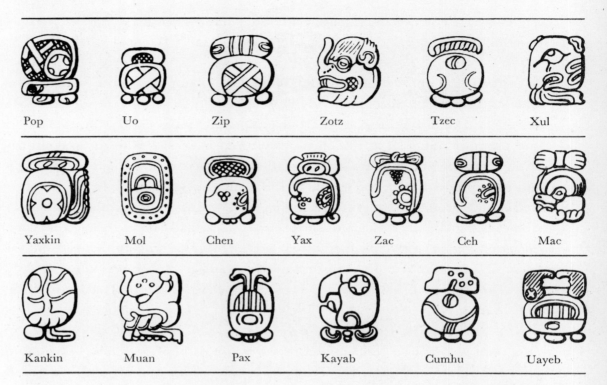

| Pop | Uo | Zip | Zotz | Tzec | Xul |

| Yaxkin | Mol | Chen | Yax | Zac | Ceh | Mac |

| Kankin | Muan | Pax | Kayab | Cumhu | Uayeb |

16 Month glyphs

the Jews from what they believed to have been the date of the creation (3761 BC). The Maya followed a line of thought similar to the Jewish, but they still allowed for the possibility of previous creations. Their calendar begins with a date arbitrarily designated 13.0.0.0.0. 4 Ahau 8 Cumku, and, with two or three exceptions, their calendar calculations are based on that starting-point.

The exact correlation between the Maya calendar and our own is still disputed. Of those that have been advanced, two stand out as the most likely: that of Herbert Spinden, which calculates their starting-point as 4 October 3373 BC, and the Goodman-Martínez-Thompson correlation, which puts it at 12 August 3113 BC. Recent radiocarbon datings of wooden lintels from Tikal seem to confirm the Spinden correlation, but there are still many other factors to be reconciled before it can be accepted fully. The dating used in this book is based on Goodman-Martínez-Thompson.

No attempt will here be made to describe the Maya calendar – strictly speaking there are four separate calendars – in detail. This would take a substantial book on its own.[14] Suffice it to say that the further archaeologists have penetrated into its secrets, the greater has grown their admiration for the mathematical ability of these people, who were already using the digit 0 in compound numerals centuries before mathematicians in India, and whose astronomical calculations cannot be matched by any other comparable civilization.

The numerals and the script were a source of ornamental material to the unknown artists who decorated the great buildings in the same manner as they did the stelae. Had their skill been less, their good taste less confident, the wealth of ornament might seem excessive. But skilful arrangement and ingenious distribution of their material, coupled

with the greatest care in execution, ensure that the omnipresent decoration is always of the highest artistic standard.

> It is in the very nature of ornamental art that it is the purest form of expression of a people's artistic ideal. Simultaneously, it is a paradigm, in which the specific characteristics of the absolute artistic ideal are made plain. This is enough in itself to demonstrate the importance of its role in the development of art. It ought to constitute the starting point and the foundation for all considerations of art and aesthetics, which could then proceed from the simple to the complex. But instead, figurative art is preferred on the grounds that it is the 'higher' art, and every unformed lump and every scribble, being the earliest artistic expressions, are made the starting point for historical investigation, although they reveal nothing like as much of a people's aesthetic gifts as ornamental art. This is yet another example of our prevailing bias, which leads us to approach art from no other viewpoint but that of content and the imitation of nature.[15]

The young man who voiced this opinion in his doctoral thesis over fifty years ago might have found one of his most rewarding examples in the ornamental art of the Maya. But at that date it was completely overshadowed by the art of Egypt, Greece and Rome, to the extent that the curator of the Louvre, M. Longpérier, was obliged to display specimens of pre-Columbian American art wherever he could find room for them in his own office, because the directors of the museum refused to recognize their artistic merit.

The Chinese are the only other people whose art embraces a like wealth of ideas, but even they did not translate such prosaic elements as numerals and letters into so rich a fund of artistic forms, nor make them the source of a consistent scheme of ornamentation. The decoration which forms part of every single work of Maya art is very rarely purely ornamental, nor is it 'the simple, from which to proceed to the complex'. It is an essential element, indeed it is *the* essential element, being both the idea that the work is meant to convey and simultaneously the expression of the idea.

There is no Rosetta stone, no key which might unlock the secrets of Maya inscriptions. If the calendar, which itself took so long to unravel, is any kind of criterion, there is not a single element, however small, in this art, which is without symbolic significance. Of the religious and historical books of the priests, those which time and the elements did not efface were destroyed as works of the devil by the missionary zeal of the Spanish conquerors. Only three books, continuous folding strips, were fortunate enough to escape the bonfire, and the symbolic nature of their content and the intractability of the script continue to defy all attempts at deciphering the text. Ironically, the chief responsibility for the burning of the Maya books rests with Bishop Landa, whose *Relación de las cosas de Yucatán*, written shortly before his death, made it possible to decipher the hieroglyphs used in the inscription of dates and to unravel the calendar system. If the tropical climate and religious intolerance have prevented us from comprehending one of the most communicative and intellectual of all arts, further excavation work may yet change the situation. Scientific study of the Maya has been in progress now for forty years, and the results have been so

fruitful that there is good reason to hope that even quite detailed aspects of this civilization will eventually be clarified; the sheer number of surviving structures and monuments is much greater than, for instance, in Greece.

Before embarking on a survey of the hundred or more outstanding sites, it will be as well to make a few general observations on an art which is so foreign to us. In the Classic and the Postclassic period alike it was always a religious art. The motive for the construction of the temples, the decoration of their façades and the carving of the stone images of the gods was the desire to propitiate the supernal powers. This also inspired the idea of treating the dead as intermediaries between the living and the 'Nine Lords of the Underworld' and of giving the deceased propitiatory offerings to take with them. What we call Maya art was not art in the eyes of the Maya themselves – none of the Indian languages has words for 'art' or 'artist'. It was a prayer in stone or clay, a hymn to time (which passed as the gods directed), and an act of homage to the priest-kings set in authority over men by the divine powers. Man himself is depicted almost exclusively as a participant in religious rites, in idealized forms similar to those of the gods. His face is hidden behind a rigid mask. Human emotions, such as sorrow or joy, depicted in Aztec art for instance, are not represented here; to this rule, pictures of prisoners on stelae or frescoes of a relatively late date provide the few exceptions.

The priests kept themselves apart from the people. All their energies were devoted to the propitiation of the gods, whose immeasurable superiority conveniently absolved the priests of any responsibility when the forces of nature, personified by the gods, proved obdurate.

The pyramids, which rose higher in every generation, and the stelae erected regularly every twenty, then ten and finally, in some places, every five years, were religious works, carried out on the orders of the priest-kings and to their specifications. Thus Maya art, combining as it does the exuberance of Indo-Iranian, the static balance of Egyptian and the decorativeness of Chinese art, was founded on dogma. When some outstanding personality emerged to dominate his age and succeeded in opening new vistas in the established cosmology, then innovations in art, too, could result. In the course of a few generations, such an innovator was deified, equipped with appropriate attributes and a recognized iconographic, symbolic form, and the whole process was enveloped in a veil of legend. Kukulcán, 'feathered serpent', whose name has been preserved and whose image appears on many buildings in Yucatán, was originally a Toltec chieftain.[16] It is my belief that the young maize god, whose features always follow the same type, was likewise originally an actual person.

Since all its terms and conventions stemmed from an unbroken tradition controlled by a privileged class, Maya art is, to a very great extent, a statement of certain basic ideas. It reflects religious concepts as much as current ideas of beauty. The nameless artist never had the opportunity to express his private thoughts in his work. Bishop Landa relates that the artists withdrew into separate houses, where they fasted and observed strict continence and other rites of self-denial until their work was completed. If they broke these rules, the work was defiled, which boded ill for the community.

For all its uniformity, Maya art varies from site to site. Each has its own characteristics, principally determined by the taste and requirements of the ruling class, but also to

17 An 'altar', Copán

some extent by the geographical environment. Each displays, particularly in the position-
ing of the buildings and the great stelae and altars, a well-developed sense of the proper
relationship between architecture and landscape. If one of the slender stelae at Quiriguá
were to be transferred to Copán, it would conflict with the over-all effect there; a temple
from Tikal would destroy the compositional balance at Palenque. There was thus a rivalry
based on a desire to preserve the uniqueness of each site; this resulted in individual works
of art which transcended dogmatic limitations and formal conventions. The danger of rigid
monotony was in any case evaded by man's innate dislike of uniformity or, to express it in
more positive terms, by his delight in ringing as many changes as possible within defined
limits. The traditional belief of the Navaho Indians, that the gods would destroy man's abili-
ties if he copied an object with slavish accuracy, might explain the variety and originality
of all Indian artifacts, and especially of the artistic creations of the Maya. Their buildings
and their works of art are in tacit harmony with their natural environment and as little
repetitious as nature itself.

The luxuriance of the tropical rain forest is reflected in the formal elaboration of Maya
art, in the dense compression of figures, ornaments and hieroglyphs, in its *horror vacui*, in
its ingenious fantasies. It is reflected in the abundance of religious and mythological sub-
jects, chief among them the daily drama of the birth, ascent and death of the sun god, who is
swallowed up nightly by the Jaguar of the Night Sky. Surprisingly, there is no trace of the
eroticism which is such a feature of the art of, say, ancient China and South-East Asia.
In this respect, Maya art is reserved, modest to the point of prudery. Nudity is very rarely
depicted, and occurs almost exclusively as a sign of the humiliation of prisoners.

Mature art is already foreshadowed in ceramics of the Early Classic period. Ware of
the Tzakol ('founder') phase (AD 292–633) appears at the same time as stelae assume their *pl. 60*
distinctive form and the first monumental buildings are erected. The principal colours
are red, black and orange. Free-standing figurines of clay are rare; they generally incorpo- *pl. 15*
rate some kind of vessel. The Tepeu ware of the Late Classic period (AD 633–909), when *pls 61–2*
pottery as an art form was at its height, follows the same convention, but now the clear,
geometrical lines of the Classic ceramics tend to be replaced by elaborate ornamentation or
detailed narrative scenes, depicting public events. Tepeu vessels are decorated with natural-
istic representations of ritual hunts and religious ceremonies, incised in relief or painted.

pls 64–5
pls 67, 70
These paintings, murals in miniature, like the stelae, serve to glorify the ruling class, whose status verged on divinity. But in the later part of the period the first shadows began to fall, preceding the dissolution and abandonment of the chief sites. When the curtain rose again after a century, a new and completely different kind of ware was being produced on the Yucatán peninsula, in which the rich colours of the earlier ware were replaced by relief and incised decoration.

In general, these comments on the fine arts also apply to Maya architecture. Both religious and secular architecture of the Classic and Postclassic periods was largely plastic, its chief concern being the construction of façades conceived in plastic terms, rather than the enclosure of space, as in European architecture. Even the largest temples and palaces contain only a small number of narrow, passage-like rooms, which were prevented from being any wider, in the Classic period at least, by the use of the corbel vault.

The Maya sites were not cities in our sense, but purely religious centres, composed of temples for the gods, palaces for the priest-kings and houses for the astronomers and artists. The ordinary people were dispersed over a wide area, living near their fields in small wooden huts thatched with leaves; normally they came to the 'city' only for religious festivals, for attendance at sacrificial ceremonies and prayer, and for the ensuing market. Even so, large numbers of them must have been employed throughout the year, except when their presence in the fields was absolutely essential, building, extending and rebuilding, to meet the priests' apparently insatiable demands. Great mounds of earth had to be shifted, stone transported from quarries miles away, and the massive structures erected solely by manual labour.

fig. 51
The actual positioning of various buildings appears to have been carefully worked out to astronomical ends. The relationship between three temples and two stelae at Uaxactún permits the precise orientation of the sun's position at the equinoxes and the solstices.

Not only various Mexican and Central Andean peoples built temples on top of pyramids; this practice was also a feature of the 'Old World' civilization of the Sumerians. The pyramid is a visual symbol of the infinite distance between earth and heaven, between men and the gods. The pyramids of the Maya are among the most beautiful and the most elegant ever built. Their steep and majestic stairways make them look far taller than
pl. 121
their actual height. The temples themselves are relatively small and contain only a few narrow rooms. They are crowned by lofty, gabled roofs, whose function is optical rather than structural, counteracting the bulk of the pyramidal base. It is hard for us to realize that these buildings, the stelae and the altars were all, as in Greece, originally painted in brilliant colours, The cruel light of the sun and tropical downpours have denuded the façades and, unfortunately, caused almost all the frescoes which originally decorated the numerous interiors to disappear as well. The Indians' abiding love of bright colours can, however, still be seen in their dress and in present-day folk art.

pl. 168
Maya mural paintings are genuine frescoes. The colours were applied on a layer of plaster 1–3 inches thick while it was still damp. Chemical analysis of the paints shows them to have been mainly made up of minerals; calcified stones and iron and copper oxides. Superficially the paintings resemble Egyptian frescoes in execution and technique. The colours are flatly applied, without any attempt to reproduce highlights or shadow. The

most common subjects are religious ceremonies. The human figure is always shown frontally and the head in profile. The frescoes are seldom the work of a single artist; in her analysis of those in the Temple of the Warriors at Chichén Itzá, Ann A. Morris has established that at least fifteen artists were involved, probably under the supervision of a single master.

Maya architectural techniques remained unchanged for centuries; but after the Toltec invasion, when pillars began to replace the corbel vault, it became possible to construct broad halls. Many of these pillars still stand, but the roofs, made of perishable materials, *pl. 257* have long since vanished. The round arch, which dominated the architecture of western Europe from Roman times onwards, was unknown to the American Indians, but this limitation need not lessen our admiration for the remarkable achievements of the Maya.

A site which in recent years has received a great deal of publicity is Tikal; here scholars from the University of Pennsylvania, and Guatemalan archaeologists, have been engaged *pls 12–19* for the last ten years in excavation and restoration of its monuments. There are more than *fig. 51* a hundred important sites in the lowlands; Tikal, in the heart of the Petén jungle, is the largest, and is to be reconstructed as a permanent memorial to the lost civilization. There, late in 1959, Stela 29 was discovered, which robbed nearby Uaxactún of the distinction of possessing the earliest dated stela discovered so far. The date on Stela 29 is 8.12.14.8.15. 13 Men 3 Zip, which corresponds to 6 July AD 292.

Several square miles have already been excavated at Tikal, including the sites of the great temples and palaces, granaries and reservoirs. When excavation work was begun, conditions were much the same as those encountered by the first European to describe the site:

> On the steep hills that we passed are a large number of ancient buildings, some of which I realized were dwellings. Although they are very high and my strength was little, I clambered up to them, but with great difficulty. They are constructed in the form of a monastery, with many narrow passages and numerous living rooms. They are all roofed, whitewashed with lime on the inner walls and surrounded by a platform. There is an abundance of lime in this region, as all the hills are of limestone. The buildings here have a form which does not occur in other provinces [i. e. Yucatán], where they are constructed of hewn stone without any mortar – even arches. Here the stone walls are completely coated with lime...

The author of this description was Padre Avendaño, who was the leader of a mission in Mérida and came to Petén to convert the heathen Indians. Warned by natives who had already been baptized that the Chakan Itzá planned an attack on him, he fled, accompanied by some converts, and attempted to escape through the jungle to northern Yucatán. It was January 1696 when he came upon the temples of Tikal, without realizing that the 'steep hills' were in fact massive pyramids. The ruins were covered in dense vegetation. Shortly after the halt in Tikal, the valiant priest's strength failed altogether, but his companions carried him in a litter until they reached a Spanish settlement after thirty-three days. His tale of a lost city in the jungle fell on deaf ears. It was not until several decades later that Colonel Modesto Méndez went to investigate what truth there was in the natives' rumours of the great city abandoned in the forest, and found them confirmed.

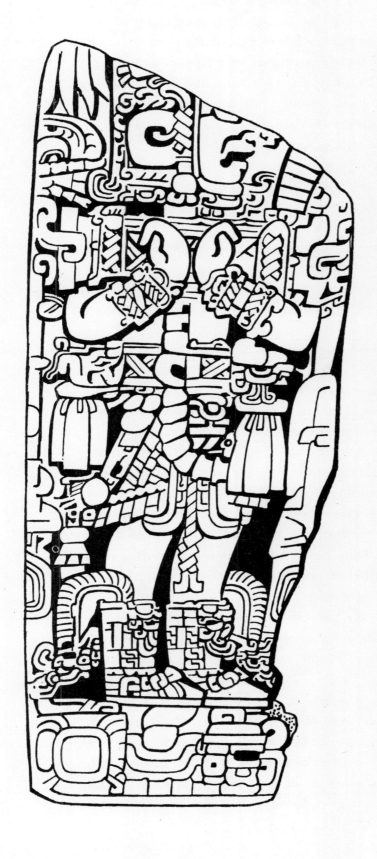

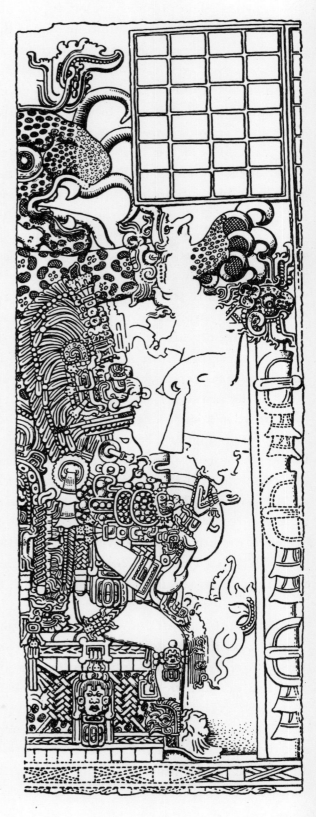

18 Stela 1, Tikal; one of the oldest stelae on the site
19 Part of a wooden lintel from Tikal

There is another tale that centres around one of the first European visitors to Tikal, this time involving an 'art theft', unlikely though it may seem that anyone at that early date should see any artistic merit in the images of Maya 'devils' and their plethora of weird signs. It may be that Gustav Bernoulli, the great Swiss botanist, realized that there was more in the elaborate carvings than the aberrations of the heathen imagination. At all events, he was so impressed that he helped himself to the finest of the carved wooden lintels and, since its weight hampered his own further travels, arranged for a friend to transport it directly to Switzerland at his expense. Bernoulli died before reaching home, but the lintel completed the journey and is today one of the most valuable exhibits in the Völkerkunde-Museum in Basle. Another of these extraordinary, richly decorated lintels is in the British Museum. The only one left in Tikal is a mutilated fragment.

pl. 17

Anecdotes of this kind are comparatively rare, but they serve to convey how one or other of the lost cities, spotlit by the enthusiasm of a scientist or missionary, became a nine days' wonder, only to be as quickly forgotten again.

Anyone visiting Tikal today is taken first of all to Group H. What meets his eye is unlikely to correspond to any preconceived ideas he may have formed of the 'Rome of the New World'. It is all new, white and devoid of romance. Many rains will have to fall before the restored walls and pyramids acquire an aura of 'historical' authenticity. The visitor who has already seen the tactful reconstructions carried out by the Carnegie Institute in Yucatán will be bitterly disappointed with the restoration of Building 78.

Twenty minutes' walk away from this group, the visitor is halted in his tracks by an astounding sight. As he stands in the Great Plaza, gazing up at the lofty temple-pyramids all about him, he will feel something of the sense of awe that must have possessed the subjects of the priest-kings in the Maya heyday. Impressions of greatness, power and cruelty will crowd in upon him, exciting simultaneous feelings of dread and admiration. The Temple of the Great Jaguar (Temple I) and the Temple of Masks (Temple II) face one another along the east-west axis, insurmountable barriers of stone. On the north and south sides the rectangular plaza is enclosed by smaller buildings, which skilfully exploit natural rises in the ground. The total effect of the square is claustrophobic, not unlike a prison yard. This impression is heightened by the walls of vegetation which have forced their way in between the buildings, and vanishes only when one has climbed laboriously up the steep, stucco steps to Temple I. Once at the top, a different world opens up, one which reverses all our previous sensations. From this height the great, enclosed plaza seems minute. As the eye travels over the jungle, other temples emerge among the green tree-tops. Now one thought is uppermost: how tiny and insignificant the people must have appeared to the priests from this height, and how insignificant the people must have felt in the shadow of these towering structures inhabited by the gods.[17]

pls 12-13

It is not just the height of the six great temples, the tallest of which rises to some 200 feet above ground level, that distinguishes Tikal from other centres. It is the severity and massiveness of the architectural style, an unambiguous statement of conscious power. To take but one example: the roof of the Temple of the Inscriptions (Temple VI), which takes its name from the hundreds of inscriptions that cover its surface, rises to twice the height of the temple itself. Another major difference between Tikal and other sites is the enormous

number of buildings; on the area of six and a quarter square miles excavated so far, the traces of no fewer than 2,500 buildings of all kinds have been counted.

Many buildings have collapsed with the passage of time, but there is no sign that violence played any part in the process. With the stelae, however, it is often quite obvious that the human faces on them have been deliberately disfigured. Frequently a whole monument has been broken and removed from its original position. Until five years ago Stela 31 *pl. 18* was walled up inside a pyramid, and even so the face of the priest-king carved on it was erased. What was the reason for this destruction? Was it the fury of the masses, rising against their overlords? Was it the struggle for power between rival priestly castes? We have no idea – yet. A military cause, the defeat of the inhabitants of Tikal and the sack of the city by the victors, is improbable: conquerors, the world over, have always imposed something of their customs, their habits, their individual stamp on the conquered territories, but there are no traces of anything of that kind having happened at Tikal.

The single inconsistent find so far comprises some examples of a kind of pottery which was produced between the twelfth and fifteenth centuries. It cannot have been made on the site, which was abandoned in the ninth or tenth century and never reoccupied. The explanation may lie in the practices, still observed, of the Lacandón Indians, the only tribe of the Maya not to have been converted to Christianity. To this day they visit the sites of their ancient temples and leave offerings for their gods (cf. note 1). It is quite likely that Tikal was one of the places where such sacrifices were made, the vessels used being left behind.

There are still many questions, the answers to at least some of which the archaeologists hope to have found by the time the Tikal project is finally completed. How this vast city with its imposing buildings came into being in such a very hostile environment is a problem that has already been satisfactorily resolved. The Maya maintained a remarkably lively trade in the harder kinds of flint and obsidian, which they needed for working wood and other stones, and the region of Tikal has the most abundant supply of flint in the Petén. The situation is comparable to that in the highlands of Mexico, where the virtually inexhaustible supply of obsidian, a vitreous volcanic rock, met the greater part of the needs of the neolithic culture there. Tikal's pre-eminence was founded on the ready supply of tools for the craftsmen and an abundance of water from a small natural lake (which has since dried up) and several artificial reservoirs.

The excavations have established that the site was occupied continuously for more than two thousand years. The earliest pottery sherds belong to the Mamom phase (1500–300 *pl. 16* BC) and lie beneath a layer of Chicanel ware. Stela 29 bears only the first of an unbroken sequence of dated inscriptions from AD 292 to 869. What subsequently happened to drive the population to abandon their fields, houses and temples will be discussed later.

Uaxactún, ten miles away, bears an over-all similarity to Tikal, but it is much smaller and was certainly of much less importance as a religious centre.

pls 20–45
fig. 55 Copán lies a long way to the south and east of Tikal, across the border with Honduras. In area the second largest Classic site, and the easternmost outpost of the Classic culture, Copán differs from Tikal as a university city does from a national capital. Where the awesome pyramids of Tikal beset and threaten, the buildings of Copán are spacious, its great

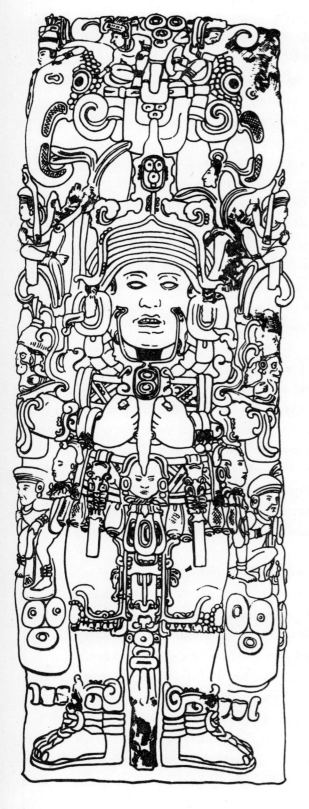

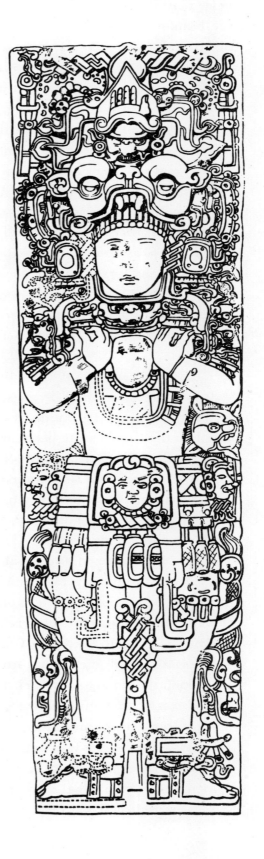

plazas open, allowing a view from almost every point of the mountains that skirt the fertile valley of the Rio Copán. The flights of steps, too, are less intimidating than those at Tikal; broader, less steep and lower, most of them are adorned with hieroglyphs. One, known as the Hieroglyphic Stairway, bears between 1,500 and 2,000 carved glyphs.

pls 27–8

The façades of the buildings were originally decorated with innumerable carvings in trachyte, a greenish stone with a dull sheen; these now, for the most part, lie broken and scattered among the ruins. So numerous are they, that it seems that almost every stone on the site must have had a religious or ritual significance. The only stone carvings to have been re-erected so far are the stelae, which rank high among the works of Maya art, and some statues of gods portrayed with their animal attributes. In their relief carving, the Copán artists approached sculpture in the round.

The visitor will search in vain for a smiling face, or any suggestion of genre or individual motifs in the work of the sculptors of Copán: here, even more than at other sites, it is the impersonal pride, the uncompromising attitude of lofty disdain, of the priest-kings that characterizes the representational art. The only human subject worthy of depiction was the perfect man, of dignified bearing and radiant beauty. Representations of death, too, are often encountered, but here it has none of the menace that attaches to it in Mexican art. For the most part these images are in fragments, having broken away from the façades of certain buildings.

The representations of nature gods are frequently enmeshed in an abstruse symbolism. The serene face of a god, or a deified man, gazes calmly out from the middle of a stela or an altar, surrounded by a riot of dense ornamentation and inscriptions. The contrast of the naturalism and repose of the face and the restlessness of the abstract ornamentation creates an unusual tension, which is more evident among those masterpieces of the Maya imagination, the stelae of Copán, than anywhere else. The most serene face ever created by this culture was found in the ruins of Copán: that of the young maize god, which, as in early representations of the Buddha, or Christ in Byzantine mosaics, bestows a sense of comfort and assurance upon believers.

pl. 45

pls 37–43

Juxtaposed with human faces are those of animals or of death. Rampant jaguars line the flights of stairs, and other monsters threaten from the palaces or lie broken on piles of rubble. In front of the stelae are objects with zoomorphic designs – a combination of beasts of prey, poisonous snakes and toads – which archaeologists take to be altars.

Thanks to its situation some 2,000 feet above sea level, Copán enjoys one of the most congenial climates anywhere in the jungles of Central America. The numerous caves hollowed out by the river in the porous volcanic rock offered shelter to man in prehistoric times. The present-day inhabitants of the region maintain that everything flourishes in their isolated valley: 'Put a walking-stick in the ground and by next year it will be a flowering tree.' Some of its produce, such as the local tobacco, is prized the world over; the tobacco plant may even have originated here. There are no indications of any indigenous civilization having developed here: the architecture, the calendar, the religion, were all brought from outside. The earliest inscriptions are of the fifth century, and it was at about this time that Copán developed its individual style; before long the arts and sciences there had attained a level unsurpassed elsewhere in Maya civilization. A congress of astronomers was

held at Copán 857 years before Galileo recanted before the Inquisition. The likenesses of sixteen delegates are carved in relief on Altar Q, with glyphs beneath the figures to indicate *pl. 35* which of the various Maya centres they represent. Perhaps the purpose of their meeting was to agree on a standard calendar for the whole area or to revise it; they may even have engaged in precise calculations relating to the eclipse of Venus, which occurred at that time.

Copán's role as a cultural centre seems to have come to an abrupt end, no dated monuments or buildings having been erected after AD 805. When Spain sent soldiers, monks and administrators to the valley seven centuries later, it was 'still very densely populated'. In their train they brought sickness and epidemics which almost completely wiped out the native population. An official report states that only seven people escaped death by the plague. For centuries thereafter the fertile land was left virtually uninhabited.

The origin of the name Copán is uncertain. Probably the Chorti – a primitive Maya tribe – named the ruins after their chieftain, Copán-Catel, who tried to defend the valley against the white invaders in 1530. His adversary, Hernández de Chávez, can never have seen the ancient city, or he would certainly have mentioned the enormous collection of heathen idols in his reports. The first description by a European is in a letter written to Philip II in 1576 by the *Licenciado* Doctor Don Diego García de Palacio, *Oidor de la Audiencia Real de Guatemala*, from which the following passage is taken:

Hard by the road to San Pedro, the first town in the province of Honduras, there are some ruins called Copán, which show signs of a large population and include some magnificent buildings, of such accomplishment and splendour that it seems impossible that they should have been constructed by the natives of the region. They stand on the steep banks of an attractive-looking river in a broad, well-chosen hollow, temperate in climate, fertile and abounding in fish and game. Among the ruins there are hills which create the impression that they, too, were raised by the hand of man. Before we reached them, we came upon the remains of thick walls and great stone eagles which had on their breasts rectangular plaques inscribed with signs that we could not understand. Among the ruins we discovered other stones in the form of giants, which the oldest among the Indians claimed to be the guardians of the sanctuary. Searching further, we found a stone cross, three hands high, with one arm broken off. Penetrating deeper into the ruins, we came upon many stones carved with great skill, among them a great statue, more than four yards high, which resembles a bishop in his pontifical vestments, with an elaborately worked mitre, and rings on the fingers. Near by there is a well laid-out square with flights of steps, like those in the Colosseum in Rome, as described by writers there. Some of the squares contain eighty steps, some of the finest stone, cut and laid with the greatest skill. On this square there are also six great statues, three of which represent men wearing a garter at the knee and covered in mosaic. Their weapons are also decorated. Two of the others are women with long robes and headdresses in the Roman style. The statue resembling a bishop seems to be holding a casket or money-box in its hands. We think they were idols, for a great stone stands before each of them with a small basin and a groove down which the blood from a sacrifice could drain away. We also found smaller altars for the

burning of incense [copal]. In the centre of the square there is a vast basin made of stone [the ball court], which appears to have been used for baptisms and also for sacrifices. After crossing the square we climbed a very long flight of stairs to a higher courtyard, which was used for other ceremonies. How much care was expended on its construction can be seen from the excellent working of the stone. On one side of this complex there is a tower or terrace, which rises up above the river. A large section of the wall has collapsed, revealing the entrance to two very long, narrow and well-constructed tunnels or passages, which lie beneath the building. I was unable to discover their function or the reason why they were built. At this point there is also a great staircase with many steps leading down to the river. There are many other things besides, which prove that this was formerly the seat of a great power and had a thriving population, civilized and considerably advanced in the arts, as the various figures and buildings attest.

I took the greatest pains to discover from the Indians and from their ancient traditions, what kind of people lived here and what they knew or had heard of their ancestors. But they no longer had any of the books which told of their history, and I do not believe that there is anyone in the whole district who still possesses a copy. They said that in ancient times a great lord came from Yucatán, who erected the buildings and returned to his own country after a number of years, leaving everything here desolate. And that is what seems the most likely. It is clear that in style these buildings are similar to those that the Spaniards first discovered in Yucatán and Tabasco, and where they also found the figures of bishops and armed men as well as crosses. And the fact that these things are found nowhere else, but only in the regions I have already mentioned, leads us to believe that the builders were all of one and the same nationality.[18]

It is quite natural that Don Diego should have interpreted things he had never seen before in terms of his own religion. His equation of the priest-kings of the Maya with sixteenth-century princes of the Church is perfectly valid, but he was wrong in his assumption that the ball court was a vast baptismal font and an arena for human sacrifice. The Spaniards were very fond of dwelling on the practice of human sacrifice among the American Indians, as though it justified the brutality of their conquest and colonization, but the evidence that it was common in the Classic period is not wholly conclusive. Apart from some isolated stelae (Piedras Negras) and some frescoes at Bonampak, which depict half-naked prisoners at the mercy of their richly clad conquerors and allow the inference that they are to be sacrificed, the only evidence of human sacrifice is provided by skeletons found in the tombs of rulers, and it is by no means proven that the victims did not accompany their masters into the realm of death voluntarily, rather than under compulsion. Human sacrifice does not seem to have taken on ceremonial forms and become widespread among the Maya until the Postclassic period, under Mexican influence.

Don Diego's description of the ruins is too imprecise for us to be able to judge the extent to which things have changed and the buildings deteriorated since his day. The course of the river has been diverted, so that the ruins are no longer liable to flooding in the rainy

season. The approach to the site is easier now; workmen are employed to hold the rank vegetation in check and to preserve the antiquities at what is the only major Maya temple-site in Honduras. Copán presents to its rare visitors today an appearance not unlike that of the park of an English stately home.

Here the archaeologists of the Carnegie Institute too have done sterling work. Nearly all the remains have been replaced in their original positions, and the buildings only restored as much as was necessary to prevent further collapse. A small grave beside Stela D is a reminder of the dangers which face archaeologists when working in the jungle. Dr John G. Owens, leader of the Peabody Museum's second expedition, fell a victim to malaria, and, in accordance with his dying wish, was buried on the spot.

Copán has suffered a good deal at the hands of plunderers of one kind or another. The settlers in the nearby village of San José de Copán took ready-hewn stones from the stairways and palaces instead of quarrying new stone for their streets and houses. In the early days of discovery, too, the acquisitive instinct aroused by the superb sculptures resulted in many of them being carried off to be the prize exhibits of museums in Europe and America.

Thirty miles from Copán as the mailplane flies is the smaller site of Quiriguá, on the malarial plain of the Rio Motagua. Here the dense vegetation concealed the tallest of all the Maya stelae for a surprisingly long time: it was not until 1840 that the owner of the land in question discovered the slender and beautifully carved monuments. To him they were of no value, but, with Latin American *grandeza*, he offered them to John Lloyd Stephens as a gift to the United States. Stephens was optimistic about the relative ease of transporting them – downstream to the Gulf of Honduras and thence by sea – and planned to send two of the largest monuments to New York. Fortunately this plan was never put into effect, or the stelae would be standing today in a nightmare jungle of skyscrapers.

pls 54–5

It was late in June 1960 that I flew from Guatemala City to the small village of Quiriguá, which has given its name to the nearby ruins. It is one of the most dismal places in Central America. Its inhabitants, a mixture of all races, live in bleak tin huts or wooden tenements. The largest building in the village is the fever hospital put up by the United Fruit Company of North America, whose many beds stand empty most of the time and are made available to visitors to the ruins, myself among them. Until a few years ago, the region, where 'United' owns extensive banana plantations, was infested with malaria. The doctors succeeded in reducing the incidence of cases from over a thousand a year to about a dozen, although the number of mosquitoes in the area remains as high and their bite, however harmless, is still abominably painful.

Early on my first morning there, an employee of the company drove me out to the ruins in a thirty-year-old truck and proposed to call for me at three o'clock, when it would start raining. Looking up at the brilliant, cloudless sky, I could not believe that it would rain and asked him to come later. But he was right; that day and every day, punctually at three o'clock, the rain descended in torrents.

The ancient Quiriguá – as with so many of the Maya sites, its original name has been lost in the mists of time – appears to have been set up at two other places, before the priests were satisfied with its present location about half a mile from the banks of the Motagua river. Anyone who has previously visited Tikal and Copán, with their grand layout and

imposing buildings, will be disappointed in Quiriguá. The large buildings which once ringed the Court of the Stelae have vanished, leaving only some of their foundations and crumbling plinths. The temples of Quiriguá were not built to last for millennia. It is to its stelae – slender, beautifully formed pillars of red sandstone – that it owes its position among the great Maya sites. No other site can match the record at Quiriguá, where dated stone monuments were erected regularly and without a gap over a period of eighty-four years, from AD 726 (Stela S) to AD 810 (the inscription on Temple I).

pl. 55 Standing 35 feet high and weighing 62 tons, Stela E at Quiriguá is the largest known anywhere in the Maya empire. It was neither the first nor the last to be erected on the site, and we know of no reason why it should be two or three times as tall as its fellows. It is unique for a further reason: its long rows of hieroglyphs include the only mistake ever to have been discovered among the calendar inscriptions. Instead of 9.14.*13*.4.17 12 Caban 5 Kayab, the mason carved 9.14.*12*.4.17 12 Caban 5 Kayab, which is an impossible date, something like 31 February. Why the mistake was not corrected, the erroneous glyph chipped out, the hole plugged with cement and the right glyph carved, can only be explained by religious fatalism: that which had once been recorded could not be altered.

The mistake was discovered by Sylvanus G. Morley, that able Americanist who, had he been born a Maya, would certainly have been an astronomer himself. One of his colleagues described him to me in the following words:

> If Morley were excavating New York and dug up the Rockefeller Center, he would rush from floor to floor, from room to room, until he found a desk with a calendar on it. Then, without bothering to sit down on a chair or on the desk, he would start calculating and would reconstruct the whole of our civilization from that calendar.

Morley died a few years ago, leaving a name that will be forever linked with the study of the Maya. For all its humorous overstatement, this parable is completely true to life, for Morley suspected that the calendar was at the root of the priests' universal sway over the peasants, and that it is the key to the religion and the science of the Maya. It is an hypothesis that has received increasing support year by year since Morley's death.

With the moss and creepers removed, the stelae of Quiriguá stand upright again on their old site, which has been cleared, while the remnants of the buildings that once surrounded the plaza are still deep in vegetation. The atmosphere is eerie, as though the old priests still gathered from time to time. In no other place did I have such a feeling of being watched by unseen eyes.

Copán exercised a very strong stylistic influence on the monuments at Quiriguá, a later site. The stone and the techniques used here are, however, very different, and so are the dimensions. The stelae are more slender than at Copán, and are sometimes as much as three times as high; moreover the sculptors made no attempt to achieve the three-dimensional effects of the Copán sculptors, the inscriptions as well as the garments of the figures being carved in a shallower relief. Only in the portraits of the priest-kings was the great tradition of Copán upheld.

Building at Quiriguá started before the end of the ninth century. Subsequently, as at other Classic sites, it was engulfed by the hostile jungle and not rediscovered until 1840,

when the owners, the brothers Payes, decided to clear part of the land. This was at the time when Stephens and Catherwood were exploring Copán. On hearing of the newly discovered idols, Catherwood decided to go to Quiriguá and draw them, and so helped to bring them to the attention of the world at large.

Two other cities, similarly linked, lie on the western edge of the Maya cultural zone: *pls 107–40* Palenque and Comalcalco. Palenque was the first site that I visited, and I still consider it *fig. 60* to be the loveliest. It has none of the air of oppressive silence that broods over other sites. *pls 144–6* Built at a point where the lowlands begin to rise gently towards the hills, the temples and palaces harmonize with each other and with their setting. To the peasants working in the fields they must have presented an imposing and beautiful sight, while the priests on the steps of the pyramids saw the land spread out before them. Almost every building is a work of art in itself. It is the only site where the baroque architecture of the Maya verges on the rococo. For centuries Palenque, like many another Maya site, was believed to contain nothing more than mounds of earth, faced with stone or plaster to prevent them from collapsing. Among these mounds, treasure-hunters, self-styled archaeologists, and curious travellers had poked intermittently and to little effect, until the excavation and restoration of Palenque was entrusted by the Mexican government, with the financial support of Nelson D. Rockefeller, to Alberto Ruz Lhuillier, who, in 1948, made an unusual discovery *pl. 108* in the inner room of the thirteen-centuries-old Temple of the Inscriptions. *figs 57–8*

> The floor of this temple differed from those in other buildings by reason of the great stone flags, which were beautifully worked and fitted together almost perfectly. Some of them were particularly large. One of these slabs in the inner room attracted our attention because it had a double row of holes bored in it, so that the heavy stone could be lifted. When I came to scrutinize it, I realized that the floor was higher than the bottom of the walls and that there must be another room below.

The flagstone was raised and a passage, blocked with sand and stones, was discovered. *pl. 111*

> It took four field seasons, each of between two-and-a-half and three months, before we reached the foot of the stairs. . . . There we found a passage, blocked with solid masonry. Sacrificial offerings, clay vessels, red shells, earrings, small pieces of jade and a genuine pearl were spread out on the ground before this wall. When we had removed it, another small wall was revealed at the end of the passage. In the section between them lay the bones of five or six young men, all in a poor state of preservation.[19]

Eighty-two feet below the floor of the temple and six and a half feet below the base of the pyramid, the passage ended – or so it seemed. A really close look revealed that it was blocked by a triangular stone slab. On 15 June 1952, the years of patient labour were rewarded when this last obstacle was removed and the archaeologists saw before them the tomb of a king, *pls 109–15* intact with all its rich and wonderful funerary gifts.

The dramatic circumstances – the slow, hampered progress towards the interior, the combination of hope and uncertainty on the part of the archaeologists, and at the end of it all the magnificent finds – make this a tale to match that of the excavation of the tomb of Tutankhamen in the Valley of Kings. But whereas the Egyptian find added comparatively

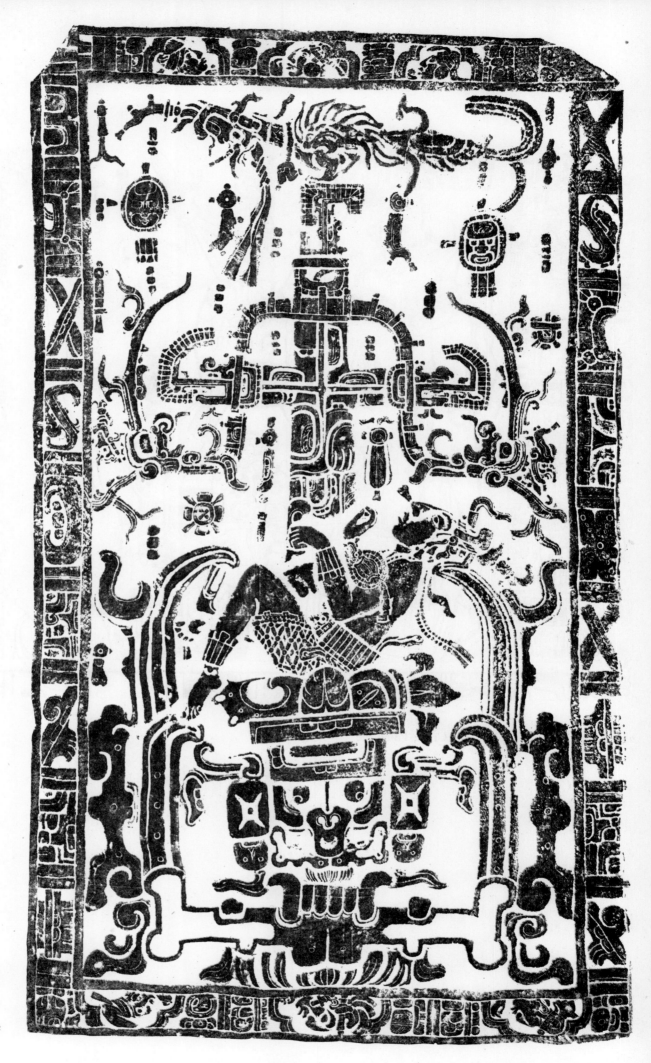

22 Rubbing from the stone slab
covering the sarcophagus in
the crypt of the Temple
of the Inscriptions, Palenque

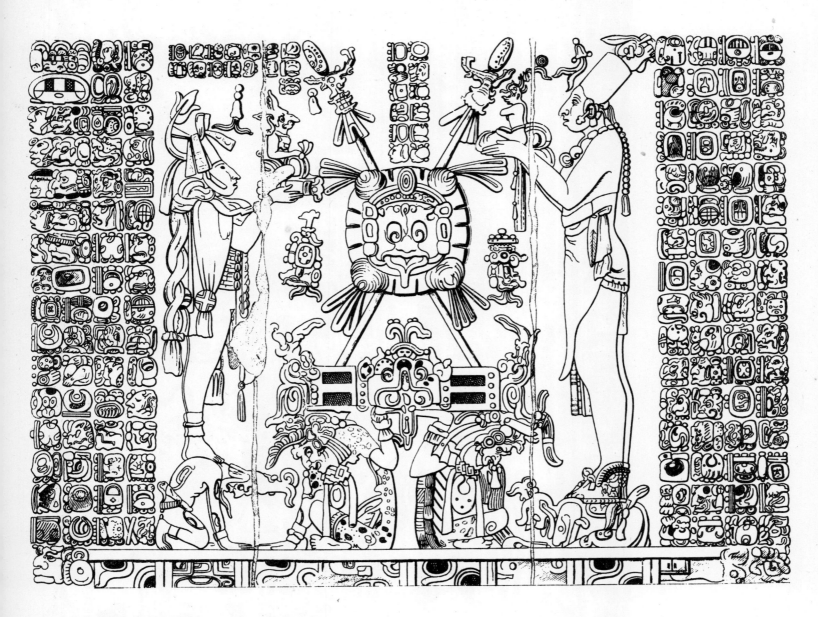

23 Relief in the Temple of the Cross, Palenque

little that was new to the already extensive fund of knowledge concerning the civilization of the Pharaohs, this discovery at Palenque was a major step forward in Maya studies. The king, whose subjects attended him on his journey into the after-life, was buried with a splendour unique in the whole of Maya civilization. The spacious crypt (29 feet long, 12 feet wide and 21 feet high) is the only one to have been found inside a pyramid. Nevertheless, all manner of hypotheses were once again advanced by way of explanation: the Palenque tomb proved that the civilizations of pre-Columbian America were descended from those of the Far East, or from the early cultures of the Mediterranean, and so forth. And yet the only other tombs discovered in Maya territory to this day are small and have no temples erected over them; the Temple of the Inscriptions remains an isolated exception.

While the contents of Tutankhamen's tomb, the only Pharaonic tomb to have been left more or less intact, aroused great and enduring public interest, the sensational find at Palenque is much less widely known. Not the least reason for this must be the absence of any gold treasure. The metals considered precious in other parts of the world were never very important to the Maya, who had no coinage. The priest-kings preferred the subtle tones of jade to the brilliance of gold. The only gold objects that have been found date from the Postclassic period, and were produced under Toltec influence.[20]

pls 120, 123 After the Temple of the Inscriptions, the tallest building on the site, the Palace is the most dominant; it is a rectangular complex of broad stairways, numerous rooms, long corridors and a three-storey tower, grouped round four large inner courtyards. It stands on an articifical mound, on a platform measuring 260 × 330 feet. From the outside it makes an impression of unwelcoming austerity, like a medieval monastery. The changes of style throughout the building show that it had been continuously extended and altered for nearly a hundred years. In the oldest part, the north-east courtyard, the broad stone steps are lined by massive stone blocks, carved with squat human figures of more than life-size. Their archaic form, with the Classic Maya profile, represents the first stage in a process of artistic development that matures into the elegant, graceful stucco reliefs to be seen in other parts of the Palace. An inscription in the north-east court bears a date corresponding to AD 603, around the time when most of the building in Palenque was done; the last relevant dated inscription corresponds to AD 784.

The three-storey tower in the Palace was an architectural innovation which, for some unexplained reason, never caught on in neighbouring centres. A staircase leads up to the first floor, and a ladder may have been used to reach it. When the first Europeans set foot in the ruins, the roof and the top floor had already collapsed. They have recently been rebuilt, but somehow Christian concepts crept into the architect's plan, and the tower now strikes a slightly discordant note in the harmony of the rest of the site.

The Palace was primarily a dwelling-place for the priests. Three latrines, one with drainage channels, the others with pits, and a steam bath for the ritual cleansing of the priests, suggest that it housed a large number of people.

pl. 121

fig. 61 The Temple of the Sun is a gem of Maya architecture, and forms one of a group of three temples, all rather similar, with two rooms in each, which stand on pyramidal mounds at three sides of a plaza. They are known as the Temples of the Cross, of the Foliated Cross and of the Sun, the last owing its name to the bas-relief tablet in its inner room which

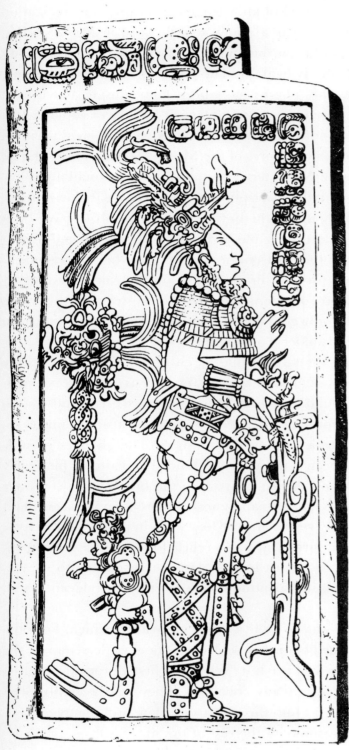

24-25 Reliefs in the Temple of the Foliated Cross, Palenque

depicts a group of priests surrounding the mask of the sun god. It is the best-preserved of all Maya buildings of the Classic period; though the paint that once covered the exterior has been washed away and the stucco decoration on the roof and the frieze has been severely damaged by forest fires, the thick walls have for thirteen centuries triumphantly withstood the onslaughts of the jungle.

Unlike every other Classic site, Palenque has no carved stelae. Dated inscriptions are incorporated in the excellent bas-reliefs and in the high-relief stucco decorations. Occasionally the artists have used single glyphs as independent forms within the larger panels – as at Quiriguá and Copán on the far side of the Maya empire. Most of the inscriptions date from the latter part of the seventh century, but sherds have been found which testify to the occupation of this very favourable site as early as the Formative period. Finds dating from the final phase include artifacts of a non-Maya culture, which is very unusual on lowland sites. Fragments of onyx vases, ceremonial axes and the so-called stone yokes are unmistakably works of the El Tajín culture, which was based well to the north, on the Gulf coast. These objects may be evidence of a brief military invasion which struck the occupants of Palenque so severe a blow that they never recovered from it, or they may simply have been imported by way of peaceful trade. The question will only be answered when Palenque has been excavated systematically.

Not far to the east of Palenque the river Usumacinta forms the frontier between Mexico and Guatemala. Upstream, on the Guatemalan bank, lie the ruins of Piedras Negras, the site of the Black Stones, as the natives called it. It was discovered in 1885 by Teobert Maler, an Austrian officer who came to Mexico with the luckless Emperor Maximilian. After the emperor's execution, Maler exchanged his sword and pistols for a camera and notebooks and devoted the rest of his life to the study of ancient Indian civilization.

pls 173–5 Piedras Negras is buried deep in dense, uninhabited jungle, and is extremely hard to reach. An expedition went there thirty years ago and removed its finest stelae to the Museo Nacional de Arqueología in Guatemala City and to the University Museum in Philadelphia, thus making them available to a wider public. The site was very thoroughly excavated on that occasion and for the first time it was possible to distinguish and date the various phases of the Classic period with a fair degree of accuracy. The chief finding, which has been confirmed by the excavation of numerous other sites since then, was that architecture remained relatively simple up to the beginning of the seventh century. The corbel vault, which is such a feature of Maya architecture, does not seem to have made its first appearance in Piedras Negras until AD 652; the centre was abandoned barely 150 years later, for reasons that have not been established.

An incidental discovery the Piedras Negras expedition made was that the style and techniques of building peasant houses have not altered from the beginning of the Classic period to the present day. Then as now, they consisted of upright posts driven into the ground, lath and plaster walls and grass roofs.

pls 168–72 The stelae of Piedras Negras and the mural paintings of nearby Bonampak introduce, for the first time, a warlike note into the otherwise pacific art of the Maya. Visual evidence of wars of conquest is provided by pictures of half-naked prisoners, waiting to hear priest-kings in gorgeous attire pronounce their fate. Victors and vanquished alike show the same

unmistakable Maya profile, the sharply projecting nose and the flattened skull induced by artificial deformation in infancy, and prized as a mark of beauty. These carvings and paintings alone are enough to refute Arnold Toynbee's theory that here was the one peaceful civilization in the whole history of mankind.

Several days' march farther upstream, the Usumacinta doubles back upon itself round the ruins of Yaxchilán, on the Mexican bank. This place must once have presented a wonderful sight to passing boats, but now lies so thickly overgrown that the ruins can be seen from neither the air nor the water. The reliefs carved on the stelae and lintels are masterpieces of the sculptor's art. Alfred Maudslay collected a number of these valuable works on his expedition at the end of the last century, which are now the pride of the British Museum. *pls 158–67* *fig. 59*

The only advantage I enjoyed over earlier travellers to Yaxchilán was the little aeroplane which saved me a week's tramping by taking me to Agua Azul, a settlement confined to three huts. From here two Indians paddled me downstream for several hours in a dugout canoe. The dense forest grows right down to the water's edge, and when we finally reached Yaxchilán the trees almost completely hid the buildings from view. I spent several days there but was unable to take any good photographs, what with the overhanging trees maintaining a perpetual twilight, the moss blurring the outlines of the reliefs and the thick tree trunks blocking all the lines of sight. Nobody had warned me about the poisonous spiders, the size of eggs, which spin their webs everywhere, nobody had mentioned the masses of bats in the vaults, or the hundreds of loathsome toads, the size of chickens, which swarm at night over the moist earth. None of these, however, constitute a serious danger, any more than the few prowling jaguars, or the numerous snakes which abruptly slither away from underfoot. The only danger is getting lost. Even in Tikal, a scheduled tourist attraction, a German photographer lost his way and was not found until all that was left of him was a skeleton, a camera and the cash from his pockets.

I roamed uneasily about among the ruins, finding it difficult to believe that this was once an active trading and religious centre. I was accompanied by a small Indian boy, whose family was settled here by the Mexican government to deter treasure-seekers and plunderers. He was familiar with all the buildings: he showed me first the Palace of the King, whose likeness in stone now sits, incongruously, in front of the building. The figure, about three feet high, fell at some date from a niche on the second story; the head broke off and rolled yards away into the thick grass. The boy led me past fallen stelae. Nervously I entered the damp, dark rooms of the houses, scrutinized the walls and discovered remnants of frescoes. In spite of the gloom I tried to photograph the exquisite relief carvings on the lintels of doorways, but my flashlight apparatus failed to illuminate their outlines in this damp atmosphere. I found that the only way to capture the full beauty of the carving was to take rubbings. *pl. 159*

Yaxchilán is yet another site that shows not the least sign that it was destroyed in war; no one has been able to find out why or when the city was abandoned.

Classic Maya civilization reached its maximum expansion in AD 790, the equivalent of which is recorded in inscriptions in nineteen centres, from Copán in the west to Palenque in the east, and from Edzná in the north to Seibal in the south. The end of the *katun* sixty years later was recorded in no more than three centres, Uaxactún and Oxpomul in the lowlands of Guatemala and Tila in Chiapas. The last date (AD 909), marking the end of the Classic era, is found on a small jade ornament from Tzibanché.

Such a spectacular eclipse might have followed war or civil war, but these would surely have left some tangible evidence. There are no signs of civil war until the end of the Postclassic period, centuries later. Mayapán and other sites in Yucatán point to destruction by force, but the Classic period of Maya civilization died silently. If it had been brought to an end by some form of plague there would, again, be evidence in the concentration of human remains. It was the 'white gods' who first brought yellow fever, measles, smallpox and chicken-pox to the American Indians. The traces of the epidemics which came in the wake of the conquerors, like those of the civil wars, are to be found all over the continent – except for this lowland area of some 25,000 square miles, a region that contains all the Classic sites and which was virtually uninhabited by the sixteenth century.

Violent changes of climate and earthquakes have also been postulated, but once again, there are no visible signs of anything of the kind. Not one of the numerous temples and palaces in the lowlands, not one of the Classic stelae, over a thousand in number, has been shattered by an earthquake.

It would be in keeping with the devout character of the Maya if an exodus had taken place as a result of the priests reading evil omens in the heavens, but would the people have evacuated all their great centres? Would not ancient traditions have been kept alive in new settlements? As it is, there are only a few instances of observance of the old forms and none at all of the old, deep-seated faith. Dated inscriptions are very rare. It is obvious that a profound change took place in the structure of society. Secular buildings predominate in the Postclassic period and very few temple pyramids are in use; this indicates that the priests had lost their dominant position to secular rulers, and hardly suggests that the former had engineered a mass migration.

Soil exhaustion would be a feasible reason for the move in many areas: the lack of manure, the steady growth of the population and the decline in crop yields, meant that the peasants had to go deeper and deeper into the forest to clear new land. The increased distances from the fields to the centres, in a society which had no wheeled transport, must have made the distribution of food difficult. At Tikal, Uaxactún, Yaxchilán and Piedras Negras, the soil does indeed appear to have been exhausted, but there are no signs of this in the fertile territory around Copán and Quiriguá, and only limited signs of it around Palenque. Yet all the major sites were abandoned.

In fact, just because the erection of stelae ceased around the year 850, it does not necessarily mean that there must have been a general exodus. But that there was some spread northwards is witnessed by the various dated inscriptions found in areas which did not flourish culturally until centuries later, and by the enchanting terracotta figures from graves *pls 185–223* on the island of Jaina, off the west coast of Yucatán, nearly all of which belong stylistically to the Classic period.

By and large, it would seem that the chief reason for the abandonment of the temple-cities, which occupied a period of some 120 years, was the decline in power of the priests; there may have been also a popular rising. Perhaps the priests were too absorbed in the movements of the stars, too fascinated by the workings of the universe to pay much attention to the hunger and poverty of the people. Perhaps their ambitious building programmes drew too many people from the fields, leading to a shortage of food, which sparked off a revolt which grew into a bloodless revolution. The story of the creation narrated in the *Popol Vuh* contains a precedent in the revolt of the animals and household utensils against the tyranny of men. And of all the Indian tribes, it has been the Maya who most frequently bearded the white man, their last rising being as late as 1910. The elimination and disfigurement of faces on so many Classic stelae are consistent with the idea of a revolution against the priests.

Without the power of the priests, without a religion to protect them against the forces of nature, the people were less capable of withstanding them. We can visualize one clan after another leaving the forest for the bush country to the north. Those who remained in the lowlands will have reverted to hunting and primitive methods of agriculture, a way of life still led by the Lacandón today.

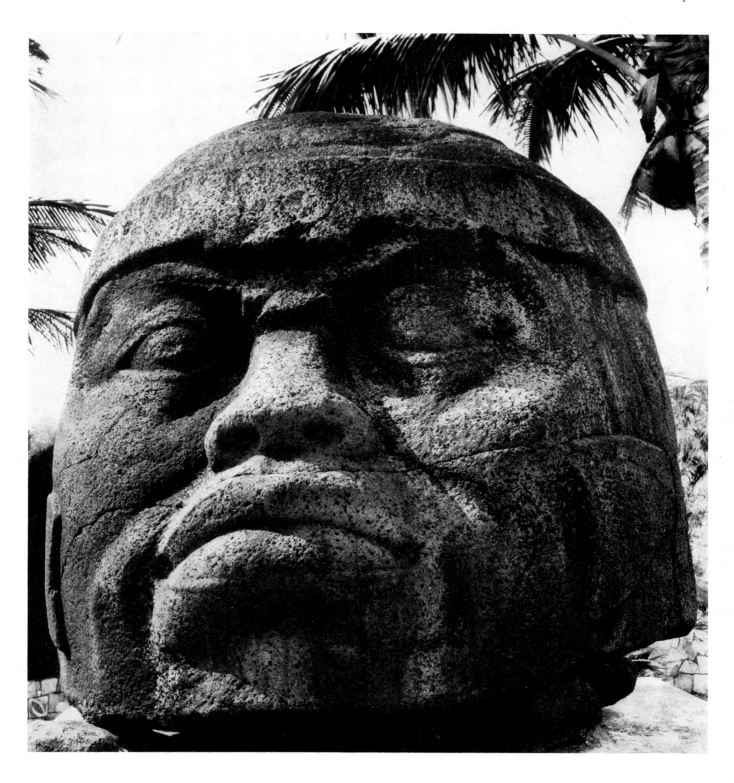

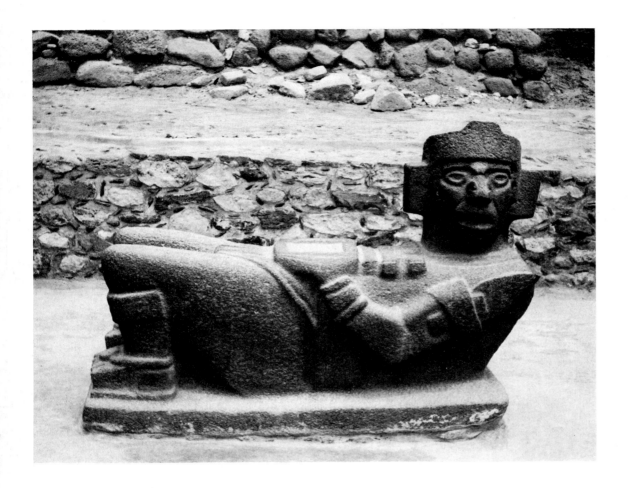

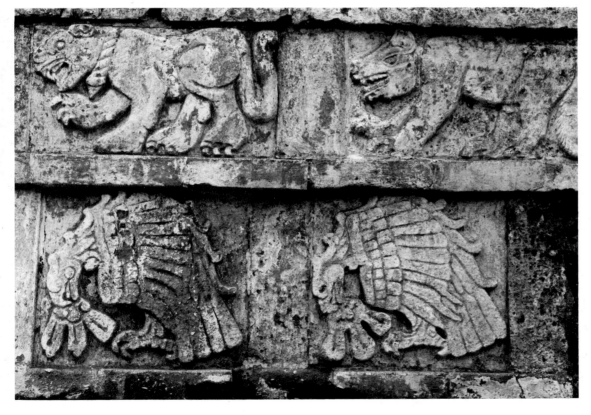

27 *Chacmool* in front of the Temple of Quetzalcóatl, Tula
28 Frieze of jaguars, coyotes and eagles on the Temple of Quetzalcóatl, Tula

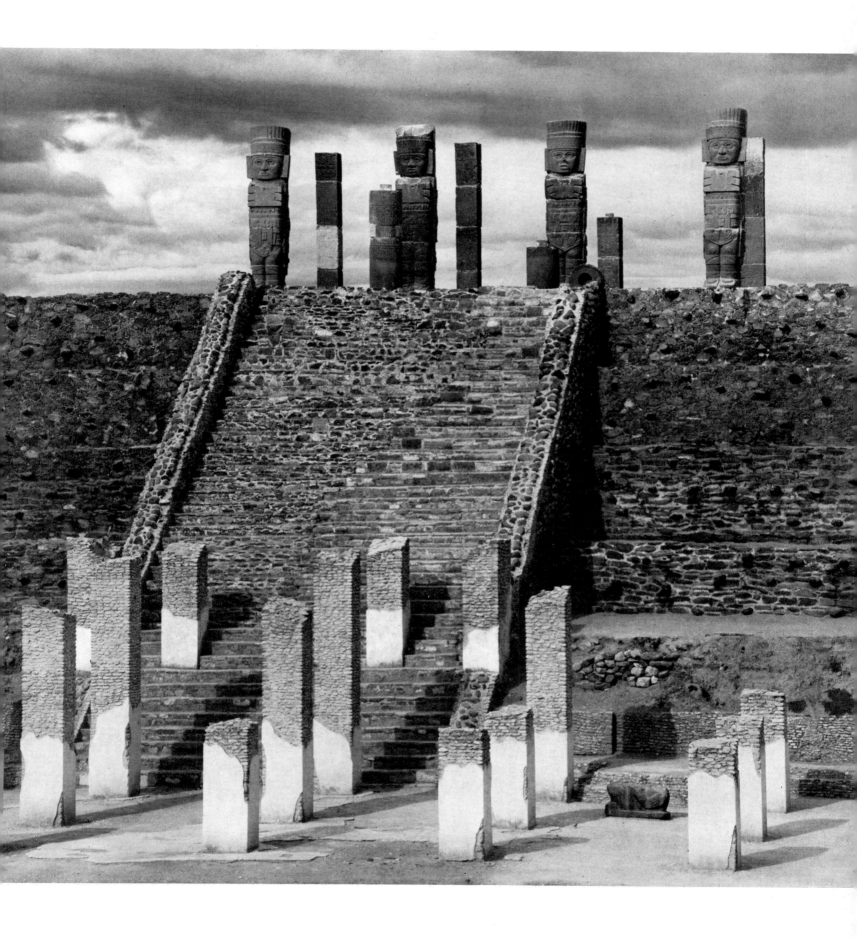

30 Relief of a Toltec warrior, Tula

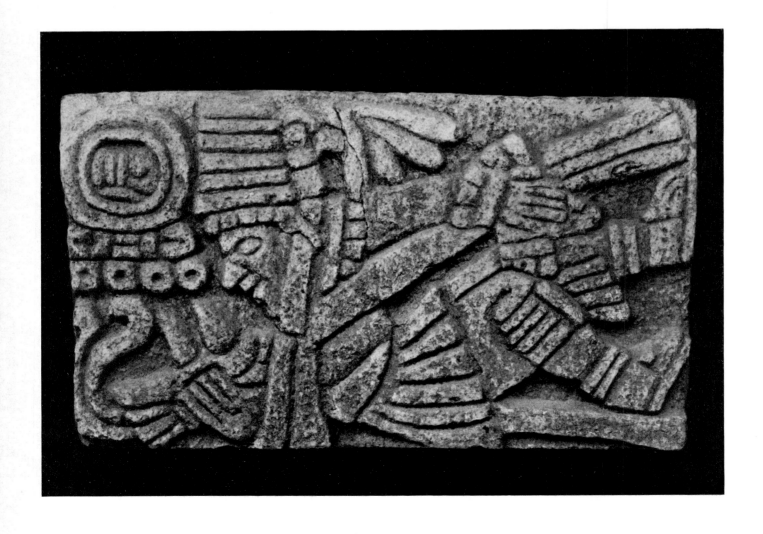

5 Postclassic culture

Following their sudden and mysterious decline, the Maya disappear from history for about a century, not emerging again until the beginning of the eleventh century on the Yucatán peninsula.

The peninsula was already inhabited in the Classic and Formative periods. Some of the sites – Tulum (where there is a stela dated AD 564), Edzná, Cobá and Chichén Itzá – were already established as northern outposts of the Classic civilization of the Petén, but their role was at that time insignificant. The old centre at Chichén Itzá was abandoned at the same time as the temple sites in the lowlands, and there is the same eclipse of the Maya in Yucatán for a century, until the extreme north was stirred by political activity and a new civilization formed with its roots in the peninsula.

The new environment brought little benefit to the peasants: the soil was no more fertile than that which their ancestors had tilled in the rain forests, and the secular aristocracy which had taken the place of the priests was no less stringent and merciless in its demands. In place of jungle vegetation, the peasants had thorny scrub to clear. Instead of staggering under loads of earth and lime for the lofty pyramids of Tikal, they were compelled to polish the 20,000 stones which went to construct the House of the Governor at Uxmal. Moreover, in leaving the forests, the Maya abandoned the protection they offered. There were no natural barriers in Yucatán. A well-planned network of excellent roads, built to link the centres of government, made it all the easier for foreign conquerors to overrun and destroy them later.

The almost proverbial independence of the Maya, the colourful individuality of each tribe, proved their undoing on the peninsula. The centres of administration achieved political union, but it was not permanent. The three most powerful centres, Mayapán, Uxmal and Chichén Itzá, formed the league of Mayapán (1007–1194), under the leadership of the Cocom dynasty. The ruling families in the Postclassic period were of non-Maya origin, which would not have happened had the native, priestly aristocracy not been superseded. The foreigners were, however, quickly acclimatized. No foreign idioms, for instance, entered the language that either the priests or the people had used. According to the *Books of Chilam Balam*, the foreign rulers came from Tabasco around the year 1000; they were probably Toltec refugees from Tula in central Mexico, who seized power in a very few years by virtue of their superior organizational abilities, and created a hybrid culture with that of the Maya. But the situation is far from simple, for while Mayapán and the new centre established on the old site at Chichén Itzá show unmistakable Toltec traits both in

the crafts and in architecture, in the region ruled over by the Xiu dynasty, whose capital was Uxmal, and who are also designated foreigners, there are no traces whatever of Toltec influence.

The two centuries that the league of Mayapán lasted saw Postclassic Maya culture at its zenith, although political power lay in the hands of foreign dynasties whose appearance was of recent date. Under the Cocom in Mayapán, the Itzá in Chichén Itzá and the Xiu in Uxmal, there was a cultural renaissance, but the move towards the creation of a unified state foundered on the obstinacy of the individual ruling houses, who were reluctant to submit to a common overlord and felt that the league diminished their own sovereignty.

Where the visual arts and architecture are concerned, we seem to sense in the new home of the Maya a spirit different from that which pervades the Classic sites. Their new masters profited from the lesson of the collapse of the priests' power and ensured their own position by military strength. As with other human civilizations, this proved to be the beginning of the end. The process of self-destruction is symbolized by the disappearance of the human face from Maya art of the Postclassic period. The essentially human countenance of the young maize god vanishes in Yucatán, to be replaced by the geometrical, stylized mask of the rain god, Chac, whose huge, empty eye-sockets, jaws and what looks more like an incipient elephant's trunk than a nose testify to a conscious effort to instil terror in the beholder. The form appears on almost all the older buildings in Yucatán. The reliefs are now mainly given over to warriors, sacrificing and waging war. The new, martial spirit is propagated by both art and religion, and the range of expression is correspondingly diminished. Alike in subject matter and in form, harshness and brutality replace the former sensitivity and refinement. *pl. 45* *pls 232-3*

In the decoration of ceramics, relief carving was at first preferred to the rich painting of Classic ware; later, this degenerated into perfunctory incised markings. *pl. 289*

Architecture, from the eleventh to the middle of the thirteenth century, alone kept that most impressive feature of the old style: the steep stairways. These are less common in Yucatán, but where they occur they form an integral part of the architectural composition, just as in buildings of the Classic period. The flights at Uxmal and Chichén Itzá are as precipitous and bold as at Tikal and Palenque. Looking down while climbing them, the ground seems to lie almost vertically below: it is as if one were entering the legendary world of the Maya gods, leaving the earth behind.

The buildings in Yucatán which date from before the thirteenth century still confront us like majestic bulwarks against encroaching decay. They still retain their dramatic relationship to each other and their quality of harmonizing with their setting. They differ from the Classic buildings of the lowlands primarily in that they were designed to reflect the glory of secular powers, whereas the latter were almost all constructed in the service of the gods. Some of the temple-sites in Yucatán show signs of an incipient renaissance, but the promise is never fulfilled. After two centuries exhaustion plainly set in.

The chronicles and legends of the Maya speak of two waves of immigration into Yucatán, one from the east and one from the west. A sequence of temples testifies to the presence of the earlier wave, and some of the areas through which it passed have given their names to architectural styles. The route can be traced through settlements along the Rio Bec,

across the Chenes to the Puuc region. Chichén Itzá and Dzibilchaltún lie to the north of the Puuc highlands, but the earliest buildings found there derive their style from the Classic period. It is the Rio Bec style that still reveals most clearly the traditional basis of religious faith. In the Puuc style the emphasis is already shifting over to secularism and feudalism. The colonization of the peninsula by the new culture and the construction of the larger centres – apart from a few exceptions such as Tulum – were accomplished between the eighth and eleventh centuries. We may deduce from the large number of buildings of the Puuc period, the uniformity of the style – which differs fundamentally from the Classic style of the lowlands, yet displays almost exclusively Maya elements – and the short period of time in which they were all constructed, that the area was densely populated and society there well organized. Nevertheless, the dimensions of the buildings and the high standard of craftsmanship in the Puuc region, which was almost uninhabited before the eighth century and was abandoned after the eleventh, pose a number of archaeological problems.

The highlands of Yucatán are sparsely inhabited today and could hardly support villages of any great size, much less a town. The water-table lies too deep. The *cenotes*, waterholes opened up by local ground subsidence, which provide water for human use and agriculture all the year round in the rest of the peninsula, are not to be found in the highlands. The inhabitants were forced to construct artificial reservoirs (*chultunes*) in which they stored supplies of drinking-water for the six dry months of the year. Although the topsoil is deeper here than anywhere else in the region, they were nevertheless eventually compelled to leave the hills and make new settlements near *cenotes*. The magnificent centres in the Puuc range, Kabah, Sayil, Labná and Uxmal, were occupied only for a limited period, for their artificial cisterns could not gather enough rainwater to sustain the increasing population. The settlement of the hills was an impressive experiment, but it proved useless in the long run. The hundreds of masks of the rain god on temples and palaces bear witness to the fervent prayers that were offered up for water.

The Toltec invasion initiated the final transition from the Classic to the Postclassic civilization. The *Books of Chilam Balam* (lit. *chilam* = 'prophet-priest', *balam* = 'jaguar') recount that the three most influential dynasties, who determined the nature of the Postclassic era, traced their descent from Quetzalcóatl, who in Yucatán was called Kukulcán. According to legend, the Mexican Quetzalcóatl, 'feathered serpent', was the leader under whose instigation the Itzá resettled and enlarged the site of Chichén Itzá ('the mouth of the well of the Itzá'), and it is this site which, more than any other, reflects the foreign influence in its architecture and the other visual arts. Stylistic elements and technical innovations of Toltec origin, based on quite different ideas and religious concepts, make their first appearance around the beginning of the eleventh century. To find stylistic parallels,

figs 27–30 an art historian must look seven or eight hundred miles west, to Tula, the former Toltec capital, where recent excavations have disclosed an art and an architecture which has close affinities with those carried south-eastwards by Quetzalcóatl and his band of Toltecs on their journey to Chichén Itzá.[21]

The Toltec immigrants who restored Chichén Itzá must have made their way into Yucatán long before Tula was destroyed in 1168 by the Chichimecs ('race of dogs') invading from the north. The stylistic innovations they introduced are too numerous to be

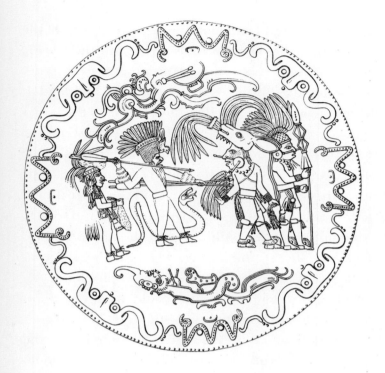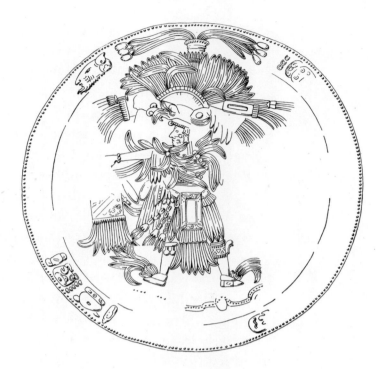

overlooked. The most notable is the substitution of the image of the feathered serpent for the mask of the rain god on many of the later buildings, on free-standing pillars and on decorated balustrades. The new god is also to be found in reliefs, surrounded by uniformed warriors in much the same way that the old gods were surrounded by priest-kings. The only difference between these works and their models in Tula lies in the superior technical skill and artistic refinement, which suggests that they were executed by Maya craftsmen. The Toltecs brought two other, less important, types of divine image to Yucatán: the *chacmool* and the Atlantean figure. The latter, usually a life-size figure with raised hands, probably symbolized the props by which the heavens were supported, while the recumbent *chacmool*, with its head turned to one side and holding a basin in its lap, was probably intended to be a guardian of the temple.

The old Maya ideal of beauty, the flattened skull, is nowhere to be seen among the divine images of their new rulers. We have only the decoration on simple pottery and the skulls from graves to show that this deformation was still customary among the subject race.

During the two centuries of Toltec rule, a large number of splendid buildings were erected at Chichén Itzá, chief among them the Temple of the Warriors, the Castillo, dedicated to the feathered serpent, the ball court with the Temple of the Jaguars, and the circular Caracol. The craftsmen were able to give wider expression to their ideas by using gold, copper, onyx, rock crystal and turquoise.

pls 257, 268
pls 274–7
pl. 279

Mayapán was founded from Chichén Itzá. Here more care was lavished upon the houses of the aristocracy than on the temples of the gods. The central area was surrounded by two walls, the inner one separating the houses of the ruling caste from those of the warriors and artisans in the outer ring – a clear indication of the social distinctions and of the rulers' mistrust of the people. Mayapán was ruled by the Cocom dynasty, who claimed descent from Kukulcán, the feathered serpent.

pls 296–8

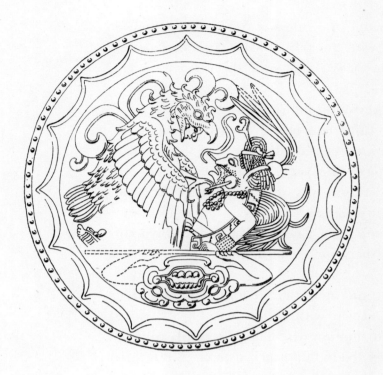

31 Gold disc from the Well of Sacrifice
at Chichén Itzá, depicting two Maya warriors
fleeing before a Toltec chieftain

32 Gold disc from the Well of Sacrifice
at Chichén Itzá, depicting a Toltec general

33 Gold disc from the Well of Sacrifice
at Chichén Itzá, depicting a Toltec 'eagle knight'
fighting a Maya warrior

While archaeological evidence tends on the whole to confirm the traditional native
chronicles where Mayapán and Chichén Itzá are concerned, in Uxmal the situation is con-
fused. Like the neighbouring sites of Kabah, Sayil and Labná, it was built in the pure Puuc
style and was largely impervious to Toltec influences. According to the chronicles, Uxmal
was 'founded' in 1007 by the Tutul Xiu dynasty, but in all probability this involved nothing
more than the reoccupation of a much older temple-site. The members of this dynasty,
which continued to play an important role in later history, were foreigners from Tabasco.

In the very year, AD 1007, which one of the *Books of Chilam Balam* gives as the date of
the Xiu settlement of Uxmal, the three most powerful centres, Uxmal itself, Chichén Itzá
and Mayapán, formed the league of Mayapán which held together until 1194, or from 987
to 1185, according to other reckonings. If the *Books of Chilam Balam* are to be relied upon,
peace reigned throughout these two centuries, until suddenly Chac Xib Chac, the prince of
Chichén Itzá, carried off the bride of the ruler of the small neighbouring city of Izamal, in
the middle of the wedding festivities. This rape had as serious consequences for the Maya
as the abduction of Helen had for the Greeks. Hunac Ceel, the lord of Mayapán, declared
war on the Itzá, and brought in Mexican auxiliaries, probably from the western part of
Tabasco, who fought with a new weapon, the bow and arrow, with the aid of which Chi-
chén Itzá was conquered. The Itzá fled into the jungle of the Guatemala lowlands and set-
tled on an island in Lake Petén, not far from Tikal and Uaxactún. The small state they esta-
blished there resisted the might of Spain until 1697. Chichén Itzá, their former capital, was
completely abandoned, but still drew pilgrims until after the Spanish conquest. Sacrificial
objects continued to be cast into the sacred well, including those made by the Coclé civiliza-
tion of Panama, brought into the peninsula by traders.

Very little is known of the period between 1194 (other chronicles give the year in which
the Itzá were defeated as 1204) and 1441, the year in which Mayapán is believed to have

been destroyed. One historical fact is that the Cocom, the rulers of Mayapán, achieved overlordship of the whole peninsula, maintaining it with the help of Mexican mercenaries, which made them extremely unpopular with the Maya and with the other princely houses.

Without the strong religious beliefs that had previously informed them, architecture, the arts and the crafts declined. Building activities came to a halt in almost all the great religious centres of the peninsula, with the result that they gradually lost their significance and were abandoned like the temples of the Classic era. The Maya records avoid mentioning the rule of the Cocom as much as possible; evidently it was bitterly resented. At some point in the middle of the fifteenth century the pent-up hatred reached boiling point and under the leadership of the Xiu large areas of the country rose against the tyrants. Mayapán was destroyed and the entire Cocom clan killed, except for a youth who was away on a journey.

After the fall of Mayapán, the inhabitants split into more than a dozen communities, each with its own chieftain, which were constantly at war with each other. The Mexican mercenaries were driven away. Some of them went to Tulum, where frescoes testify to their stay. Others, according to Bishop Landa, were permitted to build their own city. 'But they were not allowed to take local women to wife. Nevertheless they preferred to stay in Yucatán rather than return to the swamps of Tabasco.' They chose a site in the province of Canul, to the north-east of Campeche.

Once kindled, the flames of war raged endlessly among the Maya. It was a war without respite, every village was in arms against every other, and the whole land was laid waste. After their victory over Mayapán, the Xiu left Uxmal and founded Maní, a name which means 'it is past'. The surviving scion of the Cocom attempted to restore his family's fortunes in Tibulón ('we are betrayed').

The *Books of Chilam Balam* record a devastating hurricane in the year 1464, which was still remembered a hundred years later: 'To an eye roving over the land from a high vantage point, it looked as though it had been cut with a scythe. That was when the land lost the name of the Land of the Deer and the Pheasant, by which it had previously been known.'[22]

In 1480 there was a widespread epidemic: 'Very many people died of this pestilence and a large part of the fruits of the earth remained unharvested. After the end of the plague they had sixteen good years, until their passions and quarrels were aroused again.'

In 1511 the first Spaniards, shipwrecked sailors, set foot on the peninsula. They were seized and sacrificed, except for two, who escaped from the wooden cages in which they were being kept in readiness for a festival, and found refuge in the territory of a neighbouring chieftain. Jerónimo de Aguilar was later rescued by Cortés, to whom he was of great assistance as an interpreter and adviser. The other, a soldier named Gonzalo Guerrero, became military adviser to a Maya chieftain near Bakhalal. He abandoned the ways of his own people, married a Maya woman of high birth, and fought, naked but for his war-paint, alongside Maya warriors against the Spanish invaders. His fate after the conquest of Yucatán is unknown.

After making two attempts to subjugate the peninsula, in 1527–8 and 1531–5, the

Spaniards had achieved nothing more than an oath of allegiance from the Xiu. The Cocom resisted bitterly. In 1536, when there was not one Spaniard left in the peninsula, the old enmity between the two princely houses flared up again. The Xiu undertook a pilgrimage to Chichén Itzá and asked the Cocom for safe-conduct through their territory. They received assurances and for four days the pilgrims were the fêted guests of their old enemies. It seemed that the old feuds had at last been forgotten. But the hospitality was a deception. The grandson of the last ruler of Mayapán still harboured thoughts of vengeance for the massacre which had swept his family from power nearly a hundred years previously. On the fifth day the Cocom fell upon the unsuspecting Xiu and murdered Ah Dzun Xiu, his son and their forty companions. This treacherous act created a new rift between the two most powerful families of Yucatán and their respective subjects. In 1540 the Spaniards made a fourth attempt at invasion. Exhausted by civil war, disunited, and betrayed by the Xiu, who went over to the Spanish side, the natives were unable to resist the invaders and their superior arms any longer. A few years later, in 1546 and 1547, they rose against the conquerors, but by then it was too late.

It is surprising and significant that in Yucatán the peasants, unlike those of Mexico and Peru, did not make common cause with the Spaniards. It was only after the princely houses, led by the Xiu, had been converted to Catholicism, that the people gradually came to accept the Europeans in their midst. The saints of the new religion became mingled with the old gods. The hewn stones of the temples were used in the construction of churches, the masonry of the former palaces was incorporated in the mansions of the colonialists.

In the Guatemala highlands during the Postclassic period, events followed much the same course as in Yucatán. The dominant kingdom was that of the Quiché, whose authority extended at times from the mountains down to the shores of the Pacific. The Quiché capital was at Gumarcaah (Utatlán). The other most influential tribes in the highlands seem to have been the Cakchiquel and the Tzutuhil. Like the ruling houses on the peninsula, they prided themselves on their descent from the Toltec and here, too, bloody feuds raged between the dynasties.

The Spaniards made the most of this dissension, and in spite of the greater geographical difficulties found the highlands an easy prey. What follows is an Indian account of the coming of the Spaniards to the Guatemala highlands:

It is forty-nine years since the Spaniards came to Xepit and Xetulul. On 1 Ganel [20 February 1524] the Quiché were wiped out by the Spaniards. The leader, whose name was Tunatiuh Avilantavo,[23] overcame the whole people. Their faces had been unknown before this time. Until this time we worshipped wood and stone. ... Then they [the Spaniards] went to the city of Gumarcaah, where they were received by the kings, Ah Pop and Ah Pop Quamahay, and the Quiché paid them tribute. Soon after that the kings were tortured by Tunatiuh.[24]

On 4 Quat [7 March 1524] the kings Ah Pop and Ah Pop Quamahay were burned by Tunatiuh. The heart of Tunatiuh knew no pity for the people throughout the war. Not long afterwards a messenger from Tunatiuh came to the kings [of the

Cakchiquel] to demand soldiers. 'Let the warriors of Ah Pozotzil and the warriors of Ah Poxahil come to slay the Quiché,' said the messenger to the kings. The command of Tunatiuh was immediately obeyed and 2,000 soldiers [of the Cakchiquel] marched into battle against the Quiché.

Only the men from the city went; the other warriors did not come down to put themselves at the kings' service. Three times the soldiers had to go to collect the tribute from the Quiché. We went ourselves, O my sons! to collect it for Tunatiuh. The kings, Belehé Qat and Cahí Ymox, went out at once to meet Tunatiuh. The heart of Tunatiuh was favourably disposed to the kings when he came into the city. There was no fighting there and Tunatiuh was pleased when he arrived in Iximché. So the men of Castile came, O my sons! In truth, they spread fear, when they came. Their faces were strange. The lords took them for gods. We ourselves, your fathers, went to see them, when they came to Iximché.

Tunatiuh slept in the house of Tzupam. On the next day the captain disappeared, to the alarm of his soldiers, and went alone to the palace of the kings. 'Why do you wage war against me, when I am able to wage war against you?' he said. And the kings replied: 'That is not true, because many men would die in war. You have seen the remains out there in the ravines.' Then he went to the house of the captain, Chicbal. There Tunatiuh asked the kings who their enemies were. The kings answered: 'Our enemies are two, O Lord: the Tzutuhil and the people of Panatacat.' This the kings said to him. Five days later Tunatiuh left the city. The Tzutuhil were conquered then by the Spaniards. On 6 Camey [18 April 1524] the Tzutuhil were destroyed by Tunatiuh.[25]

Weakened by civil war and lacking over-all leadership, the Indians of the highlands put up less resistance to the white invaders than the people of Yucatán had done. The conquest was virtually complete by the time Cortés led a punitive expedition to Honduras through the jungle of the Petén in the following year, 1525.

The invincible Cortés was the first white man to pass through the old heartland of Maya civilization, while on his way to crush the rebellion mounted by his captain Cristóbal de Olid, in Honduras. Olid died before Cortés arrived, and the revolt fizzled out. On their way the Spaniards passed near Tayasal ('amid the green waters'), the Itzá capital on Lake Petén. Bernal Díaz del Castillo, a seasoned veteran of Cortés' campaigns, described the city which was to be the last citadel of Maya civilization in its decline. 'With its houses and high *teocalli* [an Aztec word, meaning temple] it shone so brightly in the sun that we could see it clearly at a distance of two leagues [six miles].' The inhabitants of Tayasal received Cortés and his men in a very friendly fashion, 'quite different from what we might have expected after our experiences with their kinsfolk in Yucatán. They willingly listened to the Spanish missionaries who accompanied our train.'[26] The good friars destroyed the heathen idols and erected Christian crosses. One incident arising from this visit makes an interesting footnote to history. Cortés left behind one of his horses, which had injured a hoof while hunting. The Itzá, who had never seen a horse before, worshipped it as a god, housed it in a temple and fed it with all kinds of delicacies. The unfortunate animal, Morzillo by

name, did not much relish the tasty dishes of poultry that it was served, and soon expired. Alarmed, the Itzá built a stone image of it. When two Franciscans, bent on converting the heathen, penetrated the region nearly a century later they were not a little startled to discover the god of thunder and lightning in equine form.

Although they were so welcoming at first, the Itzá soon changed their minds about the 'white gods'. This may have been the result of the unhappy experiences of neighbouring tribes, or it may also have been because, with a certain familiarity, they lost their fear of the strangers and regained their sense of independence.

From 1524 to 1618 they lived on according to their ancient usages, worshipping their old gods and almost forgotten by the Spaniards. The exhortations of missionaries fell on deaf ears. In 1622, over a hundred years after the conquest of Mexico, the governor of Yucatán appointed Captain Francisco de Mirones to lead a military expedition. His treatment of the Indians was such, however, that the missionary who accompanied the expedition, Padre Delgado, preferred to push on to the Itzá with eighty native converts but no soldiers. Well before they reached Tayasal, the Itzá came out to welcome them and led them with all honour into the city, where they were all butchered. Captain Mirones and his army were equally unfortunate. On 2 February 1624, while they were at divine service in the village church at Sacalum, the local Indians fell upon them and slaughtered every one.

The bitter resistance discouraged the Spaniards from attempting further conquest over the next seventy years, and while Yucatán and Guatemala had both long been converted, the land lying between them was left to hold its old beliefs in peace. It was not until 1695 that another missionary set forth, this time Padre Avendaño, whom we have already encountered at Tikal. After baptizing three hundred children, he was obliged to flee for his life. The next excursion – of a military nature this time – found a fleet of canoes manned by warriors armed to the teeth waiting for them on Lake Petén, and yet another attempt to turn the Itzá into faithful and devout subjects of His Most Catholic Majesty failed. After this the Spaniards made haste to complete the road that they had already started to drive through the hostile territory, and from then onwards, the Petén was less inaccessible than it had been.

On 13 March 1697, 186 years after the first Spaniard set foot on Maya soil, the last bastion of the Maya fell into Spanish hands after a hard-fought struggle. The victors found none but old women and children in Tayasal, the rest of the population having fled into the jungle. The number of 'idols' in the city was so great that it took the entire Spanish army from nine o'clock in the morning to half past five in the afternoon to destroy them all. Their general, Martín de Ursua, selected the chief temple, which had run with the blood of human sacrifices only a short time before, as the site for a chapel, to ward off the Evil One.

My companion on the journey from Jocotán in Guatemala to Copán was a Maya youth of perhaps eighteen or twenty. It was a long walk and a bottle of *chicha* helped to loosen his tongue. All the mountains and valleys that we crossed belonged to different owners and were under the tutelage of different gods. Before we set off the boy prayed to all the gods whose provinces we were to pass through. He explained that Jesus Christ could not be

everywhere, was not the maker of everything; the world was far too big for one god to look after all of it. (When I asked him how much of the big world he had seen, he replied that he knew the road from Jocotán to Copán, all of thirty-five miles.) This was the credo of a Maya Catholic in the year of grace 1960.

We have virtually no record of the religion of the Classic period, apart from the figures of the gods on stelae and reliefs, to interpret which is no easy matter. For the Postclassic period, on the other hand, the sources of information include the *Books of Chilam Balam*, the *Annals of the Cakchiquel* and the *Popul Vuh*, traditional chronicles written down by natives in their own language, but in the Latin alphabet.[27] The most valuable account of the Maya religion is found in the *Relación de las cosas de Yucatán*, by Bishop Landa. When Landa came to realize how thin was the soil in which the seeds of Christian doctrine had taken root in his diocese, and how deep-rooted by comparison was the belief in the old gods, so that years after the conversion children were still being sacrificed to those gods, sometimes even in Catholic churches, he was driven to take some highly controversial steps. He ordered the burning of all the Maya books and the destruction of their idols, and by his authority the Indians were persecuted with considerable vehemence. His superiors found his zeal excessive and recalled him to Spain, where he wrote the *Relación* to justify his actions. It lay mouldering in a muniment room until the middle of the last century, but since its publication in 1864 it has been an invaluable guide to the mental equipment and beliefs of the ancient Maya. Unfortunately this people has lacked a counterpart of Sahagún, the friar to whom we owe so much of our knowledge of the religious views of the Aztecs.[28] Diego de Landa won a bad name for himself by his fanaticism in Yucatán, and no doubt the Indians, reticent enough in any case, kept many of their secrets from him. Consequently our picture of their religion is at best hazy, and must be supplemented by archaeological findings.

By far the great majority of the gods are embodiments of the forces of nature, and are accordingly benevolent or destructive. They distribute their gifts to mankind with prodigal generosity or withhold them altogether. Nearly all of them change their sex as often as they change their face. They appear in male, female, and sometimes hermaphrodite form. They take both human and animal shapes, and quite often present a hybrid appearance combining elements of both orders. They may reside in the heavens or in the underworld. They may perform as dead or living creatures, and when their sphere of activity becomes too large to cope with, they divide themselves into two or more beings or recruit an army of assistants. They are incalculable by nature. It is precisely this multiplicity of appearances that makes it difficult for us to reconstruct the pattern of their relationships now that they have been forgotten. As depicted in one manuscript they exhibit the wilfulness we associate with the Greek gods: no sooner has one god planted a tree, than another appears and tears it out of the ground.

Growth and decay are the themes reflected in the Maya theogony. It is no chance that the rain god Chac is the one portrayed most frequently (144 times in the *Codex Dresdensis* alone). Particularly in later work his features are unmistakable. In Yucatán he is depicted with a sort of elephant's trunk for a nose, which has often led to the assumption that he was of Hindu origin; but this has no more validity than the assertion that the human sacrifices made to the god in the *cenote* at Chichén Itzá, the Well of Sacrifice, were invariably

virgins, thrown in alive. Considering that a large proportion of the skeletons that have been recovered from the *cenote* were those of adult females, as little credibility attaches to this fanciful tale as to the many others that appear in books about the Maya.

In some manuscripts four different Chacs are illustrated, each linked with one of the four cardinal points of the compass by the use of the appropriate colour, red for the east, white for the north, black for the west and yellow for the south. The rain god is also the overlord of the gods of the winds (*pauahtun*) and controls the thunder and lightning. He is sometimes attended by toads, who serve him as minstrels. It is easy to see why he should have been the most important god to farmers. In the Classic period he is sometimes depicted in conjunction with symbols of death, for it was quite a common occurrence for torrential storms to destroy the crops. In a more sympathetic role, he appears as the fatherly protector of the young maize god.

fig. 34 The maize god, Yum Kaax, is an essentially amiable deity, who protects not only the young maize shoots but also young married couples. He is also, as was Apollo for the ancient Greeks, the embodiment of ideal male beauty. His skull is fashionably deformed and his headdress usually consists of sinuous plants or feathers. He is portrayed ninety-eight times in the three codices. In the Postclassic period he lost some of his importance, and his image became merged with that of Yumil Kaxob, the god of the forests.

fig. 36 The counterpart of the benevolent maize god is the god of death, Ah Puch, or Yum Cimil, as he is also known, the destroyer of all life and lord of the underworld. He is generally depicted as a skeleton, or at least with a death's-head, and he often appears in the company of his grisly friends, the gods of war and human sacrifice. Ah Puch is beyond question the most terrible god in the Maya pantheon. Not only does he lie in wait for men and hinder plant growth, he actively opposes the gods of fertility. There are three creatures of evil omen in Maya mythology: the dog, the owl and the *moan* bird, which sometimes also takes a form half-human and half-vulture. All three are found as attendants of the god of death.

There were other gods of greater theological importance, such as the creator of the world and of all things, Hunab Ku, who is never represented pictorially. In the Postclassic *fig. 40* period his son, Itzamná, was the object of great veneration. He was a sky god, presiding over day and night, and the sage among the gods, who it is said taught the priests the craft of writing. He was honoured as the patron of wisdom and learning. Itzamná is generally depicted as a toothless old man with sunken cheeks, a thin beard and a hooked nose; Herbert Spinden nicknamed him 'the god with the Roman nose'. In some representations he is associated with the sun god, Kinich Ahau. Occasionally he appears as a two-headed dragon or serpent, symbolizing the vault of the sky; one of the heads is a skull with open jaws, representing the western sky, which swallows the sun at night, while the other, living, head disgorges it again in the morning. There are similar forms of this cosmic symbol in Peru and Mexico. On a stela at Yaxchilán and a relief at Palenque astronomical signs are substituted for the body of the serpent. Sometimes, too, the 'east' is associated with the image of the sun god, while the other end bears the death's-head of Ah Puch.

figs. 39, 42 Itzamná's wife is Ix Chel, the moon goddess, a capricious old crone. Her benevolent activities include teaching women how to weave and protecting them in childbirth; on the

other hand she was regarded as the originator of floods and inundations – the moon's effect on tides had not escaped the astronomers. In the codices she appears only in her malevolent aspects, being always surrounded by symbols of death; we know from other sources, however, that she was worshipped as the goddess of medicine and prophecy. Her headdress is composed of entwined snakes, she wears a necklace of bones, and in place of fingernails she has a jaguar's claws.

According to legend the sun god Kinich Ahau, also known as Ah Xoc Kin, was the *pl. 109* inventor and patron of poetry. He was also honoured as the god of music. His iconographic attributes are those of a jaguar and his huge, blind eyes are almost square. His glyph 'Kin' means 'day' as well as 'sun' and resembles a St Andrew's cross; he wears it on his forehead or on his clothing.

Xaman Ek, the god of the North Star, performed a primarily protective function. He *fig. 38* appears in the codices with black flecks, a snub nose and something of the appearance of a monkey. Very little is known of his sphere of activities.

The war god, Ek Chuah, is a more strongly pronounced personality, who also held more pacific offices. He was the lord of the valuable cocoa plant, whose beans were used in place of currency, and he was the protector of merchants, who sacrificed to him before setting out on their journeys. In this last capacity he is portrayed in the form of a merchant, with a pack on his shoulders. The Maya also saw in him a fire-raiser and destroyer of their houses. In his aspect as god of war, he is depicted with his body painted black, holding a spear. His companions are usually of a malevolent character; his friends are the gods of death and human sacrifices.

The strangest deity in the Maya pantheon, and probably unique in the religions of the *fig. 43* world, is Ixtab, the goddess of suicide. In the *Codex Dresdensis* she is depicted hanging by the neck. It is reported of her that through her offices suicides were able to enter paradise.

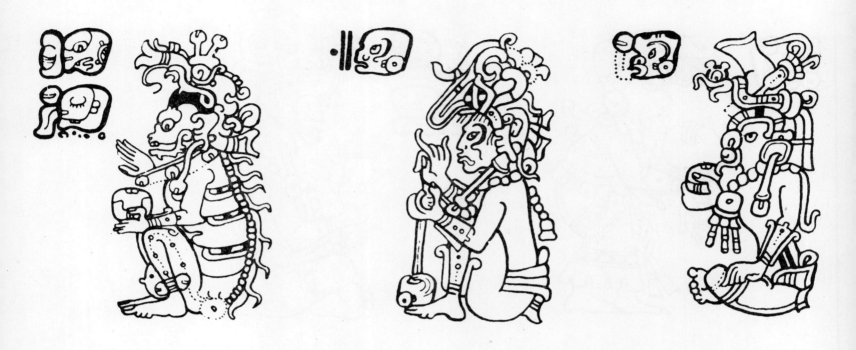

Quetzalcóatl-Kukulcán was introduced into the Maya religion by the Toltecs. He did not really have any specific function, but was often entrusted with those of the rain god and with promoting fertility. He appears on the whole to have been a beneficent deity, although human sacrifices were made to him. This practice was, however, nothing like as widespread among the Maya as the Spaniards found it to be among the Aztecs.

As well as all these anthropomorphic gods, the Maya worshipped animals like the jaguar, the bat, the vulture, the owl, the toad and practically every other living creature which was at all mysterious. 'They have so great a number of idols, it is as if their gods were not enough; there is not one animal or insect of which they have not made an image', writes Landa. Most of the innumerable gods were invented by the priestly hierarchies.

In the four centuries that have passed since the advent of Catholicism, many of the old gods have been fused in the Maya imagination with the saints of the new religion. The Virgin, for instance, has in some regions taken on not a few of the characteristics of the Moon goddess Ix Chel. But for many tribes there are simply not enough Christian saints to take the place of each and every one of the gods, who are therefore still taken to preside over certain activities. In the Guatemala highlands, baptized tribesmen still pray to the god of the forests before hunting:

> *Today I come before your face, Pokohil,*[29]
> *On your day, 4 Ix, we have come . . .*
> *We bring you half a hundred pieces of copal.*
> *Be kind, give us one of your deer,*
> *Grant us one of your beasts . . .*
> *For this I bring an offering of flowers . . .*
> *To you, who are our mother and our father.*

39 Ix Chel, the wife of Itzamná
40 Itzamná, the great god of learnin

After the hunt there is a prayer of thanksgiving:

> O Pokohil, today you have shown favour,
> And have given some of your beasts, some of your deer.
> Thank you, Pokohil.
> See, I bring you flowers for your deer.
> Perhaps you have counted them,
> And now they are not all there,
> Two of them are missing;
> They are the ones the Old One [the hunter] caught,
> You gave them to him.[30]

The cult of the dead played an important part in the religious life of the Maya, as of all the American Indian tribes. Ancestor worship was quite common and sacrifices were made in their honour. The lower classes of society buried their dead beneath or very close to their houses. Mourning rites included fasting and nocturnal wailing. Tools, weapons, and frequently a small piece of precious jade were buried with the dead, as well as food. As in ancient China and Greece, this arose from the belief that the dead would have to pay some kind of toll or fare to those in control of the nether regions.

In the early days the dead were interred, stretched out or in a flexed position, but in Yucatán cremation became fashionable, especially among the nobility. The bereaved treated the ashes with great reverence, keeping them in decorated clay urns. The Cocom dynasty indulged in the unusual practice of boiling the heads of their deceased forebears; they stripped the flesh from these heads and cut away the back part of the skull, and then modelled the features in wax. These lifelike portraits took their place among the domestic gods and propitiatory sacrifices were made to them on certain feast days.

74

The Maya, like the Mexican tribes, believed in the existence of previous worlds, which the gods had destroyed in various ways, including a great flood. They imagined the world as a large island, floating on the back of a gigantic crocodile among the waters. Above this world were thirteen heavens, piled one above the other, and below it nine underworlds. Each of these regions was ruled over by a separate god, the lowest being the realm of the god of death, Ah Puch. The Tzotzil in the highlands of Chiapas still pray to the 'Nine Lords of the Night' and the 'Thirteen Lords of the Day' as well as to the Catholic saints. They also pray to the lords of the four cardinal points, for the thirteen heavens were supported at each of these points by a deity. At each end of the earth stood a mighty *ceiba* tree, perhaps to give shade, but probably also as a symbol of the earth's bounty. They were often associated with the rain gods. Already in Classic reliefs, the tree, symbol of fertility, was *pl. 129* represented in a stylized form, very like a cross, which frequently gave rise to great confu- *figs 23–5* sion among the Spaniards and early explorers, who assumed that it had a Christian connotation. The resemblance that they found between the Maya religion and Christianity lay not only in the symbol: it was no more than a coincidence that the Maya believed in punishment or rewards in the after-life and in a divine Creator, omnipresent but never represented in art, but this analogy made the missionaries' work easier.

The Maya imagined that life after death would possess as rigid a structure as life in this world. The thirteen heavens were reserved primarily for the aristocracy, while the lower orders' only chance of reaching one of them lay in certain modes of death. For example, as with the Aztecs, warriors who fell in battle and women who died in childbirth went to one of the heavens, and the Maya also believed in a special paradise for suicides.

People of humble origin who were selected for sacrifice escaped the torments of the lower world (Mitnal), because they continued to serve the priests or the gods for whom their blood was shed in one of the heavens.

The Maya hierarchy was headed by the chief priest, Ah Kin Mai, the 'serpent prince'. He himself officiated at none but the most important ceremonies: for the most part he was

occupied with the supervision and instruction of the novices. His office was hereditary, and, in the Postclassic period, he was frequently the brother or a close relative of the reigning prince. He probably had considerable political influence. The innumerable minor ceremonies were the responsibility of the ordinary priests, the Ah Kin. A third order was that of the Chilam, who were exclusively concerned with astrology and prophecy. It was they who calculated which days would bring good fortune and which would be 'black', and foretold the outcome of projected actions. The three manuscripts which escaped the Spanish bonfires are chiefly concerned with such prophecies. The *Books of Chilam Balam* of Chumayel, Tizimin and Maní contain not only prophecies but also historical records, the two former concerning the Itzá, and the third the Xiu. Written down by Maya priests soon after the Conquest, in the Maya tongue of Yucatán but in the Latin alphabet, their form is fragmentary and the content often obscured by myth. It is likely that a transcript of the older manuscripts, which are written in glyphs, would resemble them.

Among the many demands made by the multitude of gods upon those who 'fed and sustained' them were, in addition to offerings of plants and animals, the burning of copal resin and self-mutilation by the priests. The self-infliction of pain by piercing the tongue and other parts of the body is frequently depicted, particularly in the Classic period. The blood *pl. 163* which flowed from the wounds was sprinkled on the idols in temples and houses, and if this was not sufficient to ward off great dangers, human sacrifices were resorted to. Whether the Maya practised human sacrifice in the Classic period is still an open question, but at least one stela at Piedras Negras illustrates it. It was only under influences emanating from Mexico that the practice spread and came to be widely depicted in art. Chichén Itzá is known to have been an important religious centre for at least five centuries without a break, from about the beginning of the eleventh century to 1536, the year in which the Xiu undertook their ill-fated pilgrimage. The well-known sacrificial *cenote* there was thoroughly investigated, with the aid of divers and dredgers, between 1904 and 1907. Among the numerous offerings were found a large number of ornaments of jade, copper and gold and the skeletons of *figs 31–3* forty-two people offered up to Chac, the rain god, in times of drought.

Four different kinds of human sacrifice are known from the Postclassic period. There was the sacrificing of servants on the death of a noble – a custom which certainly dated back to the Classic period[31] – and there was the drowning of victims in the sacred *cenotes*, which seems to have been confined to Yucatán. The other two methods appear to have been of purely Mexican origin and first occur in the hybrid Maya-Toltec civilization: the cutting-out of the victim's heart with an obsidian or flint knife, so that the surrounding idols were spattered with the blood, and the killing of prisoners in the course of a ritual dance, in which the victim stood in the middle of a circle of dancers who shot arrows at him.

Dance played an important role in all ceremonies. Men and women danced separately. Priests, wearing masks which were as often as not made from the skulls of slain or sacrificed enemies, frenziedly re-enacted in dance the heroic deeds of gods and tribal chieftains. Old women performed a stilt-dance, probably to provide comic relief. The rituals were accompanied by the rhythmic music of wooden drums, trumpets, flutes of bone, reed, clay or wood, bells and conches.

Human sacrifice was stamped out in Yucatán by the no less bloody methods of the

42 Ix Chel weaving (*Codex Tro-Cortesianus*)
43 Ixtab, the goddess of suicide

Inquisition. On 25 March 1565, Sebastián Vázquez, His Majesty's Clerk in Mérida, recorded that 4,549 men and women 'were hanged and tortured by the monks in the manner I have described, 84 of them executed wearing the heretic's shirt of penitence, and in addition to those that were hanged and tortured in this way, some were punished and fined. . . .' But even harsh measures such as these were not enough to eliminate every aspect of the cult: some of the old beliefs still live on in the Maya subconscious.

Apart from some pictorial evidence on stelae and ceramics, we have no record ot the social order in the Classic era. The picture that archaeologists have been able to piece together is that of a theocracy: the power in each region was invested in the priests who resided at its cult centre. We do, however, have more detailed information about the structure of Postclassic society in Yucatán and in the Guatemalan highlands.

The social divisions in Yucatán were clearly defined: the secular aristocracy, the priestly caste, the freemen, and the slaves. The nobility were known as Almehenob ('those who have fathers and mothers'). Power was in the hands of a small number of families, whose members claimed the highest religious and temporal offices by right of birth. The ruling prince was called Halach Uinic ('the true man'); his office generally passed from a father to his eldest son. The office of high priest, Ah Kin Mai ('the serpent prince'), also usually remained within the ruling family, often passing to the second son. His education was long and thorough. As high priest it was his duty to subject all his priests to a qualifying examination at the end of each *katun* (a period of nearly twenty years). At similar intervals, the prince put his assistants through an examination. He and his family resided in the major centre of worship, and the surviving ruins of their palaces testify to the magnificence of the way of life of these high dignitaries.

The position of the chieftains in the smaller communities, whose office was also hereditary, was something like that of a sheriff or mayor. They were subordinate to the ruling dynasties and were exempt from taxation. They presided over village moots, and were responsible for enforcing the orders issued by the priests and the commands of the rulers. They also supervised the paying of tribute. In time of war they took command of the men of their community, but came under the orders of a general from one of the Almehenob families, who held his appointment for only three years. During that time he had to lead a life of seclusion and abstain from eating meat and from sexual intercourse.

Land was generally held in common by the freemen. They looked for protection to the nobility, who lived off the tribute that they paid. If, as was often the case, there were not enough slaves available to work on the ambitious building projects in the cities, the free peasants were expected to help. All this had probably applied also to the Classic period. The care of the old and the sick was undertaken as a matter of course by the villagers, and they helped each other in building houses, hunting and agricultural work.

The village chieftains acted as magistrates in both civil disputes and criminal cases within their areas. 'They had laws and their penalties were harsh' (Landa). Adultery and rape were punishable by death, unless the injured husband was prepared to forgive. Treason, murder and arson were also capital offences, if they were committed with deliberate intent, whereas someone who accidentally started a fire or killed through carelessness was only expected to provide compensation, for which his whole family generally took responsibility. If the amount of damages was too great, or the family too poor to pay, the guilty man was sold into slavery. Thieves, too, got short shrift: they were sold as slaves and the proceeds given to the victim of the theft. The severest penalties were for sodomy: the Xiu are said to have burnt alive those convicted of this offence. All death sentences had to be confirmed by the higher authorities. Nobles could only be judged by their equals, and were usually punished by nothing more than deprivation of rank or honours.

Minor crimes by the ordinary people were also punished by various forms of ignominy, such as shaving the head, or a distinctive tattoo on the face. Men marked in this way were social outcasts in their own community. At Maya trials witnesses were heard and the defendant's case was put. The purpose of sentences, besides upholding morality, was always to make good any material damages incurred. A husband who drove his wife to suicide – which from the religious aspect meant that he enabled her to reach one of the thirteen heavens, which would otherwise have been closed to her – was in law obliged to pay compensation to his wife's relatives.

Bishop Landa, whose testimony on such matters is usually accurate, says at one point that the inhabitants of Yucatán never took more than one wife. Sánchez de Aguilar, on the other hand, asserts that they practised polygamy. The apparent contradiction is resolved in the light of a statement later in Landa's account, to the effect that the men were allowed to take female slaves as concubines and to sleep with them 'as often as they wanted'. It was a different matter for the wives: if they consorted with slaves they lost their own freedom. We may assume that under Maya law, with the importance it attached to material compensation, it was then possible for the husband to afford a new wife.

A young man had to work for a period of between five and six years after the marriage,

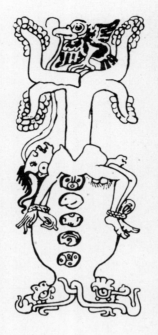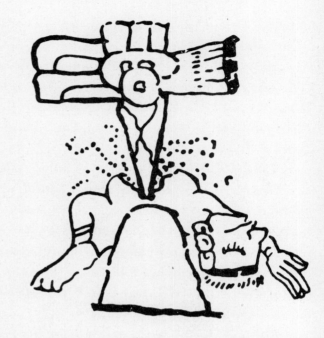

44-45 Scenes of human sacrifice from monuments and codices

for his parents-in-law, before he was considered to have fully earned his wife. Matches were usually arranged years in advance by the two sets of parents.

In spite of the high price a bride commanded, women occupied an inferior station in society and their life was not an easy one. They were segregated from men at mealtimes, they had to bear and rear as many children as they could and do more work than the stronger sex. Only noblewomen could deck themselves with jewellery, and even then they had less than their husbands. Among the Maya, looking-glasses were for the use of men rather than women.

The lowliest stratum of society was composed of slaves, usually prisoners of war and people carried off by raiding parties. They were always of humble birth, because noble prisoners were either ransomed at a high price or, in the Postclassic period at least, were sacrificed to the gods. Slaves, along with cocoa beans, pearls, precious feathers and, not least, jade were the most valued objects for barter, taking the place of metal coinage in other economies. One reason for the unpopularity of the Cocom dynasty throughout Yucatán was their practice of selling their own subjects as slaves. On his fourth and last voyage of 1502, Columbus met a Maya boat in the Gulf of Honduras, which was laden with precious fabrics, ceramic wares and fettered slaves.

Tabasco, with its sluggish rivers flowing down from the mountains of Chiapas, forms the borderland between the Nahuatl-speaking communities, which later spread over Mexico, and Maya civilization. In earlier times it was a busy forum in which the two races exchanged merchandise, ideas and even religious concepts. It was the birthplace of La Malinche, Cortés' Indian mistress, who proved so valuable to him. She had learnt the Maya language of Yucatán in childhood and was thus able, with Jerónimo de Aguilar, who had become

familiar with it during his long captivity, to interpret the wishes and commands of the 'white gods'.

Here, hidden among the mangrove forests, lie the remains of the mysterious Olmec civilization. Antiquated ferries carry you across the swollen rivers of this hot and humid land, rivers such as the Coatzacoalco and the Grijalva. As you proceed eastwards, the black earth ends and is replaced by white sand and limestone, the scenery changes abruptly and you are in Yucatán.

Yucatán sticks out into the Atlantic like the thumb of a mitten. The sandy road, by twentieth-century standards a very primitive attempt to link the isolated peninsula more closely to the rest of Mexico, runs for miles along the coast without passing any signs of human habitation. The monotony is broken only by the bizarre skeletons of trees, filched by the sea at some point along the shore, gnawed and spewed up again. At the water's edge the beach is composed of millions of tiny, glittering fragments of shell. Settlers have always fought shy of this coast. It is as free from the traces of a great historic past as it is from present-day civilization.

But Yucatán is not a desert, and the landscape soon changes again. The first small villages, Nahún and Chenkán, nestle beside delightful little bays, shallow and limpid. They are Maya villages, and their names are part of the living Maya language. The traveller will find Coca-Cola, but no bed for the night. The very next village, Champotón, stands on historic ground, its modern houses built with stone hewn long ago.

It is not until he reaches Campeche, the capital of the state of the same name, that the weary traveller finds a hotel at last. The first Spanish settlement in the Maya empire, its extensive fortifications have long been worn smooth by time, and it is today a town of great charm. It is not a Maya city at all, but a relic of colonial history, perhaps the most Spanish town in Mexico. Beyond Campeche the asphalt road leads inland through the Puuc hills to Mérida. This was the land in which the Xiu held sway.

My first encounter with the remains of Postclassic culture was not particularly impressive: the road bisects two unremarkable buildings devoid of decoration, some of their masonry incorporated in the road's foundations. The natives call the place Tacoh Hopalchén – 'jaguar's dung'. Only a few miles further along the road, we reached a very different ruined site, Kabah, whose imposing buildings drove all memory of the previous disappointment from my mind. On the right-hand side of the road, bathed in the reddish glow of the late afternoon sun, stood Codz Pop, the 'House of Masks', dedicated to the rain god. Its magnificent façade is decorated with row upon row of identical masks, set so close together that there is hardly a gap between them, yet giving no impression of overloading. Codz Pop is a tremendous vision of the forces of nature brought under control. All that the Maya artists and priests strove for is, in my opinion at least, achieved here. Large parts of the building, which once consisted of ten long rooms, have collapsed. I was reminded irresistibly and repeatedly of the fantastic rooms in the paintings of Piranesi – perhaps because of the magical patterns of light and shade woven by the sun on the mask-filled façade, and the way the side of the palace has fallen away, to betray the builder's technical secrets. The structure of the 'false' or corbelled arch and the massive masonry are almost as clear as a diagram would make them. Innumerable fragments of the great protruding nose of the

pls 232, 246–7

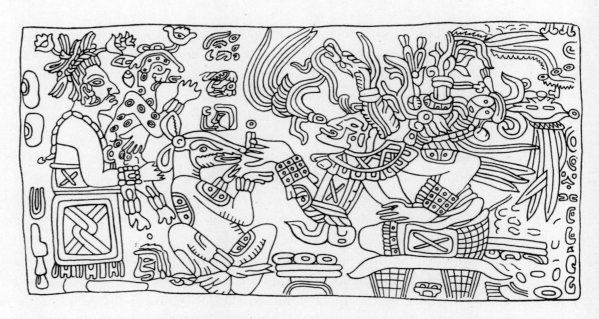

46 Mythical hunting scene, incised on a clay vase from Ixtapa, Chiapas

many images of Chac were left by the restorers to lie in tidy rows on the ground in front of this striking example of the Puuc style of architecture.

A Maya woman, in the clean, becoming costume of Yucatán, came up to the deep well in front of the Codz Pop and drew clear, fresh water, the most coveted commodity in those hills. She was the only person stirring in the deserted, twilit ruins, but she succeeded in conveying the semblance of life there. Where she lived I did not know, nor could I find her house the next day. It would have been offensive to have asked her, and a waste of time; she would have been extremely reluctant to speak to a stranger, except in her husband's presence.

It may have been in gratitude for the ancient well, with its never-failing supply of precious water, that the devotees of the rain god built the Codz Pop, and repeated his likeness countless times along its 150-foot-long façade. It is a far more ornate building than any other temple in the neighbourhood – the other settlements, after all, had to rely on *chultunes*, man-made cisterns with their inadequate supply of water.

The other buildings at Kabah also face west into the sunset, but they all fade into insignificance beside the devout ostentation of the House of Masks.

Kabah means 'he with the strong hand', and derives from a monumental stone figure representing a naked man with a serpent in his hand, found in the ruins. As in the case of other centres, the name was applied to the site long after the builders had departed.

Very little excavation, and even less restoration, has been carried out at Kabah. A large number of temples and mansions still lie beneath unremarkable mounds. I must mention one other structure, which stands on its own on a platform at the beginning of a causeway which once ran straight as a die to Uxmal: Kabah's triumphal arch. It is quite plain, simpler pl. 250 and perhaps less striking than its counterpart at nearby Labná, yet still imposing. What victorious armies passed beneath it? What defeated mercenaries were led through it into slavery?

Kabah, Sayil, Labná and Uxmal are the most famous of the centres built in the Puuc style, the Maya style of the Yucatán highlands. In the buildings of their last phase, Labná and Sayil reveal Toltec influences, at least in the techniques used. As the visitor to Sayil steps out of the gloom of the thorny bush forest on to a plaza flooded with light, his attention is at once caught by the unassertive nobility of the Palace, which faces the setting sun. Its only external ornaments are masks of the rain god, while its rather dark rooms are enlivened by striking arrangements of pillars. The Palace contains over eighty rooms in its three storeys, but nothing is known of the names or the history of its occupiers. This building alone justifies the journey into these remote parts. The archaeologists have shown great tact in restoring only one half of it and deliberately leaving the other in a state of decay.

pl. 252

Labná lies to the east, even deeper in the bush. Posterity's laconic judgment on the site has been to give it a name which means 'tumbledown houses'. In fact, its palace is a powerful structure, which thrusts up imposingly from the deep red earth towards the pale blue sky. Three different architectural styles can be distinguished here, testifying to the work of at least three separate generations. Of Uxmal (perhaps originally Oxmal-'thrice built'), alone among this group of sites, written records survive. The *Book of Chilam Balam of Maní*, the book which is concerned with the history and downfall of the Xiu, records that 'Ah Suytok Xiu settled in Uxmal in Katun 2 Ahau [AD 987–1007]'. The *Book of Chilam Balam of Chumayel*, written down in 1542, gives a more precise clue to the age of Uxmal: '870 years (have) passed since the city of Uxmal was destroyed and the land abandoned.' The chronicles and the archaeological excavations agree that the city was settled twice, once in about the seventh century and again about three hundred years later.

pls 248–51

Uxmal is visually the most dramatic temple-site in the Puuc highlands and probably in the whole of Yucatán. The way the buildings are grouped on the broad plateau makes them appear almost unreal. As with many Maya centres, it is not the vertical articulation that counts in this grouping. The height of each building is a mark of its importance. The Temple of the Dwarf dominates the site, stirring the imagination, in spite of the forbidding, unapproachable aspect it presents on every side. A flight of 118 steps leads up to its two platforms (with a chain handrail to assist the climber since the site was visited by an empress). From the summit one looks down on the Nunnery Quadrangle, with its splendid façades, the ruined ball court that lies in front of it, and the whole city. Somewhat to one side stands the House of the Governor (Casa del Gobernador), on an artificial mound. The Indian legend about the Temple of the Dwarf runs as follows:

pls 234–43
fig. 63

There was an old woman who lived in a hut on the very spot now occupied by the structure on which this building is perched, and opposite the Casa del Gobernador (which will be mentioned hereafter), who went mourning that she had no children. In her distress she one day took an egg, covered it with a cloth, and laid it away carefully in one corner of the hut. Every day she went to look at it, until one morning she found the egg hatched, and a *criatura*, or creature, or baby, born. The old woman was delighted; she called it her son, provided it with a nurse, and took good care of it, so that in one year it walked and talked like a man; and then it stopped growing. The old woman was more delighted than ever, and said he would be a great lord or king.

One day she told him to go the house of the Gobernador and challenge him to a trial of strength. The dwarf tried to beg off, but the old woman insisted, and he went. The guard admitted him, and he flung his challenge at the Gobernador. The latter smiled, and told him to lift a stone of three *arrobas*, or seventy-five pounds, at which the little fellow cried and returned to his mother, who sent him back to say that if the Gobernador lifted it first, he would afterward. The Gobernador lifted it, and the dwarf immediately did the same. The Gobernador then tried him with other feats of strength, and the dwarf regularly did whatever was done by the Gobernador. At length, indignant at being matched by a dwarf, the Gobernador told him that, unless he made a house in one night higher than any in the place, he would kill him. The poor dwarf again returned crying to his mother, who bade him not to be disheartened, and the next morning he awoke and found himself in this lofty building. The Gobernador, seeing it from the door of his palace, was astonished and sent for the dwarf, and told him to collect two bundles of *cocoyol*, a wood of a very hard species, with one of which he, the Gobernador, would beat the dwarf over the head, and *afterward* the dwarf should beat him with the other. The dwarf again returned crying to his mother; but the latter told him not to be afraid, and put on the crown of his head a *tortillita de trigo*, a small thin cake of wheat flour.

The trial was made in the presence of all the great men in the city. The Gobernador broke the whole of his bundle over the dwarf's head without hurting the little fellow in the least. He then tried to avoid the trial on his own head, but he had given his word in the presence of his officers and was obliged to submit. The second blow of the dwarf broke his skull in pieces, and all the spectators hailed the victor as the new Gobernador. The old woman then died; but at the Indian village of Maní, seventeen leagues distant, there is a deep well, from which opens a cave that leads underground an immense distance to Mérida. In this cave, on the bank of a stream, under the shade of a large tree, sits an old woman with a serpent by her side, who sells water in small quantities, not for money, but only for a *criatura*, or baby, to give the serpent to eat; and this old woman is the mother of the dwarf.[32]

The pyramid complex shows the signs of five different phases of construction. Temple I lies almost at ground level and was buried in rubble when the pyramid itself was built. When

48 Incised decoration of stylized serpents' heads
 on a tripod dish from Samac, near Cobán, Guatemala

it was uncovered again, a fine façade was revealed, decorated with masks of the rain god, astronomical symbols and human figures. Temple II, sole access to which was originally by the stairway on the east side, had its walls painted with serpent motifs. Temple III lies within the pyramid and is invisible from the outside. Temple IV is approached from the west, up a flight of steps decorated on both sides with masks of Chac, and the doorway of this small temple takes the form of the open jaws of an immense mask of the rain god. Temple V lies spread out on the summit of the elliptical pyramid. The architects of each stage were astonishingly successful at preserving a harmonious over-all effect.

Uxmal has long been one of the sights of the peninsula. Buses now bring tourists along the forty-five miles of asphalt road from Mérida twice a week. Little boys with almond eyes and golden skin offer their services as guides, sell 'idols' or undertake to carry your camera and tripod for a few pesos. One of my guides was quick to produce a small stone sculpture from his pocket. An *ídolo*, for only a few pence. It was certainly carved in the Uxmal style, and the stone was unquestionably old. I made repeated attempts to get the boy to admit that it was a forgery. '*No, Señor, es auténtico.*' At midday, as we walked around the magnificent, ornate façades of the Nunnery Quadrangle, in the rooms of which hundreds of birds rustled like the restless spirits of the past, I asked another question: 'Tell me, how long did it take your father to make it?' Quick as a flash the proud answer: '*¡Siete horas* [seven hours], *Señor!*'

After the peaceful symbols of Maya architectural decoration, the warlike realism of the Toltecs may at first be repellent. It takes a little time, when one first comes upon them in the heart of Yucatán, at Chichén Itzá, to adapt oneself to their cosmology, and to their quite different ideas and symbols. The oldest buildings at Chichén, the Nunnery, the Church, the Red House, the House of the Three Lintels and a few others, are built in the gracious Puuc style with its pleasing ornamentation. But they are overshadowed by the massive, tyrannous style of the Toltec buildings. All about one in Chichén Itzá one feels the warlike spirit of Quetzalcóatl, which rejected Maya imagery in favour of the grisly eagles and jaguars fed on human hearts, the rows of skulls, and the gaping jaws of serpents. The friezes and sculptures here commemorate the military exploits and material ambitions of Toltec princes, warriors in padded uniforms, brandishing lethal weapons.

pls 257–89

fig. 64

pls 280–1

pls 266–7

pls 264, 276

pl. 275

The largest of the four ball courts at Chichén Itzá is breathtaking. It measures 550 feet from north to south and its towering walls throw back an eightfold echo. The balustrades and the walls of two buildings that overlook it, the Temple of the Jaguars and the Temple of the Bearded Man, are decorated with reliefs. The former, a building of compact, restrained

power, is one of the finest examples of the Toltec style. Its corbel vault is the only Maya

pl. 260

element in its construction. Two vast feathered serpents, symbols of Toltec might, dominate the court. Between these sat the nobles of highest rank, to watch the game. This court has none of the sunlit gaiety of the one at Copán: the nature of the game changed under Toltec influence, and, with it, its setting. Something frightening, a sense of deadly menace, emanates from the horizontal bands of relief carvings which frame the court, and from the lowering, oppressive temples, intensified perhaps by the uncanny acoustic, which will carry a whisper 500 feet. The ball court, more than any other of the Toltec structures at Chichén Itzá, is permeated by the chill breath of the Mexican cult of the dead. By the same token, today, Mexican mothers still give their children skeletons as dolls, and Mexican confectioners make little skulls of sugar. At no other site do you feel so beset by the idea of death, and perhaps this is why the Maya never re-occupied the city after the Itzá were driven out.

pls 257–60

It took four years of excavation and repair to restore the magnificent Temple of the Warriors. The temple and the colonnades that lie before it were a great mound of stones, densely covered with thorn bushes. Nobody guessed that underneath would be found

pl. 264

pillars, some still standing, decorated with painted bas-reliefs of the figures of Toltec warriors in their sumptuous attire, from which the temple takes its name. Originally the eyes were inlaid with white shells, the pupils painted in pitch, for the sake of realism. Today the effect of the pillars ranged before the temple is like an immense foyer, whose roof has been ripped off in a hurricane. From the Castillo, built, according to Landa, in honour of Quetzalcóatl-Kukulcán, one can survey the whole impressive complex, with the desolate bush stretching away beyond. Nothing in pre-Columbian art was without symbolic significance: even the ornamentation on architecture, the form taken by sculpture and all the objects made for ritual purposes or for the individual, were dictated by other than aesthetic

pl. 268

considerations. The Castillo rises by nine stages into the sky, and these correspond to the nine Toltec heavens. The four flights of steps, facing north, south, east and west, each comprise 91 steps, 364 in all, to which is added one more, up to the sanctuary, so that the total number is that of the days in a solar year. The 52 ornamental cassettes on each side of the base of the building also had a calendric significance, for to both the Toltecs and the Aztecs, the longest unit of time was the Calendar Round of 52 Vague (solar) Years. The Castillo, the interior of which contained ritual chambers above which the main temple was

pl. 270

built, is a memorial in stone to Toltec cosmology. Inside it, a *chacmool*, whose forbidding stare derives from the skilful positioning of the pupils in its inlaid eyes, reclines in front of a magnificent jaguar throne. Painted red, encrusted with discs of jade, and with great, brilliant eyes made of the same precious stone, it stands in its original position.

pl. 279

The oldest Toltec building on the site, the circular observatory, is also the greatest technical achievement. Called the Caracol ('snail shell') because its spiral steps give it the appearance of a seashell, its windows and doors are so positioned that at certain hours on

figs. 65–6

certain days the sun shines through two aligned openings. The structure gave time readings that were accurate to within fifteen minutes.

pl. 253

Tulum, whose name means 'fortification', looks peaceful enough today, but it was the only centre in Yucatán, apart from Mayapán, to be protected by a wall.[33] 'We sailed a day and a night, and on the following day at sunset, we descried a citadel, or a city, so large that

Seville seemed to us neither larger nor better.' That was Grijalva's impression in 1518. Tulum was probably the place where Jerónimo de Aguilar and Gonzalo Guerrero had been held prisoner in 1511. The site seems to have been abandoned by the Maya shortly after the Spanish conquest. All that is known of its subsequent history is that in the sixteenth and seventeenth centuries it sheltered English, French and Dutch privateers, lying in wait for Spanish galleons laden with treasure taken from the Indians. The indefatigable and fortunate Stephens and Catherwood were once more the first to visit and describe the site. When the American archaeologist W. H. Holmes wanted to explore Tulum at the end of the last century, he found it occupied by insurgent Maya tribesmen and had to turn away.

'Bourgeois', I wrote in my diary to record my first impression, when I landed at Tulum from the island of Cozumel in a small sailing boat that I had chartered. I had been spoiled by the architecture of Tikal, Uxmal and Chichén Itzá, and I was disappointed and in no mood to appreciate the small-town style that I found here. On this site perched on the cliffs high above the Caribbean, there are neither lofty pyramids nor spacious palaces, but small, squat buildings, which give the ancient city a solid, four-square appearance. Two stelae found there bear dates equivalent to AD 559 and 564, respectively. The Castillo, with its great external staircase, is perhaps an architectural success. It stands imposingly, cutting off one end of a street, which previously ran from east to west, dividing the temple area in two. This may be the building that the Spaniards described as a tower. A closer study has revealed that the temple contains elements of at least three or four building phases, the last of them, on the evidence of the pillars, under Toltec influence. It was originally constructed as a small temple on ground level, and subsequently enlarged with colonnades. Finally, the untiring architects erected a second temple on top of the original one, which can be reached only by a ladder. The frescoes in the nearby Temple of the Frescoes are beautiful *pl. 254* in their simplicity. They depict some of the agrarian gods of the Maya pantheon. Painted entirely in blue, ochre and black, their style has presented considerable problems, since they bear less resemblance to Maya manuscripts than to Mixtec miniatures, and the closest parallels are the frescoes in the Mixtec ruins at Mitla (Oaxaca). On the other hand the stucco decorations on the façades of the same temple are, despite their deterioration, clearly recognizable in both style and motifs as Maya work.

Turning my back on Tulum, which I had gradually warmed to, and on the deep blue Caribbean, I tried to visit Acanceh and Mayapán before the onset of the rainy season. At Acanceh I found only some fragments of the stucco facing of a pyramid. These I found unremarkable, though Eduard Seler had enthused about them forty years earlier.

Mayapán, not far away, was even more of a disappointment. Of the 3,500 buildings *pls 296–8* which once stood within the five-and-a-half-mile perimeter of its walls, not one is in a condition to be compared with the structures in other ruined centres. This metropolis, the nearest thing to a city in our sense in the whole of Maya civilization, once housed over 150,000 inhabitants: it was demolished by its enemies with particular venom, and what the hand of man left undone, nature has completed.

The road back to the western, Catholic world leads through Tecoh, where the surviving inhabitants of Mayapán took refuge, and through Acanceh. It was Sunday, and each of the two villages resembled a camp of exiled princes and dispossessed kings. There was a

bullfight in one of the villages that day. The arena laid out in front of an ancient pyramid united two worlds, the Iberian and the Mayan. Innately proud in their bearing, dressed in their best, the descendants of the former lords of the land watched the *corrida* with the same enthusiasm that their ancestors had shown for the sacred ball game. Two worlds in a small village with an immense past. I looked into the almond-shaped eyes of the spectators. Were they conscious of their history? Of course not. Water and maize, beans and sisal, birth, marriage, sickness and death, dominate their lives, and it is as well that it should be so. Their laughter would fall silent, their dignified heads, hitherto held high, would bow beneath the weight of such a past. Time, which destroyed their great temples, has also healed the wounds in the memory of this people. Only occasionally, when the *pulque* has flowed freely, are the Maya overwhelmed by the deep sadness of the Indian race and there rises once more the mournful sound of an ancient song of Yucalpetén, the 'pearl at the throat of the earth', as the Maya in Yucatán sometimes called their homeland:

Yucalpetén, Yucalpetén,
All is past,
All is silent.
The Indian weeps,
His tears sink deep into the earth,
Into the sacred earth,
Yucalpetén, Yucalpetén,
All is passing,
All is silent.

	Julian Calendar	Maya Calendar	Tikal and Uaxactún	Lowland San José	Copán	Highland	Yucatán
FORMATIVE OR PRECLASSIC	3113 BC 3000 1200 400 1 AD 100	0. 0.0.0.0.	Mamom Chicanel	San José I	Formative	Las Charcas/Chiapa de Corzo I Kaminaljuyú I	Early Formative Middle Formative Late Formative
CLASSIC	300 400 600 700 800 900	8.14.0.0.0. 9. 0.0.0.0. 9.10.0.0.0. 10. 0.0.0.0.	*Beginning of polychrome ceramic ware* Tzakol 1 Tzakol 2 Tzakol 3 Tepeu 1 Tepeu 2 Tepeu 3	San José II San José III San José IV San José V	Early Classic Middle Classic *mould-made ceramics*	Miraflores Late Kaminaljuyú Esperanza Pamplona Amatle	Dzibilchaltún Oxkintok Tulum Cobá Chichén Viejo Rio Bec and Puuc (Uxmal, etc.)
POSTCLASSIC	1000 1200 1400 1500	10.10.0.0.0. 11. 0.0.0.0. 11.10.0.0.0. 12. 0.0.0.0.	*Beginning of plumbate ware*			Xinabahul	Maya-Toltec culture (Chichén-Itzá) Mayapán
COLONIAL PERIOD	1600					*Spanish colonial rule*	

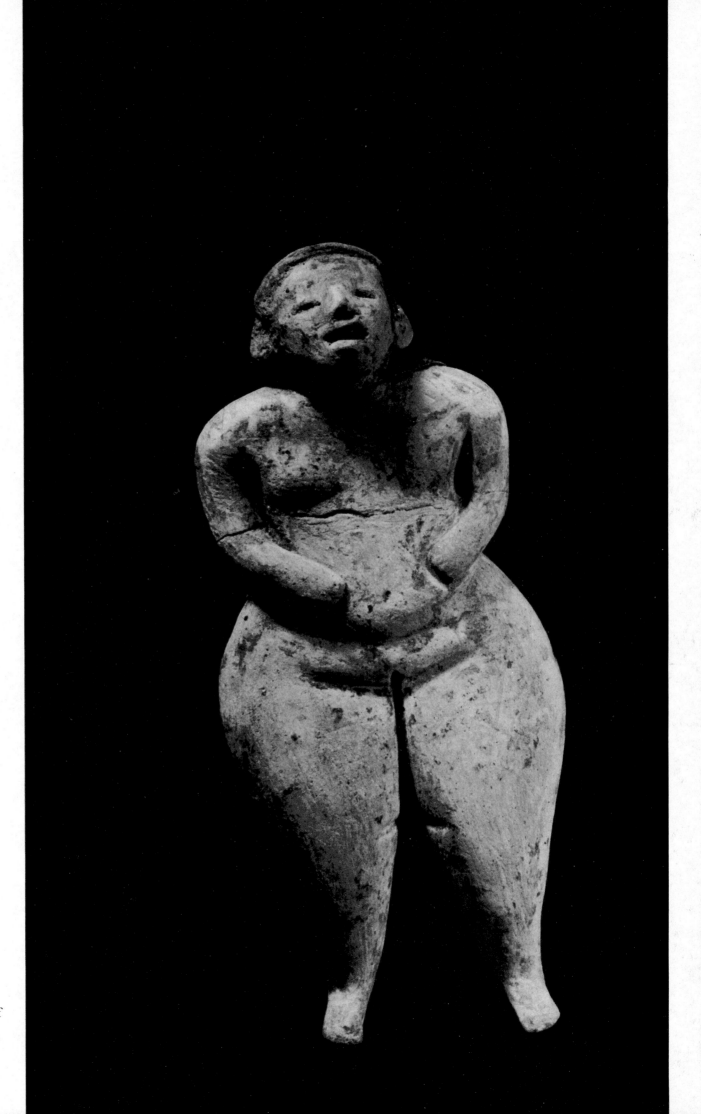

1 Standing figure of
a girl. El Salvador

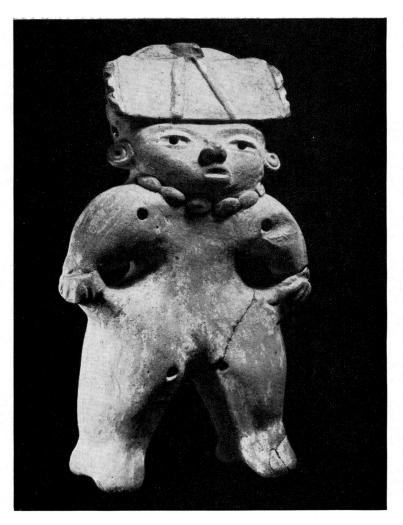

2 Model of a girl. El Salvador
3 Standing figure. El Salvador
4 Seated female figure. El Salvador

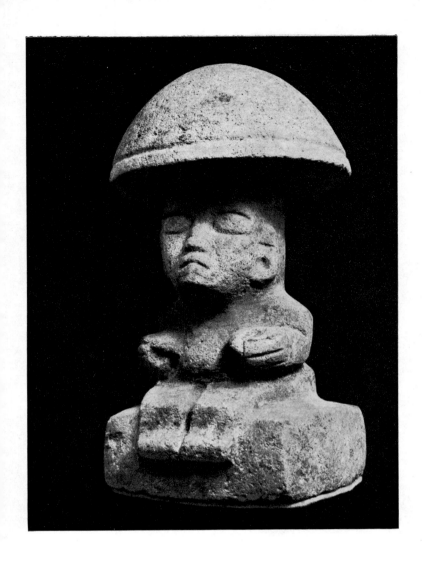

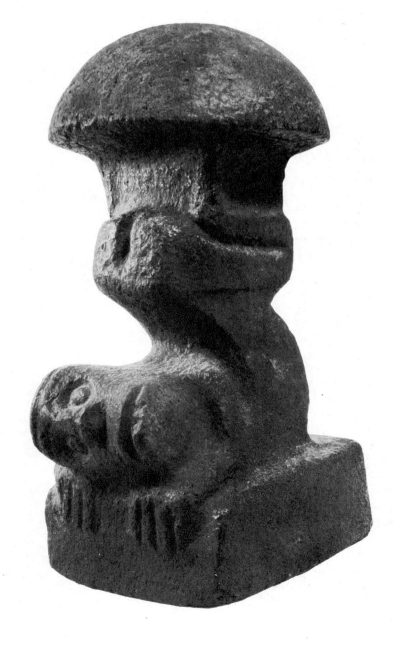

5 Mushroom stone. Kaminaljuyú
6 Mushroom stone. Guatemala

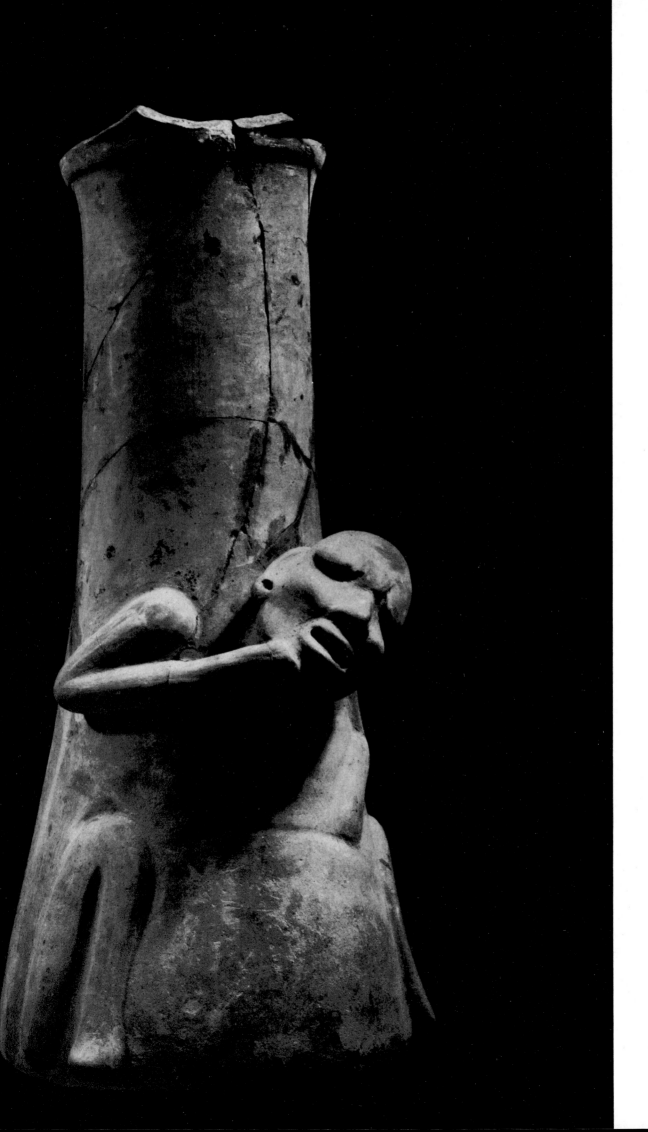

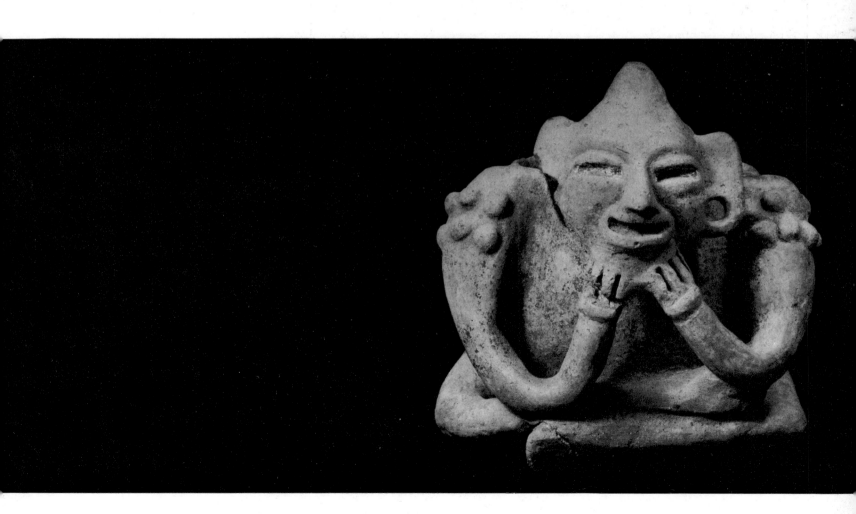

7 Tall vase. Antigua

8 Vessel in the form of an old man. Tazumal

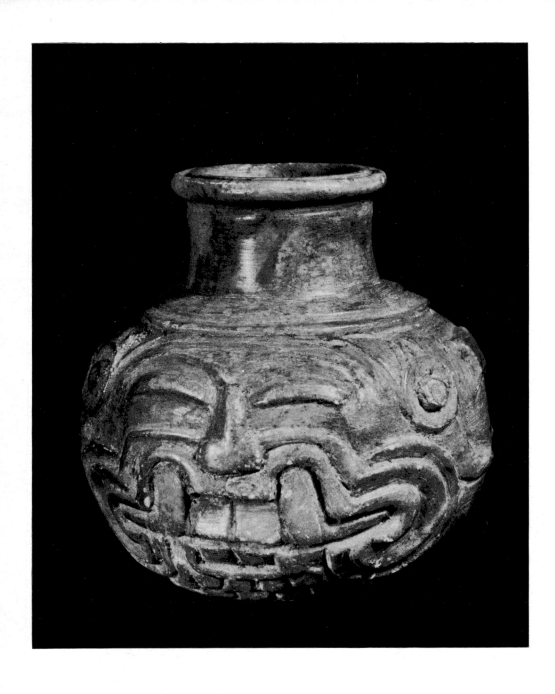

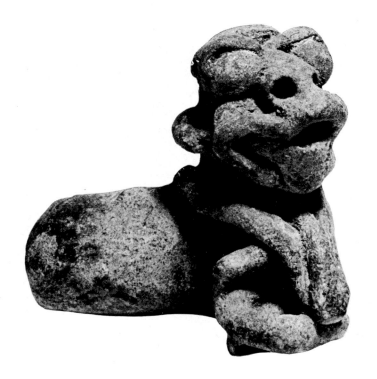

9 Small soapstone vase. Kaminaljuyú
10 Fragment of a small dish. Kaminaljuyú
11 Vessel in two parts. Kaminaljuyú

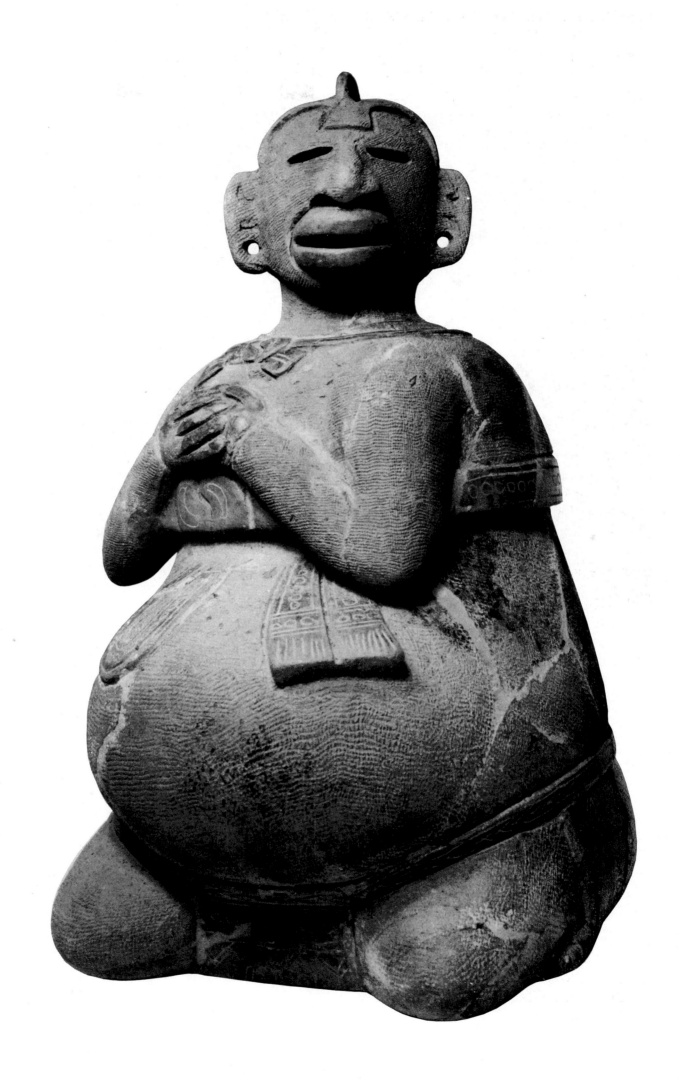

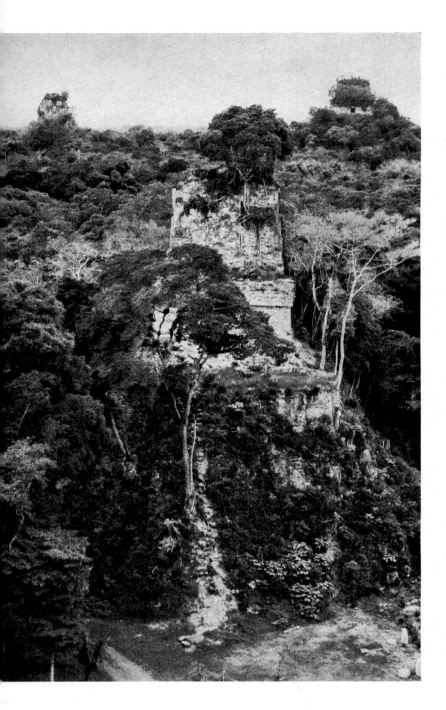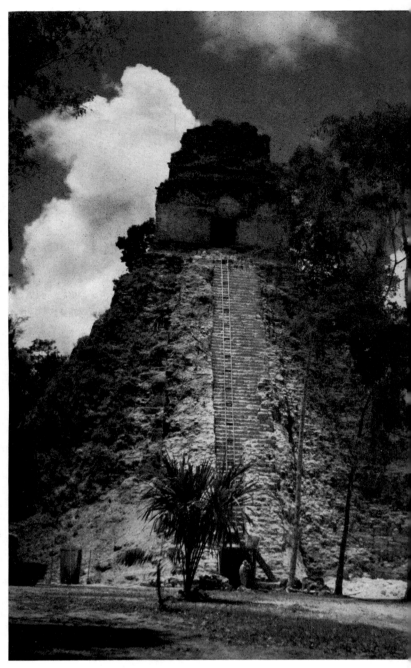

12 View of part of the Great Plaza. Tikal
13 Temple I. Tikal
14 Stela 2. Tikal

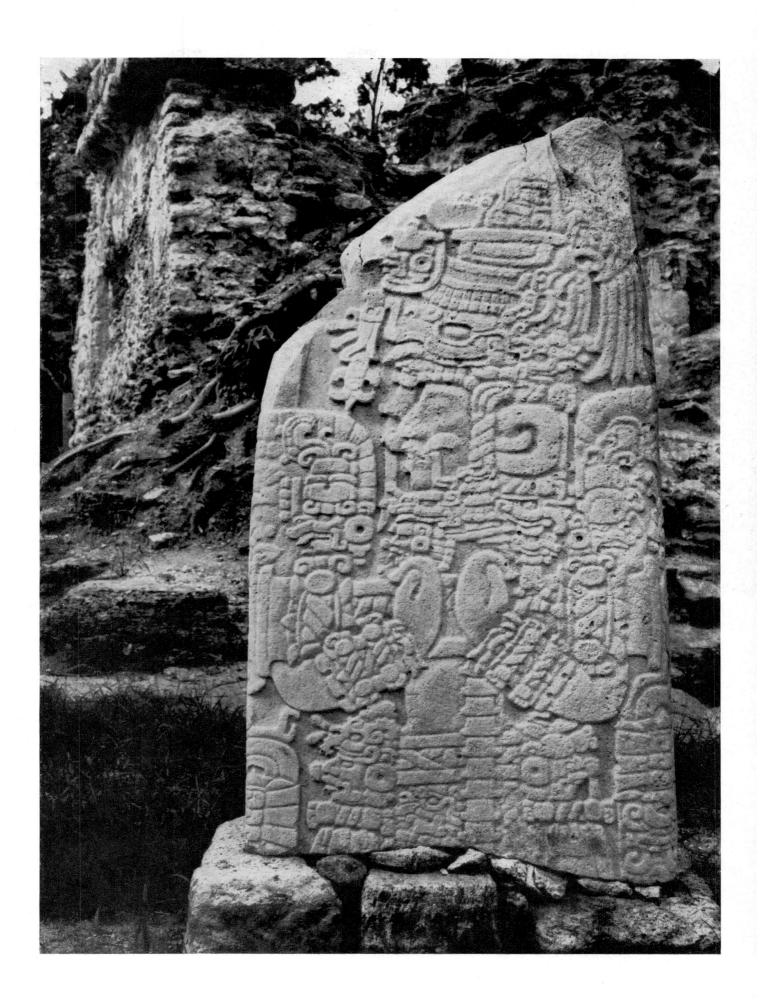

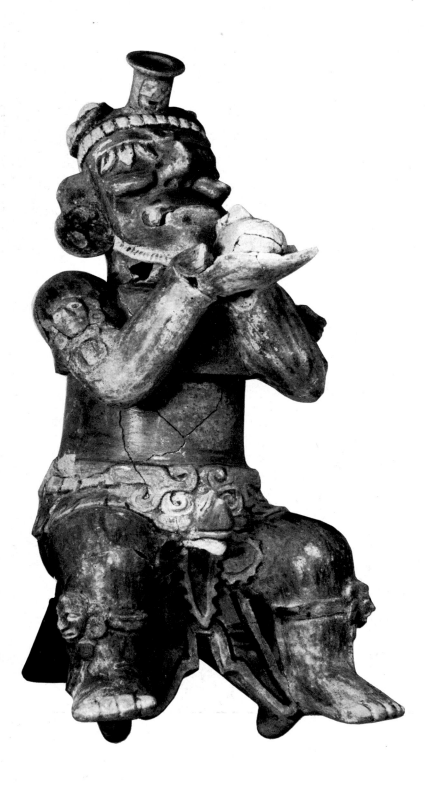

15 Figure of an old god. Tikal

16 Stela 29, the earliest known dated stela. Tikal

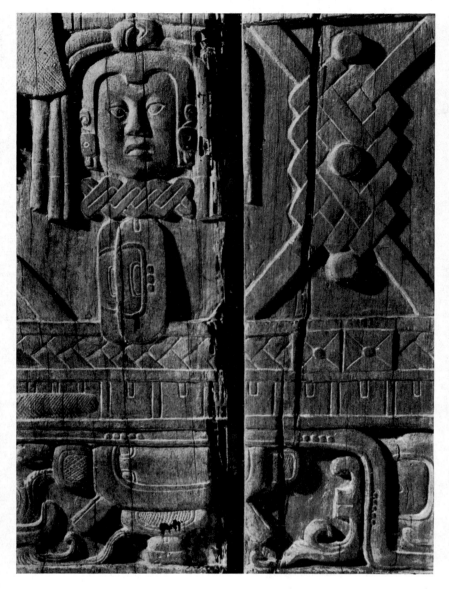

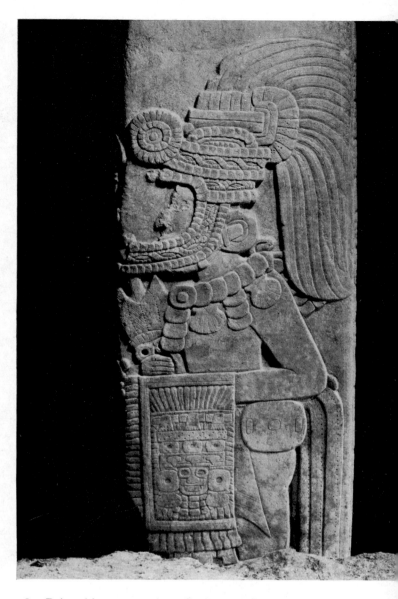

17 Detail of a wooden lintel in Temple III. Tikal

18 Priest-king, carved on Stela 31. Tikal

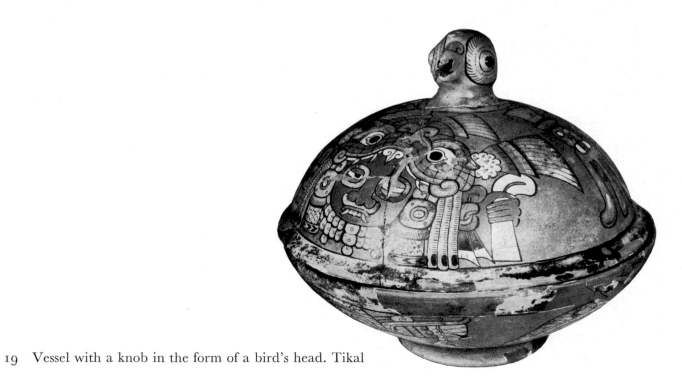

19 Vessel with a knob in the form of a bird's head. Tikal

20 Altar before Stela M. Copán
21 Altar G 1 and Stela F, on the main plaza. Copán

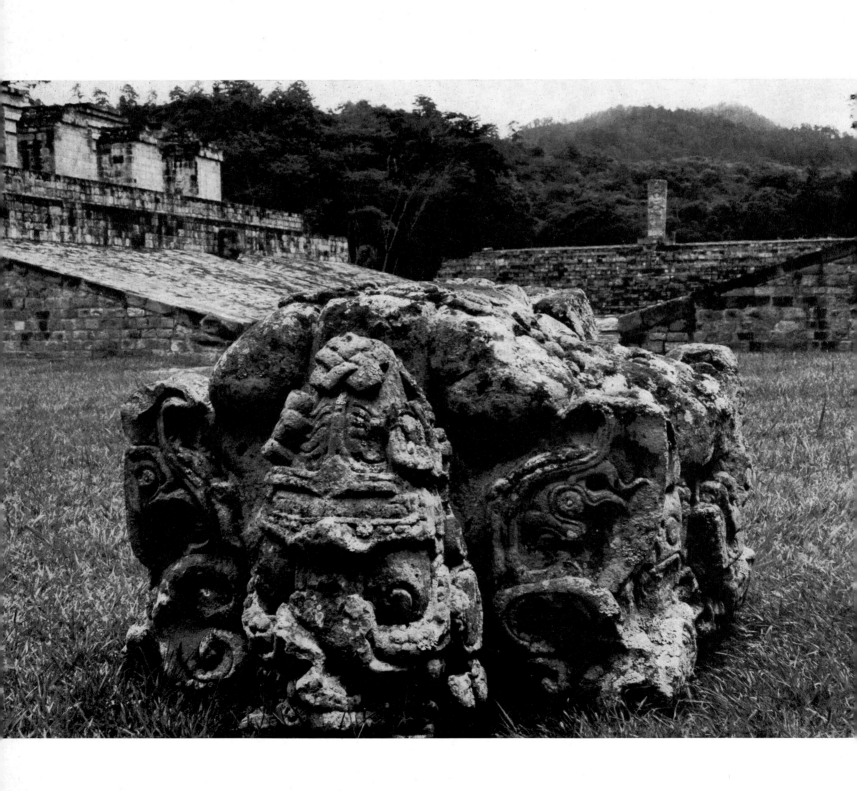

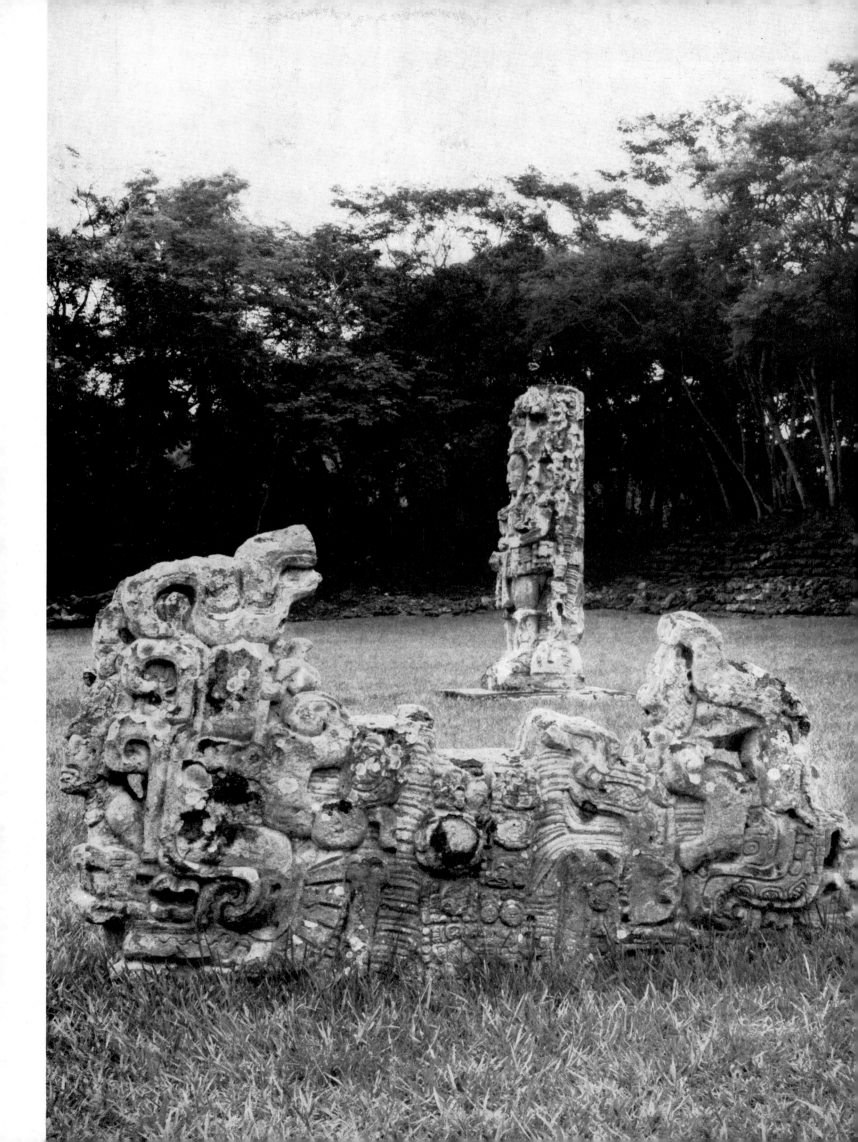

22–23 Stela A (right) and Stela B. Copán
24 Detail of Stela H. Copán

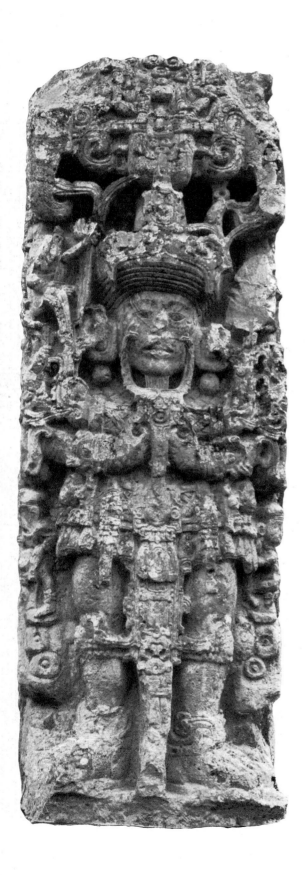

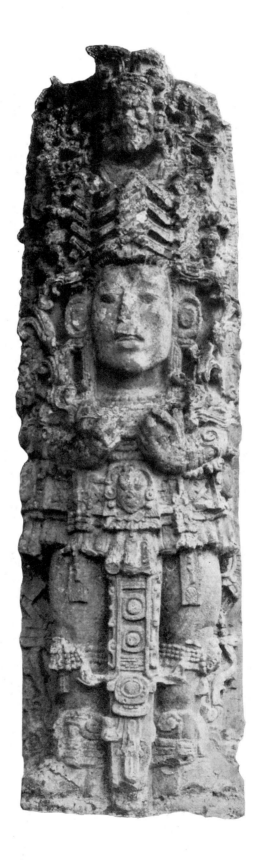

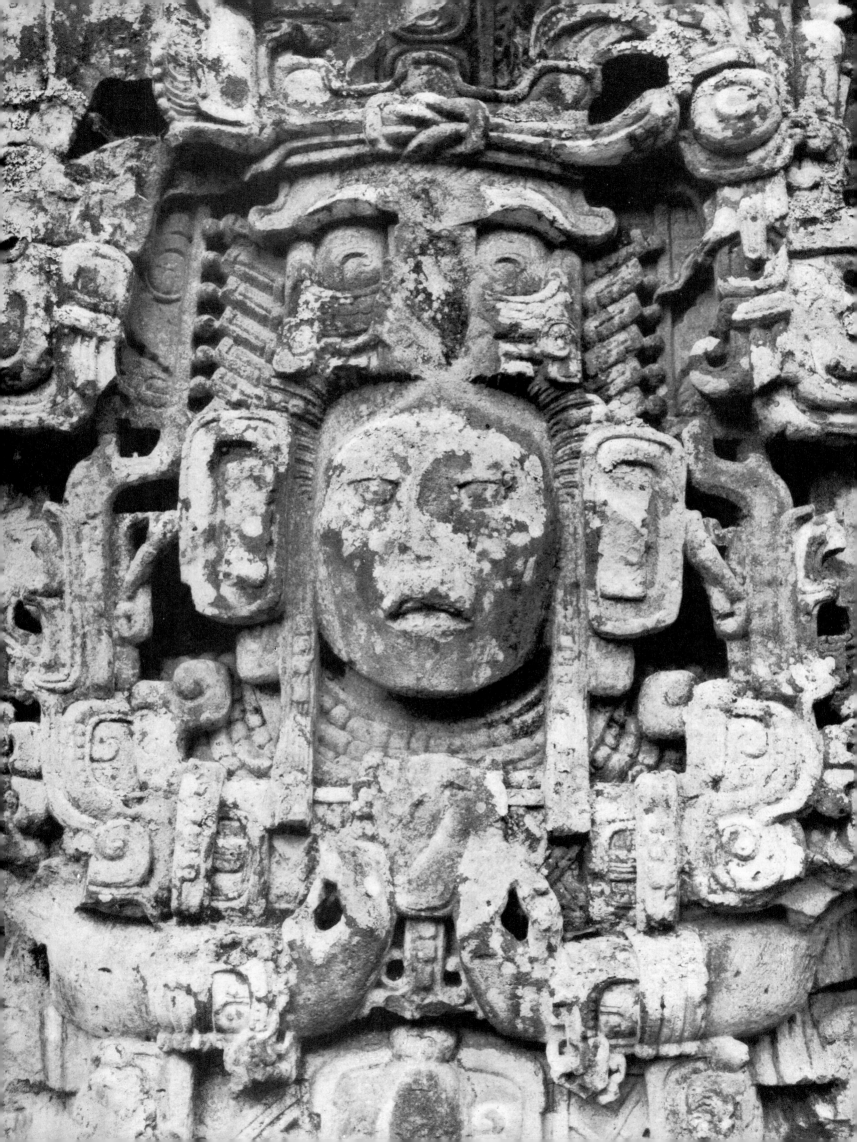

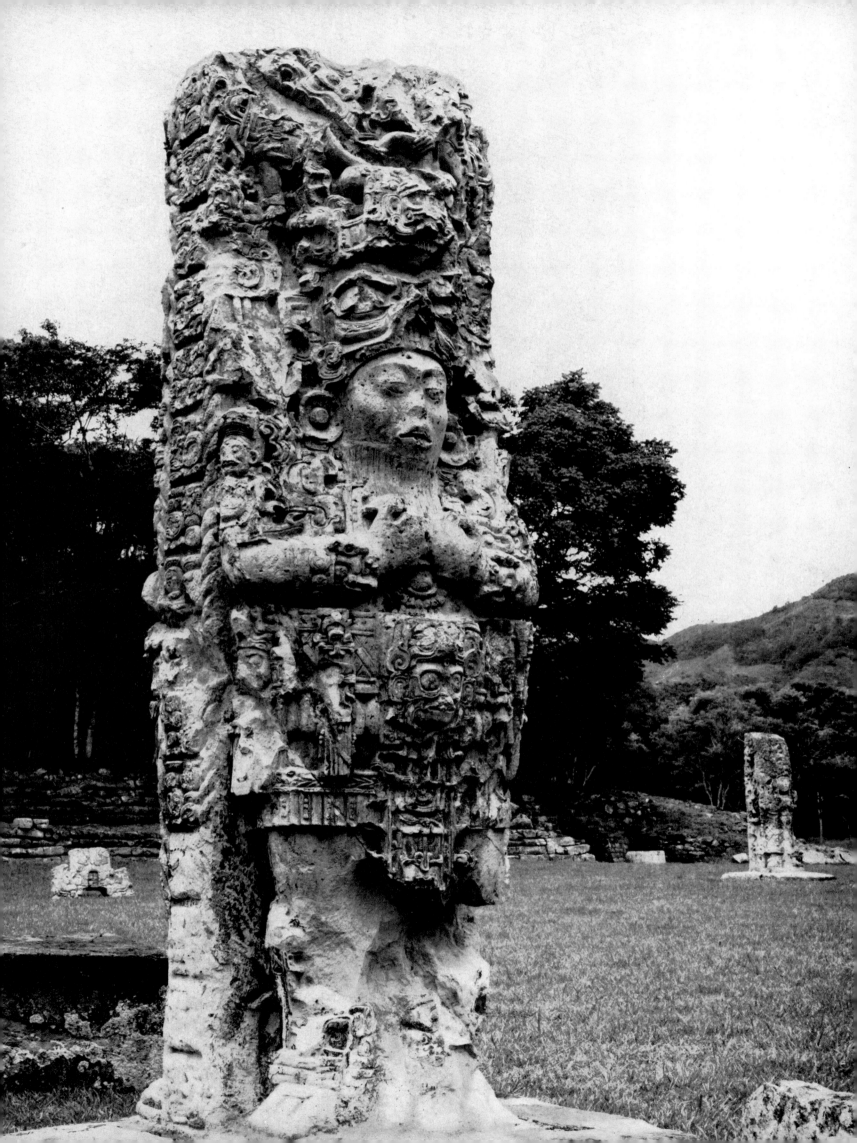

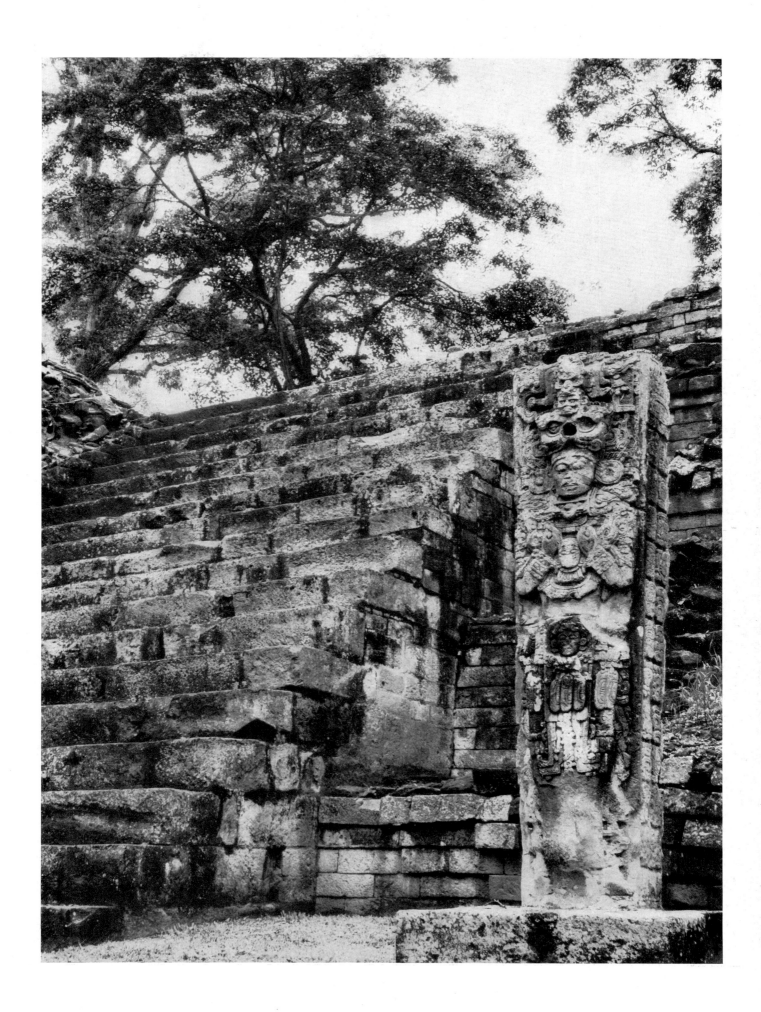

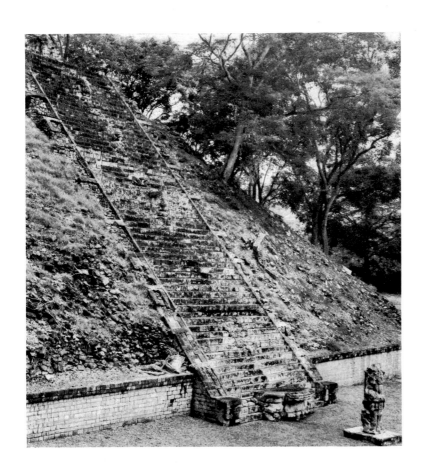

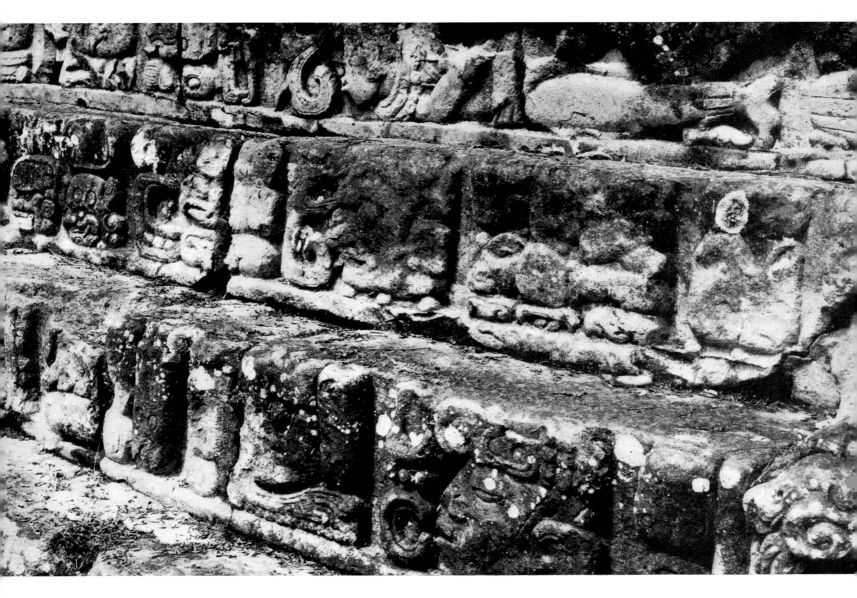

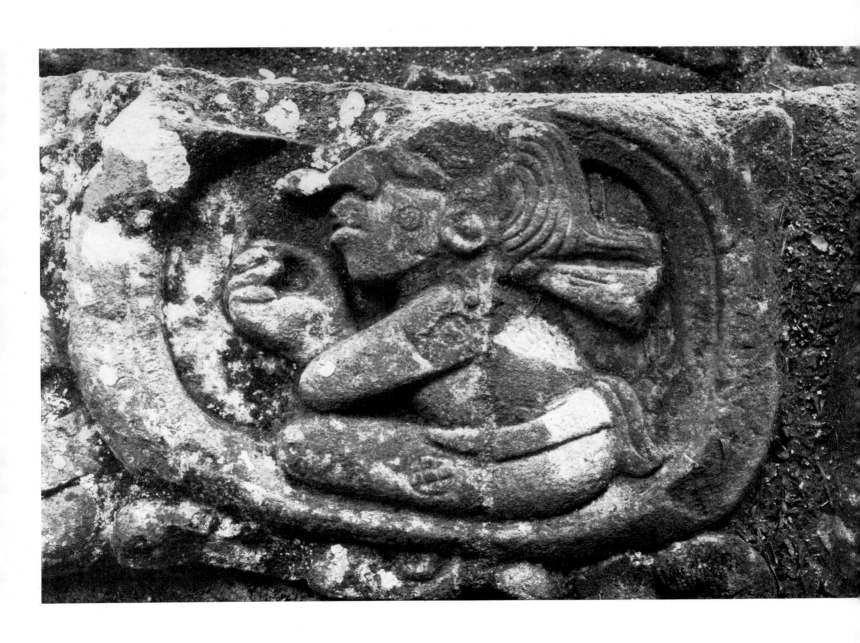

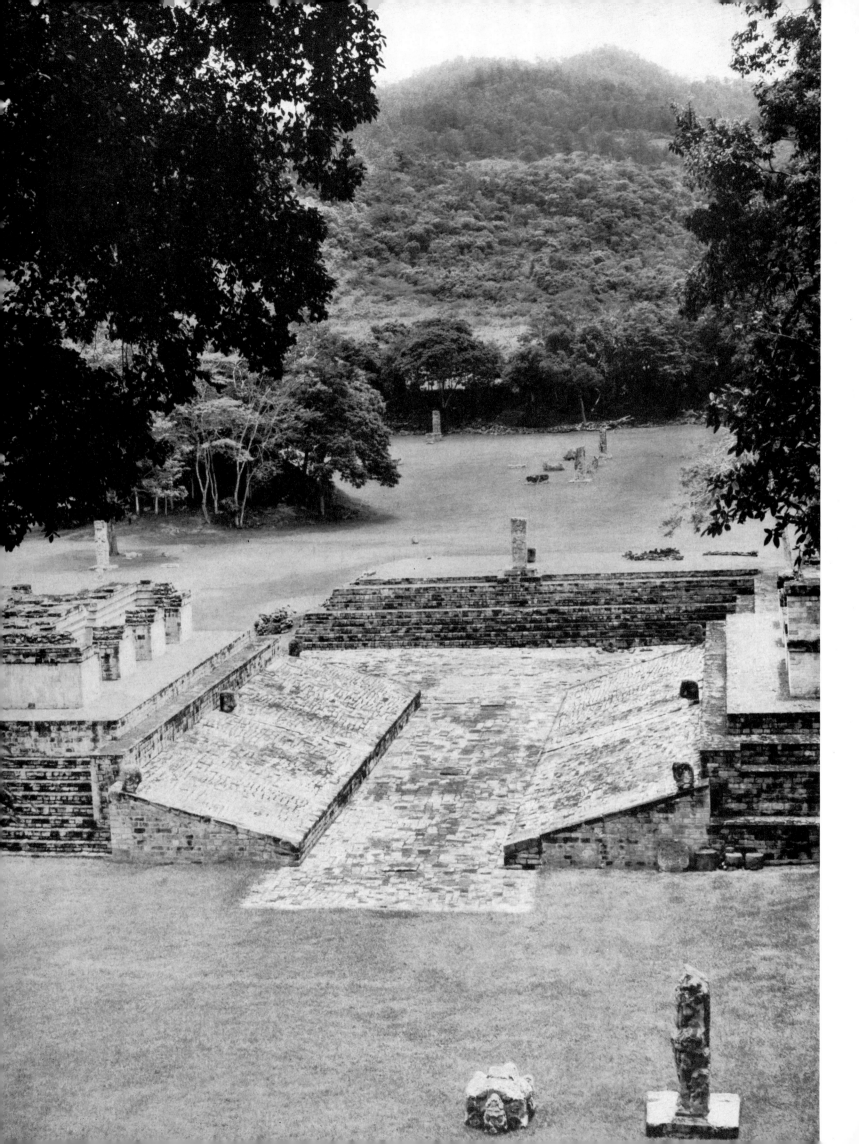

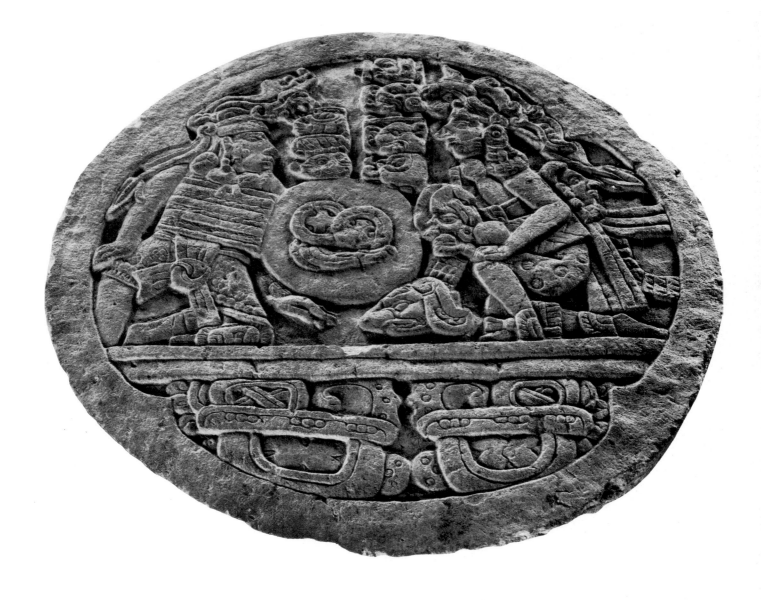

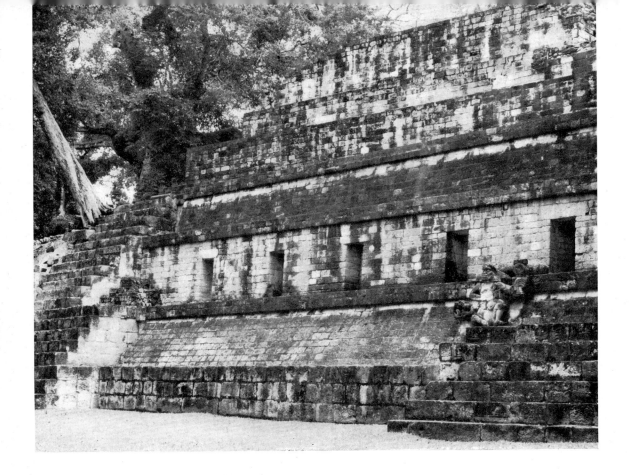

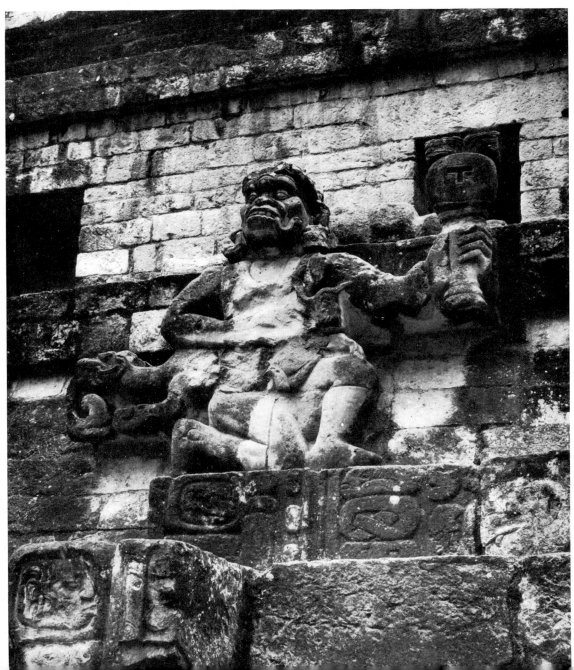

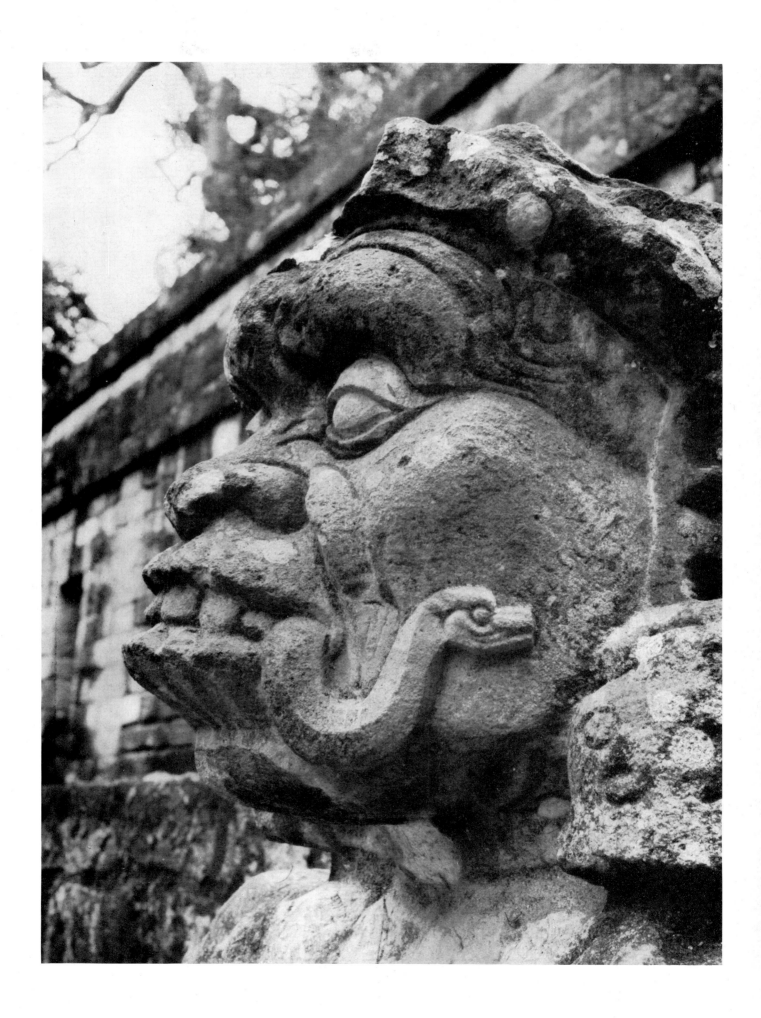

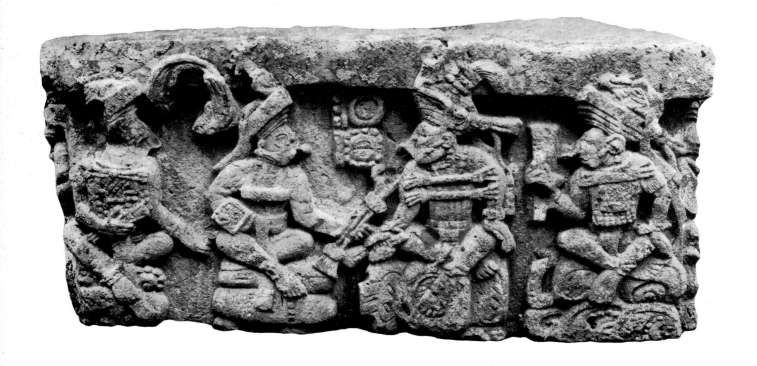

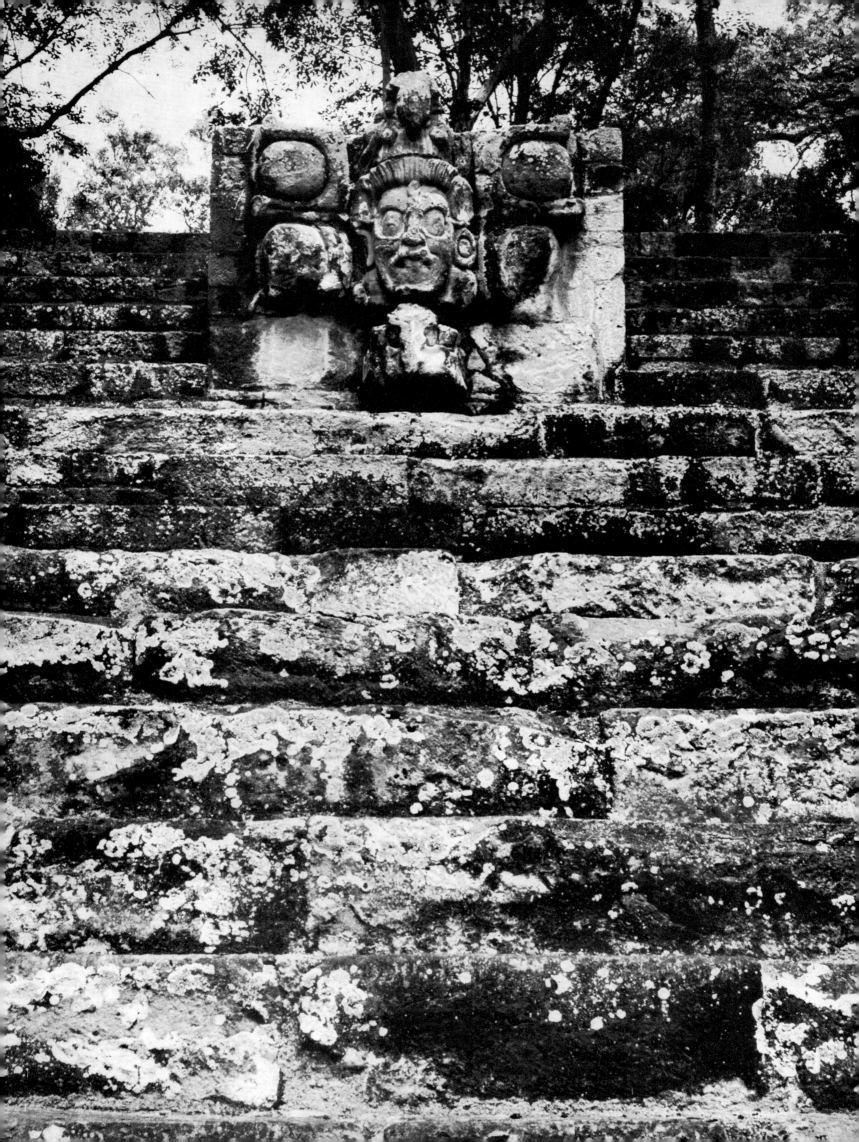

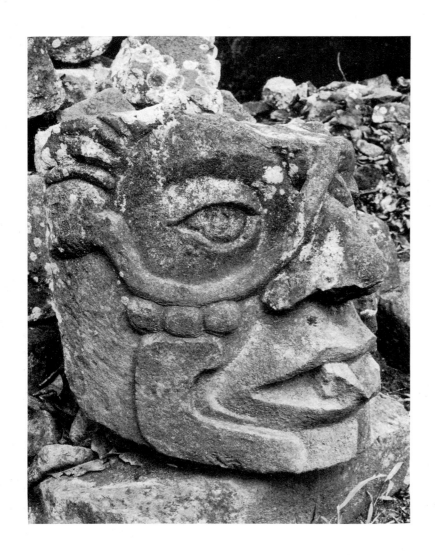
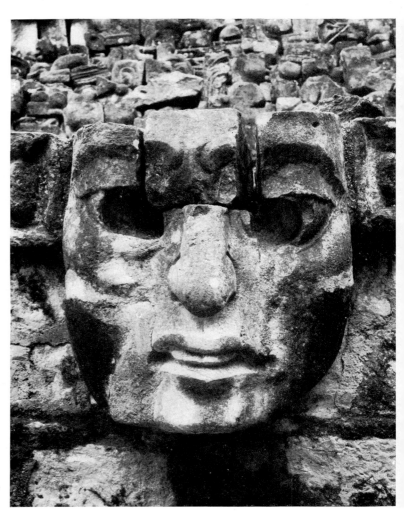
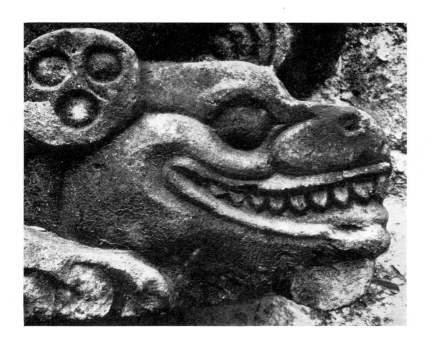
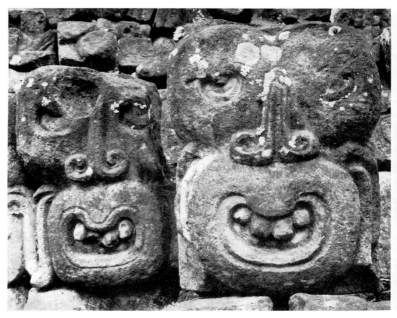

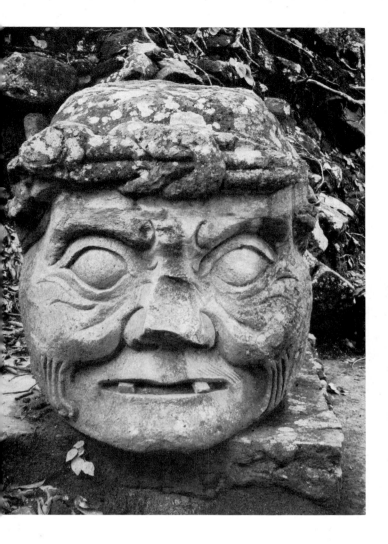

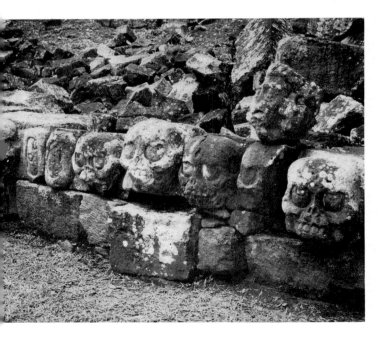

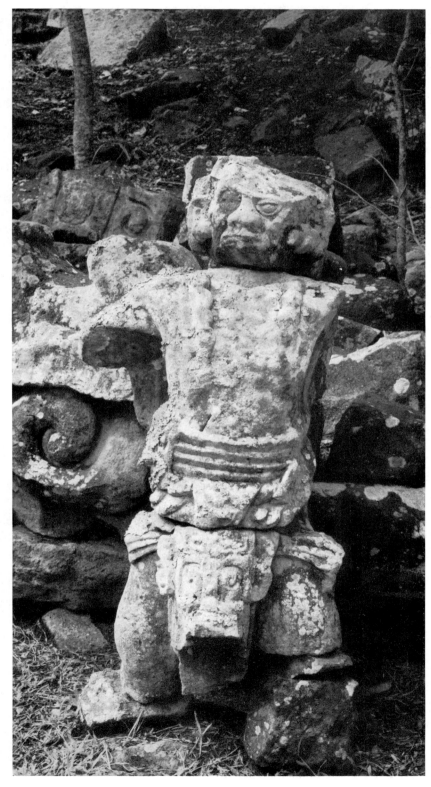

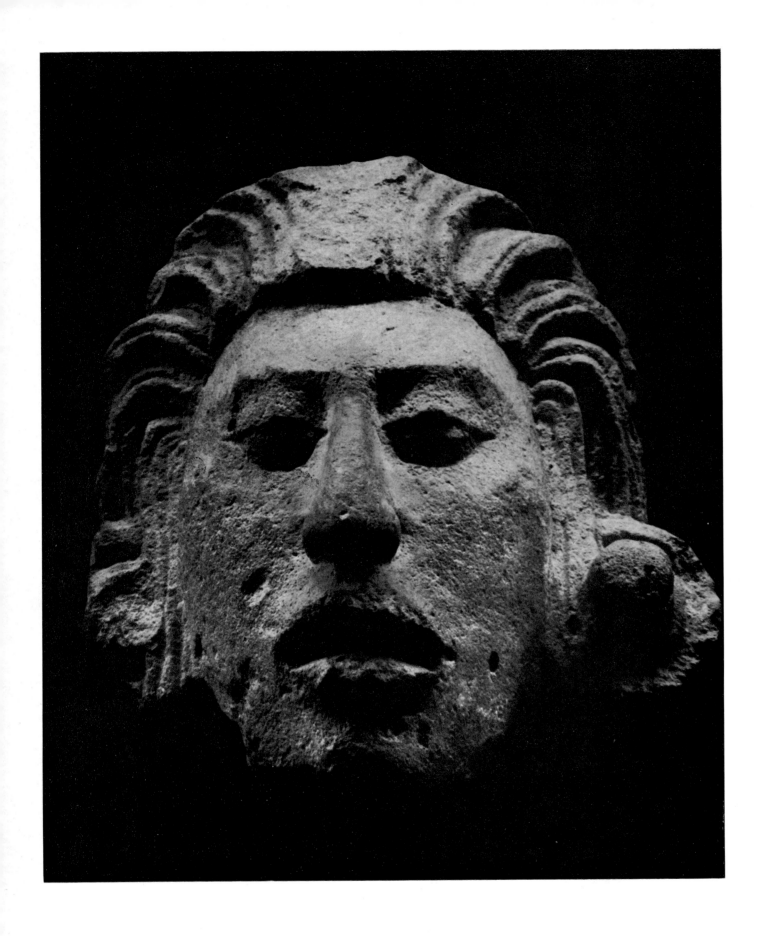

44 Head of a dignitary. Copán
45 The young maize god. Copán

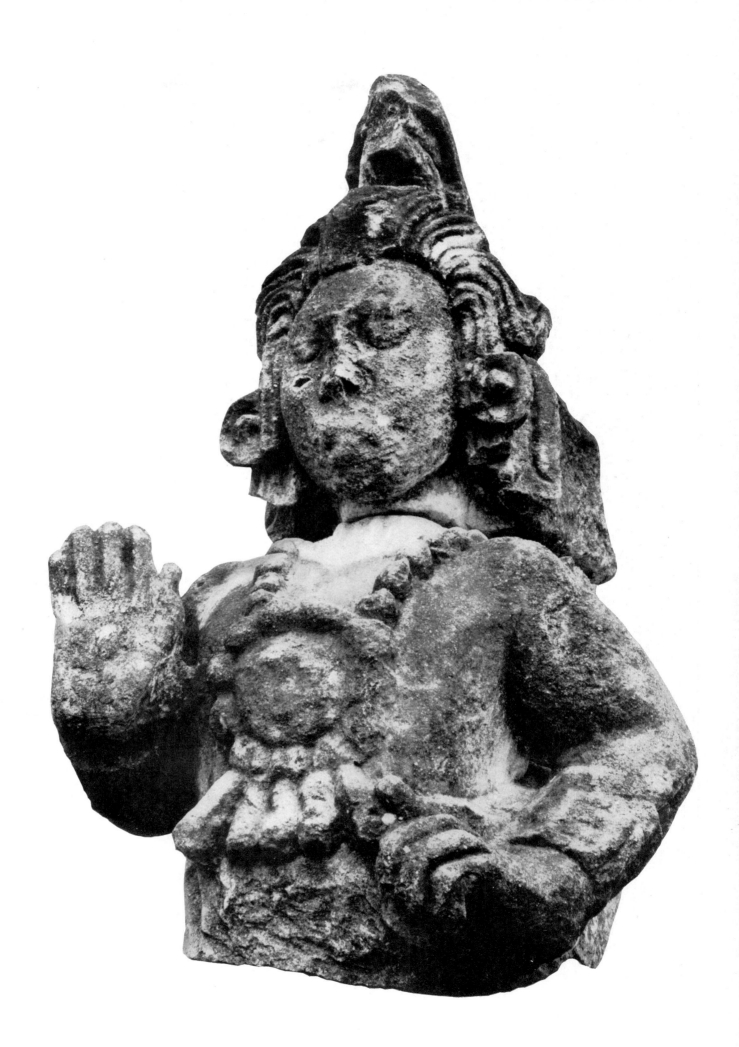

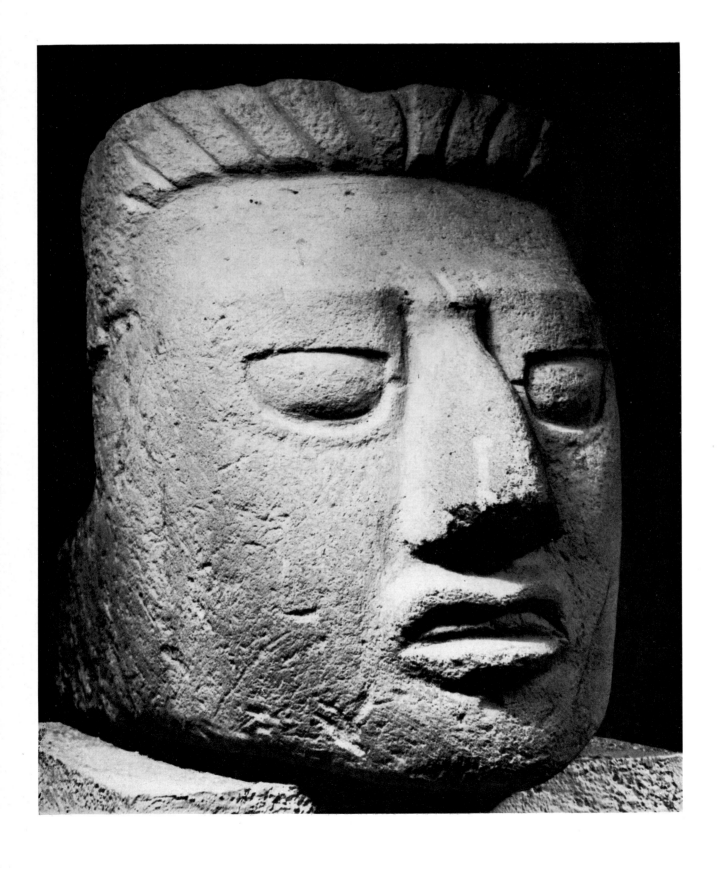

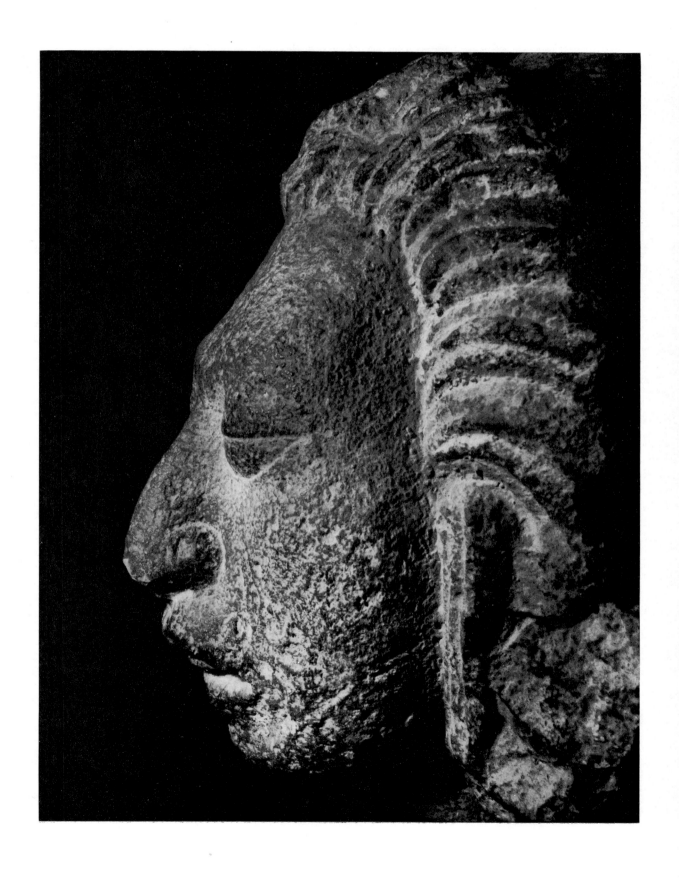

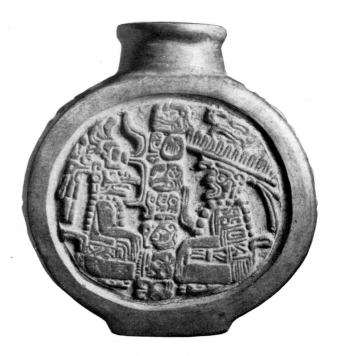

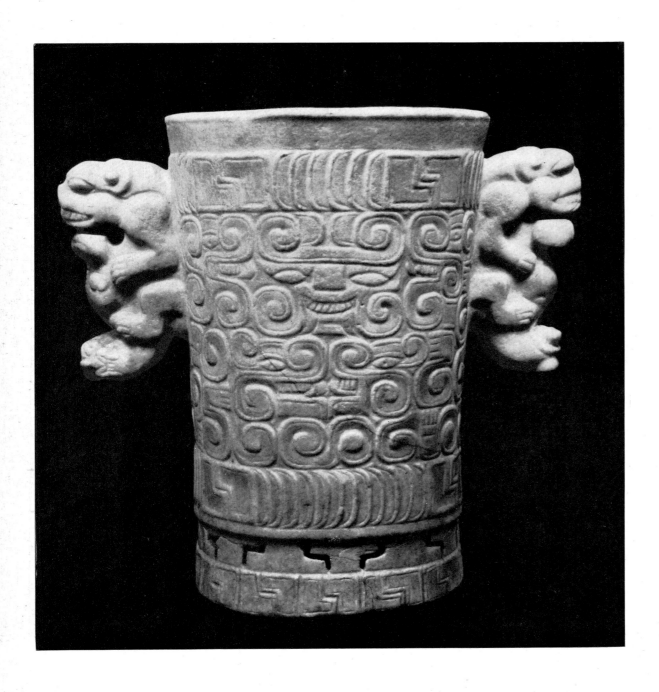

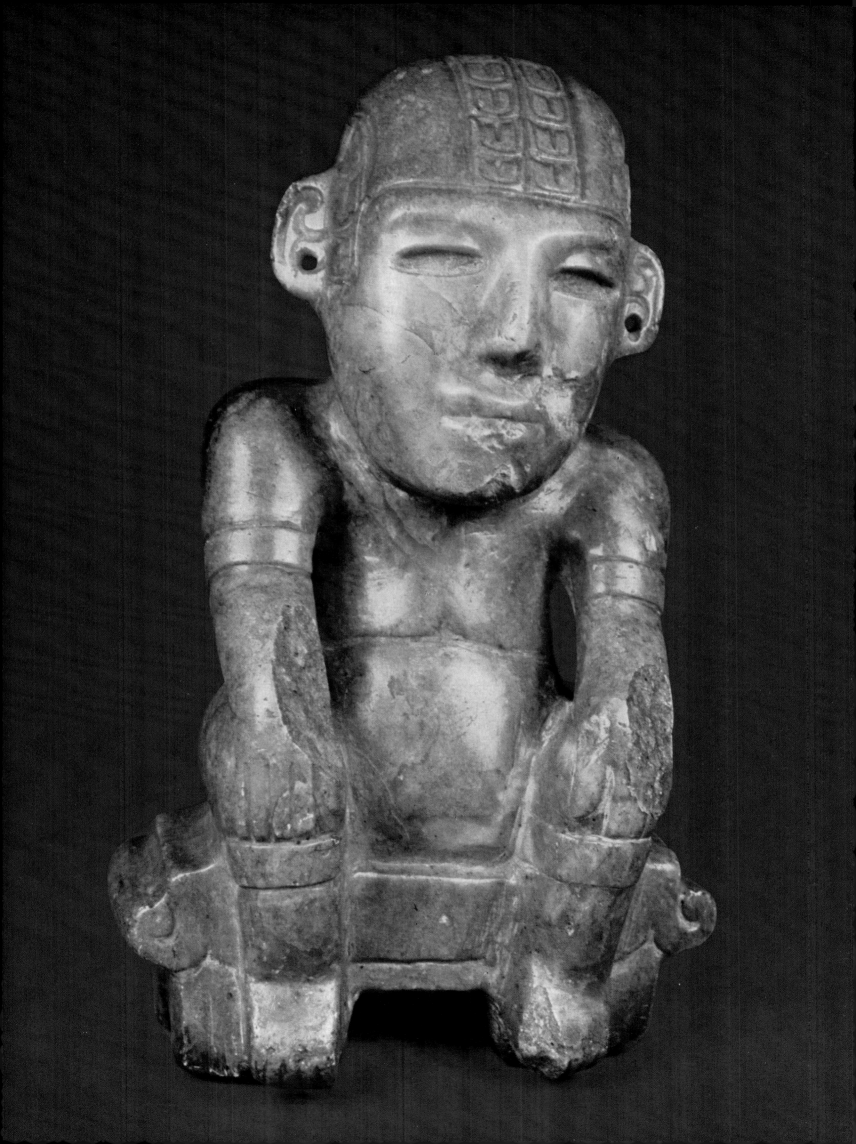

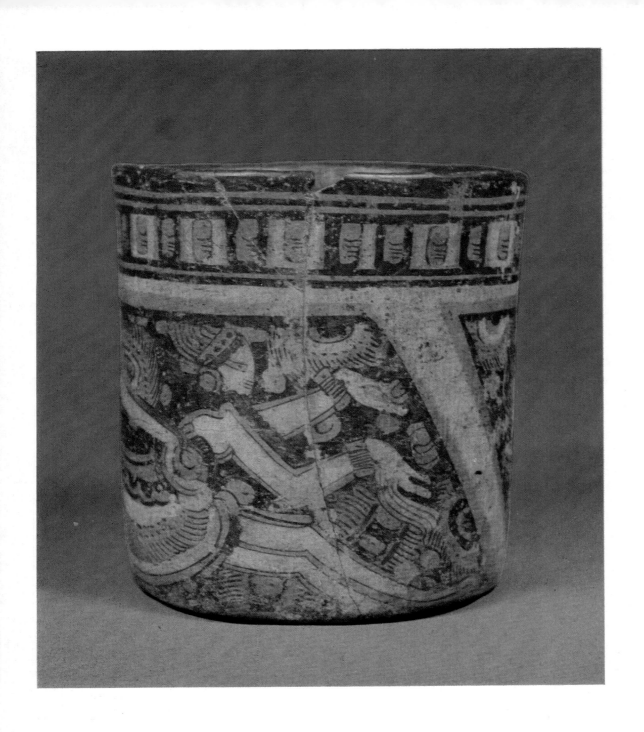

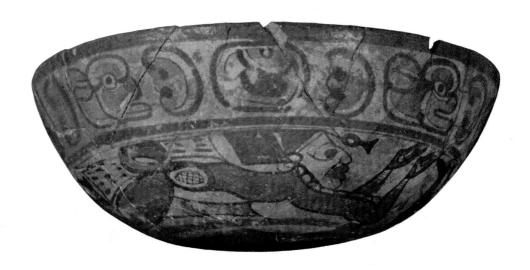

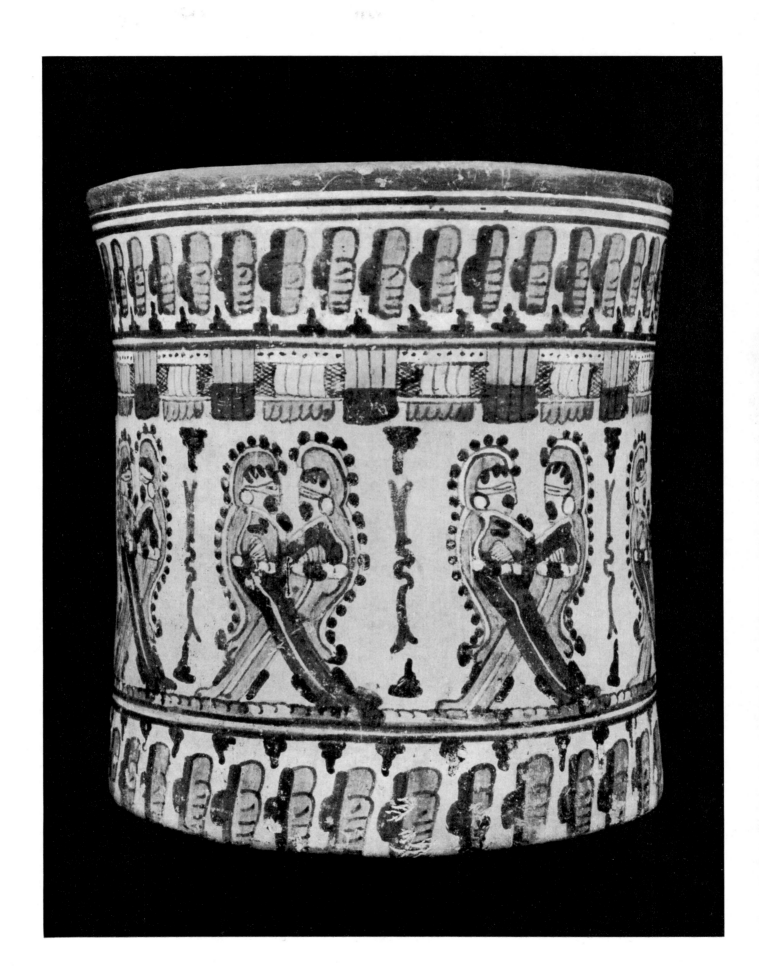

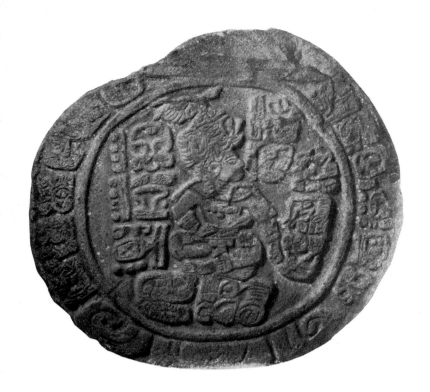

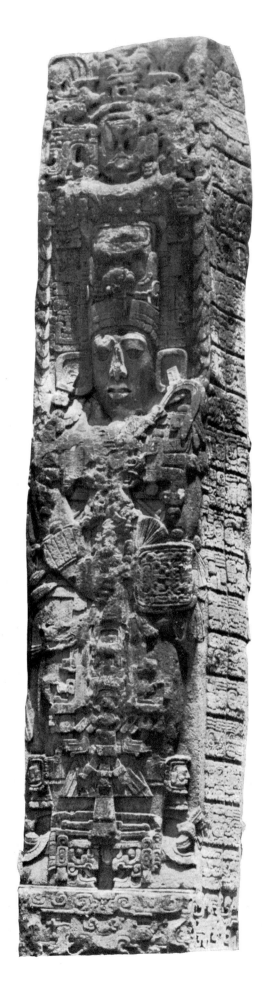

54 Altar L. Quiriguá
55 Stela E. Quiriguá

56 Decorated vessel. Uaxactún
57 Painted vase. Nebaj

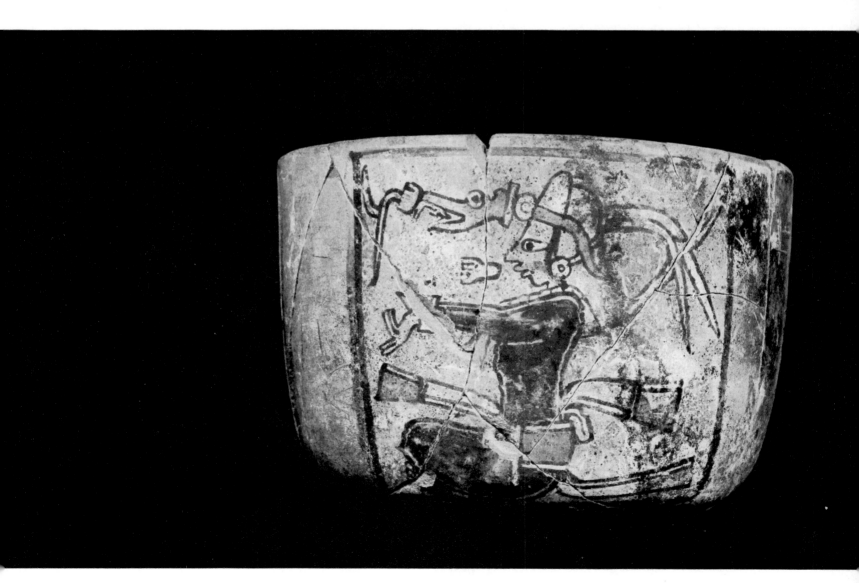

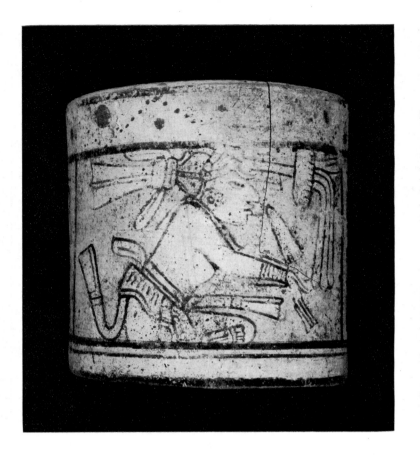

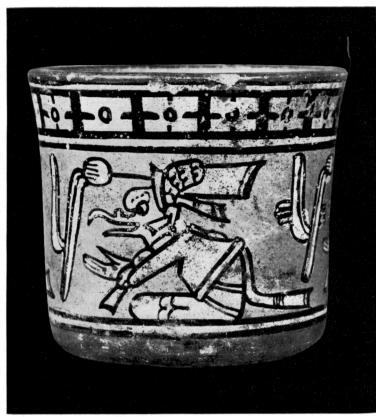

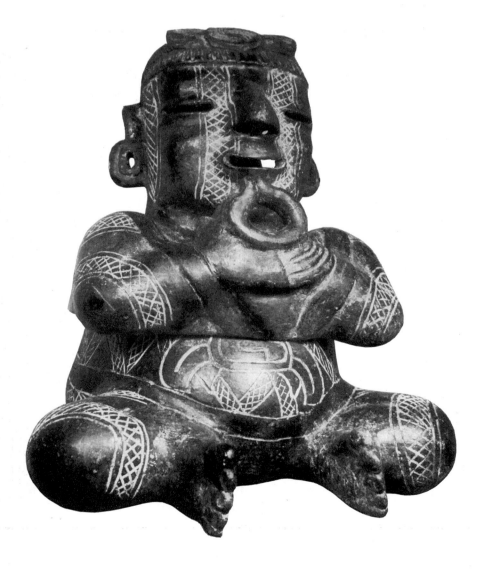

58 Painted vase. Nebaj

59 Painted vase. Northern highlands, Guatemala

60 Vessel in the form of a man. Uaxactún

61 Figure painted in the centre of a vase. Uaxactún

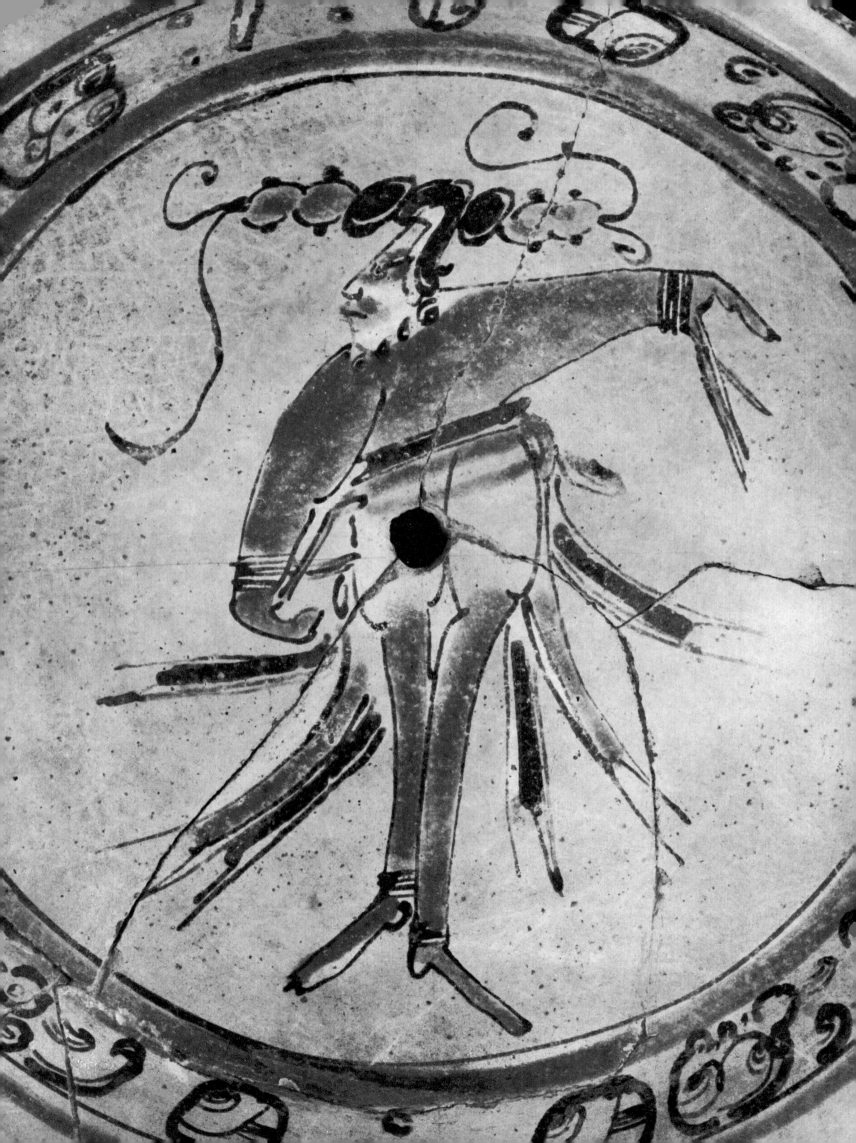

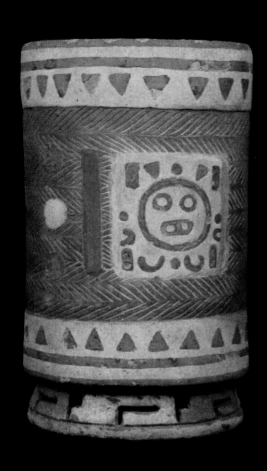

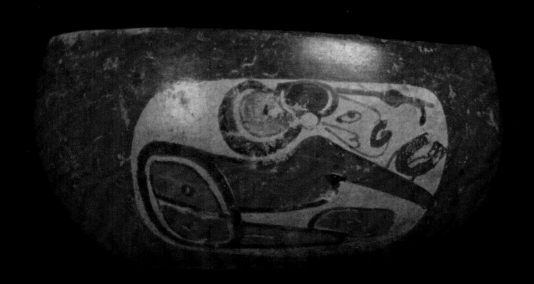

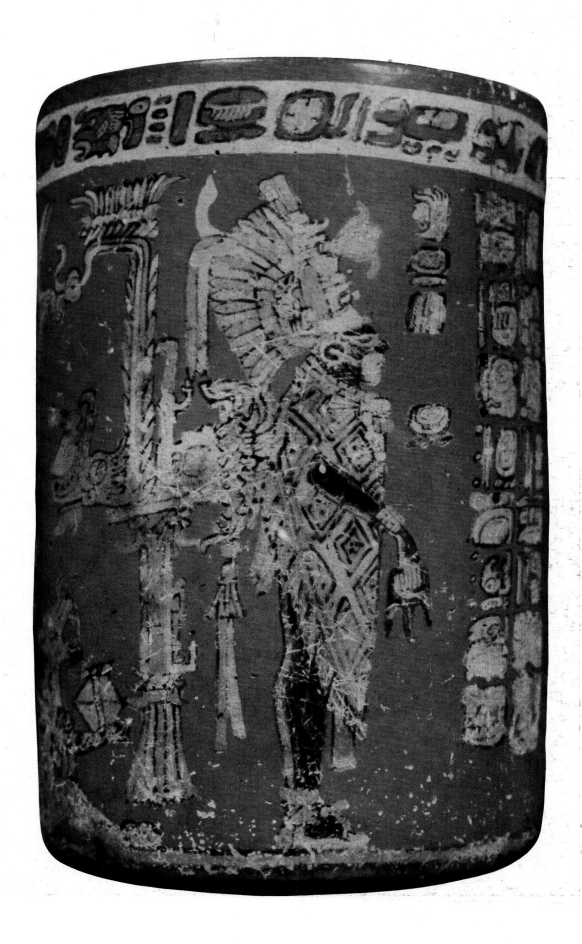

65 Vase decorated in relief. Region of Uaxactún
66 Painted vase. Chama

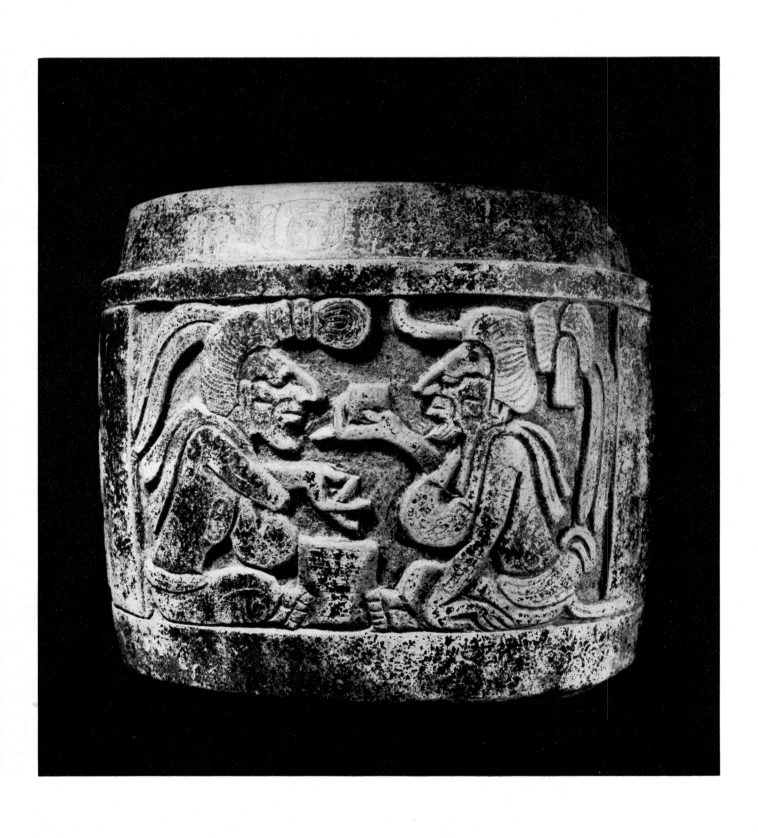

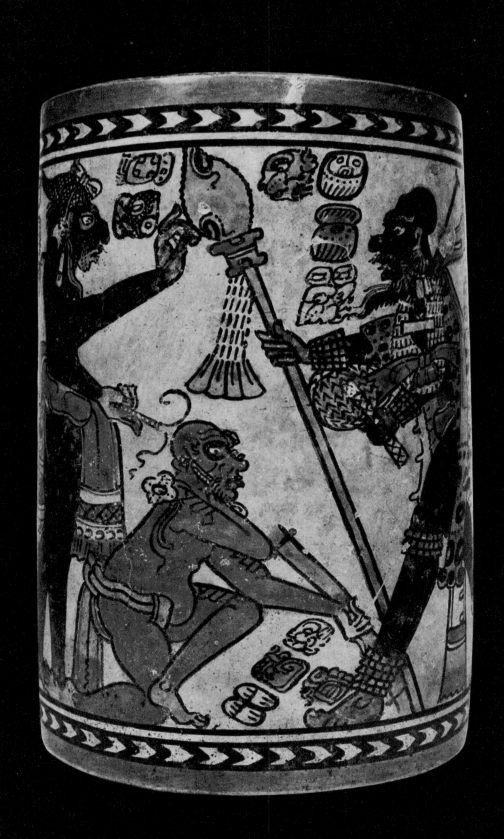

67 Fragment of a painted vase. Uaxactún
68–69 Painted vase, shown from two sides. Ratinlixul

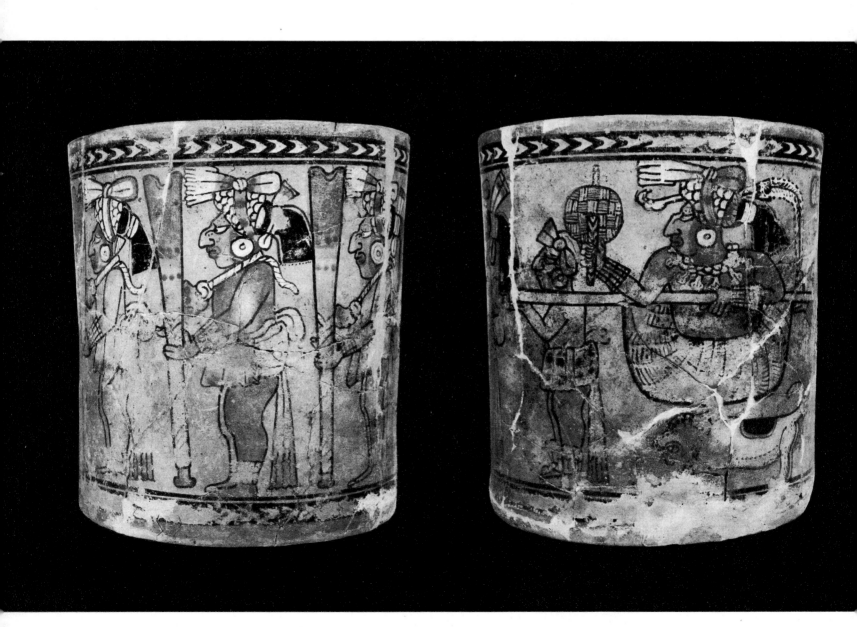

70 Fragment of a painted dish. Uaxactún
71 Painted vessel. Chama
72 Painted vessel. Chama

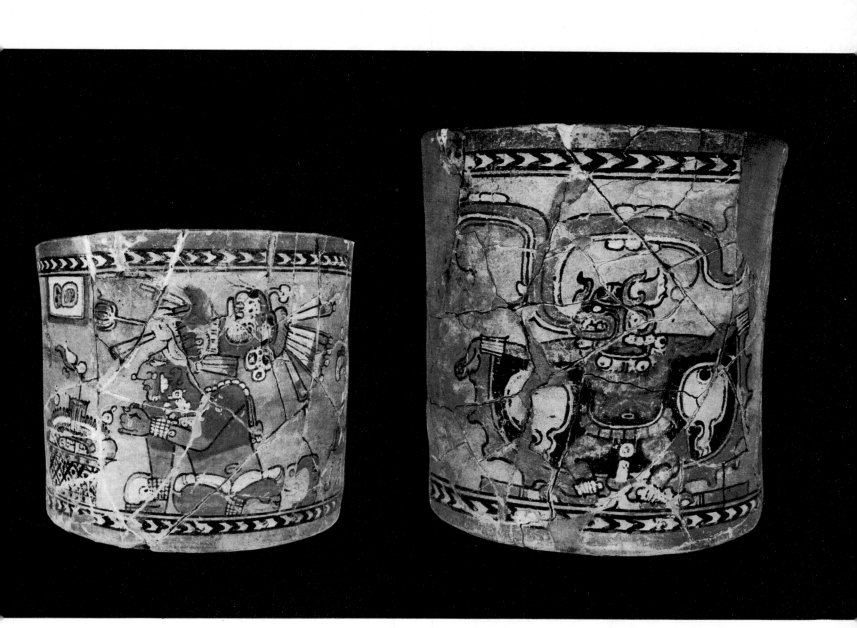

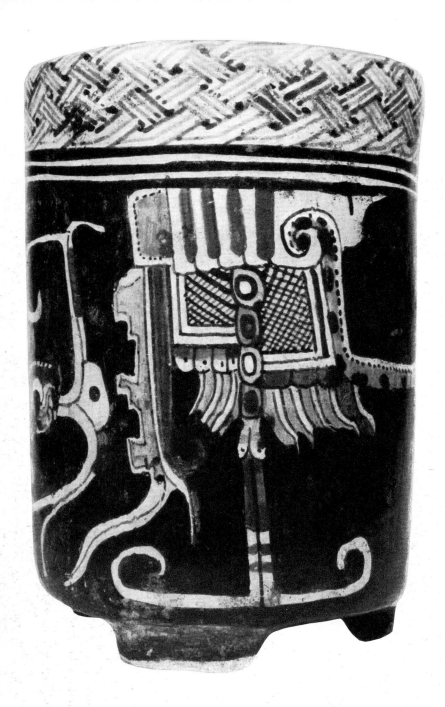

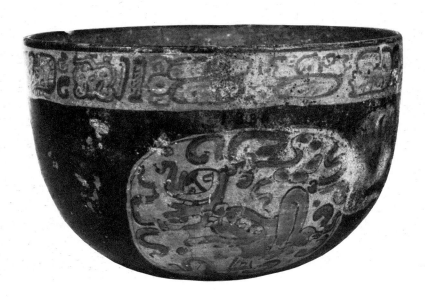

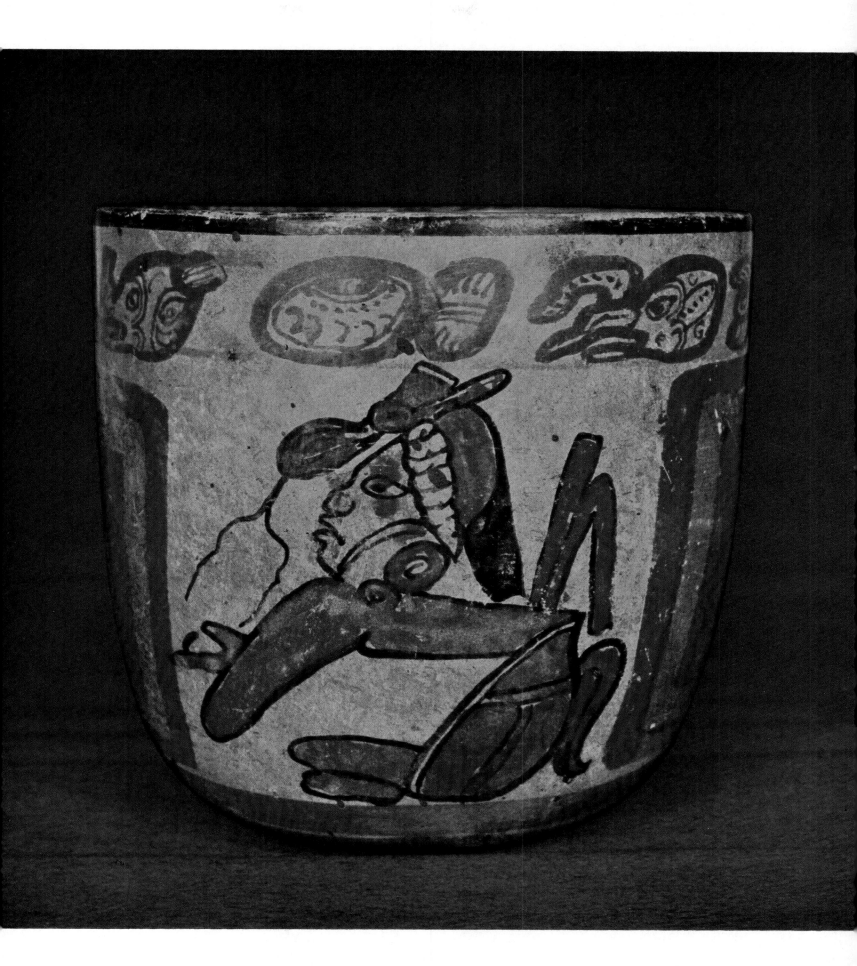

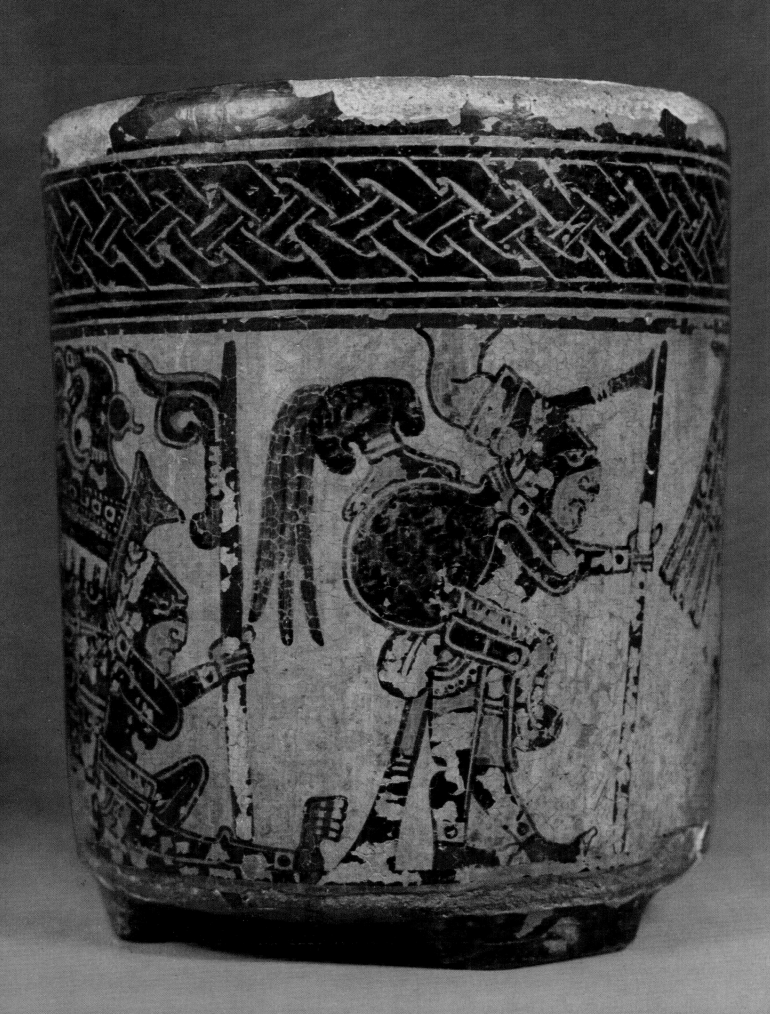

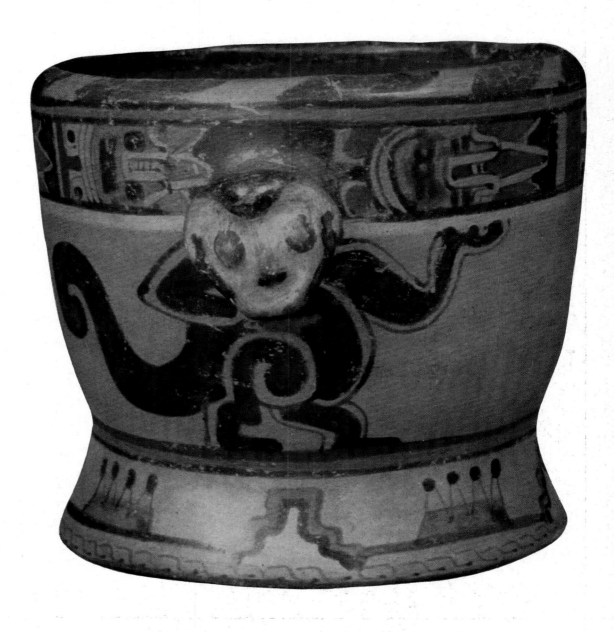

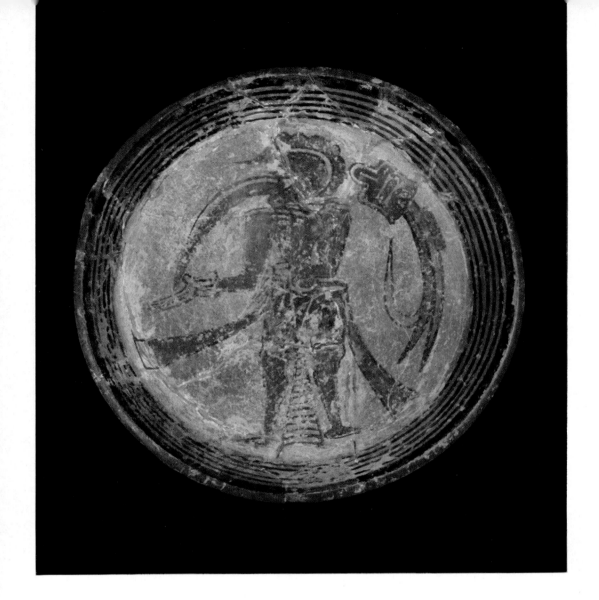

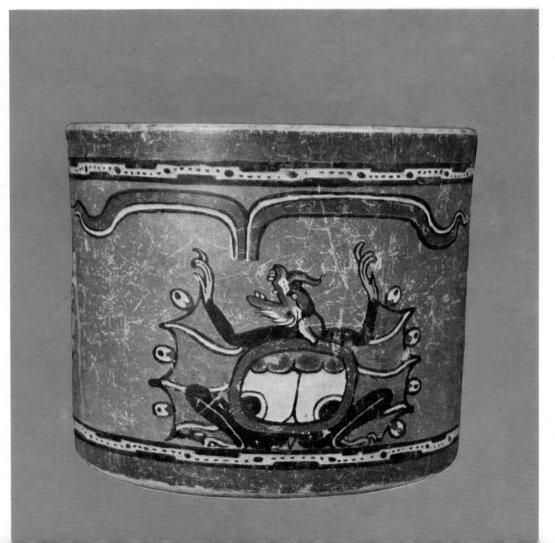

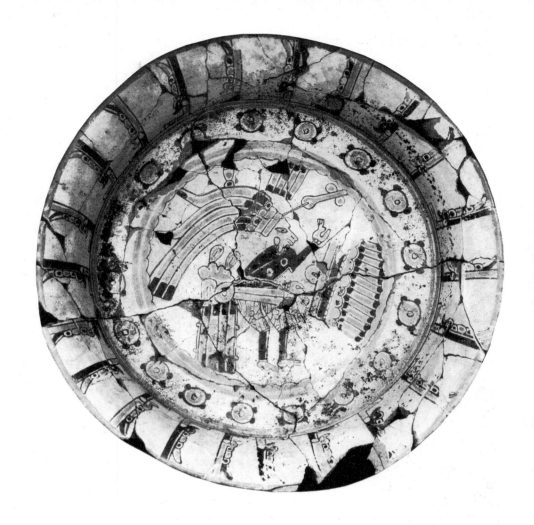

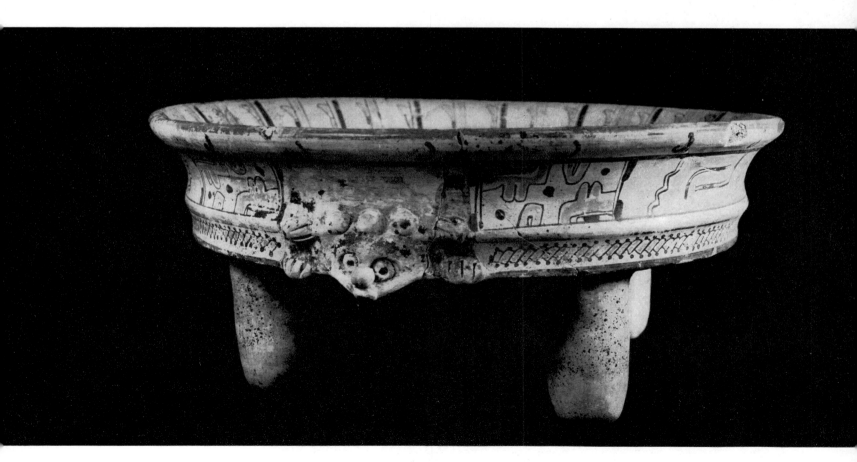

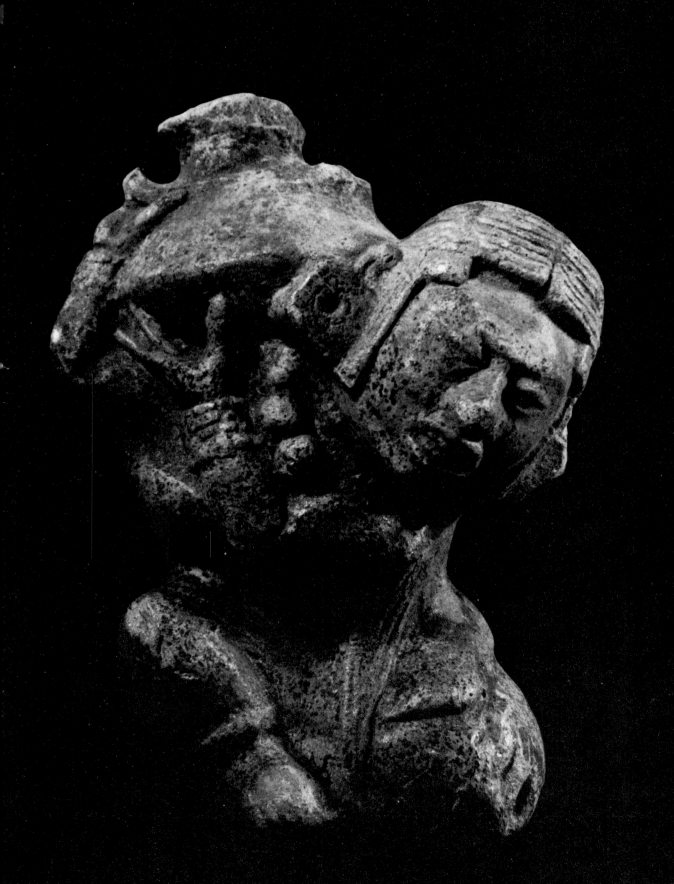

82 Vessel in the form of a crouching woman. Cobán
83 Figure of a seated woman. Cobán

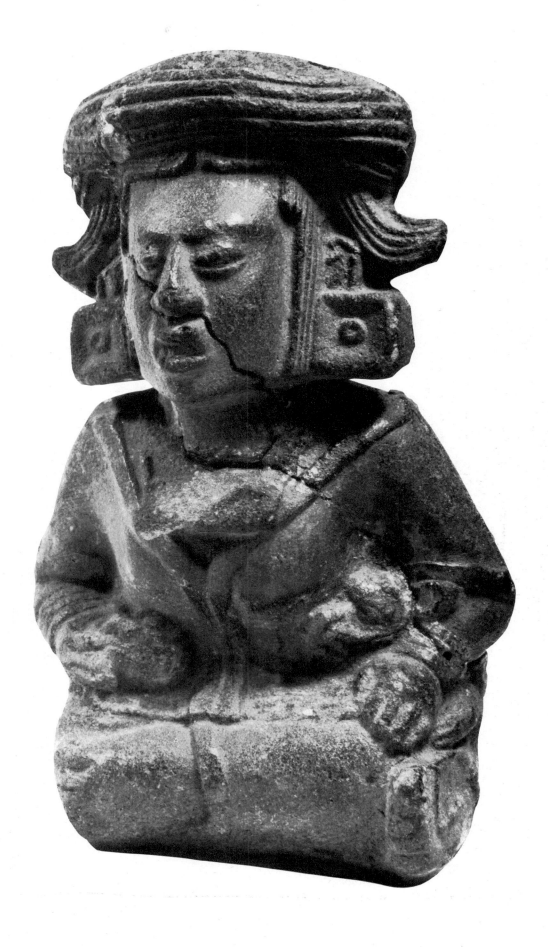

84 Clay fragment, with the figure of a priest in relief. Northern Guatemala

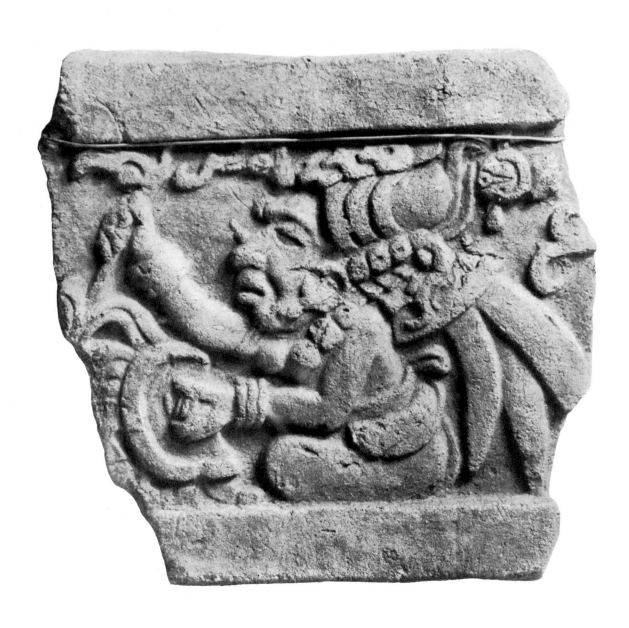

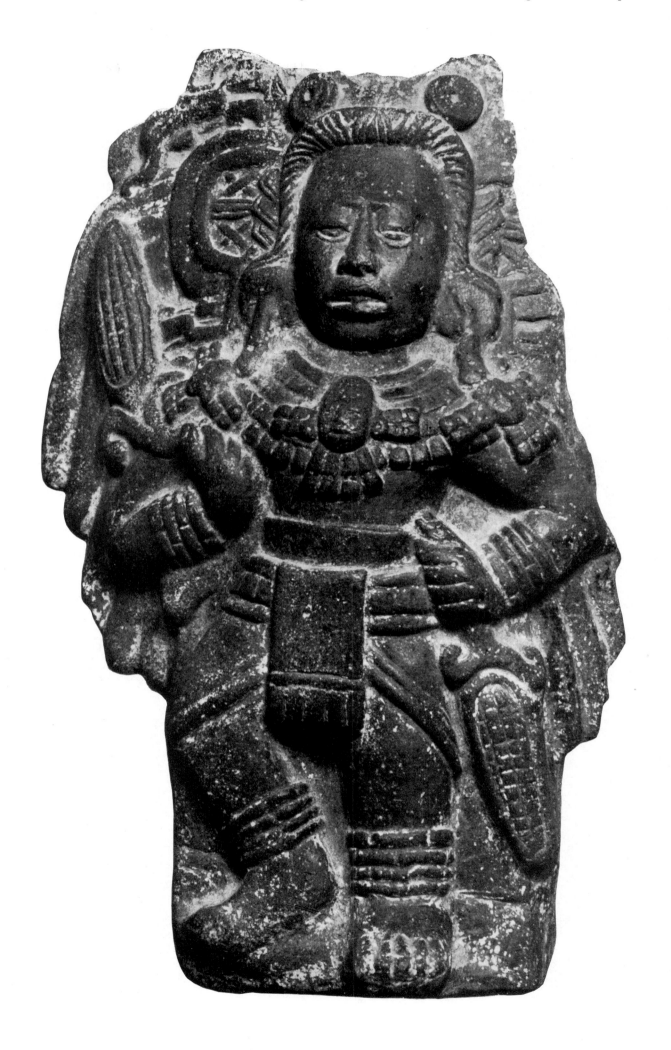

86 Figure of the sun god Kinich Ahau. Alta Verapaz
87 Two-handled vessel. Pazún
88 Tripod censer. Nebaj

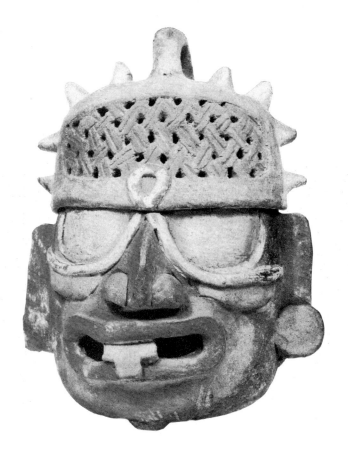

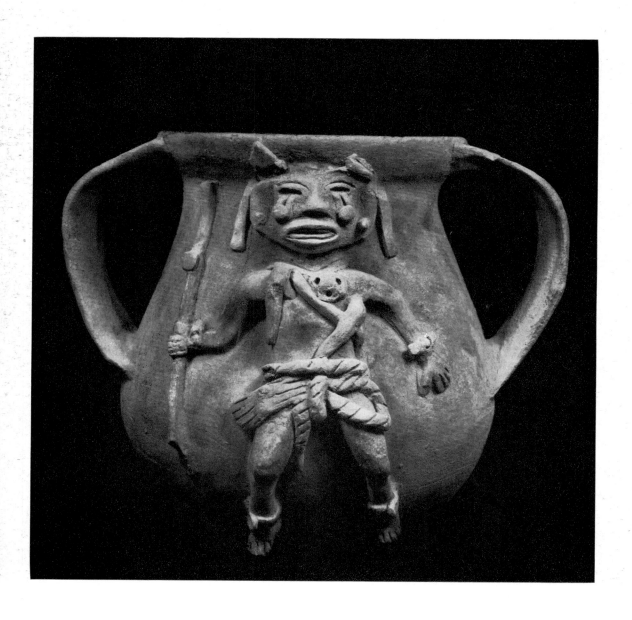

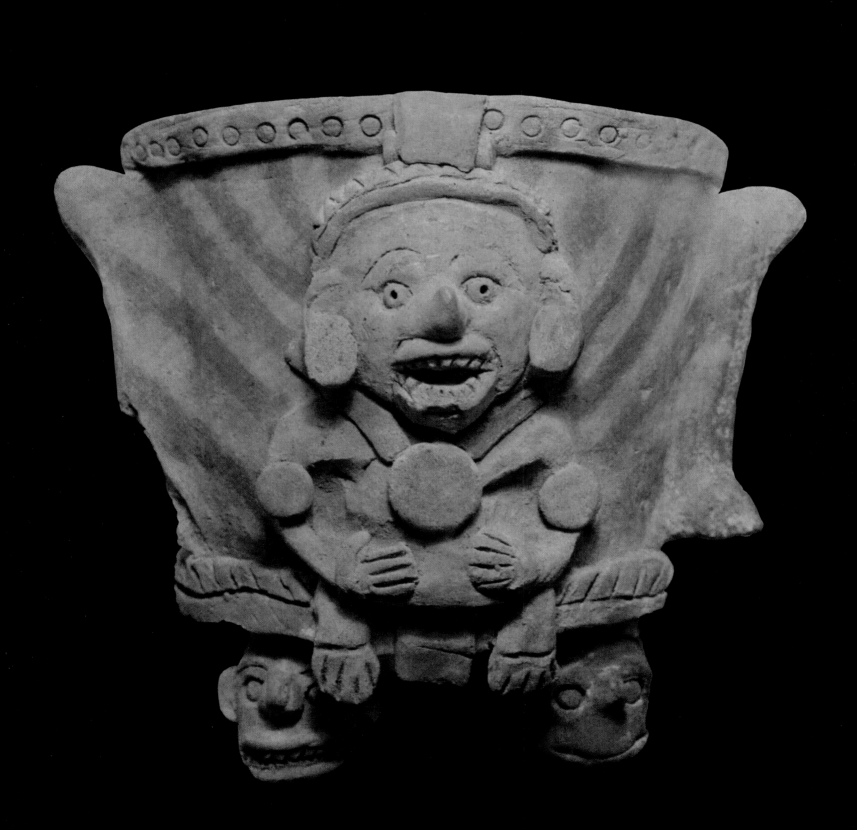

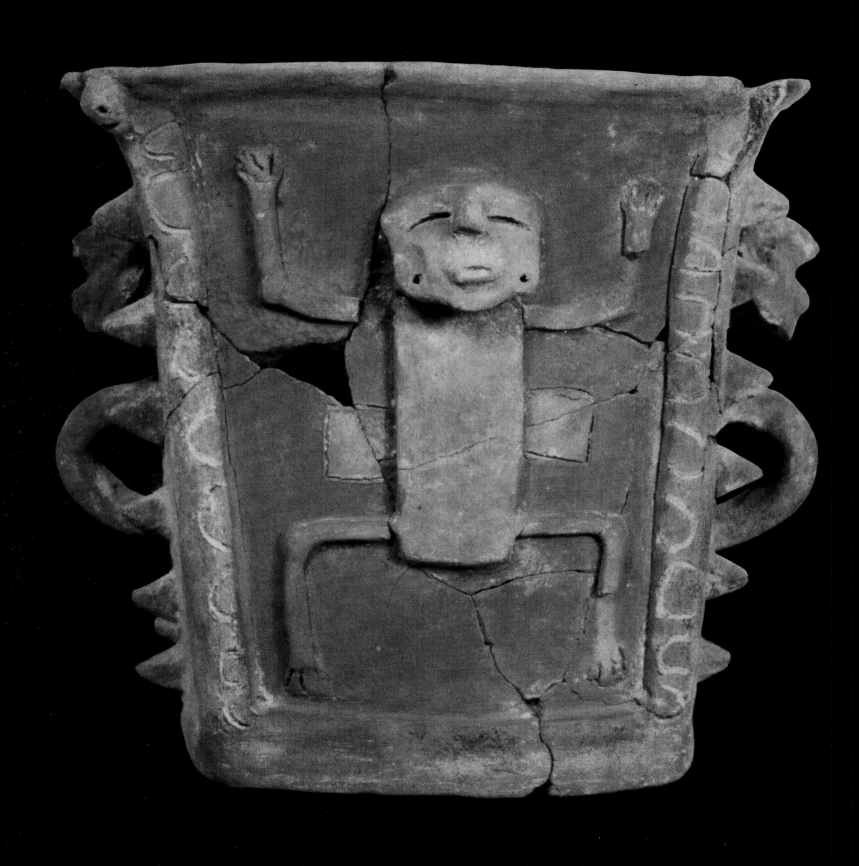

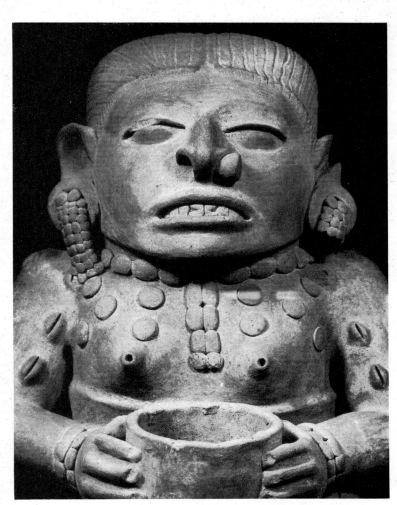

90 Fragment of a female figure. Pacific coast of Guatemala
91 Vessel in the form of a seated woman. Guatemala
highlands

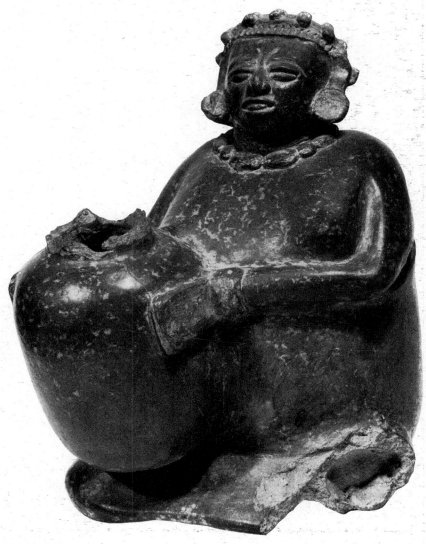

89 Rectangular vessel. Nebaj

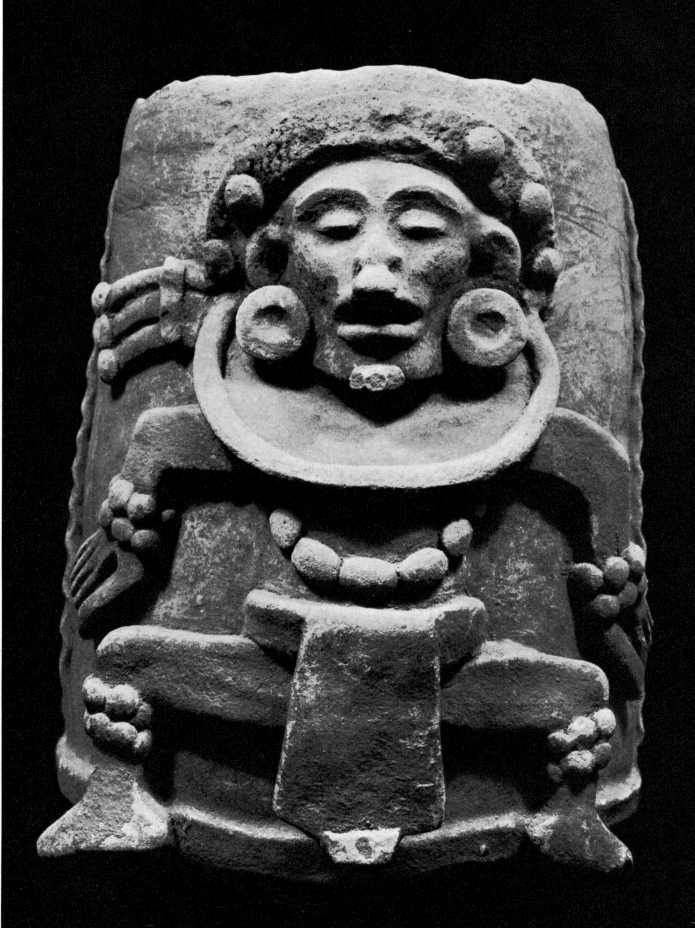

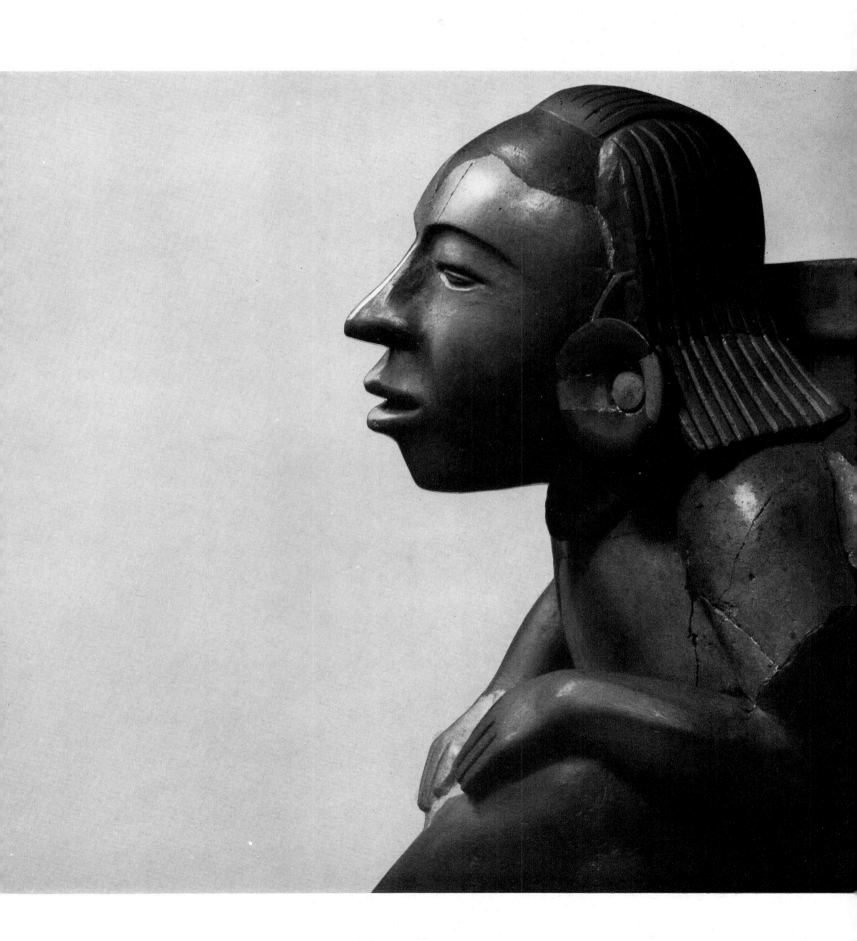

94 Solid model of a bird. Guatemala highlands
95 Tall beaker with incised decoration. Guatemala highlands
96 Ocarina in the form of a bird. Alta Verapaz
97 Figurine of a dancer. Northern Guatemala highlands
98 Ocarina in the form of a tapir. Northern Guatemala highlands

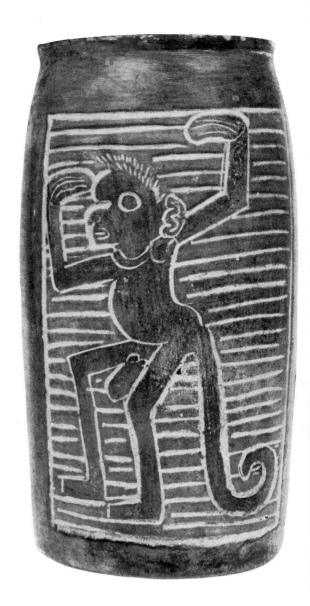

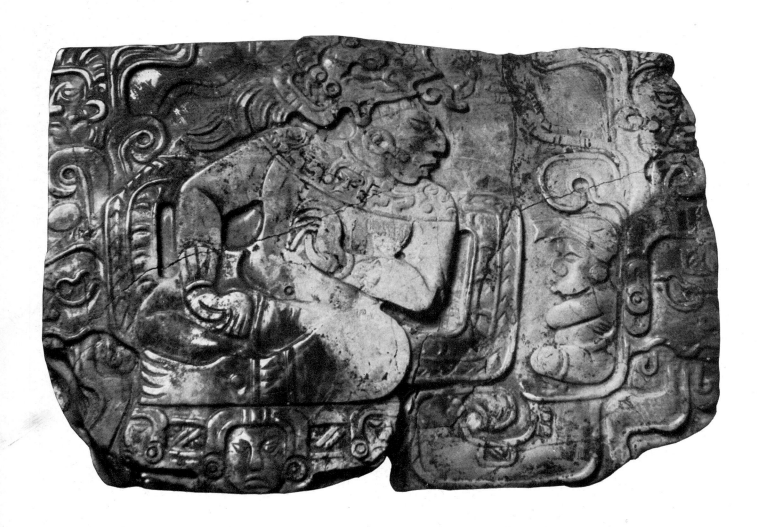

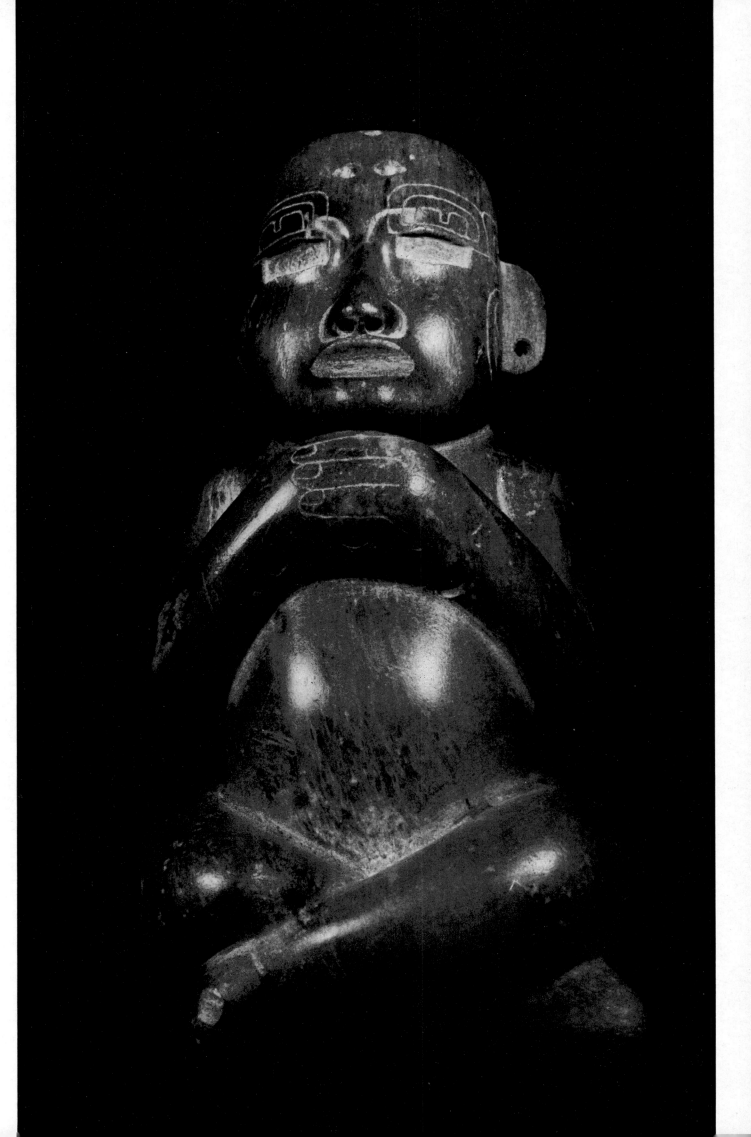

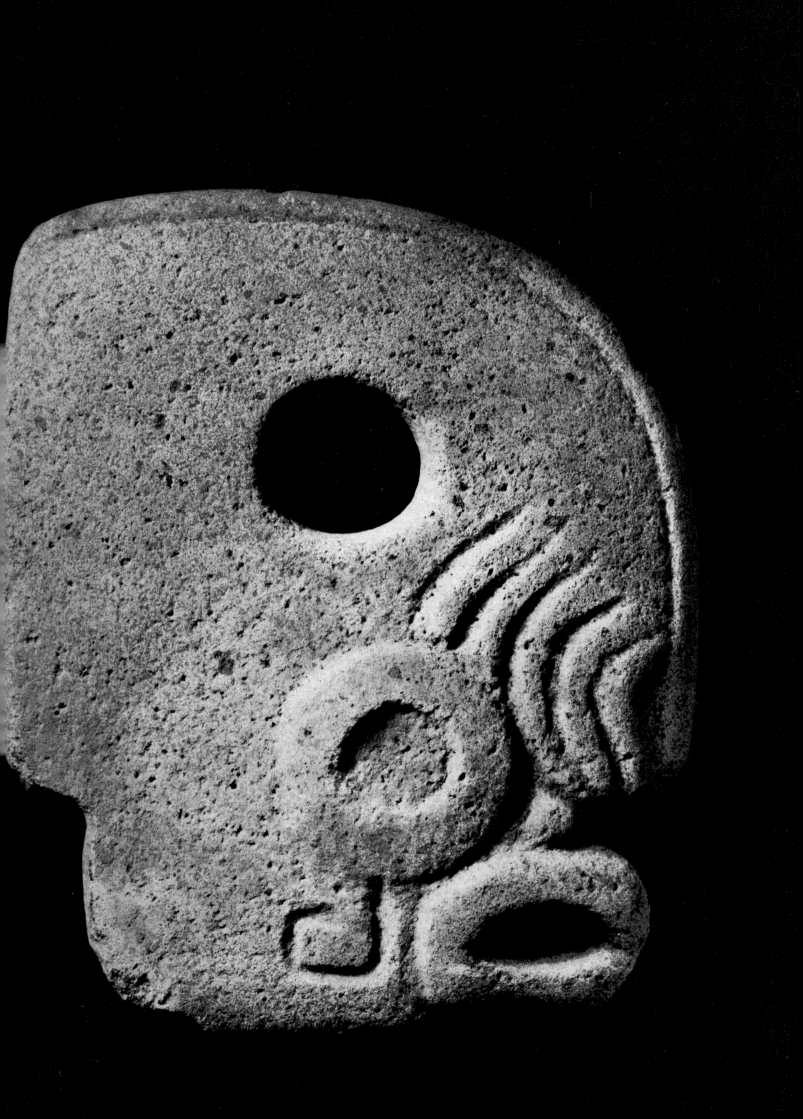

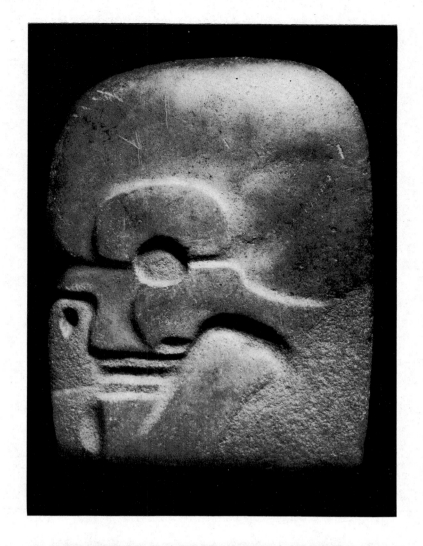

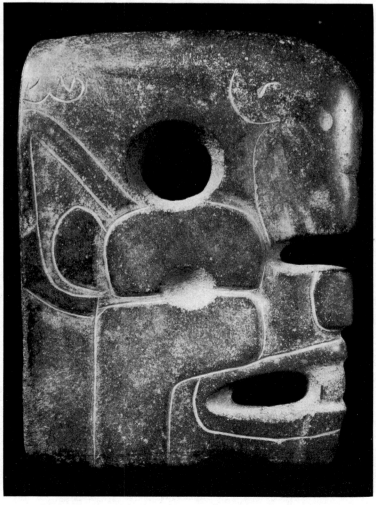

101–103 Three *hachas* (votive axes). Guatemala highlands

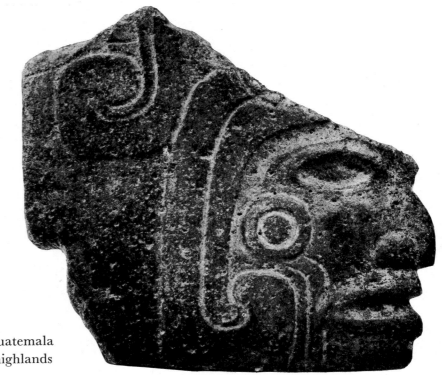

104–105 Two *hachas* (votive axes). Pacific coast of Guatemala
106 *Hacha* in the form of a bird's head. Guatemala highlands

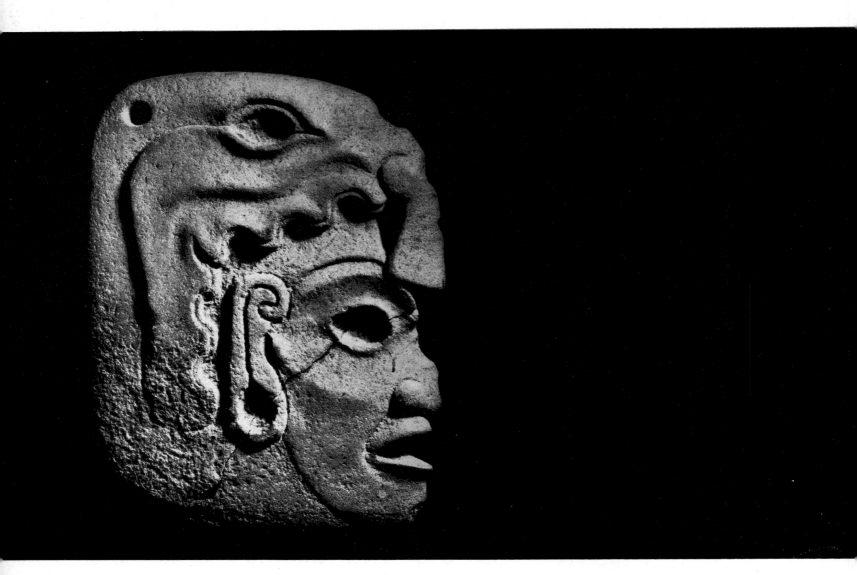

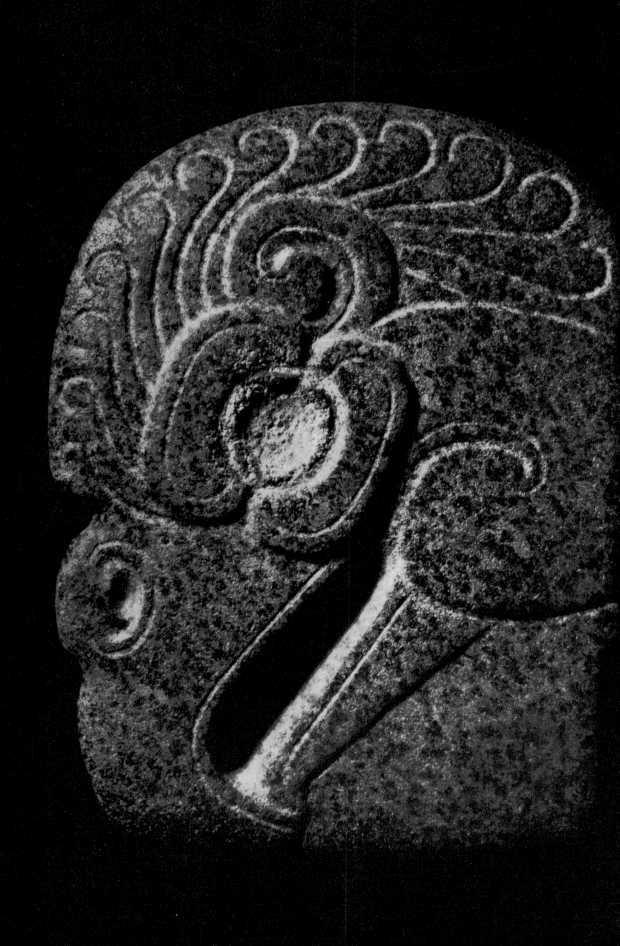

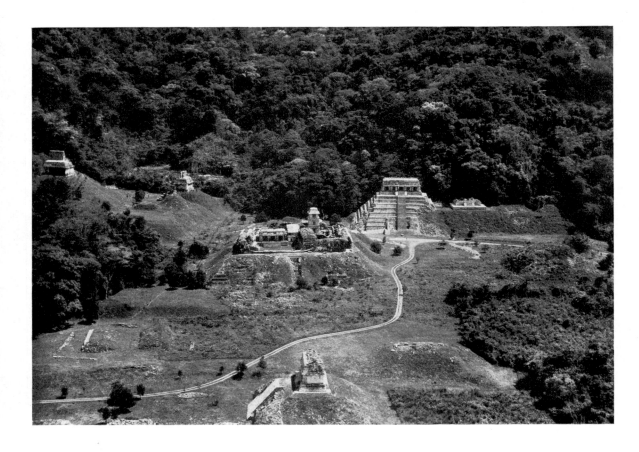

108 The Temple of the Inscriptions. Palenque

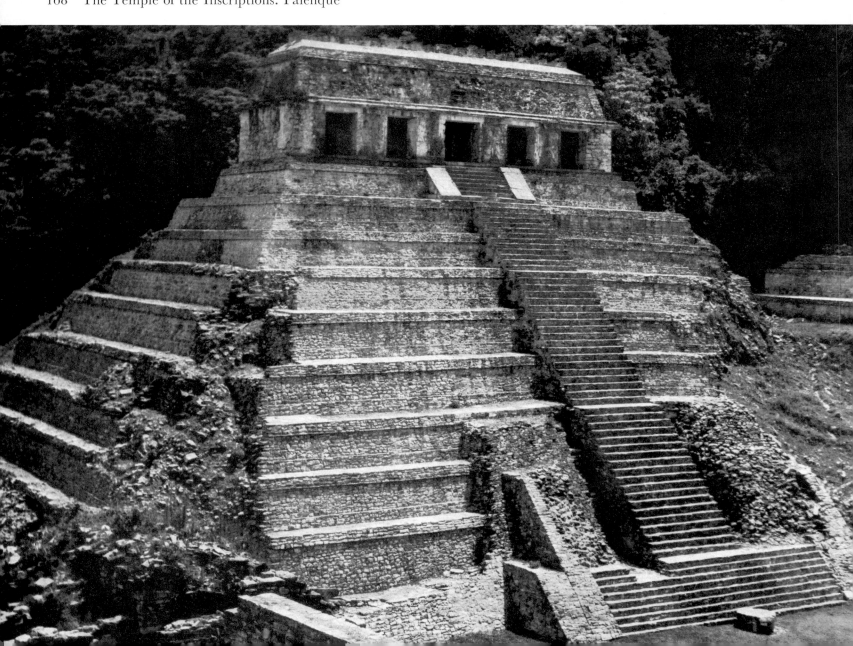

109 Jade figure of Kinich Ahau, the sun god. Palenque
110 Lid of the sarcophagus in the crypt beneath the Temple of the Inscriptions. Palenque
111 Passage leading down to the crypt beneath the Temple of the Inscriptions. Palenque

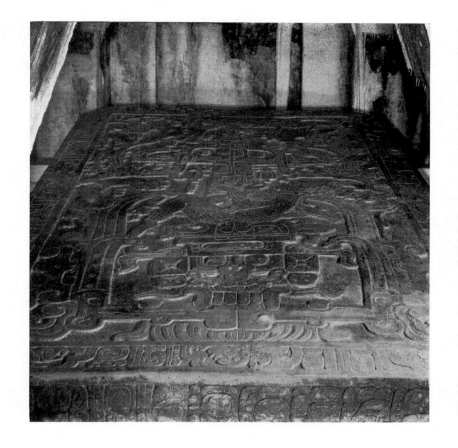

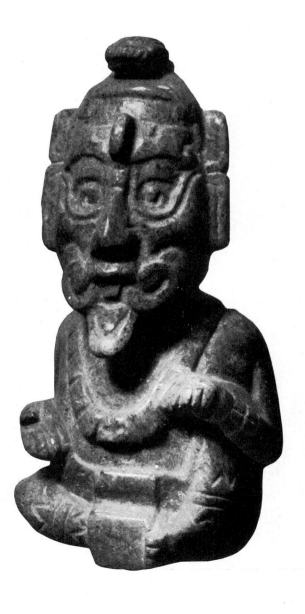

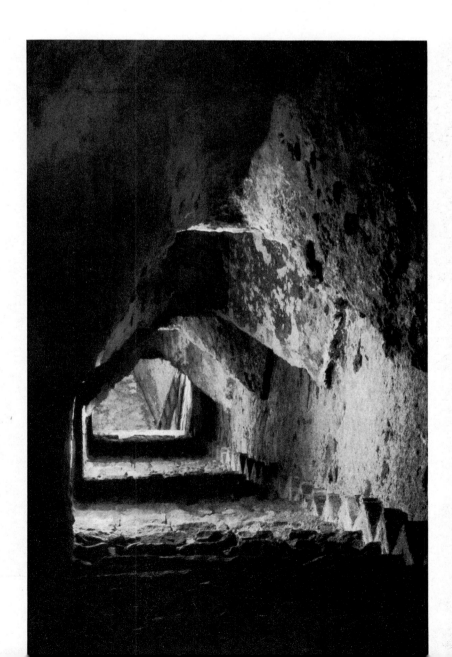

112 Bas-relief of a dignitary on the sarcophagus in the crypt of the Temple of Inscriptions. Palenque
113 Stucco relief on the wall of the crypt of the Temple of Inscriptions. Palenque

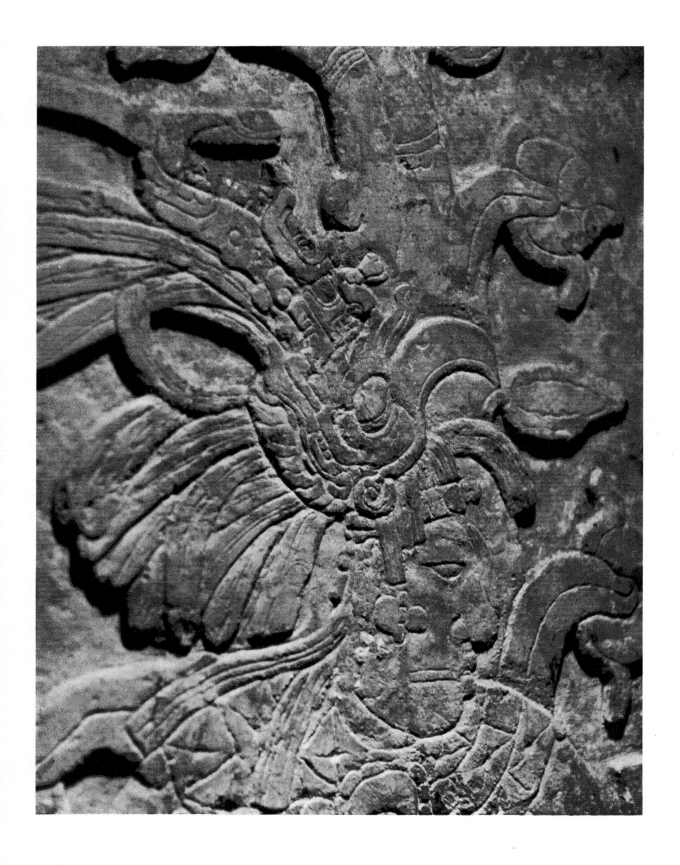

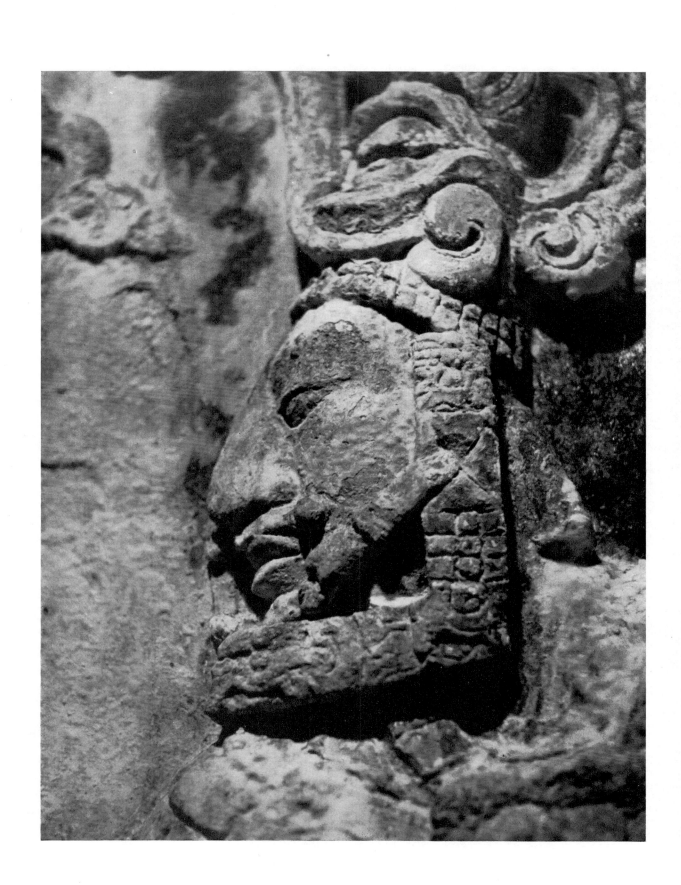

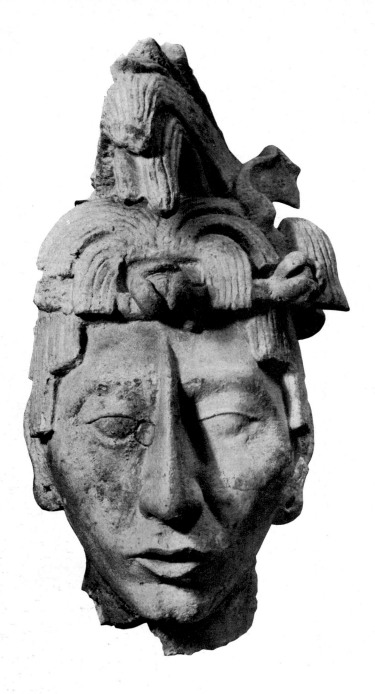

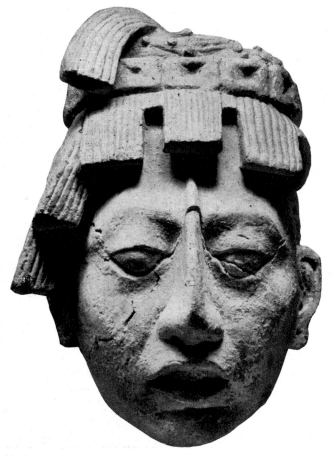

114–115　Two plaster heads from the crypt of the Temple of Inscriptions. Palenque

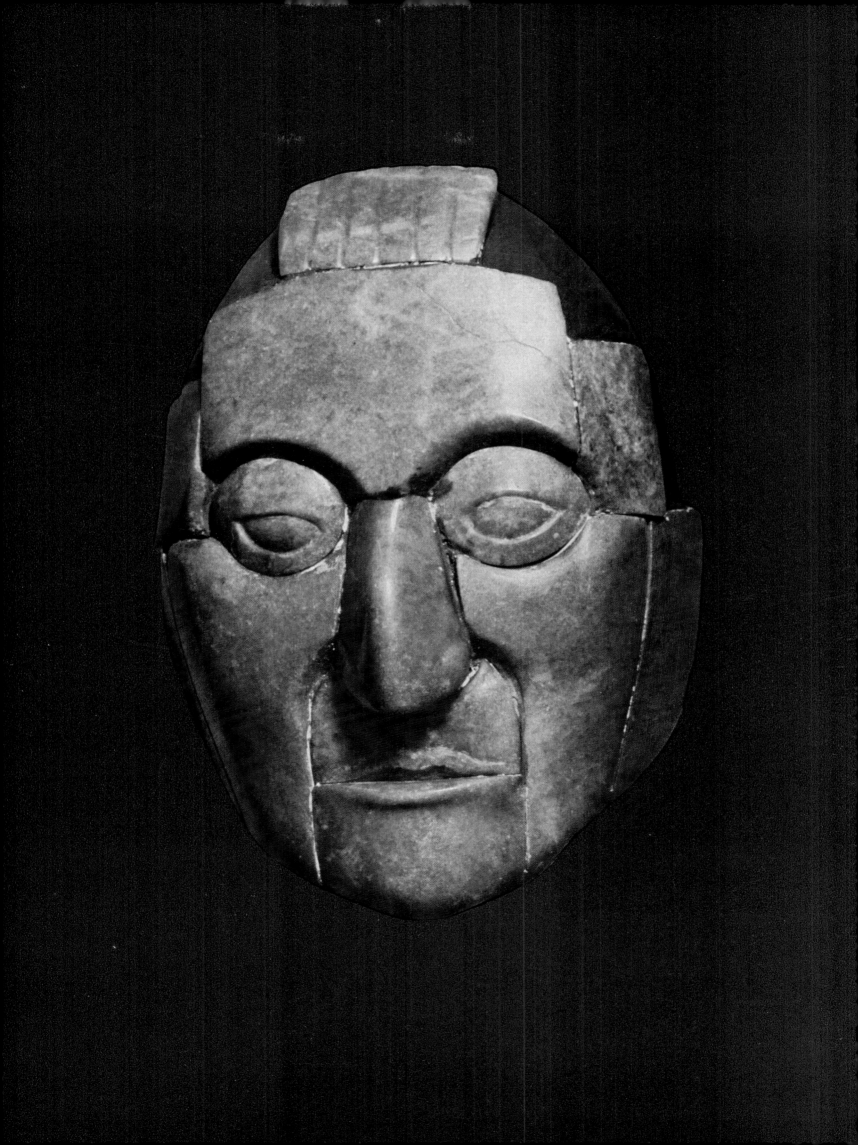

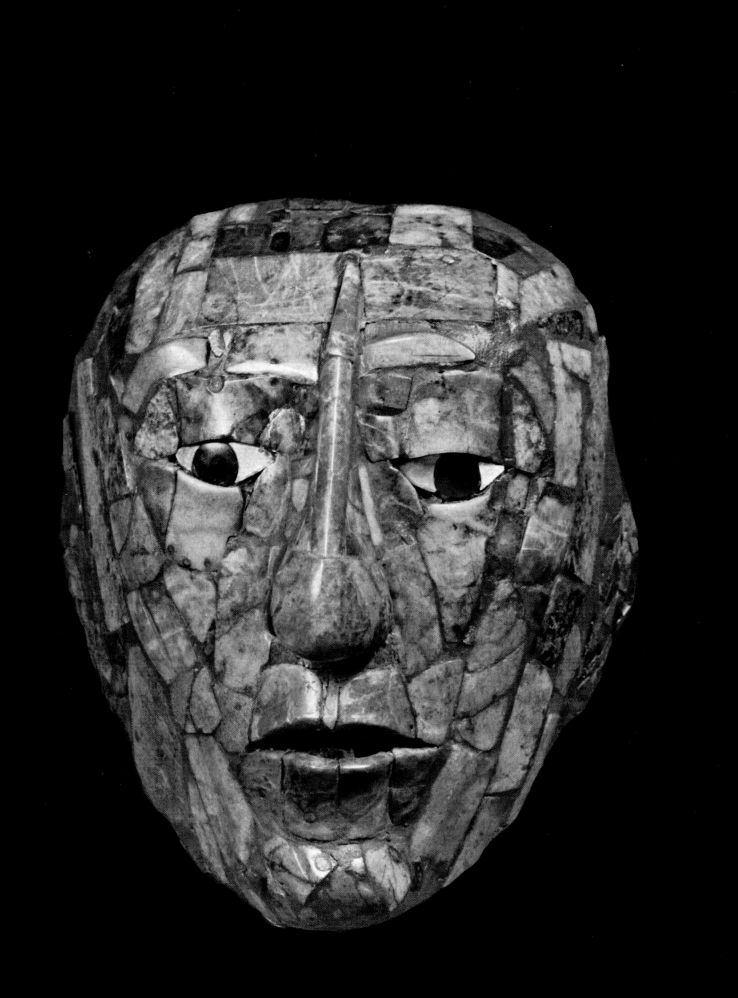

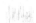

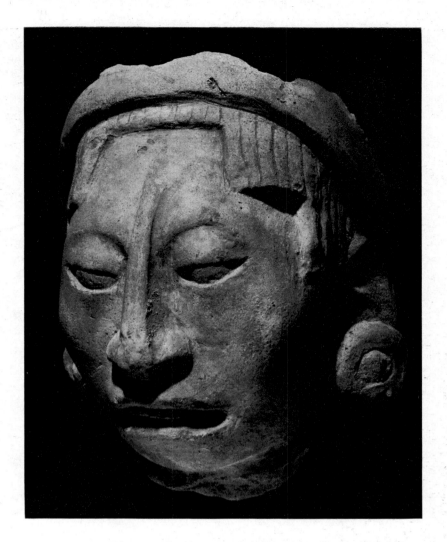

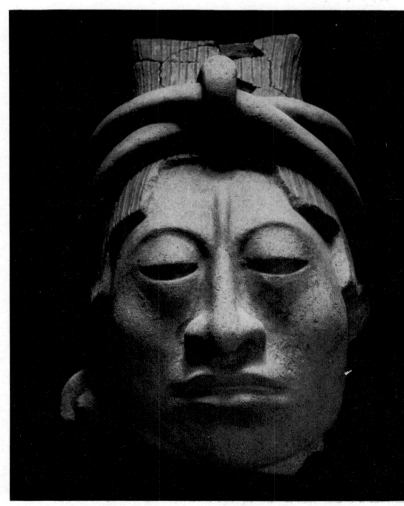

17 Jade mosaic mask. Palenque
18 Plaster head of a young priest. Region of Palenque
19 Clay head of a dignitary. Region of Palenque

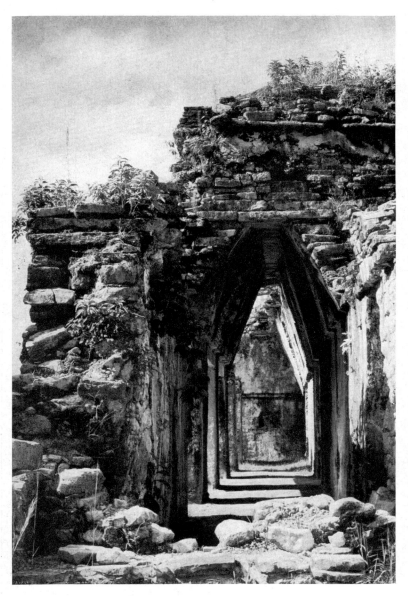

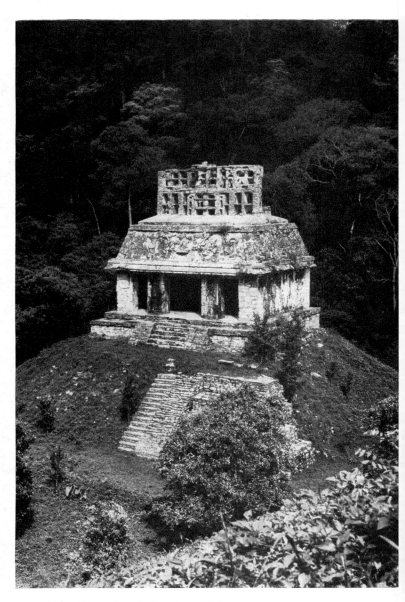

120 Corridor on the east side of the Palace. Palenque

121 The Temple of the Sun. Palenque

122 The tower of the Palace, before restoration. Palenque

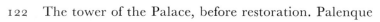

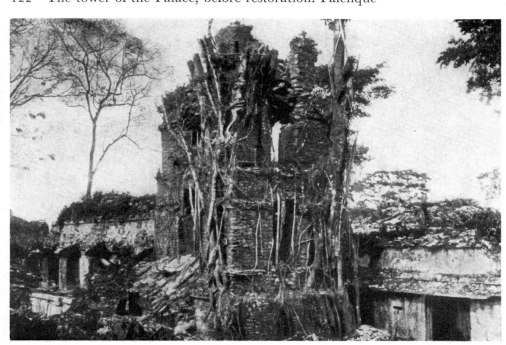

123 The Palace. Palenque

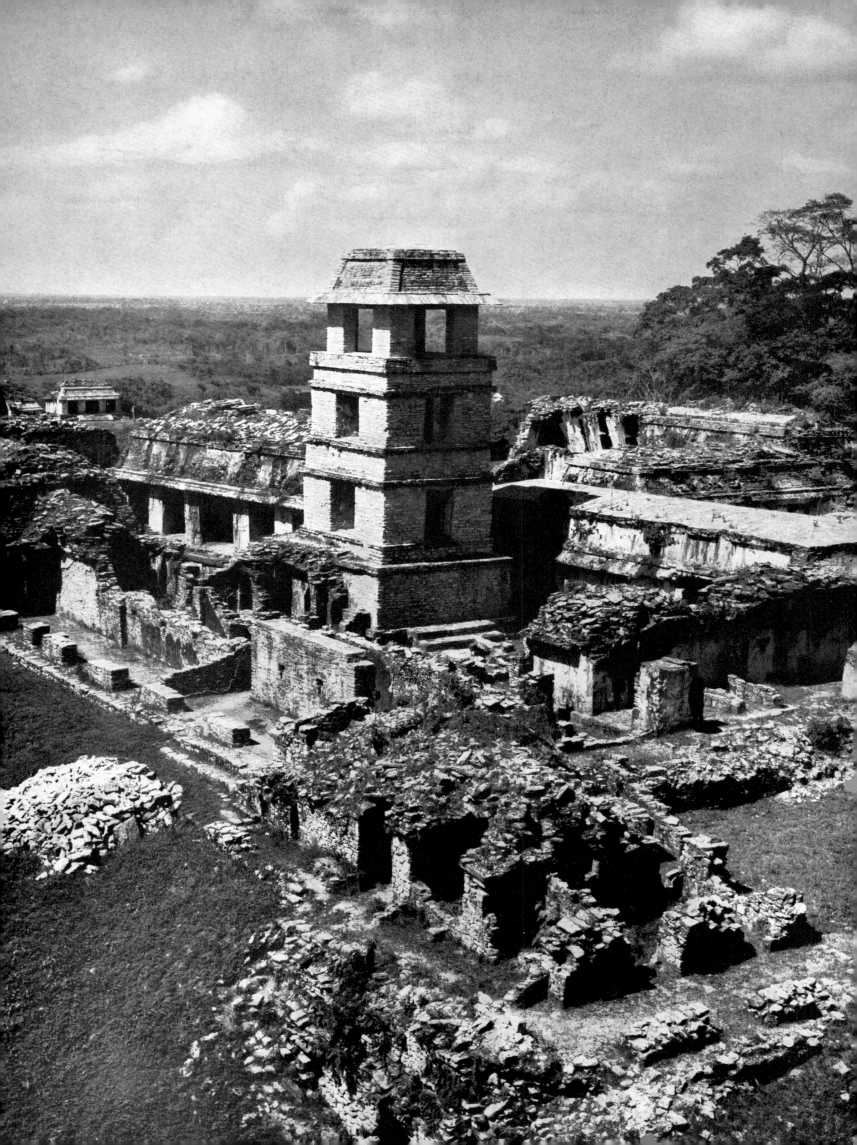

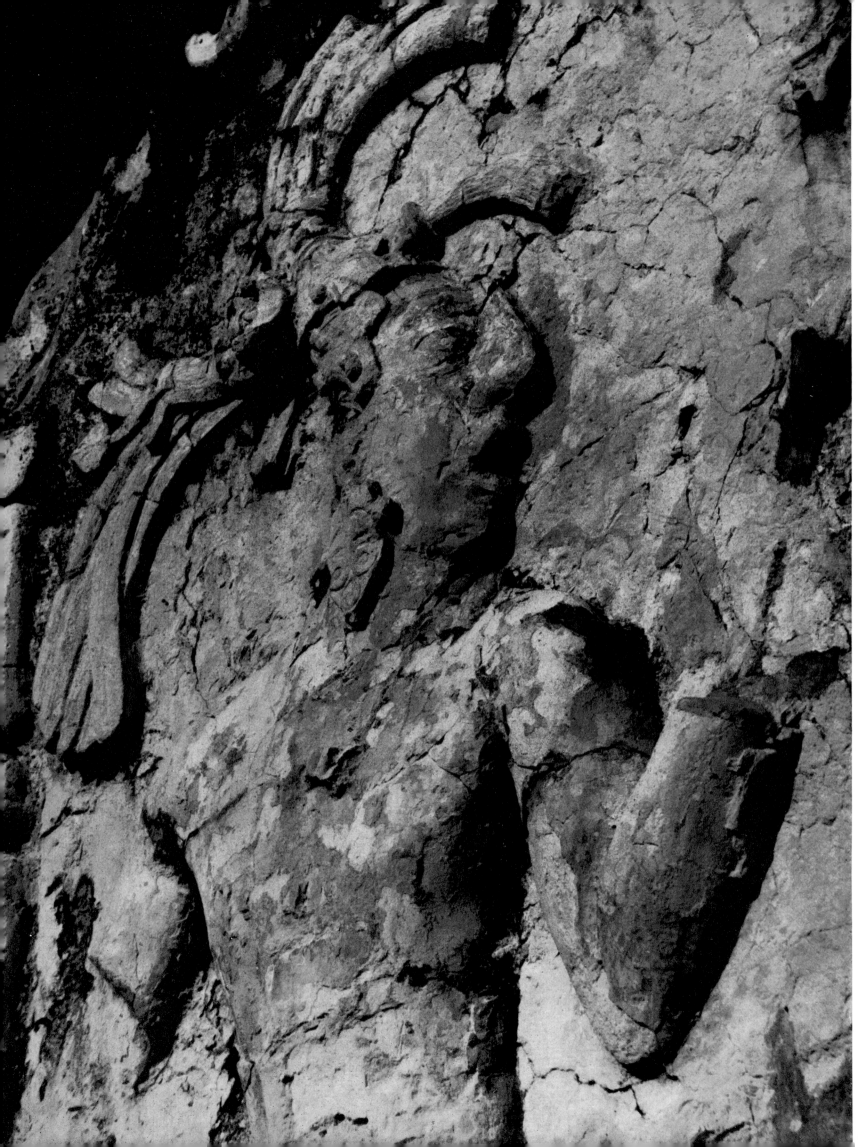

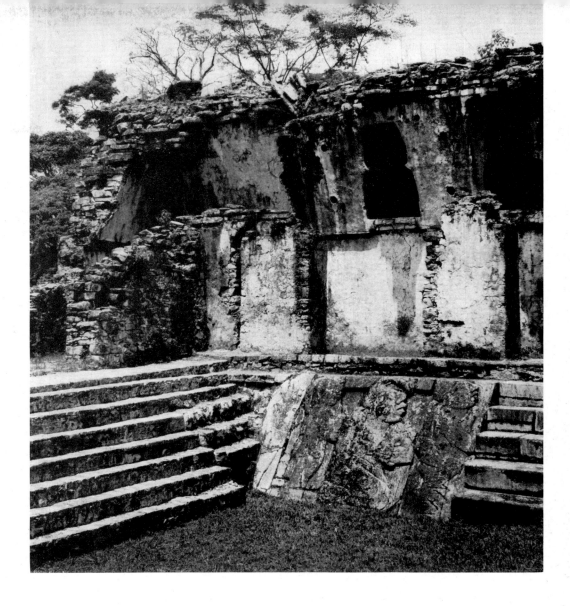

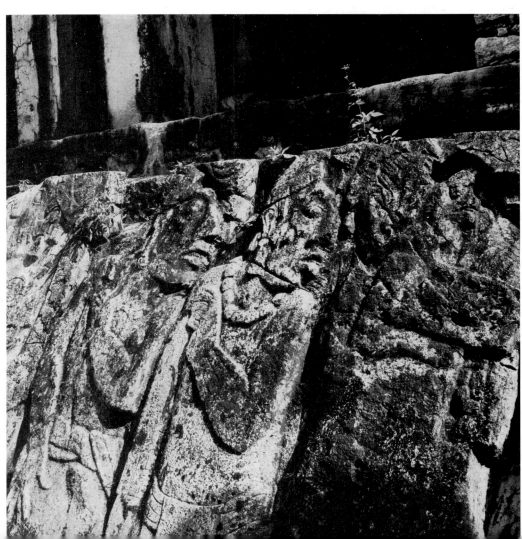

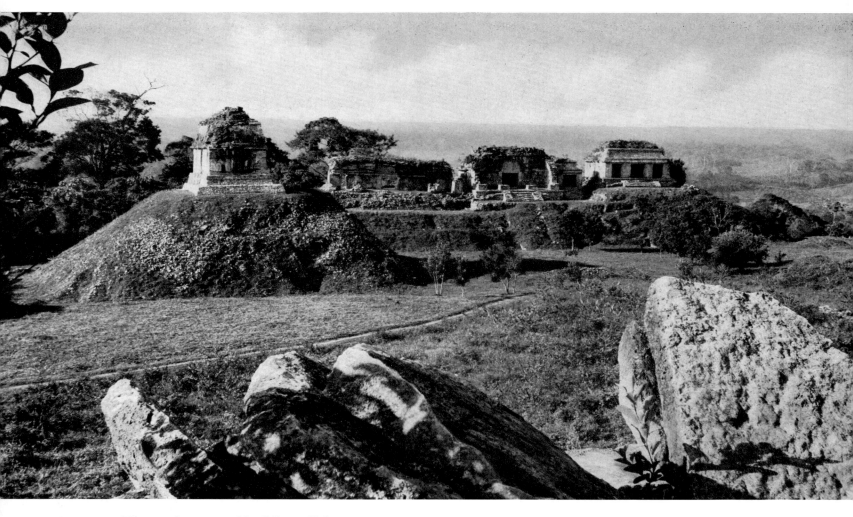

127 The north group of buildings. Palenque

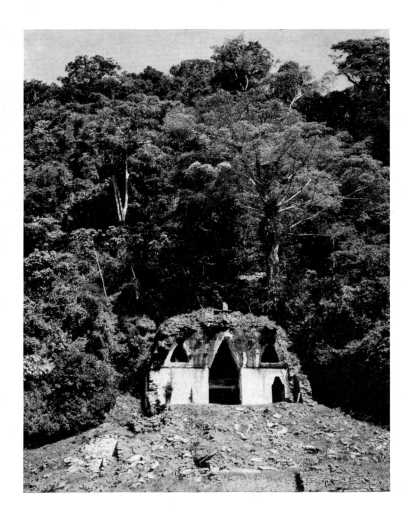

128 The Temple of the Foliated Cross. Palenque

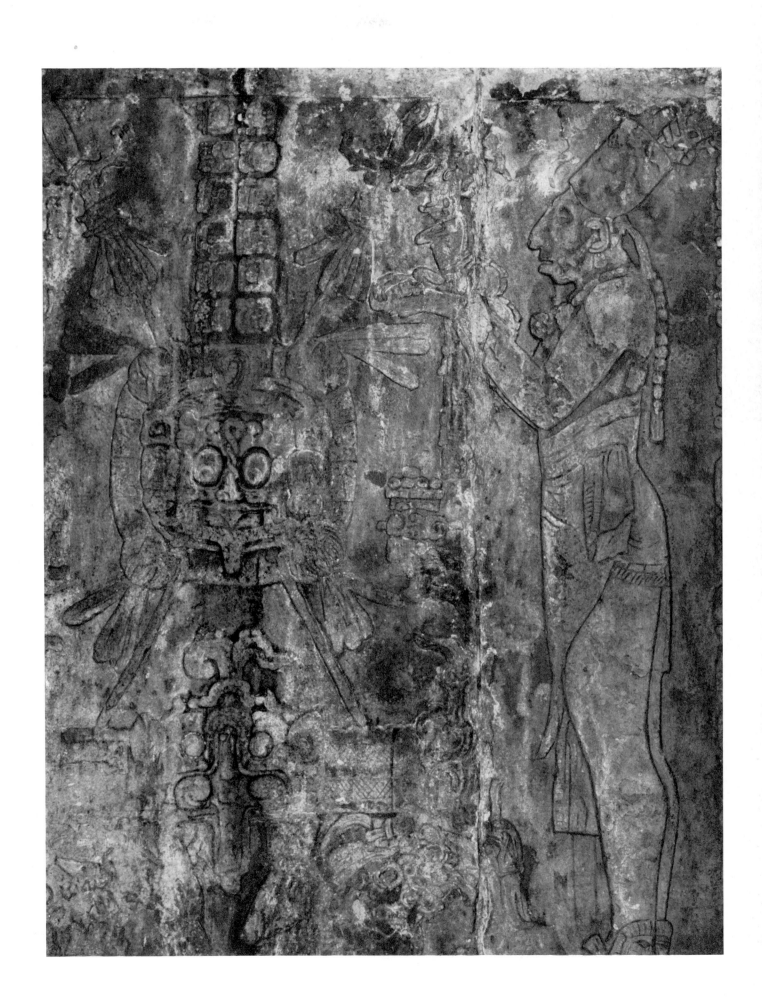

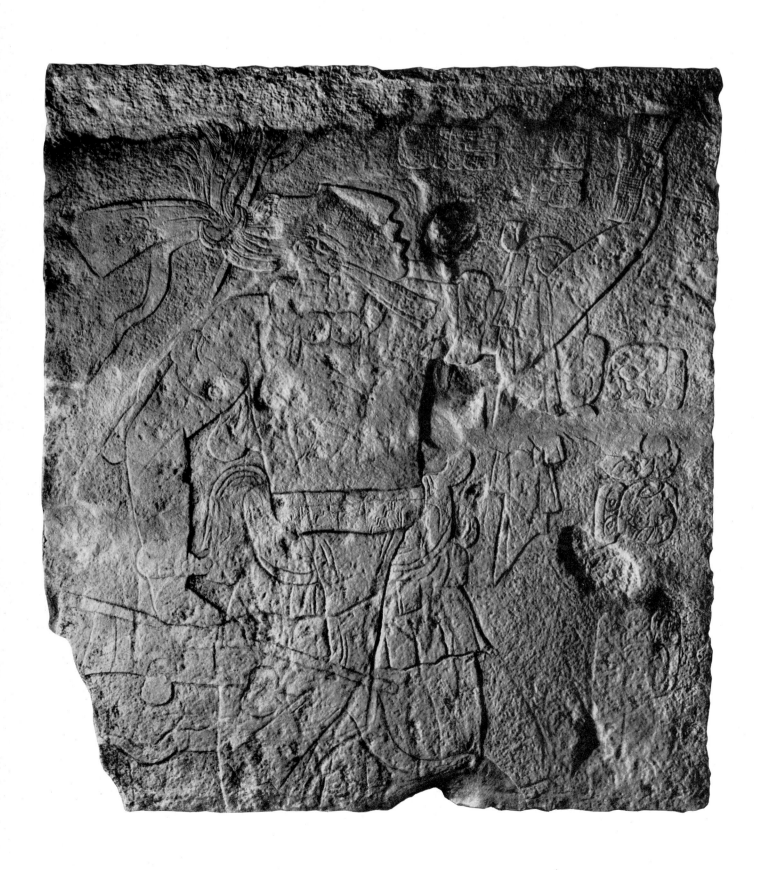

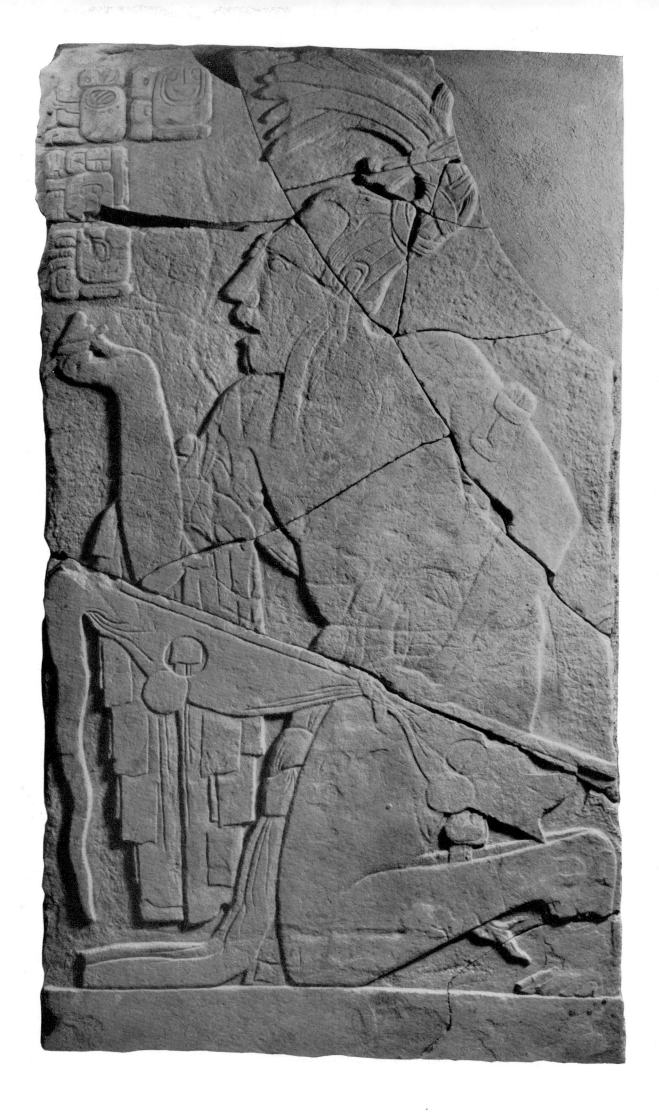

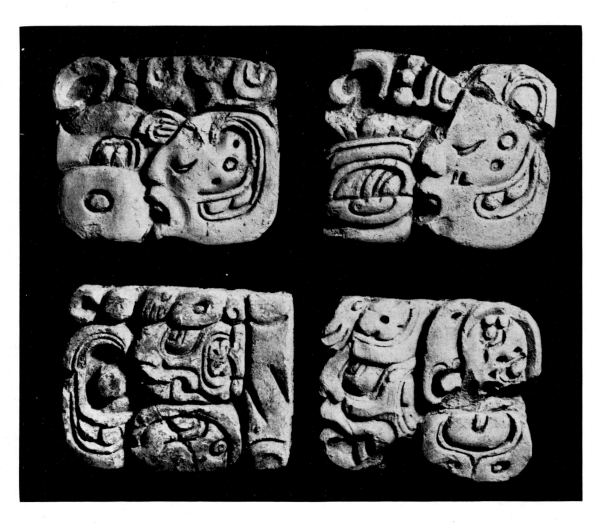

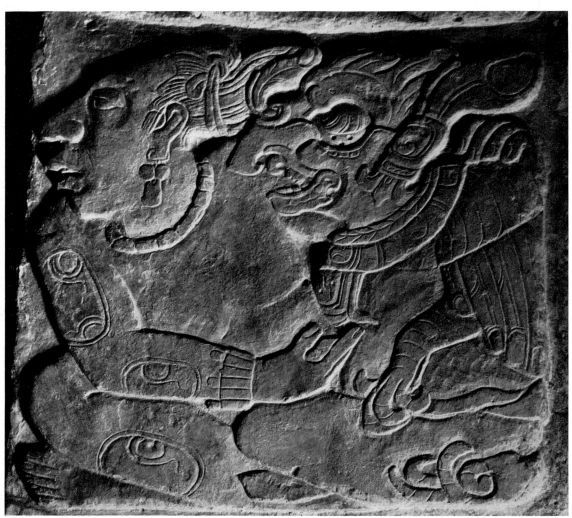

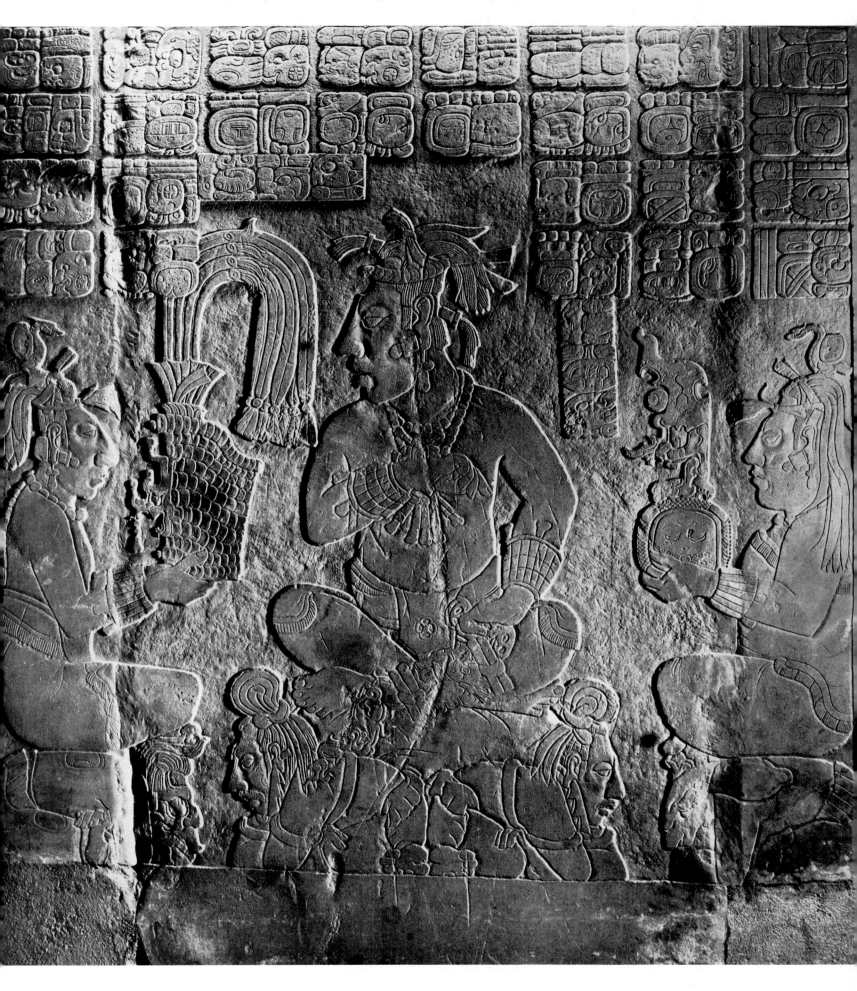

132 Four day glyphs from Temple XVIII. Palenque

133 Figural glyph. Palenque

134 The Tablet of the Slaves. Palenque

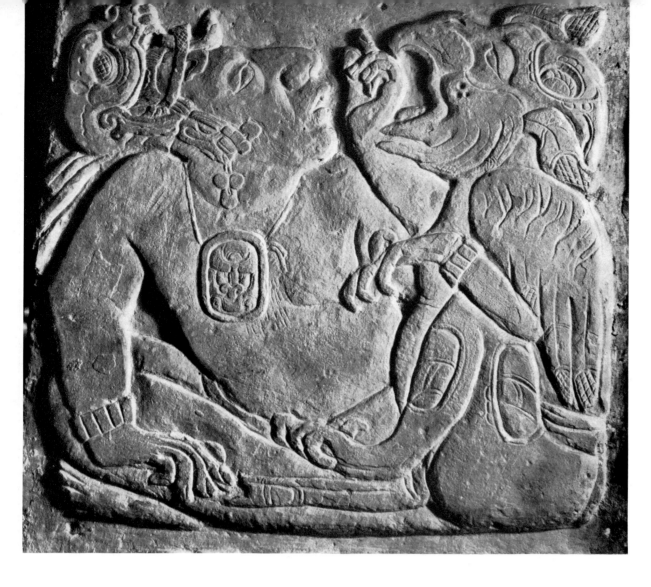

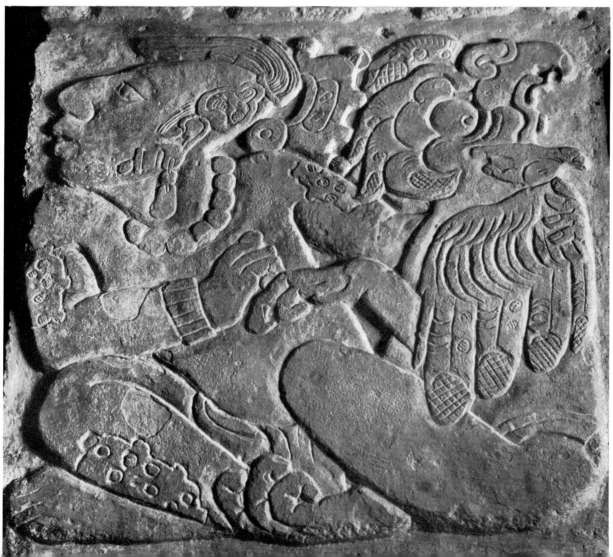

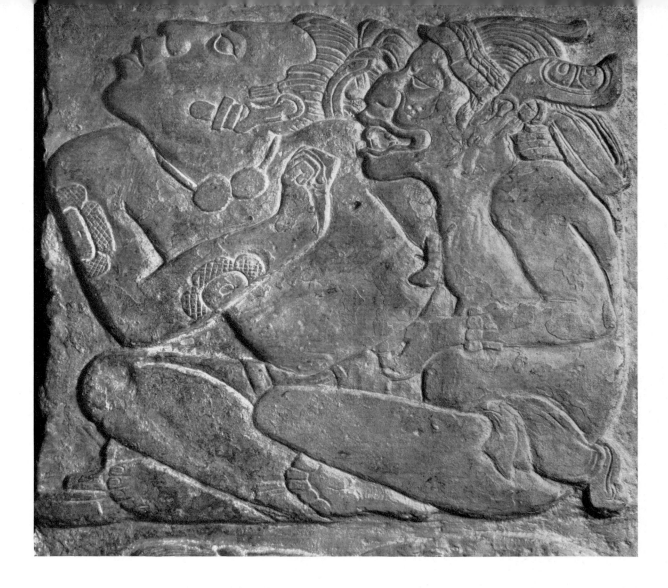

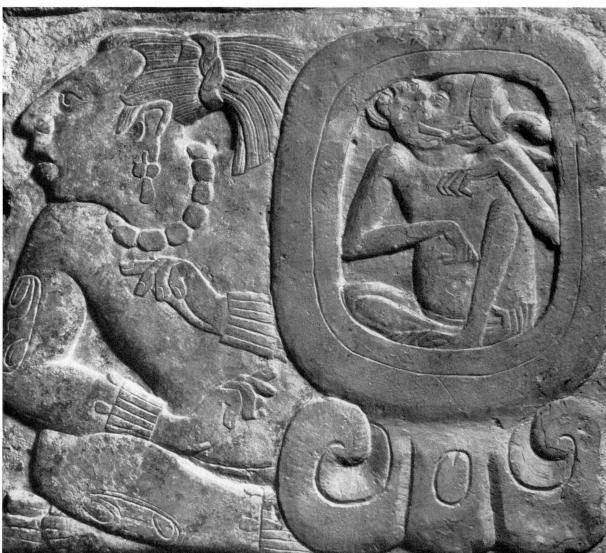

135–138 Figural glyphs
from Tablet of the Palace.
Palenque

139 Plaster head of a man. Style of Palenque
140 Head of the sun god, on an urn. Palenque

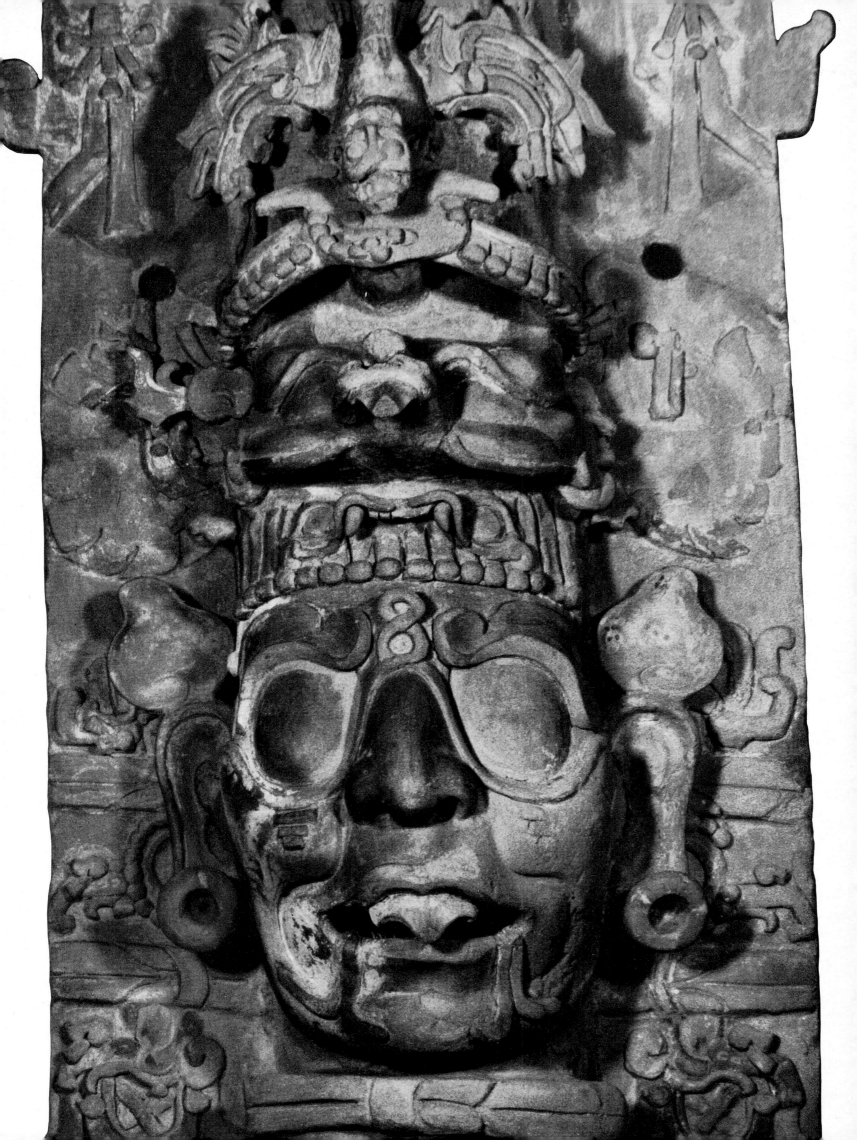

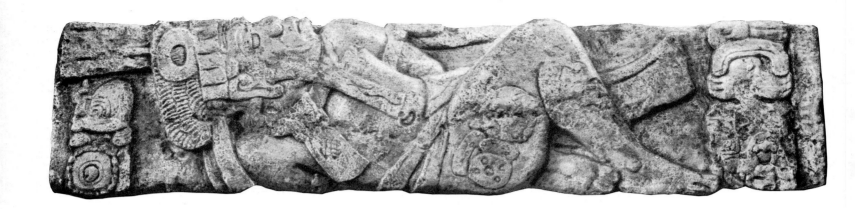

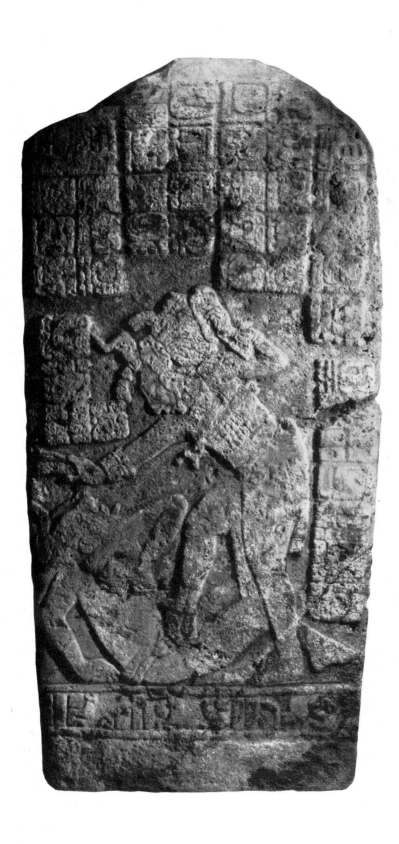

141 Carved lintel. Toniná
142 Stela. Balam-Kan
143 Fragment of a relief. Jonuta

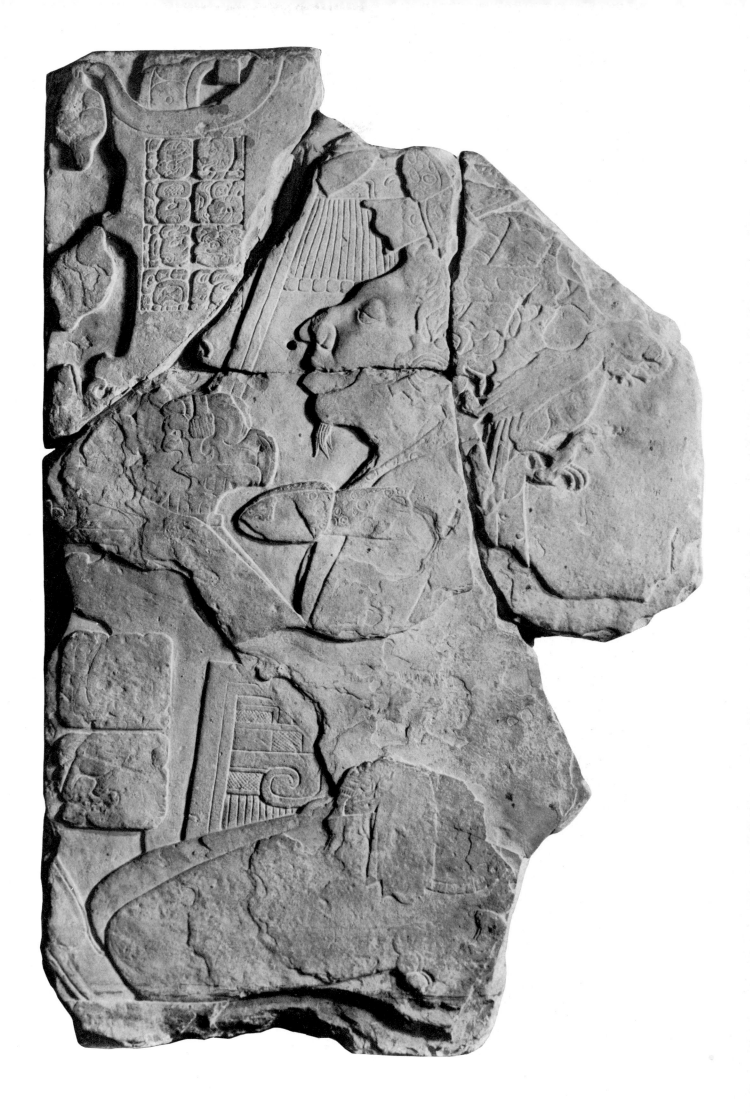

144 Plaster head, part of the decoration of a stairway. Comalcalco

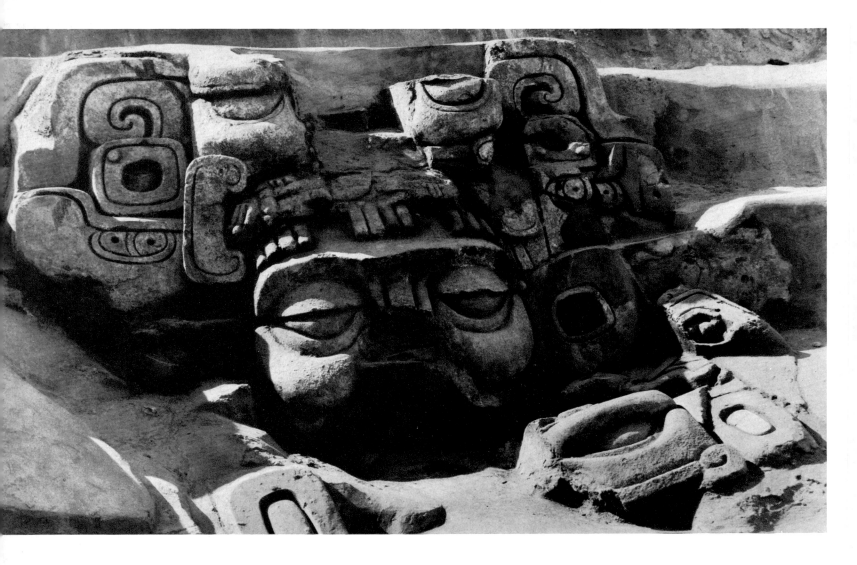

145 Comalcalco from the air

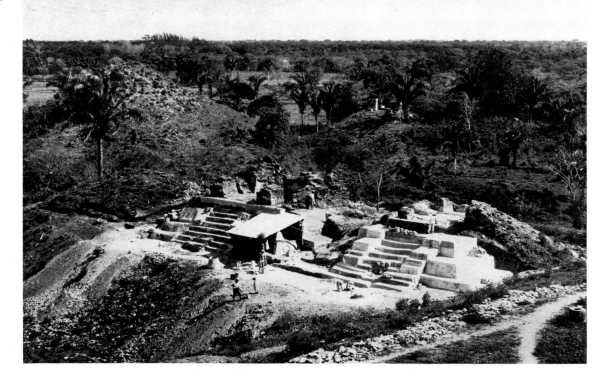

146 Plaster figure of a seated priest, from a stairway.

147 Limestone head of a prince. Comalcalco

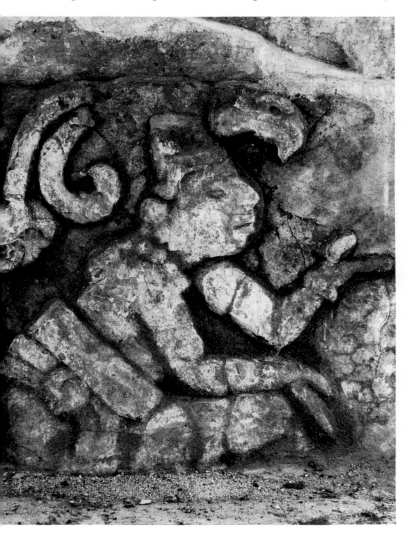

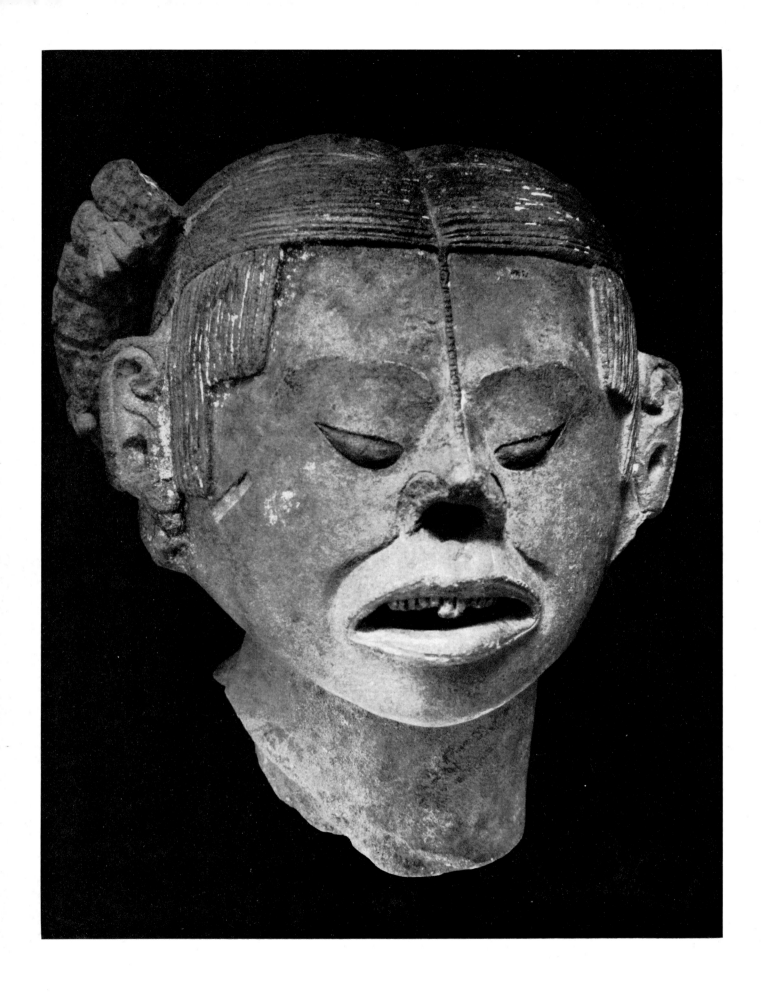

148 Clay fragment of a girl's head. Chiapas highlands
149 Clay fragment, with a human head in high relief. Tabasco

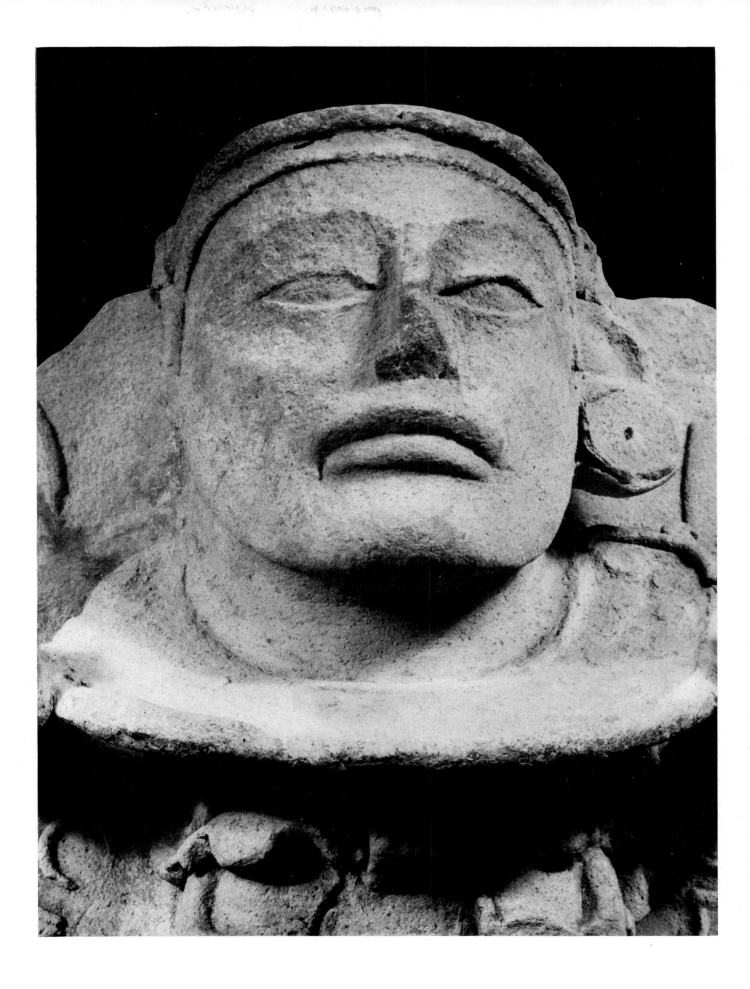

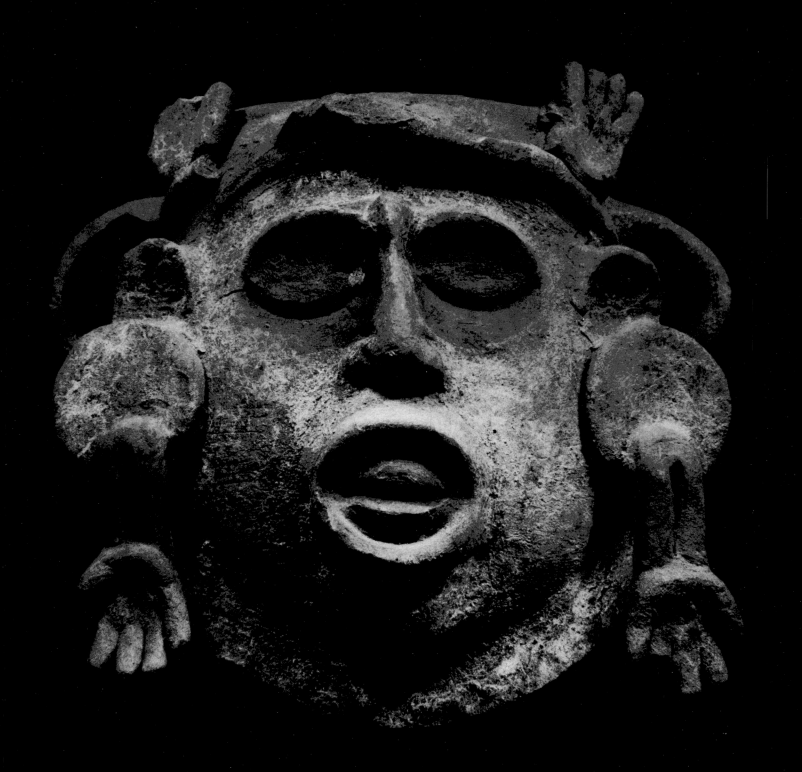

150 Censer in the form of the god Xipe Totec. Antigua
151 Vessel in the form of a man's head. Chiapa de Corso

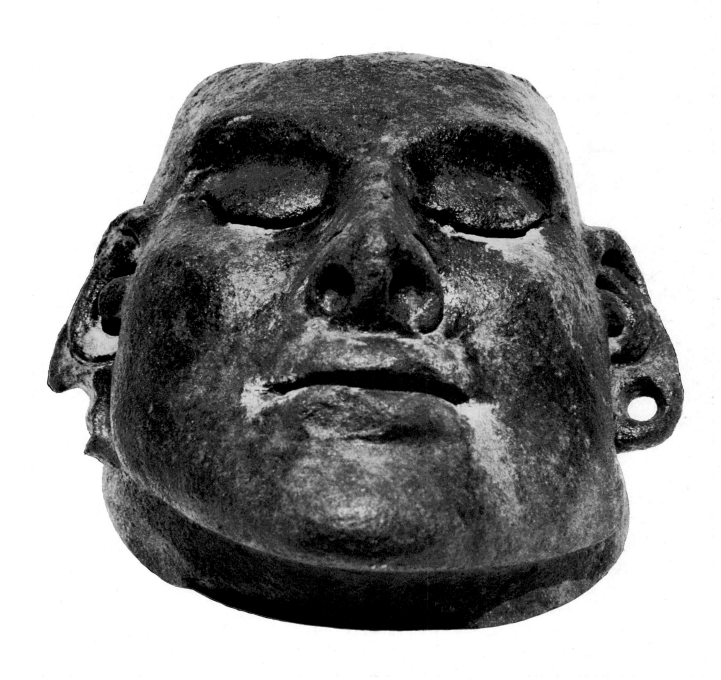

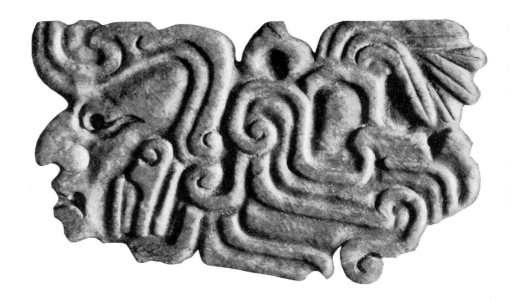

152 Jade pendant. Guatemala highlands
153 Vessel in the form of a wayfarer. Chiapa de Corso
154 Zoomorphic god. Chiapas highlands
155 Vessel with relief decoration. Tabasco

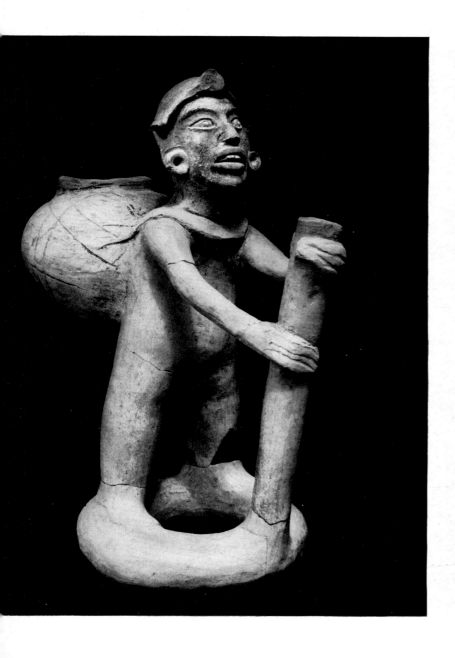

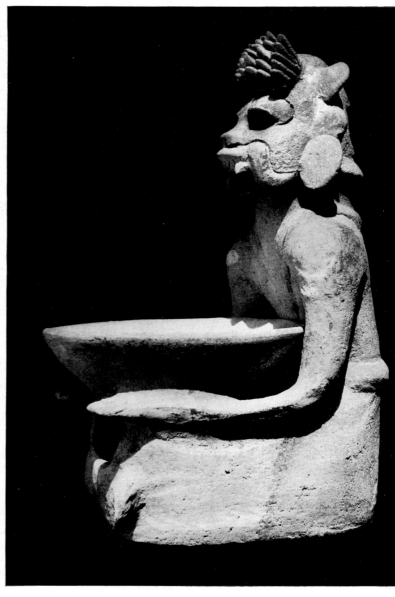

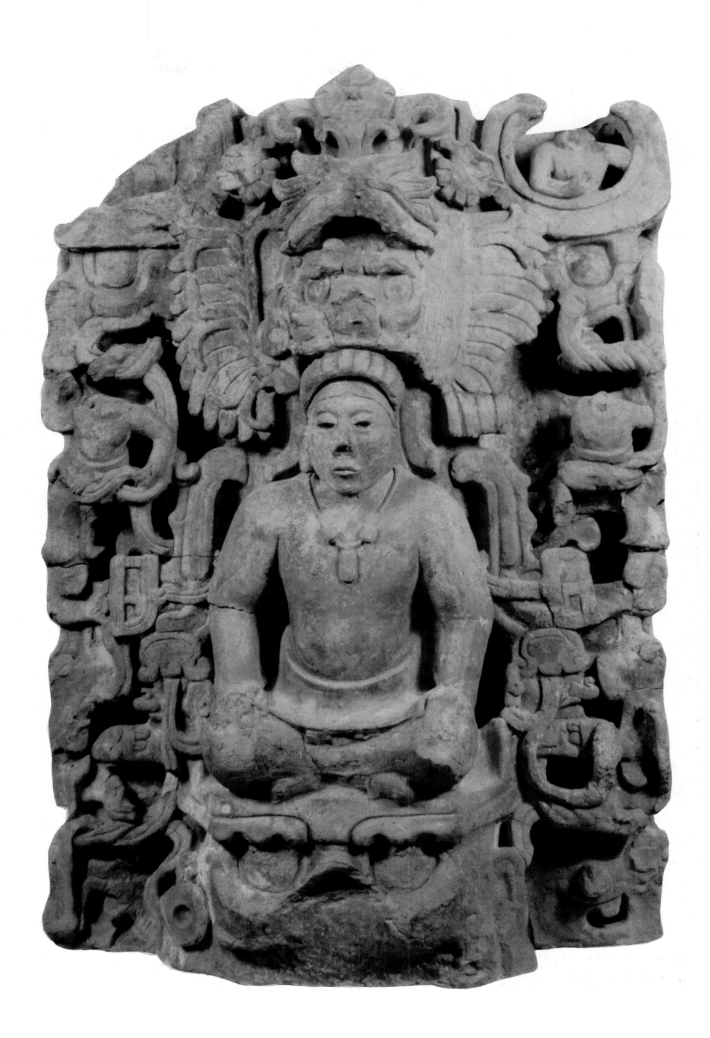

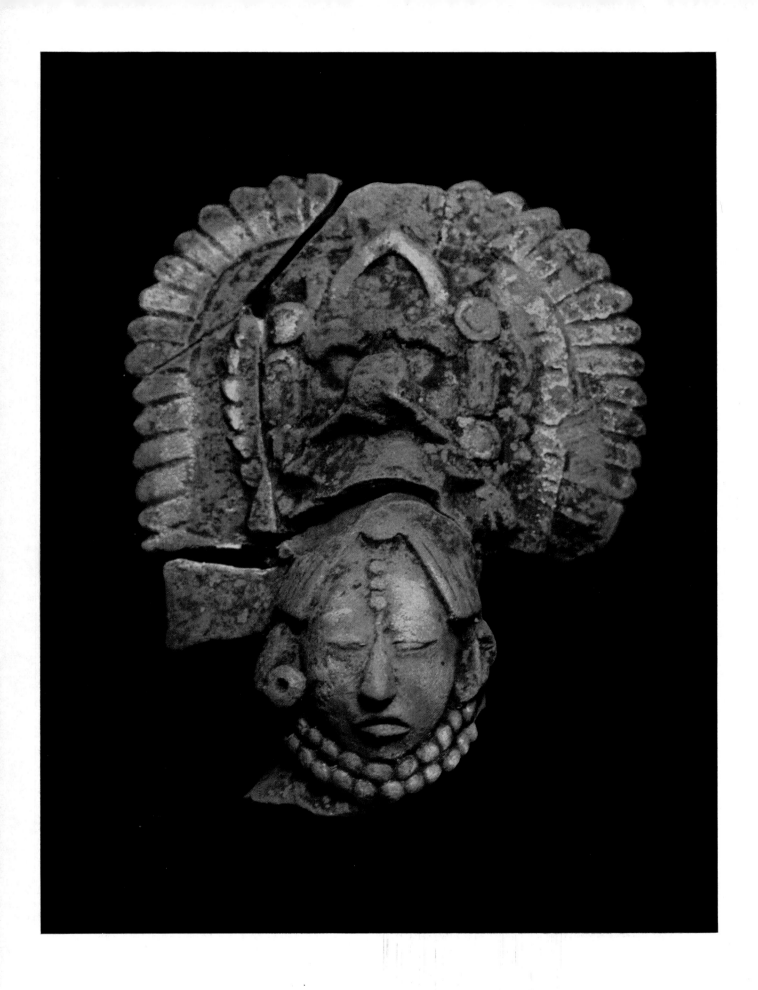

156 Small solid head of a priest. Alta Verapaz
157 Solid head. Chiapas highlands

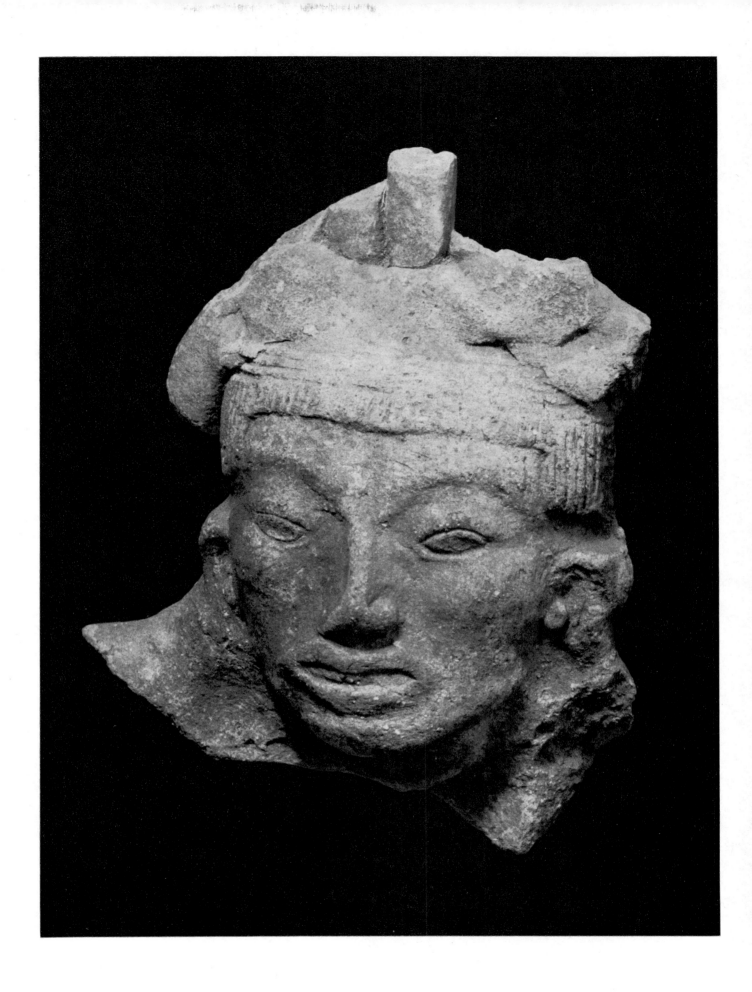

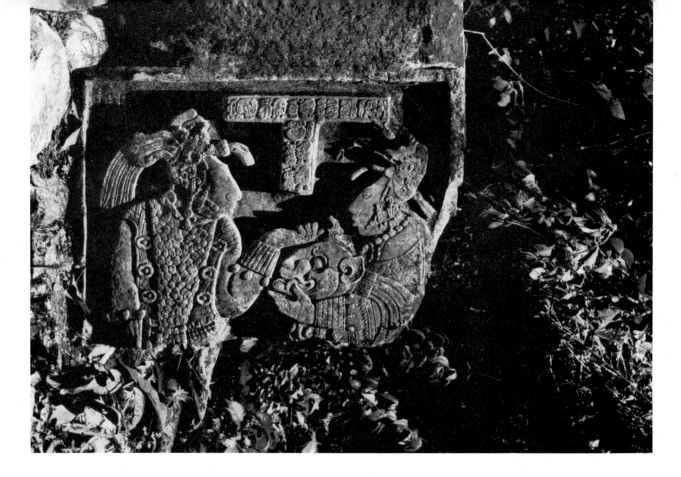

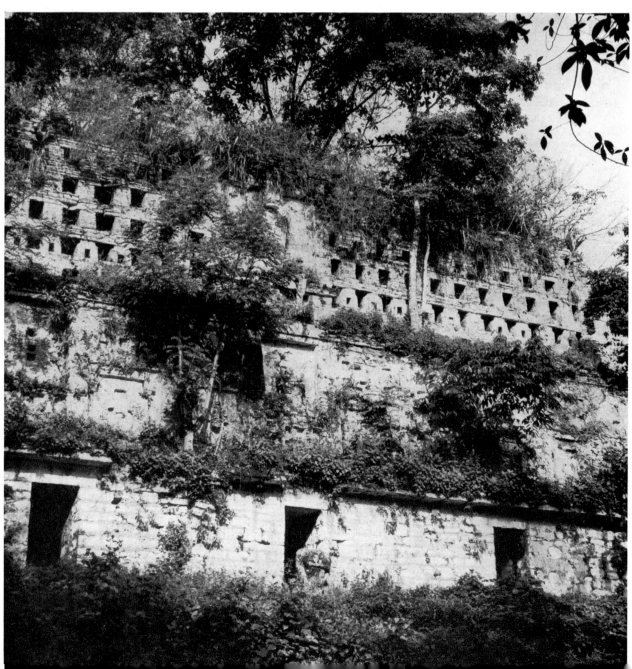

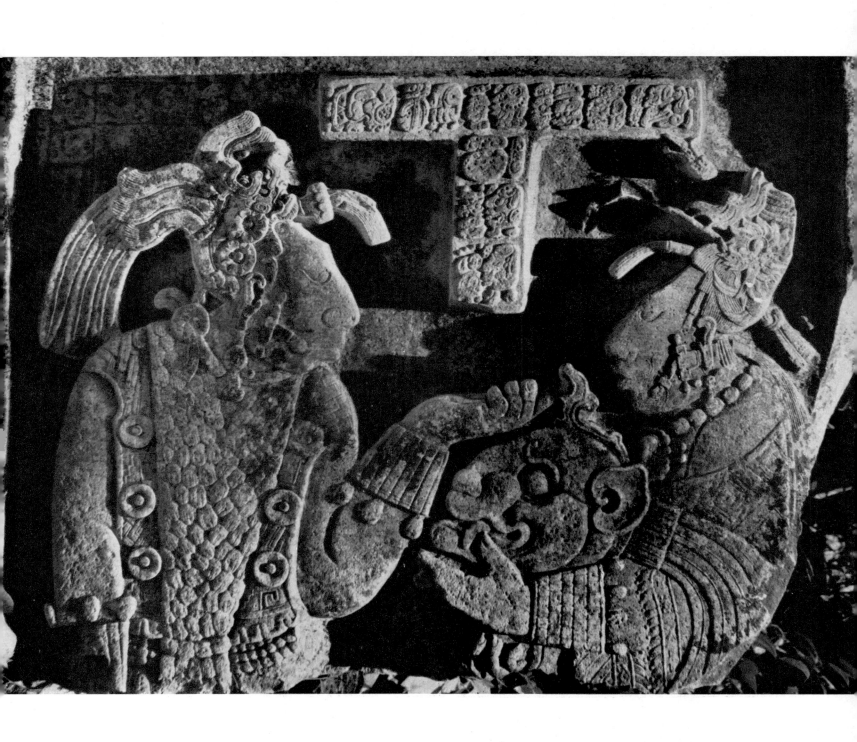

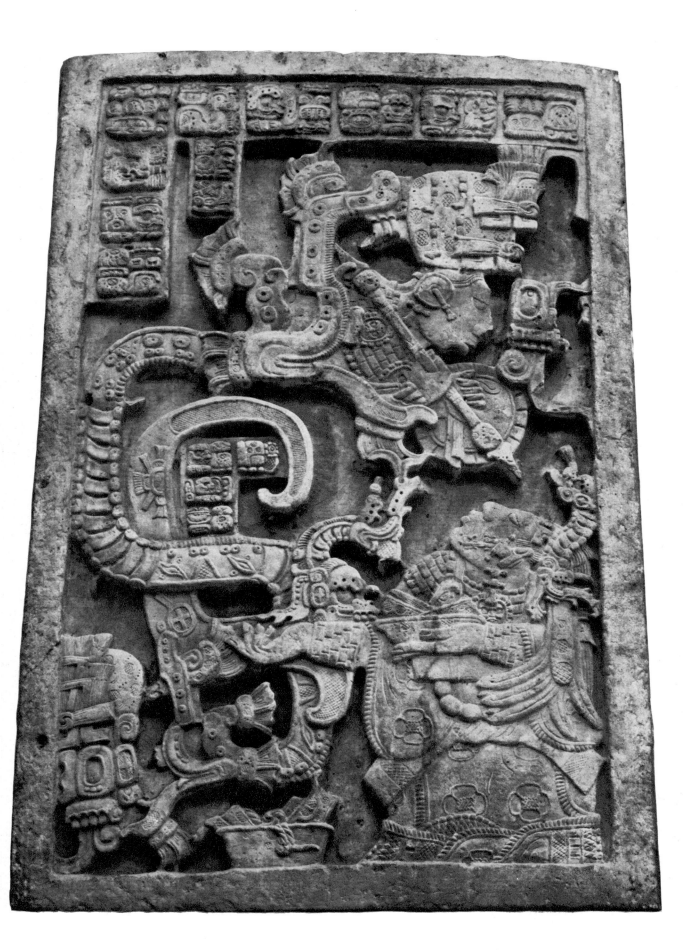

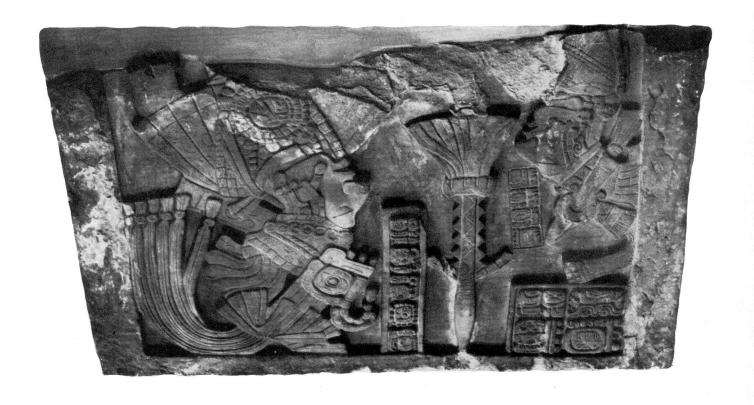

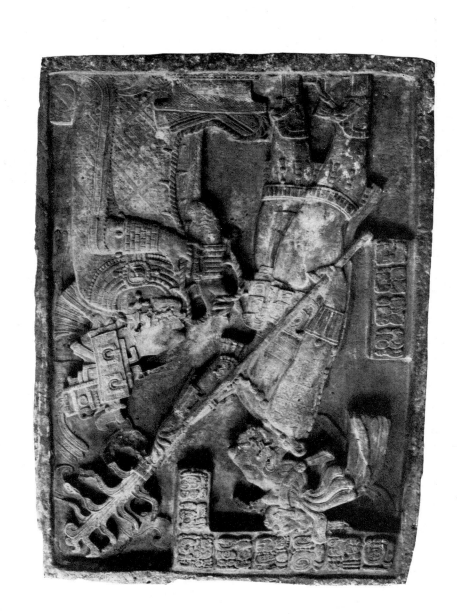

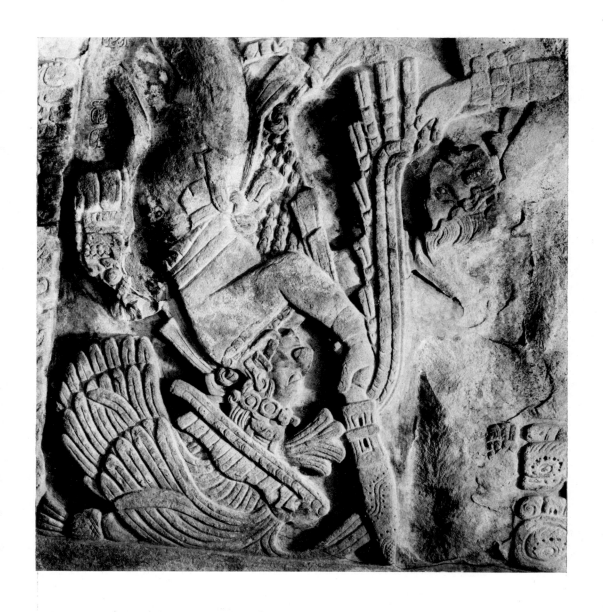

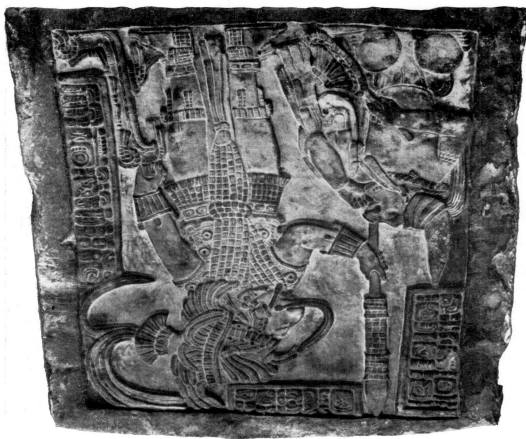

168 Detail of a fresco in the Temple of the Mural Paintings. Bonampak

169 Fragment of Stela 1. Bonampak

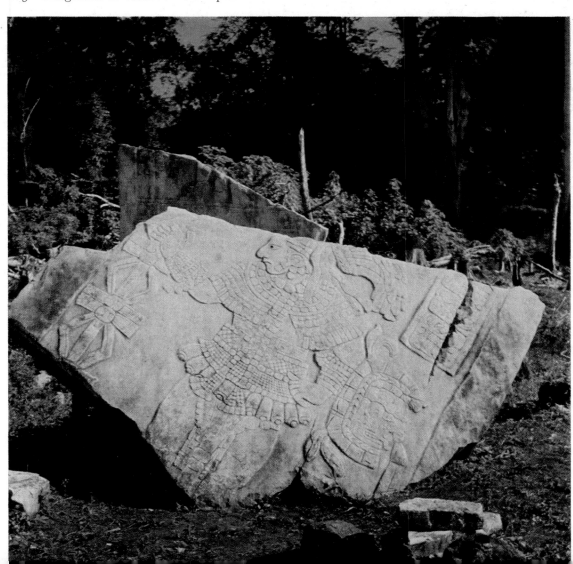

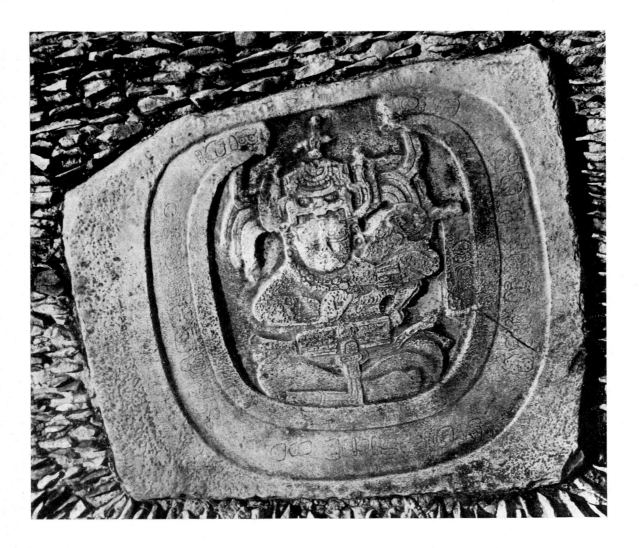

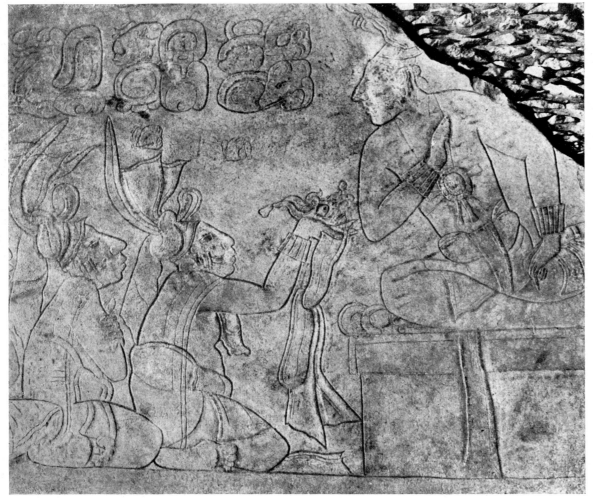

170 Shallow relief. Bonampak
171 Shallow relief. Bonampak
172 Stela on the stairway to
the main temple. Bonampak

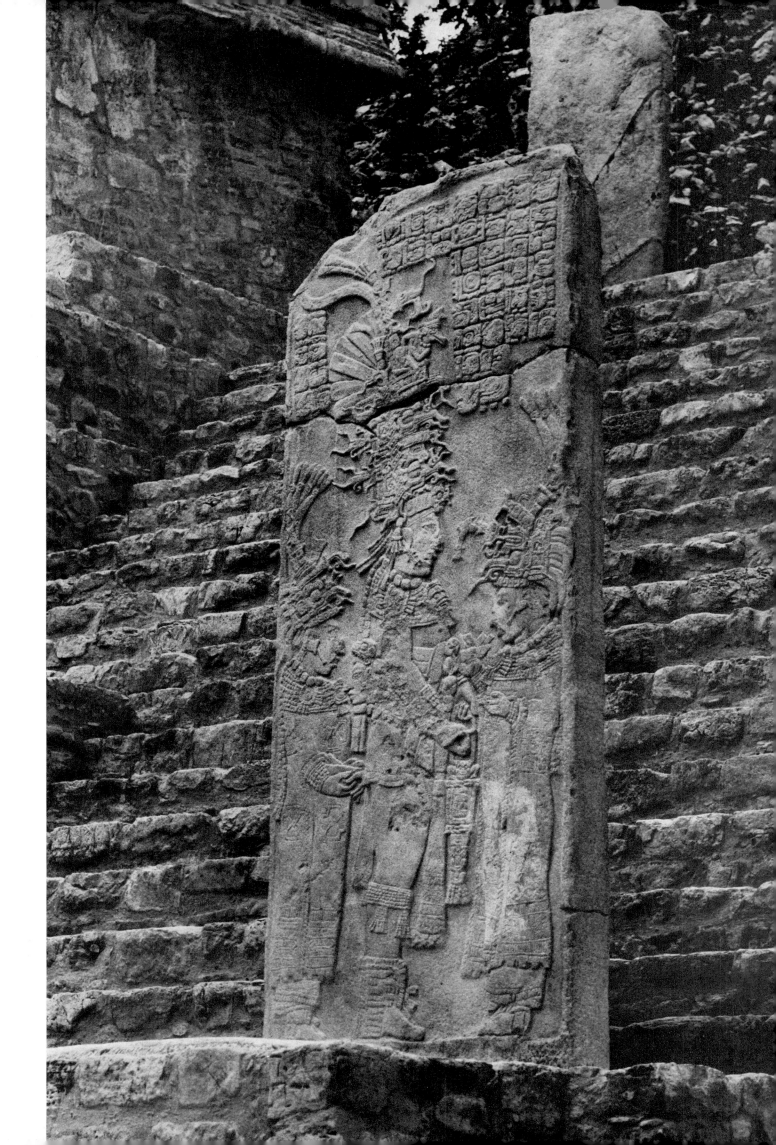

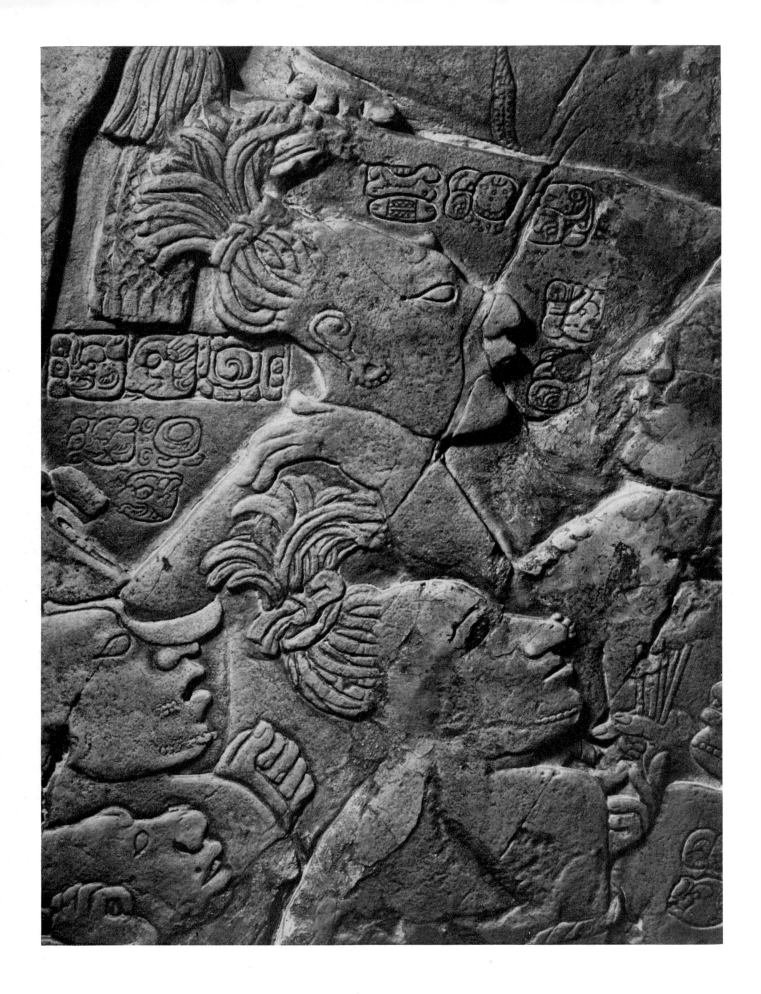

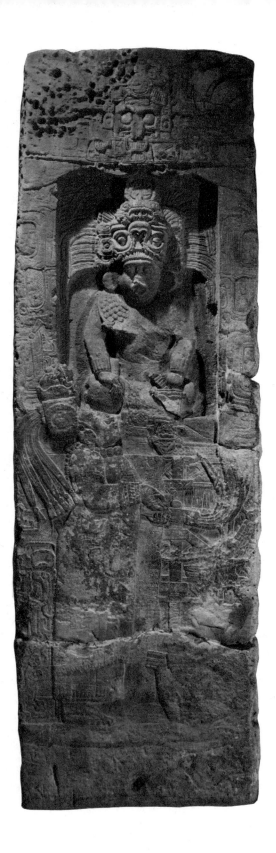

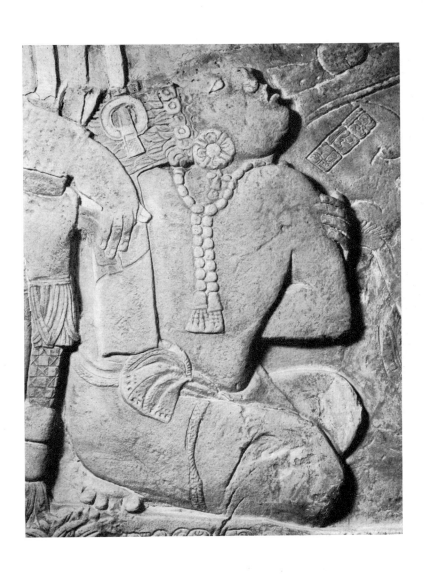

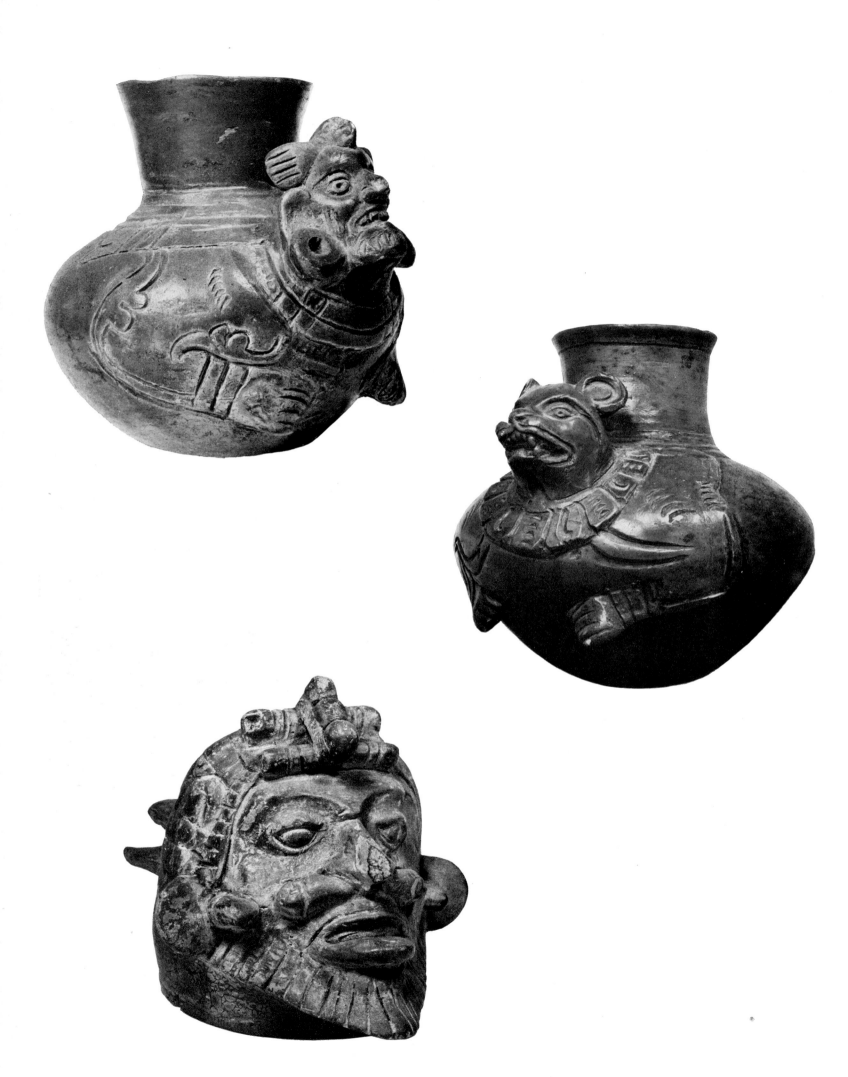

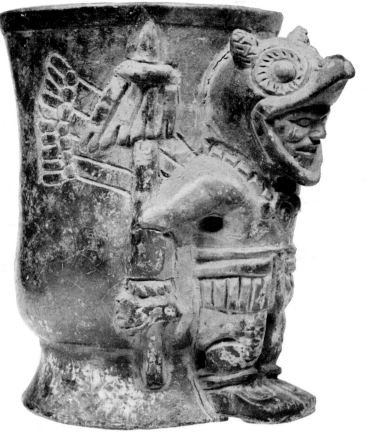

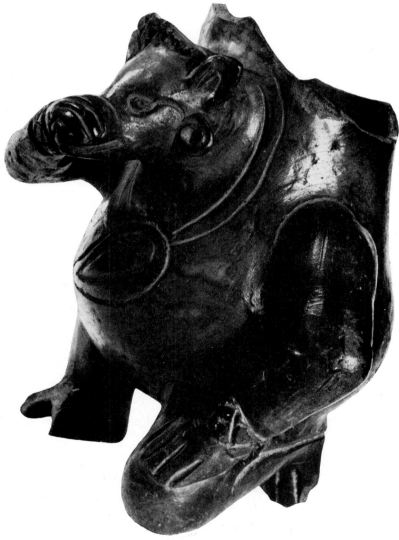

176 Vessel. Guatemala highlands
177 Vessel. Pacific coast of Guatemala
178 Head of a bearded man. Guatemala highlands
179 Vase. Northern highlands of Guatemala
180 Figure of a mythical beast. Guatemala highlands

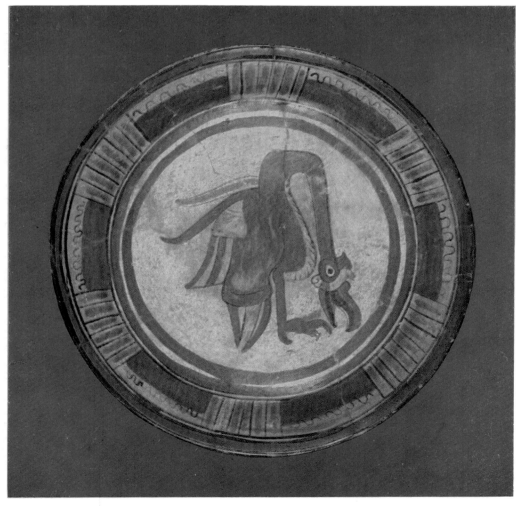

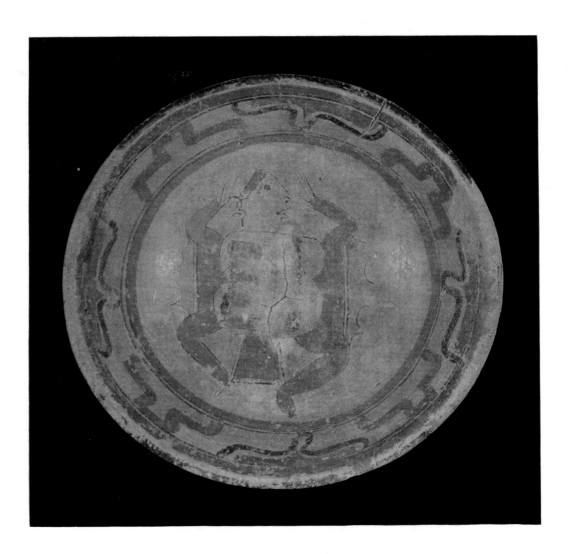

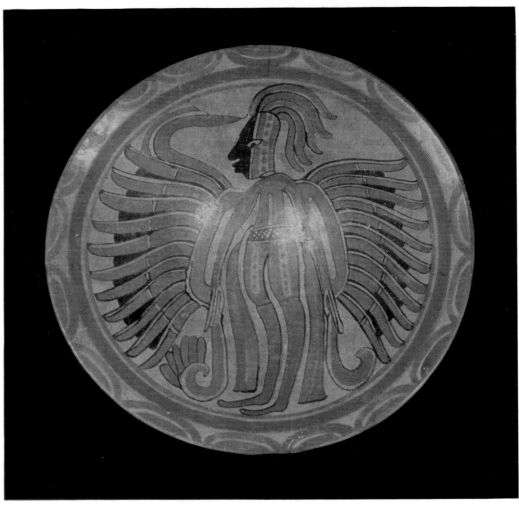

181 Painted dish. Yucatán peninsula
182 Shallow bowl with painted
decoration. Yucatán peninsula
183 Painted dish. Yucatán peninsula
184 Painted dish. Yucatán peninsula

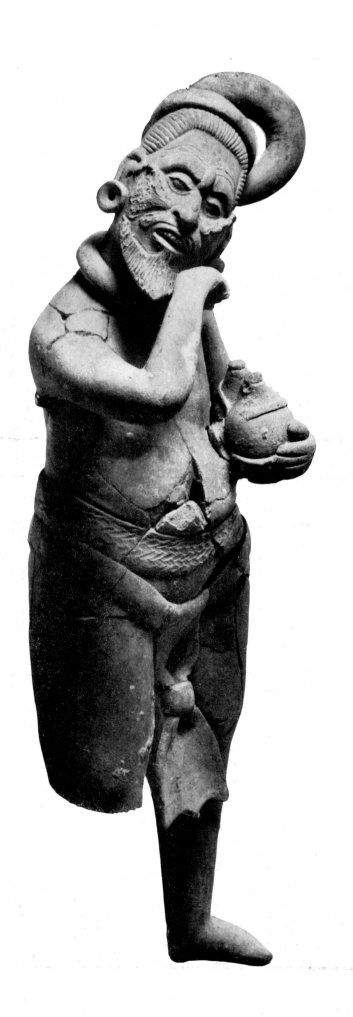

185 Solid figure of a man. Jaina
186–187 Two views of solid figure
of a dancing priest. Jaina

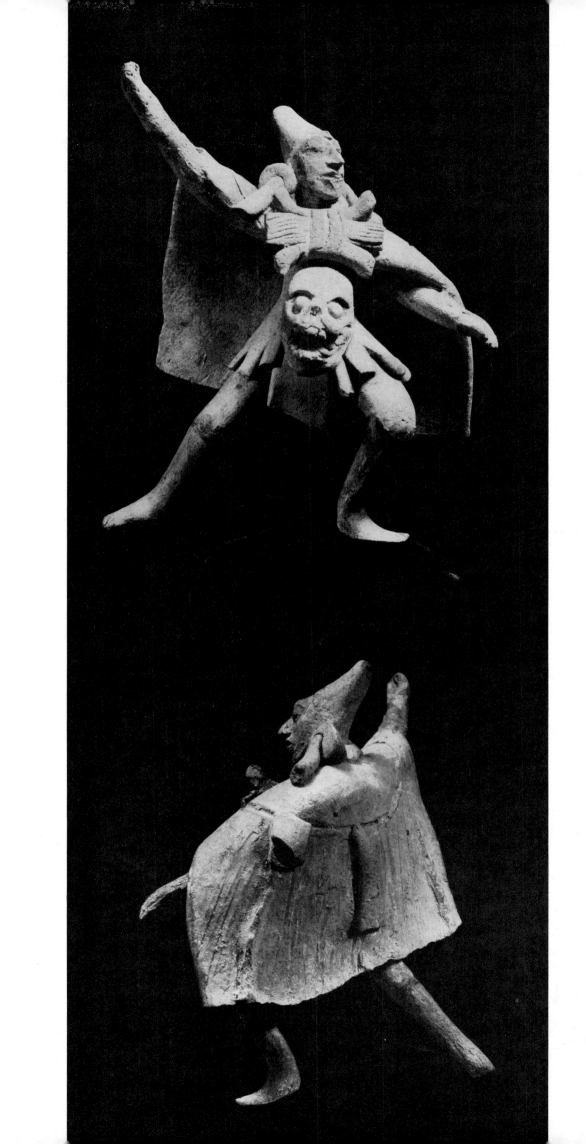

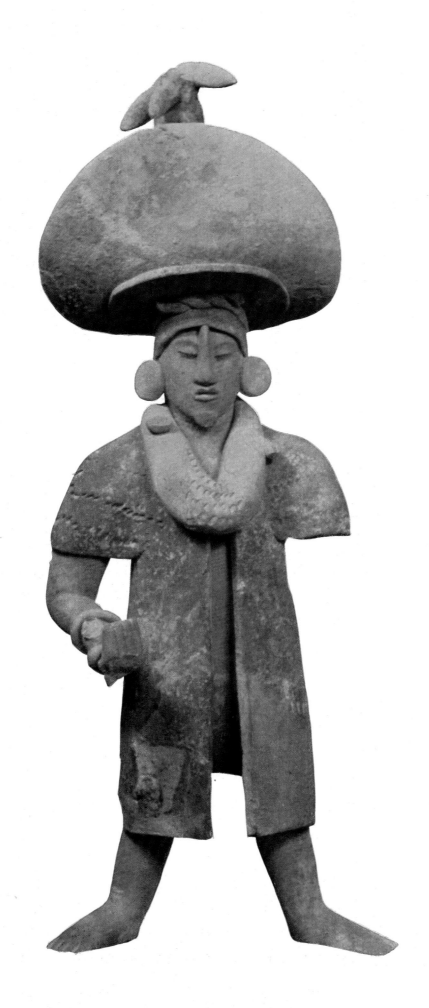

188　Figure of a nobleman. Jaina
189　Ocarina in the form of a god
or priest. Jaina

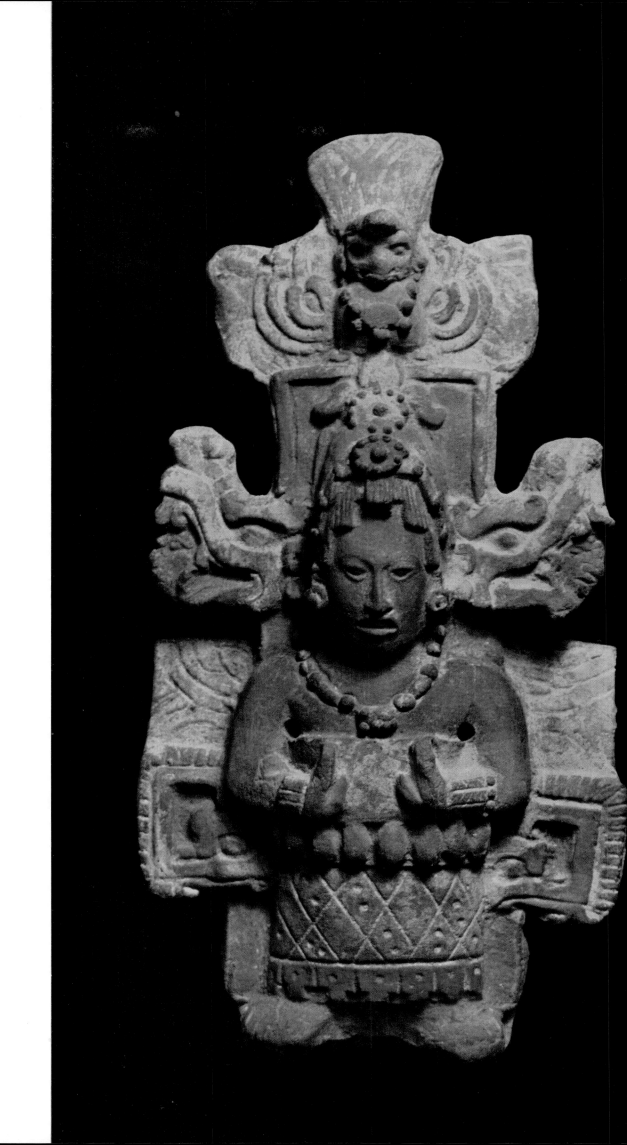

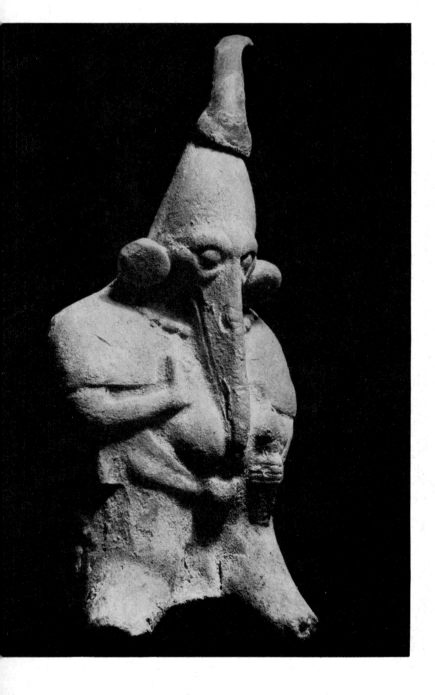

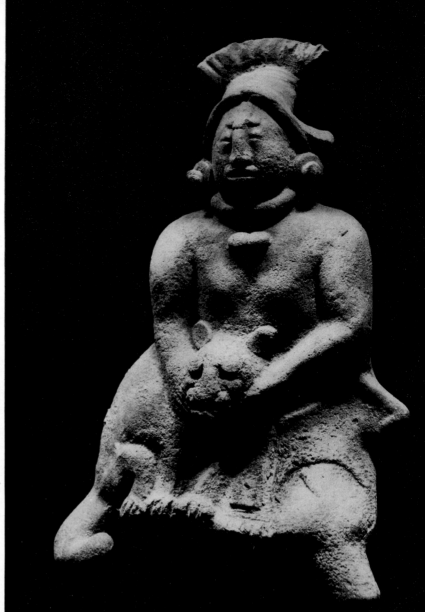

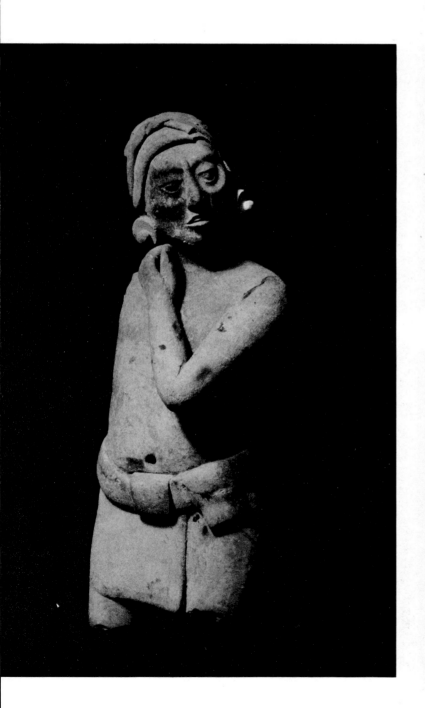

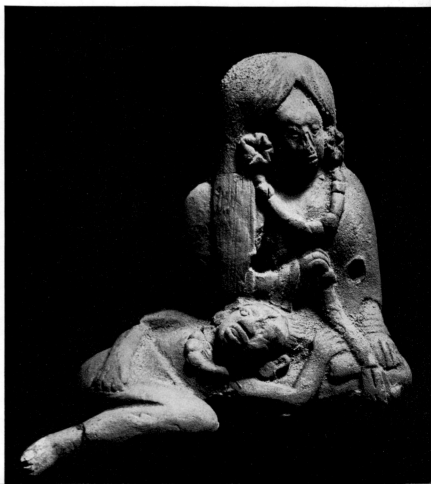

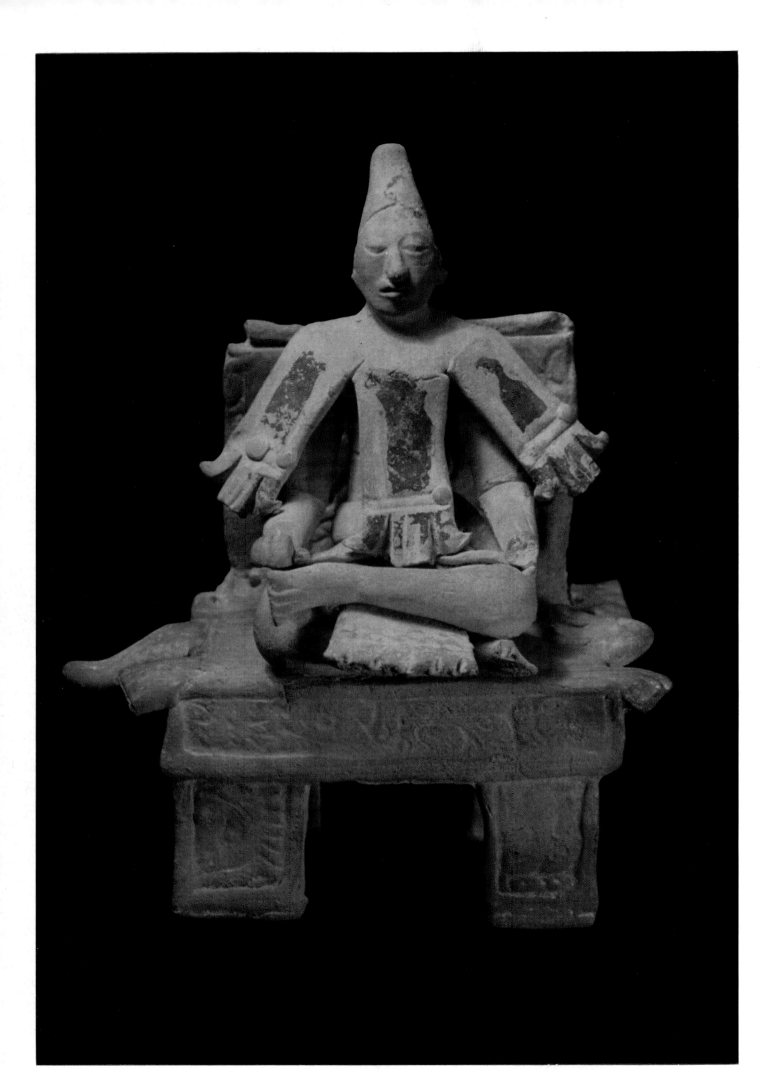

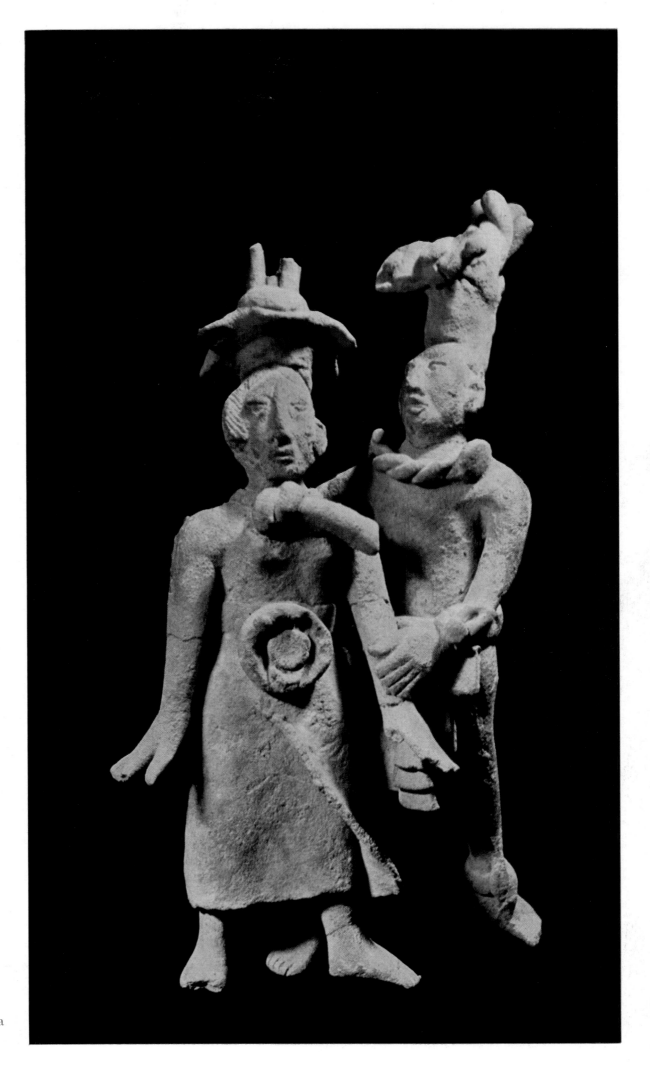

195 Priest-king. Style of Jaina
196 Pair of lovers. Jaina

197 Whistle in the form of a seated woman. Style of Jaina
198 Ocarina in the form of a woman with a child or dwarf. Jaina
199 Rattle in the form of a woman carrying an old man. Jaina

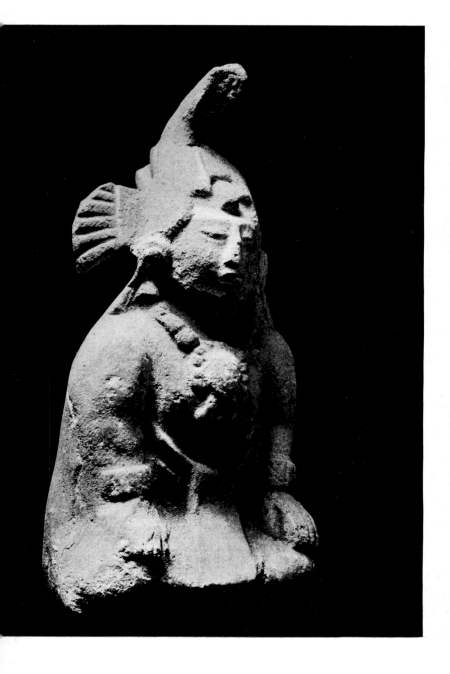

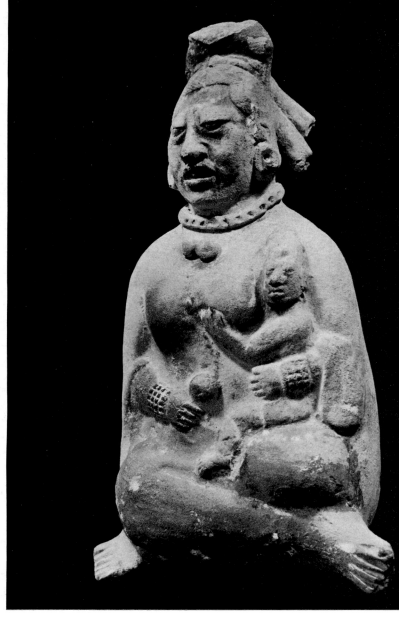

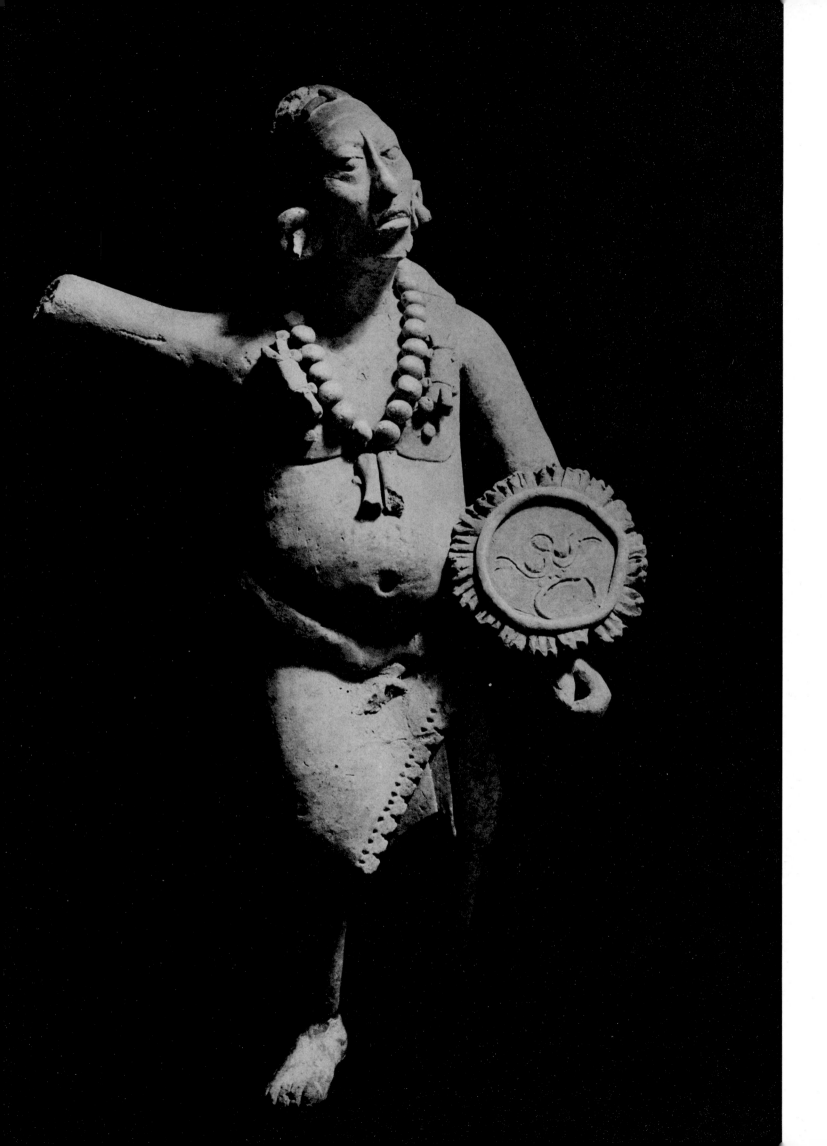

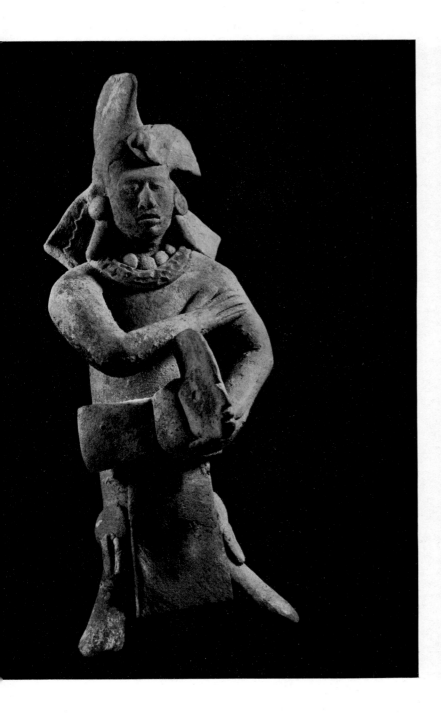

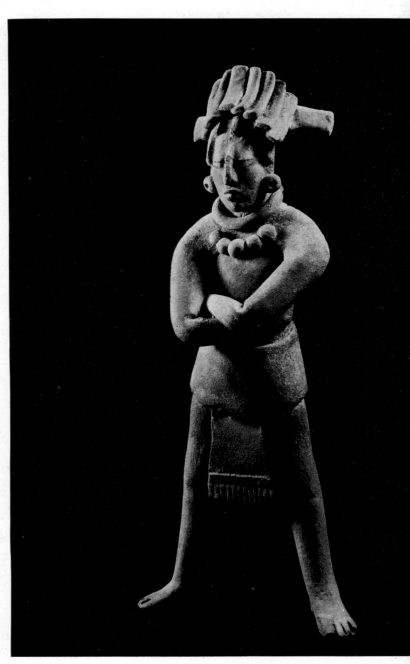

203 Ocarina in the form of an old man and a girl. Style of Jaina
204 Solid figure of woman preparing *tortillas*, with her children. Jaina

205 Ocarina in the form of an old warrior. Style of Jaina
206 Solid figure of a young warrior. Style of Jaina
207 Woman with child and puppy. Style of Jaina

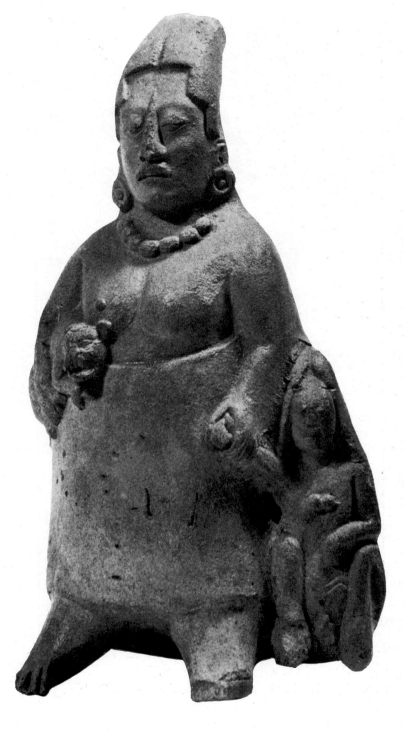

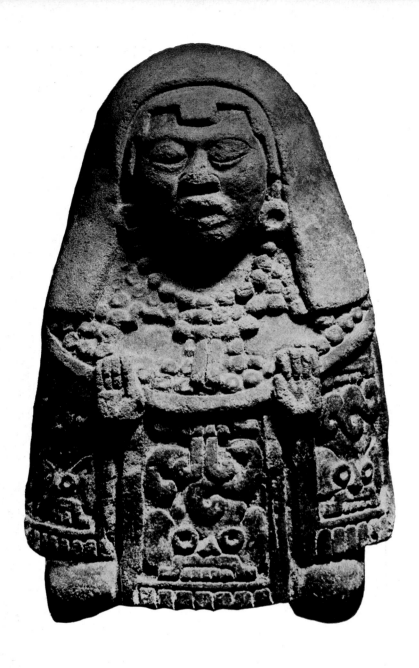

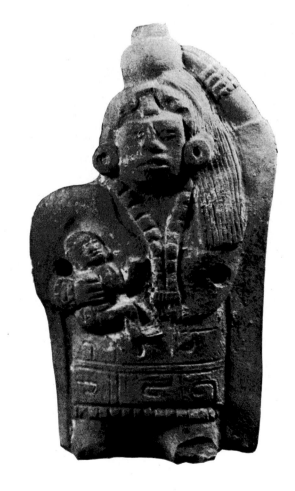

208 Ocarina in the form of a noblewoman. Style of Jaina
209 Rattle in the form of a woman. Jaina
210 Ocarina in the form of a noblewoman. Style of Jaina

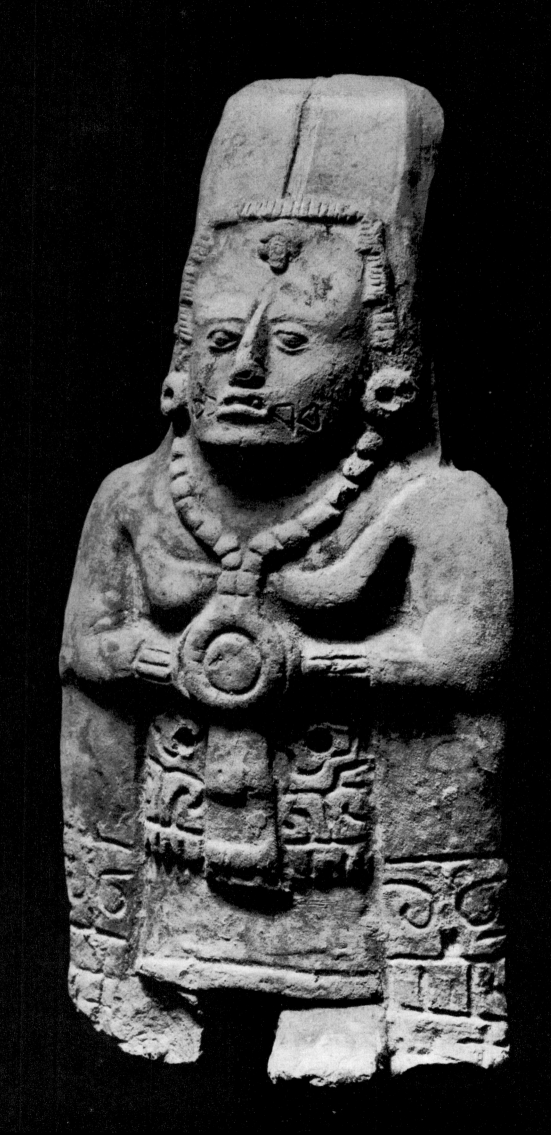

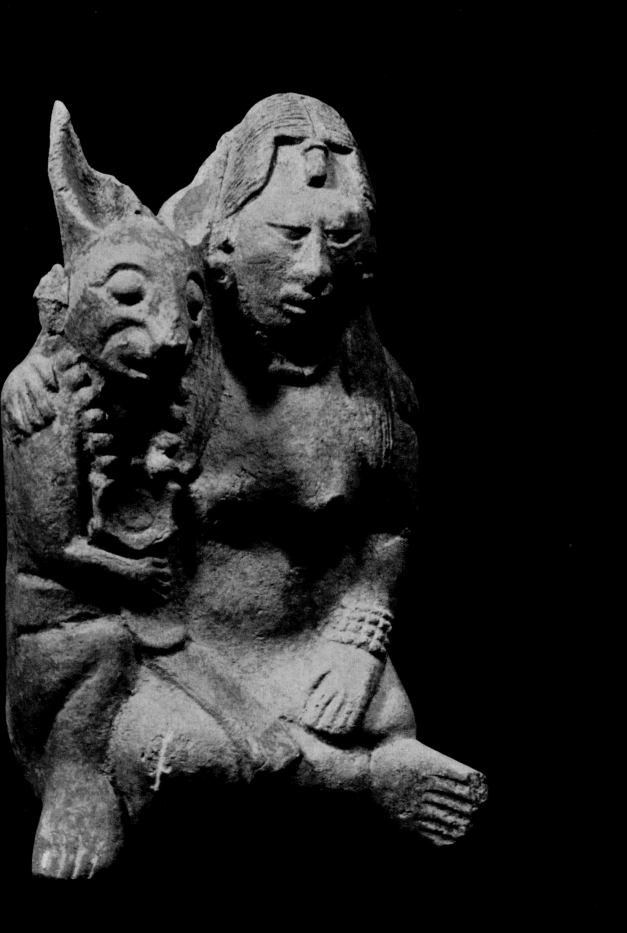

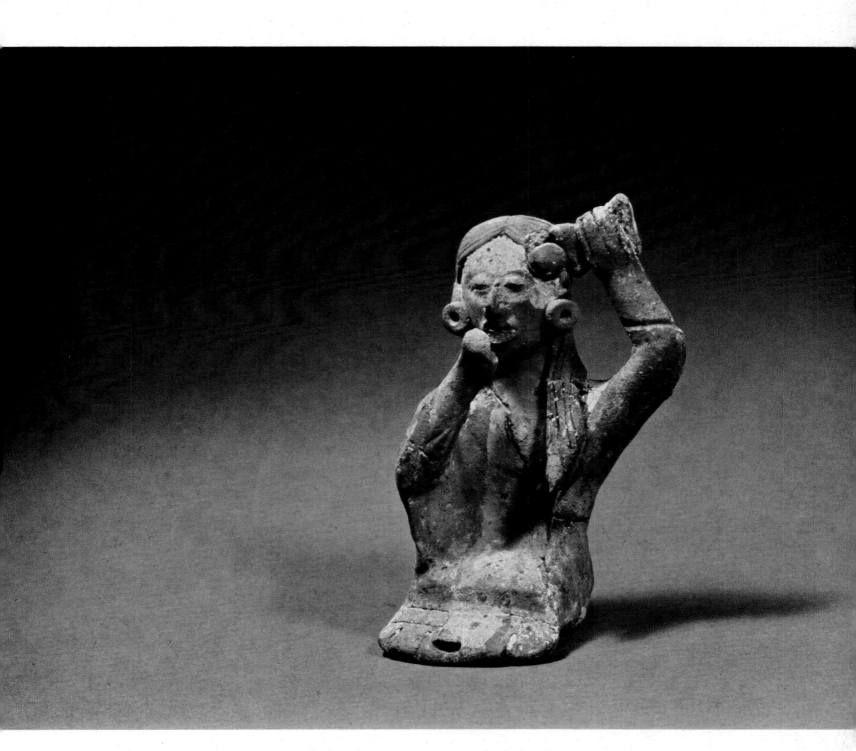

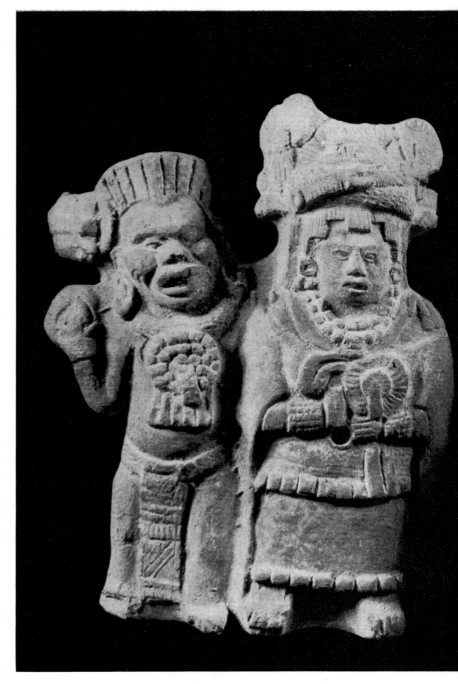

214 Rattle in the form of an old man and a young woman. Jaina

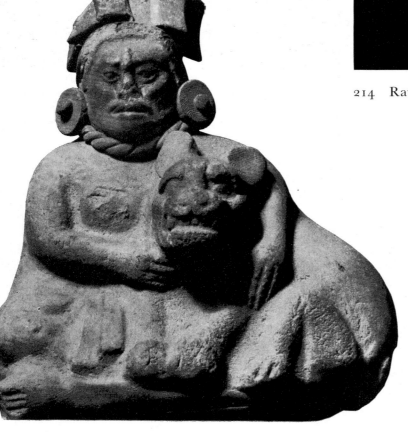

213 Figure of an old man or woman with a jaguar. Jaina

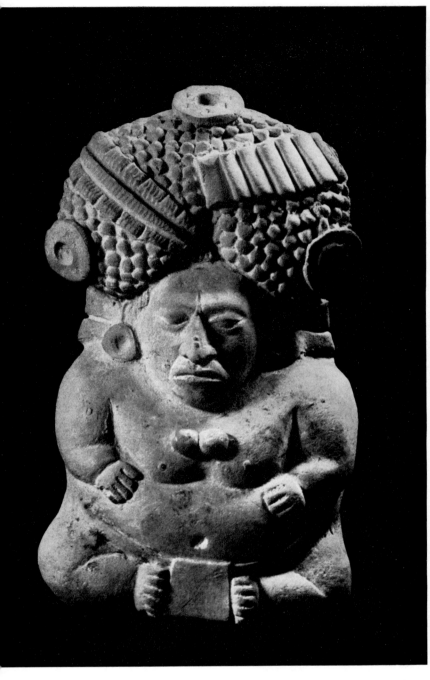

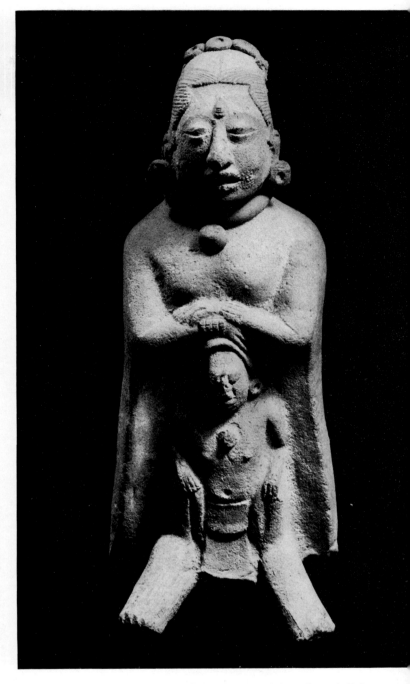

215 Whistle in the form of a dwarf. Jaina

216 Ocarina in the form of a woman with a dwarf. Jaina

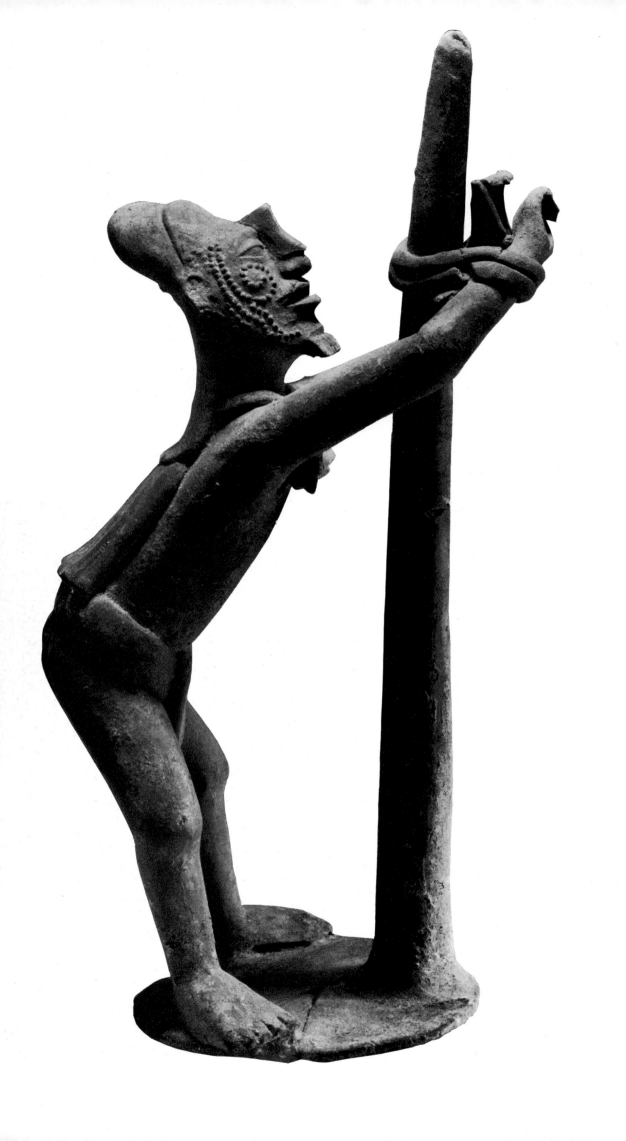

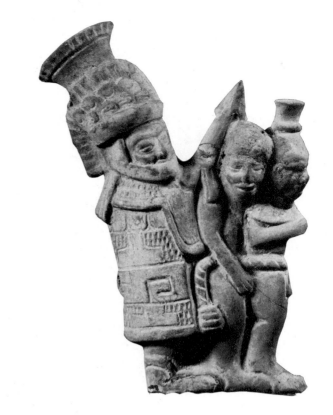

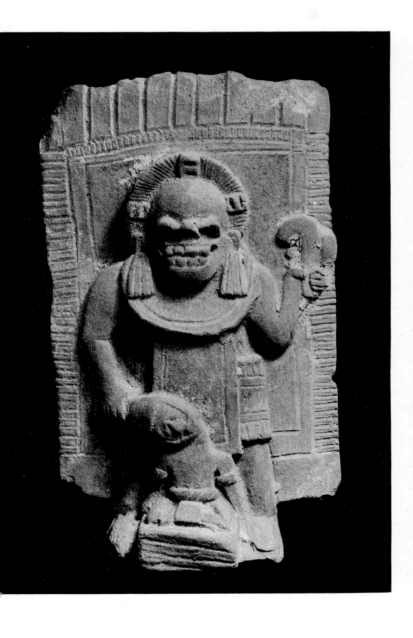

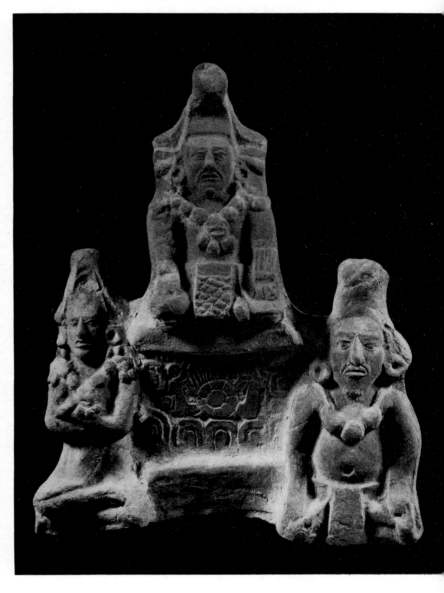

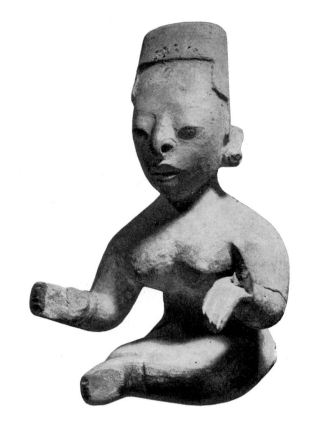

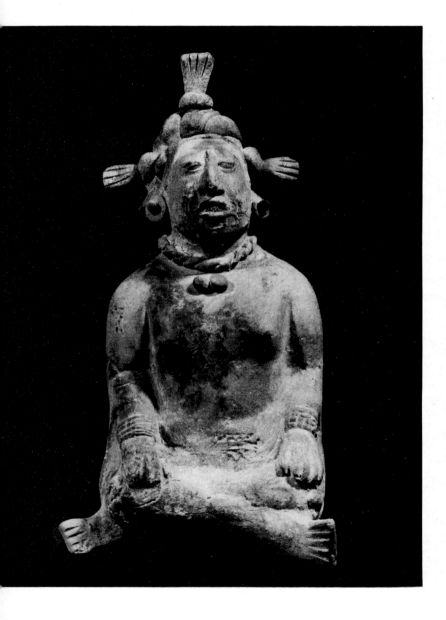

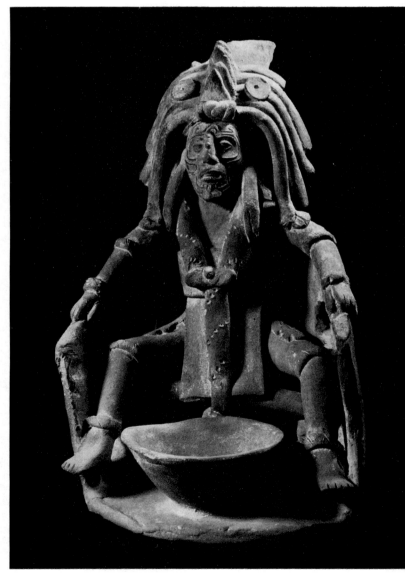

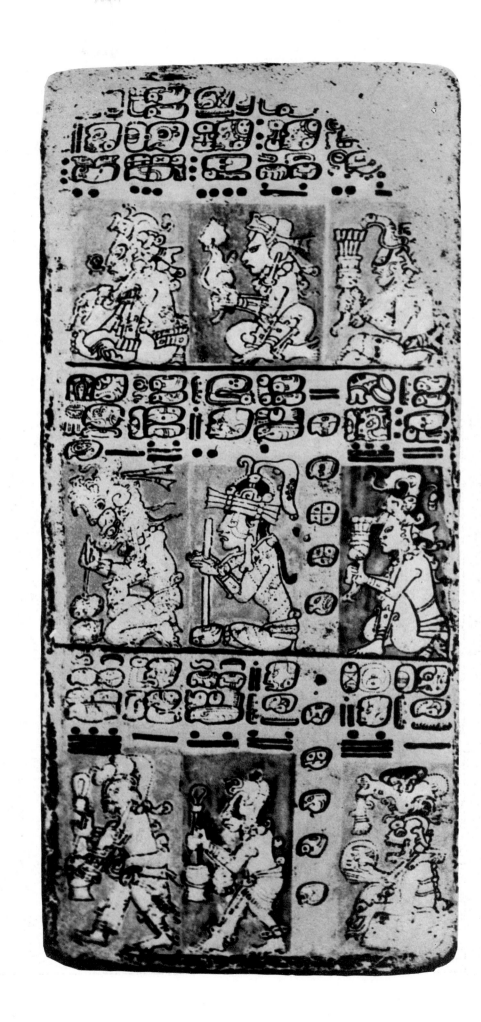

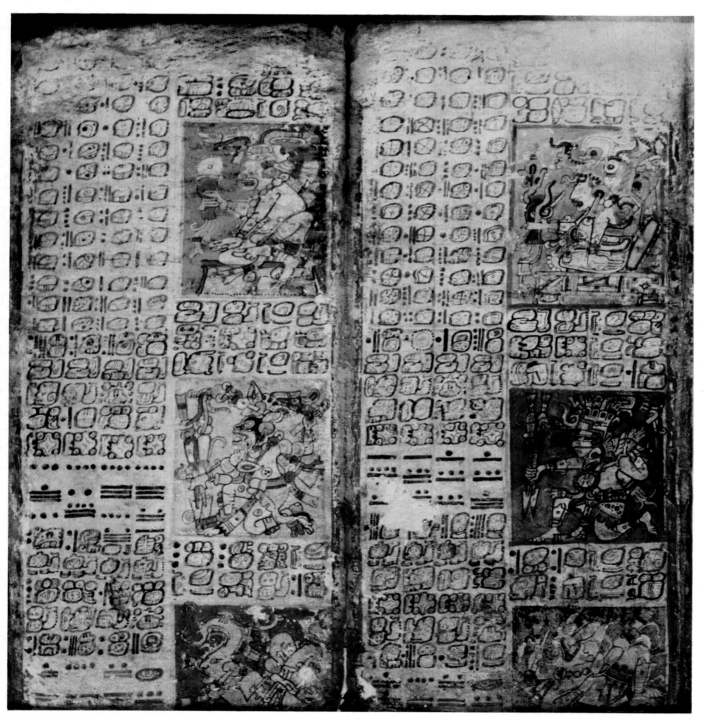

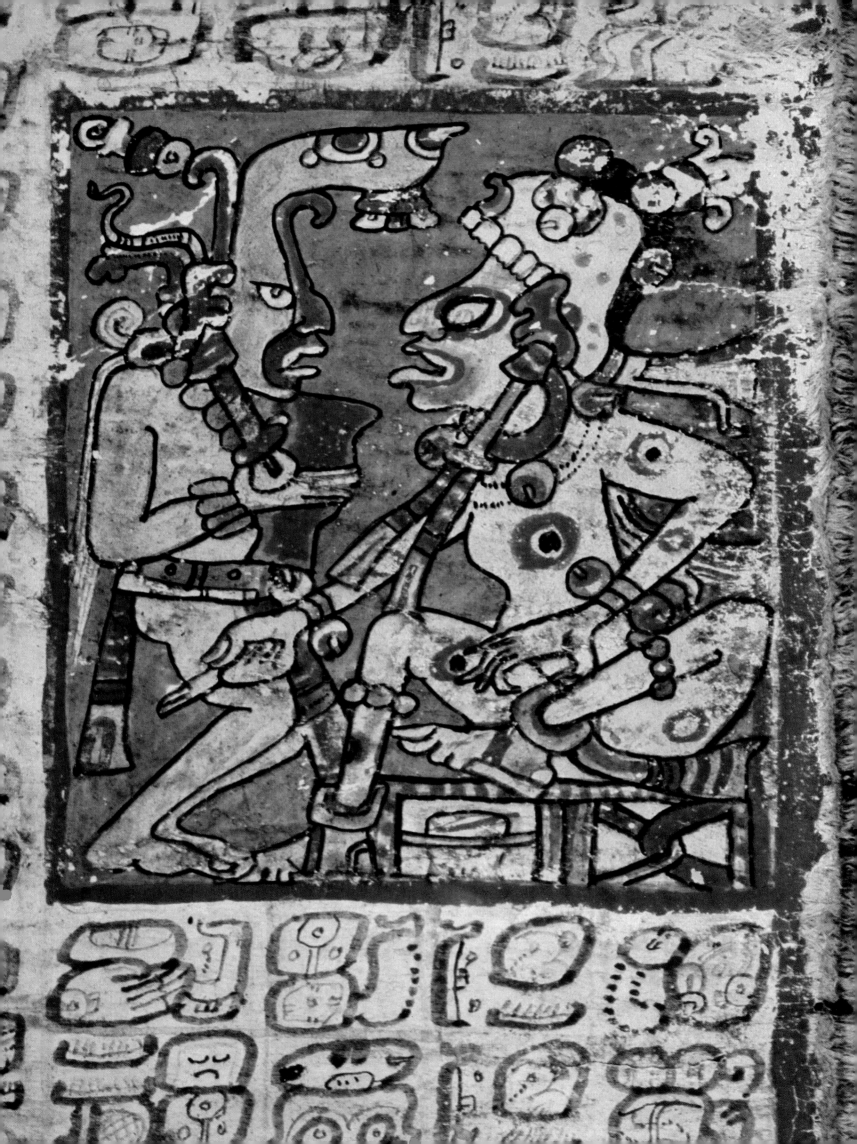

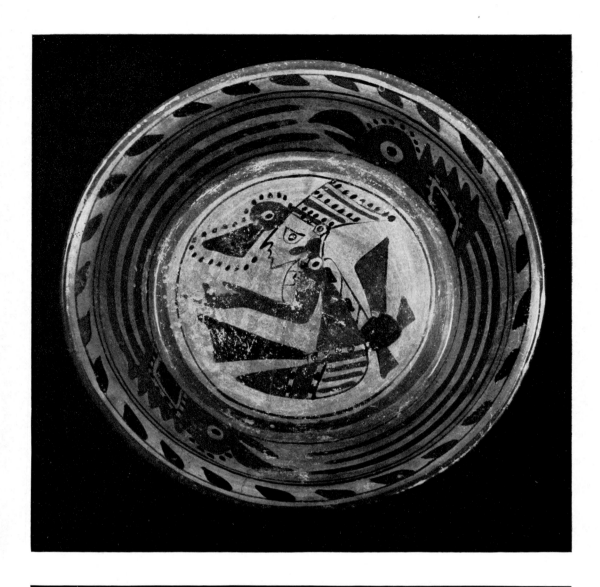

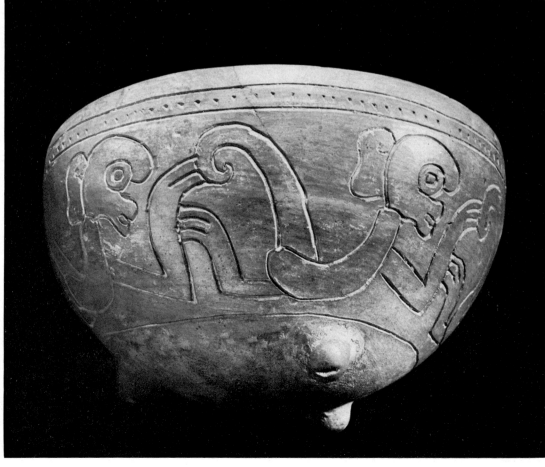

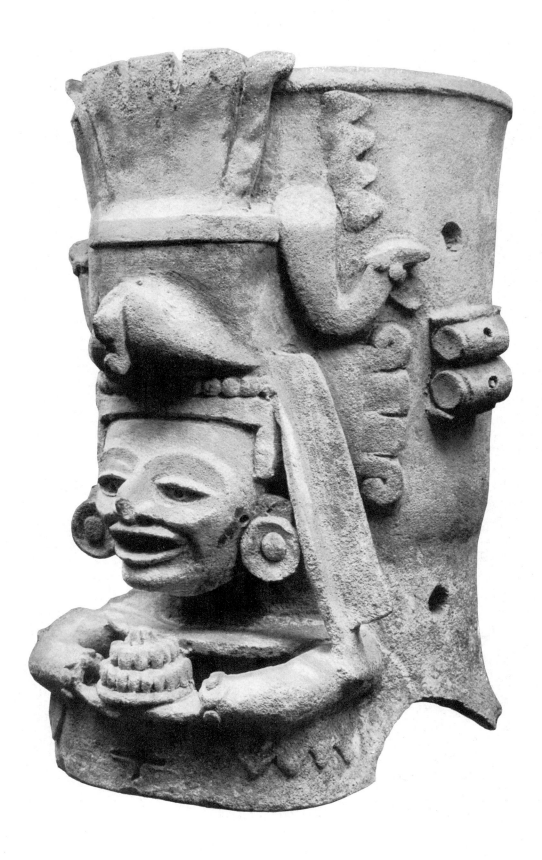

230 Uxmal 231 The Temple of the Magician. Uxmal

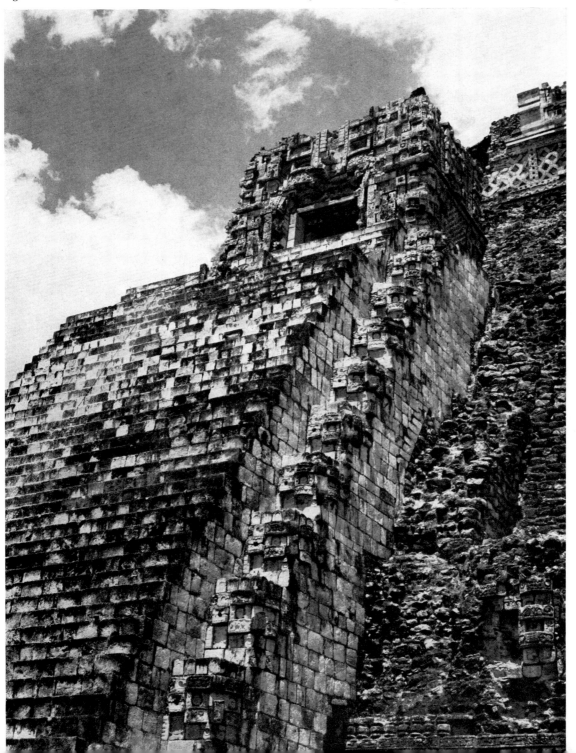

232 Masks of the rain god Chac, on a stairway leading up to the Temple of the Magician. Uxmal

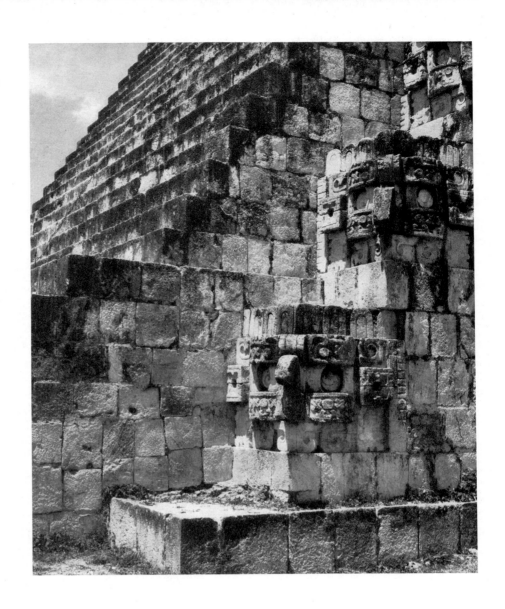

233 Mask of the rain god Chac. Kabah

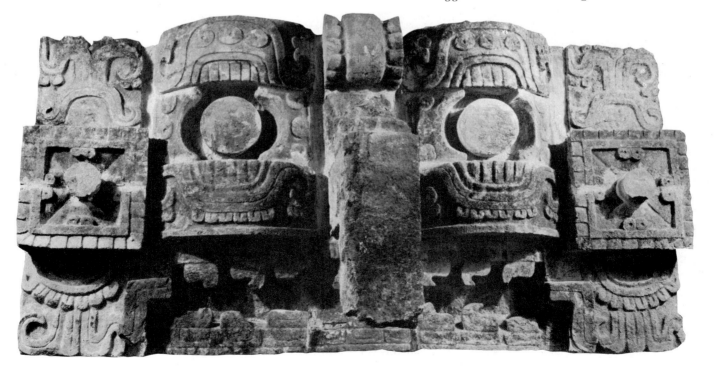

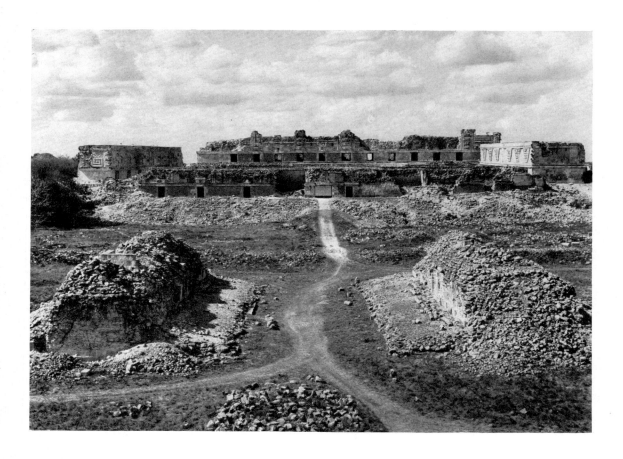

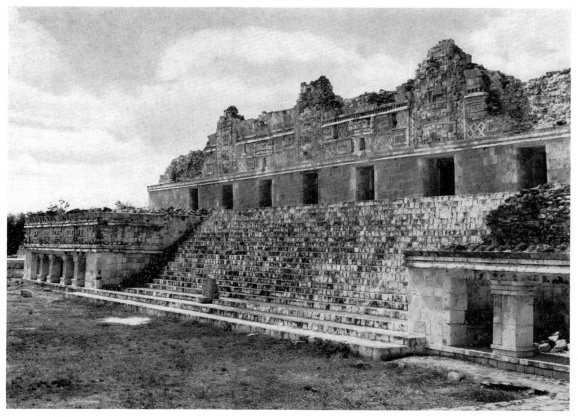

234 View across the ball court to the Nunnery Quadrangle. Uxmal
235 One wing of the Nunnery Quadrangle. Uxmal
236 Detail of the east façade of the Nunnery Quadrangle. Uxmal

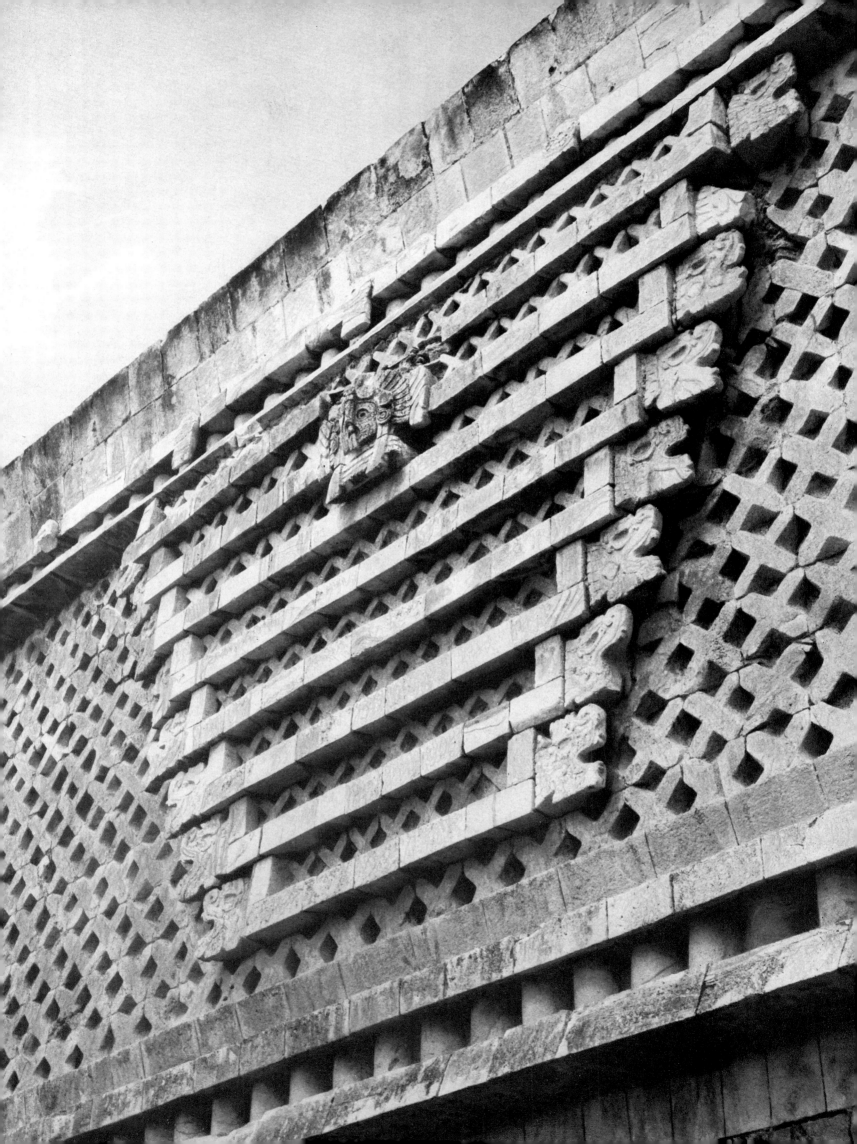

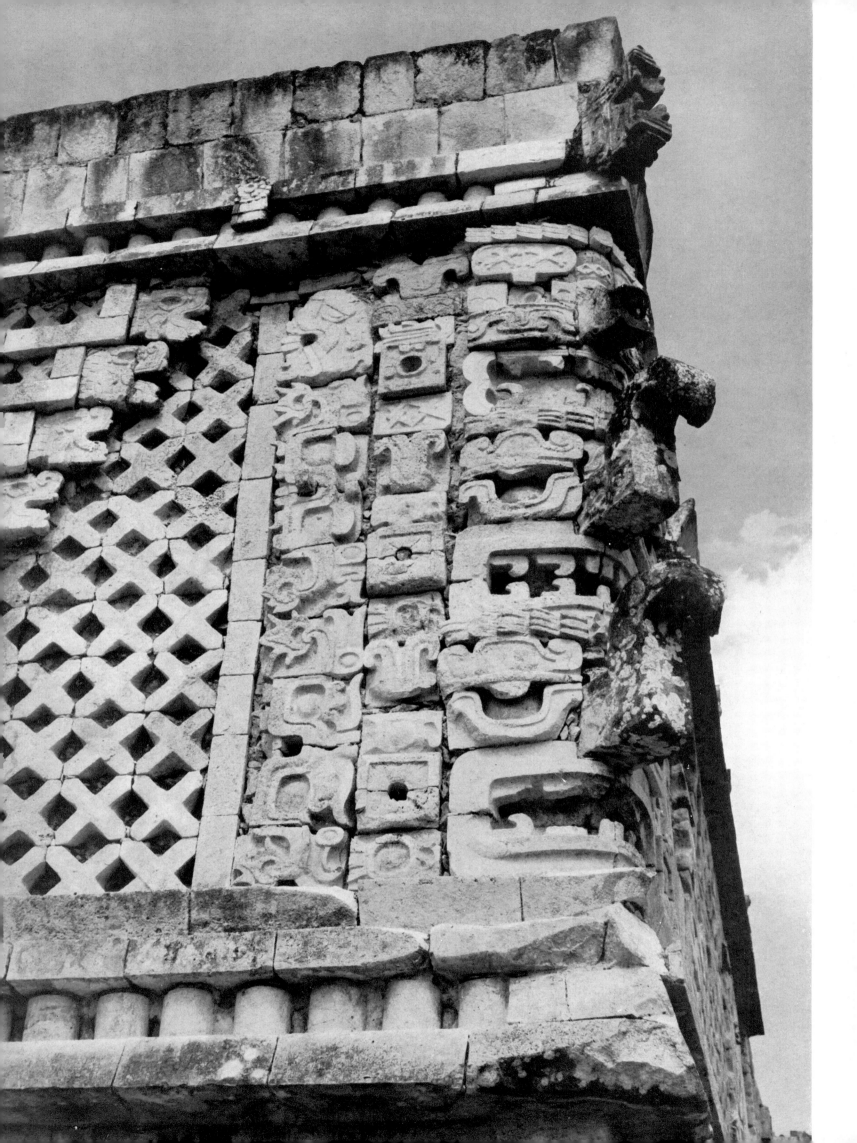

238 The Throne of the Two-headed Jaguar. Uxmal

239 The House of the Governor. Uxmal

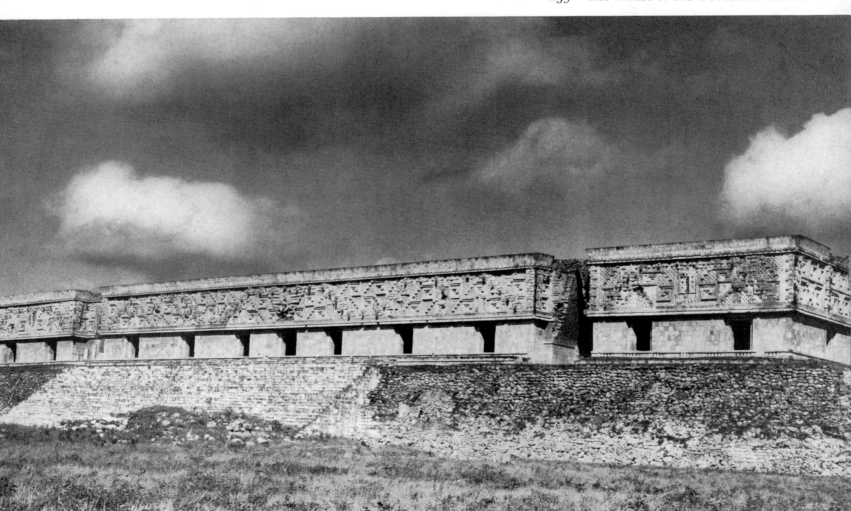

240 Stone head from a façade. Uxmal
241 The House of the Pigeons. Uxmal
242 Main entrance to the Quadrangle
of the House of the Pigeons. Uxmal

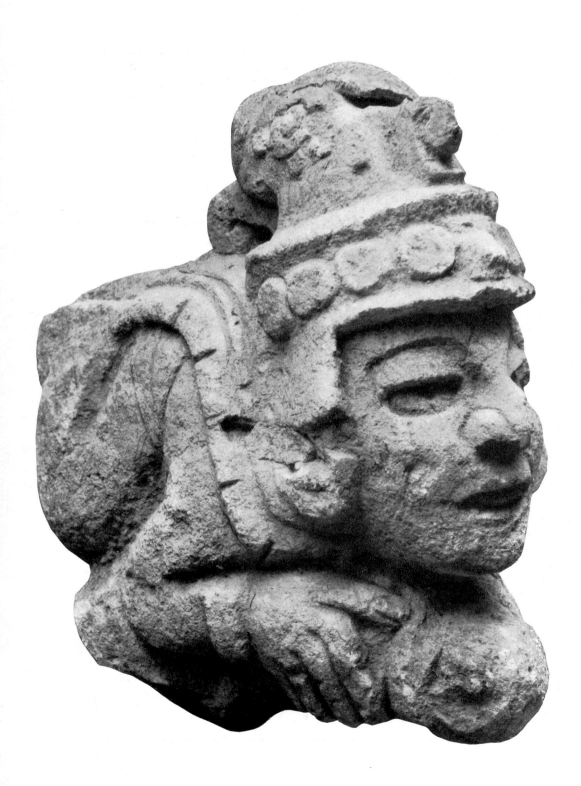

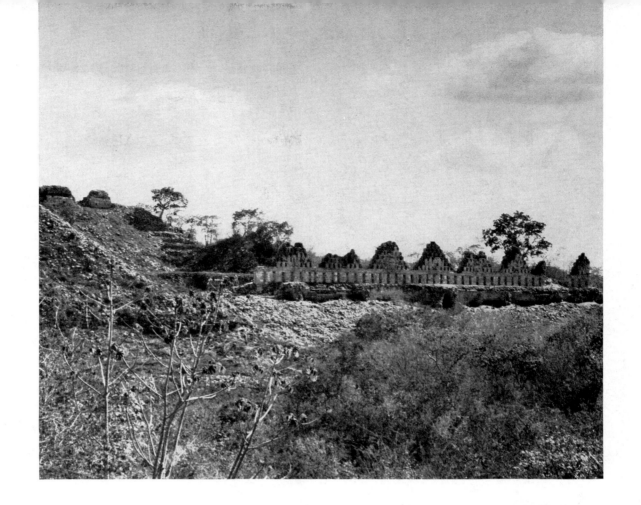

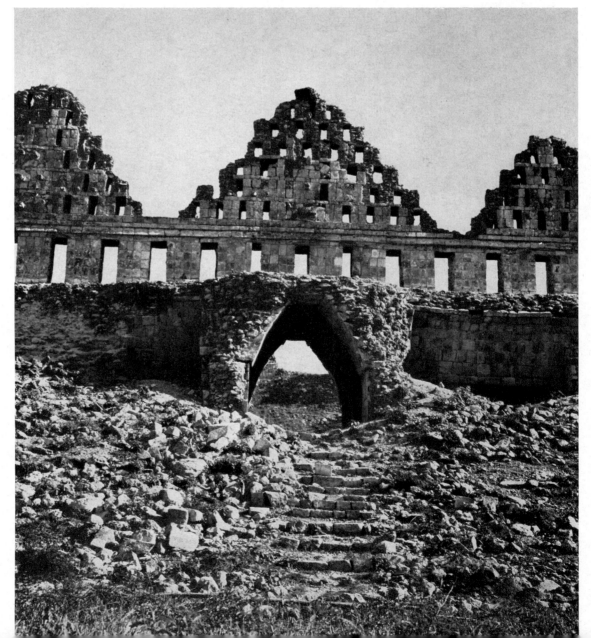

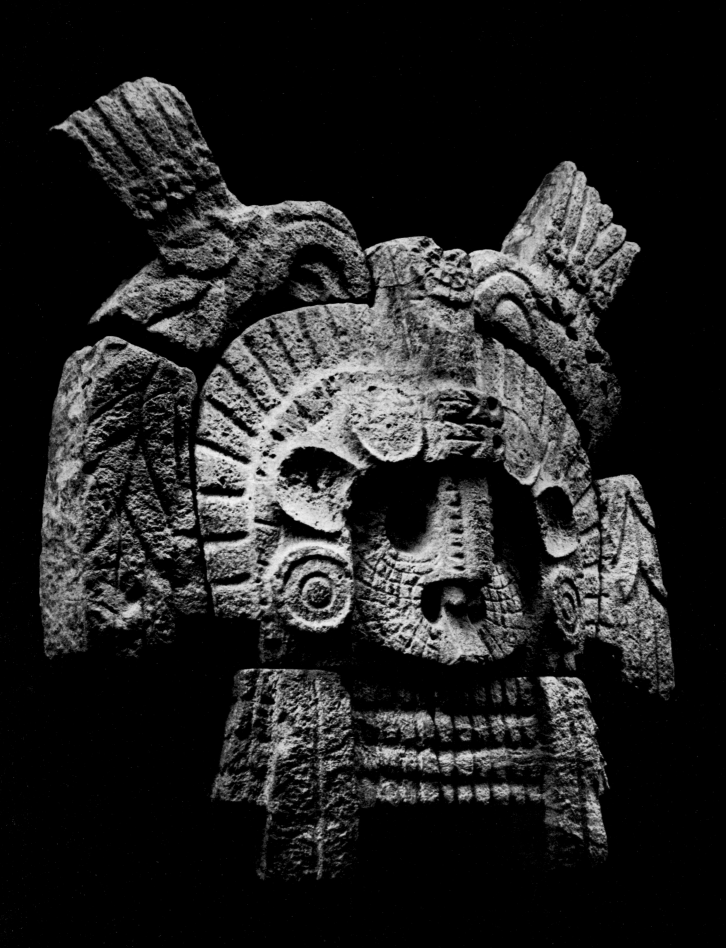

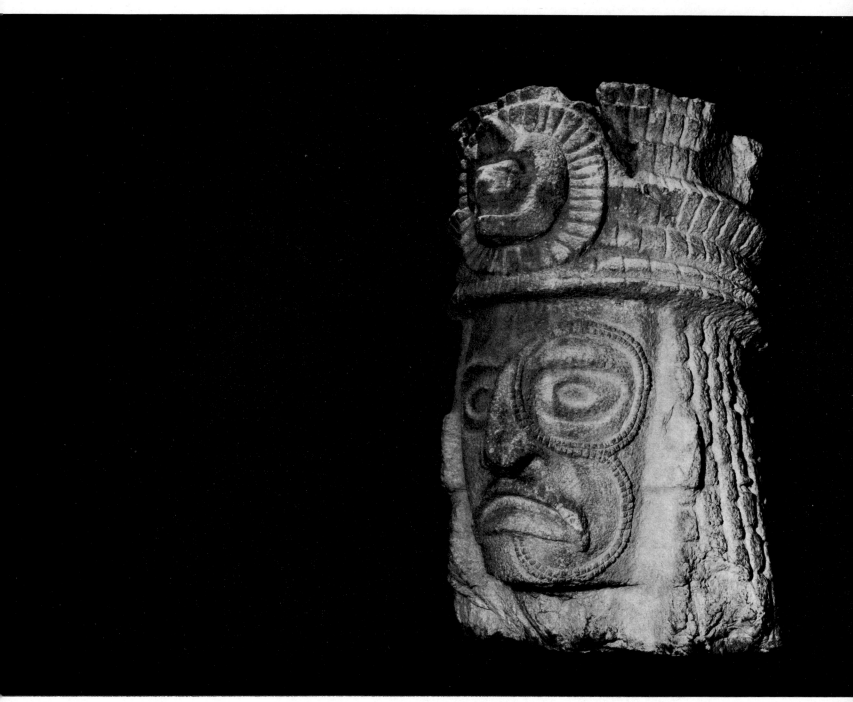

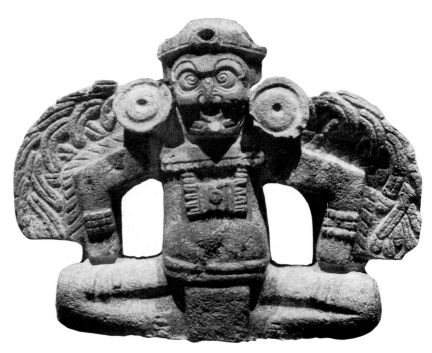

245 Old man with wings, or feathers on his arms. Xunantunich

246 The House of Masks (Codz Pop). Kabah

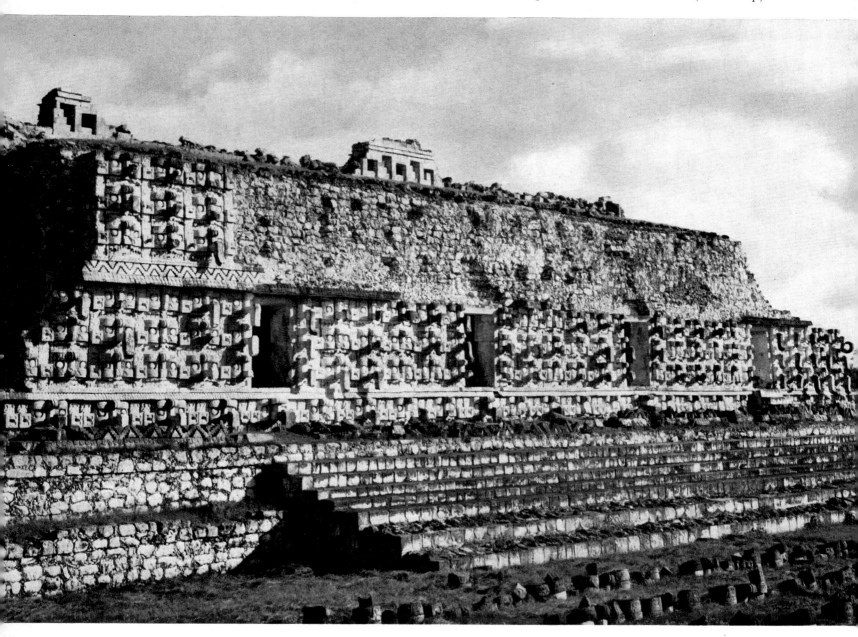

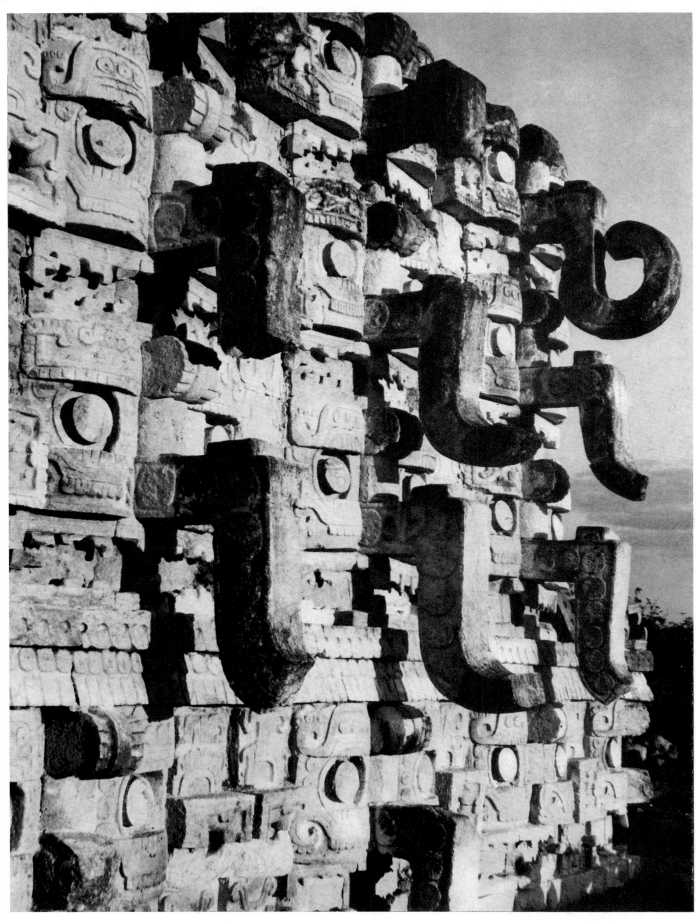

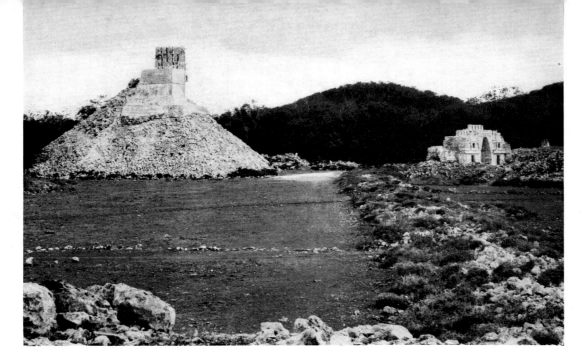

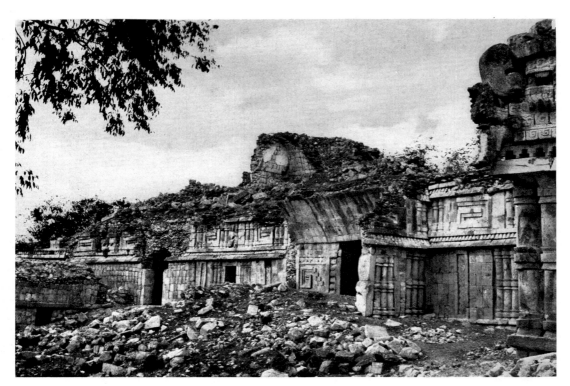

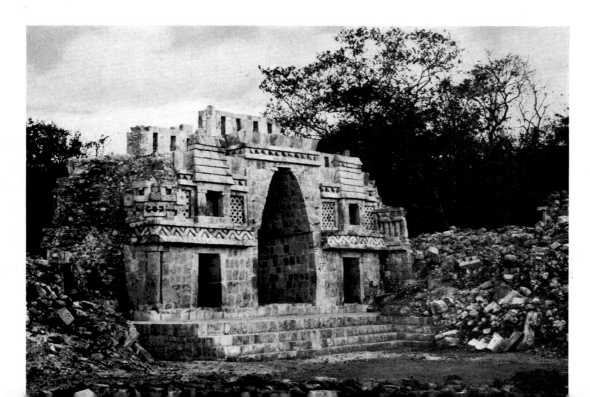

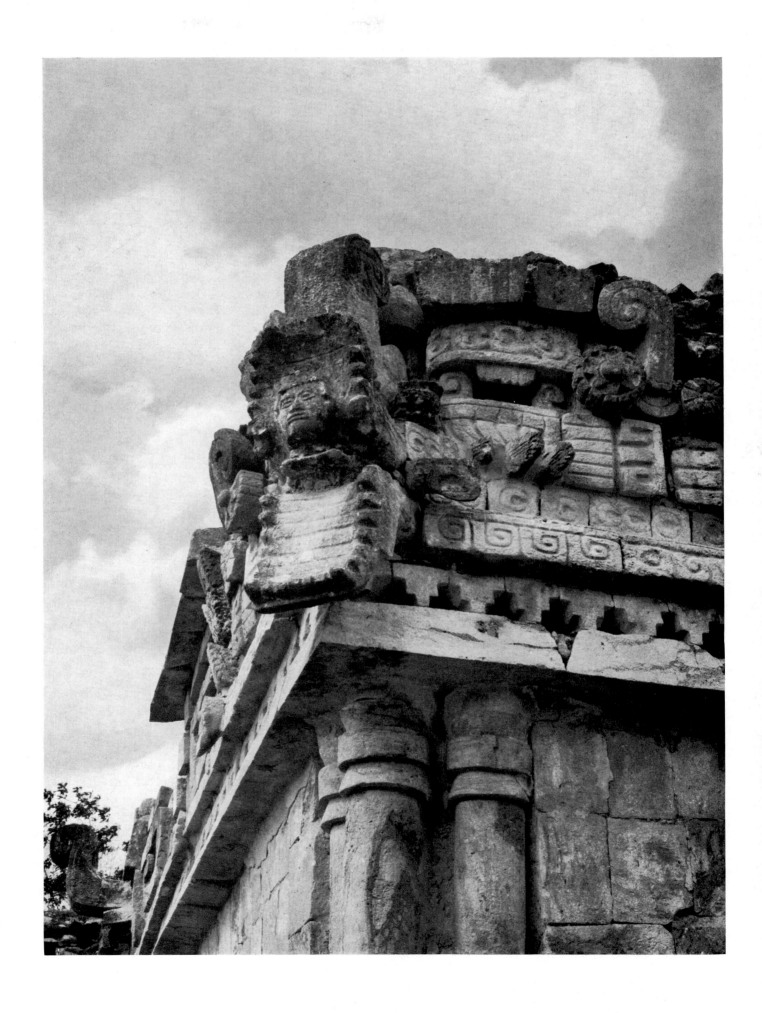

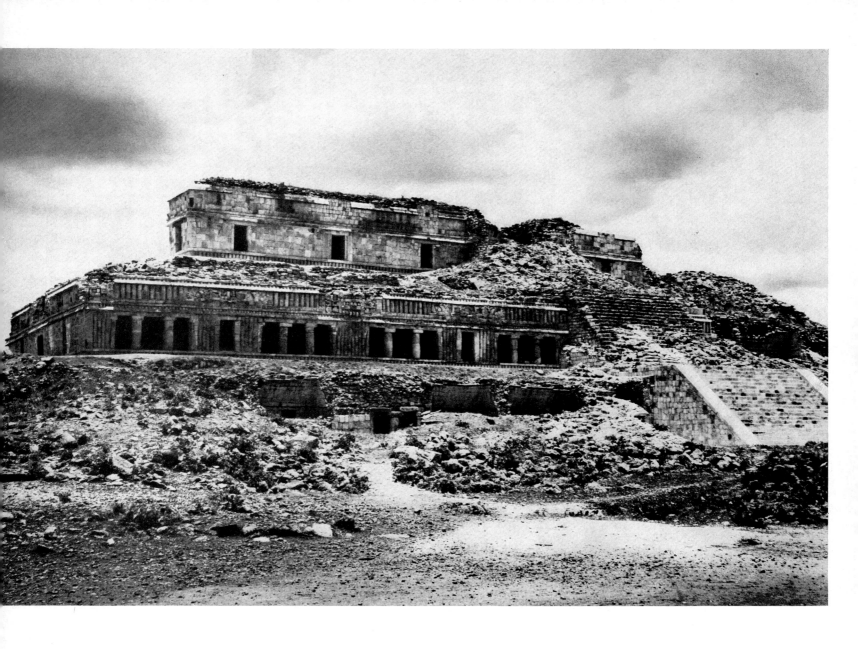

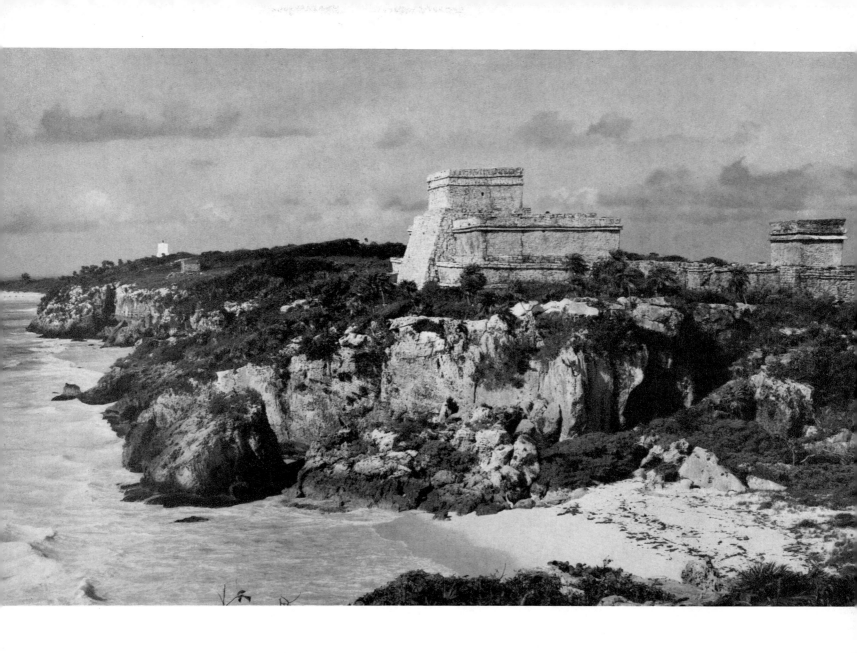

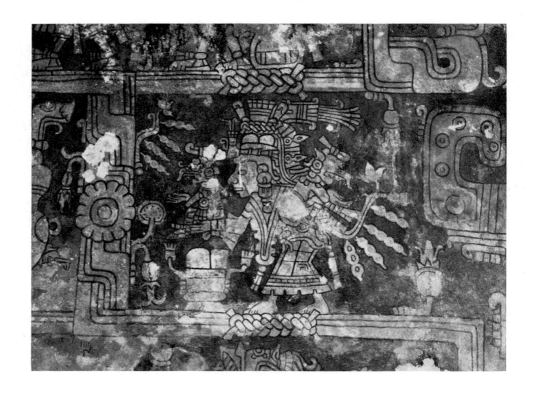

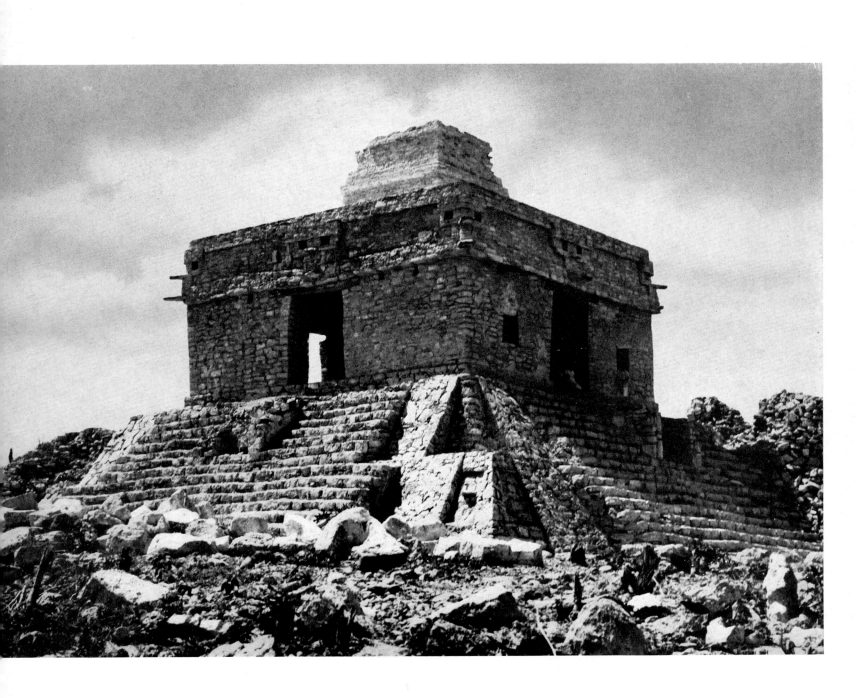

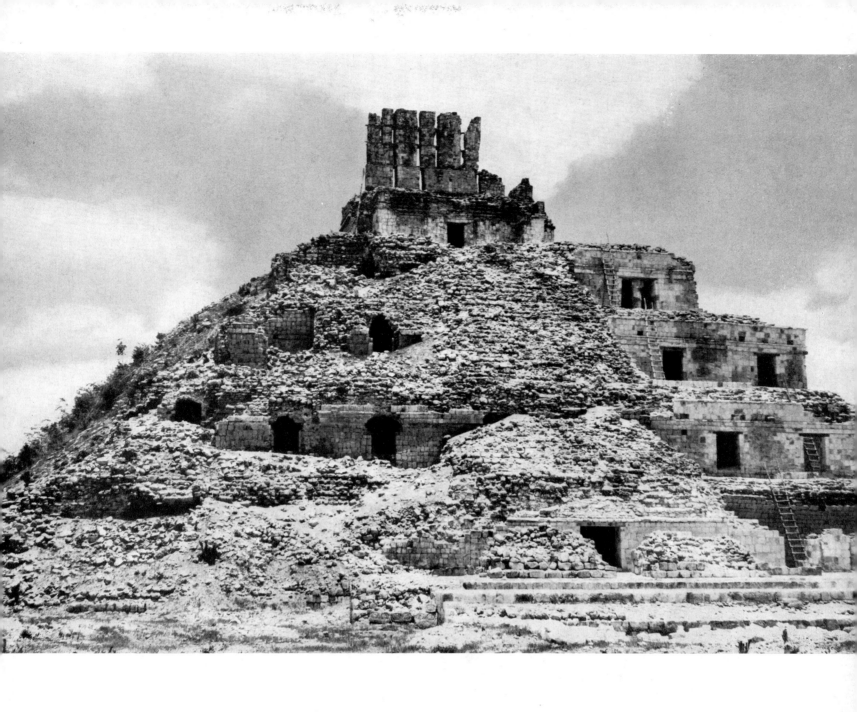

255 Temple. Dzibilchaltún
256 Temple-pyramid. Edzná

257 The Temple of the Warriors. Chichén Itzá
258 The main stairway of the Temple of the Warriors. Chichén Itzá

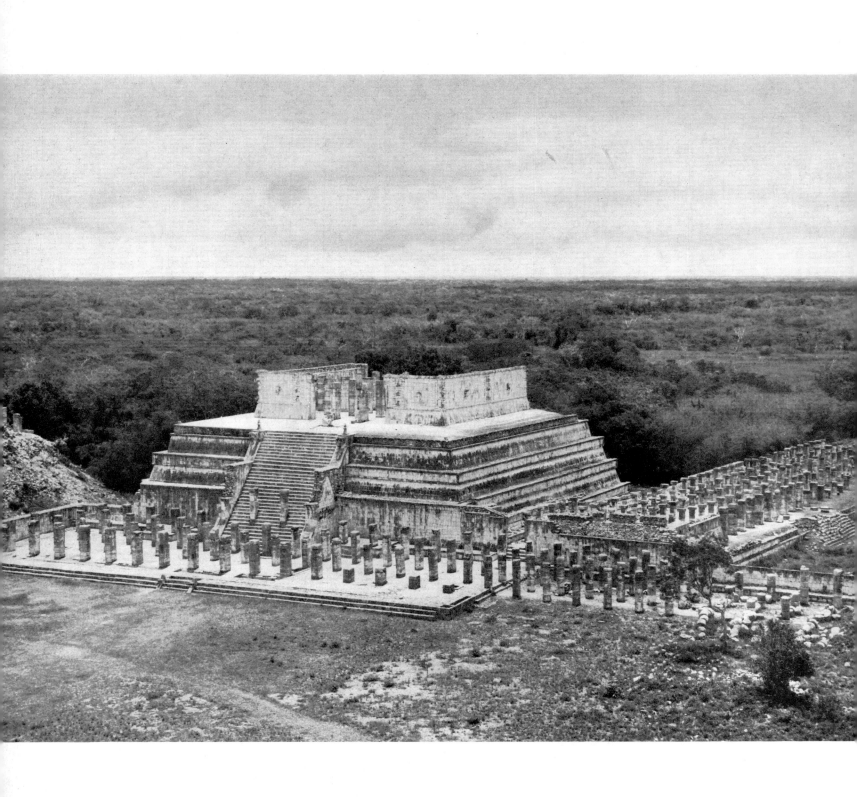

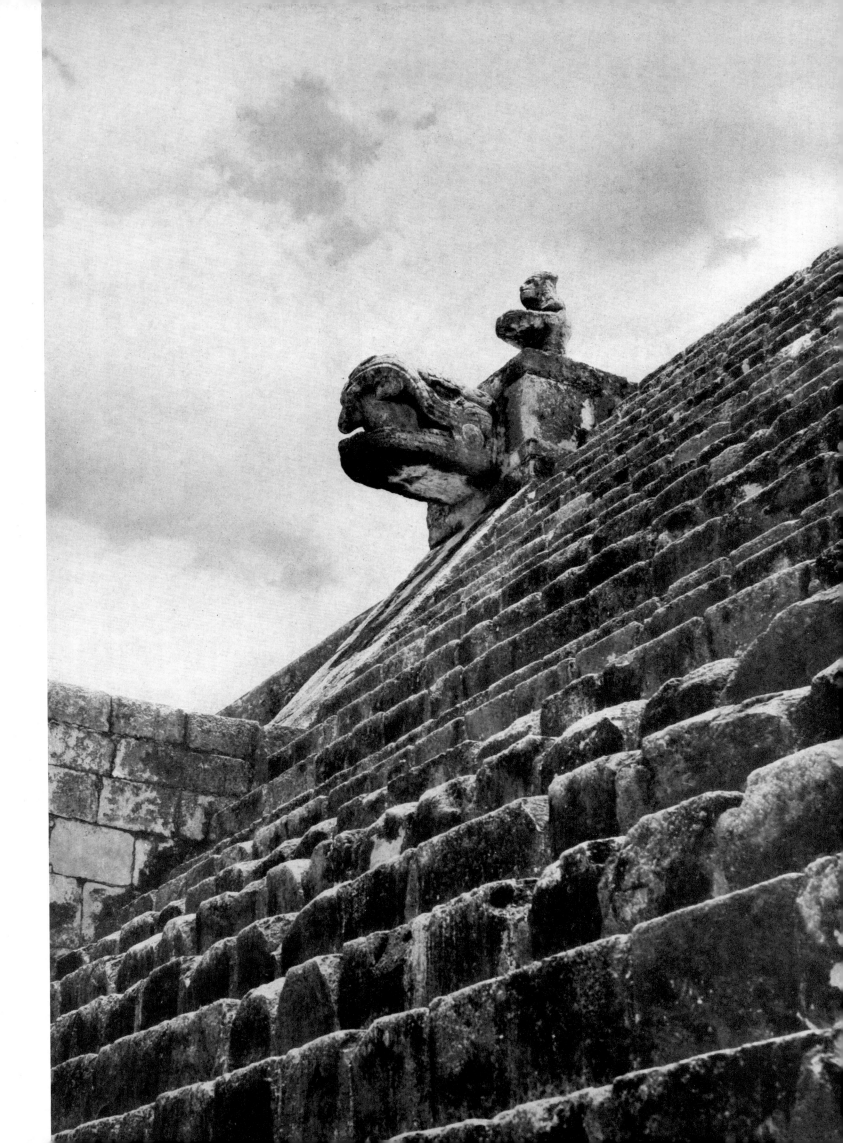

259 Detail of the façade of the Temple of the Warriors. Chichén Itzá
260 Pillars in the form of feathered serpents, before the Temple of the Warriors. Chichén Itzá

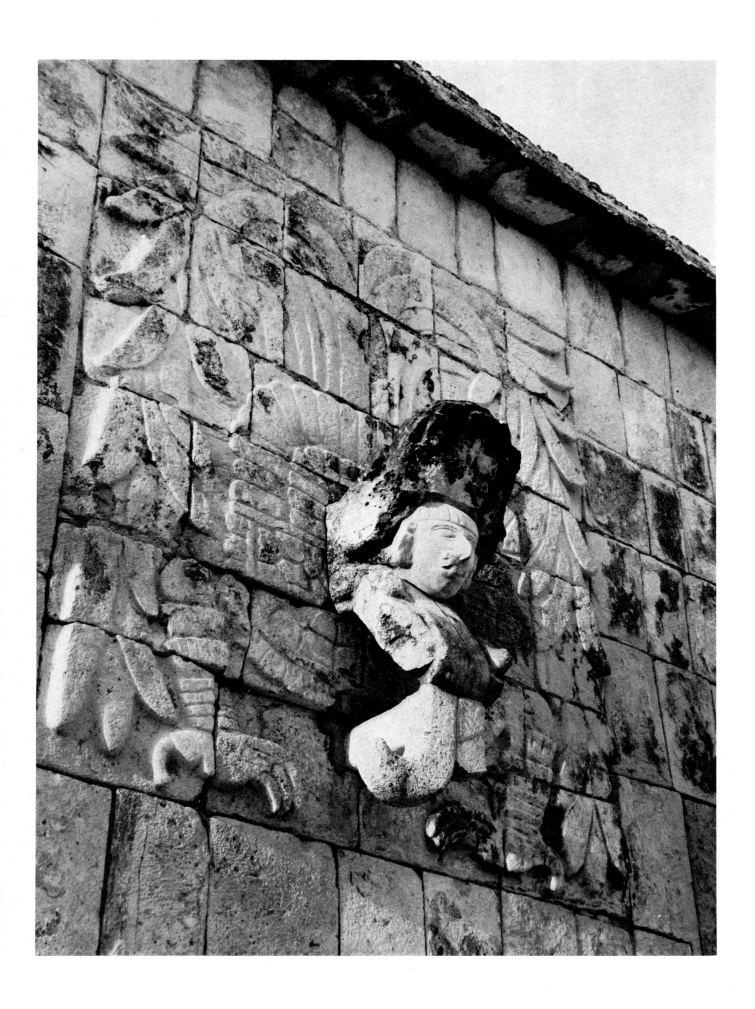

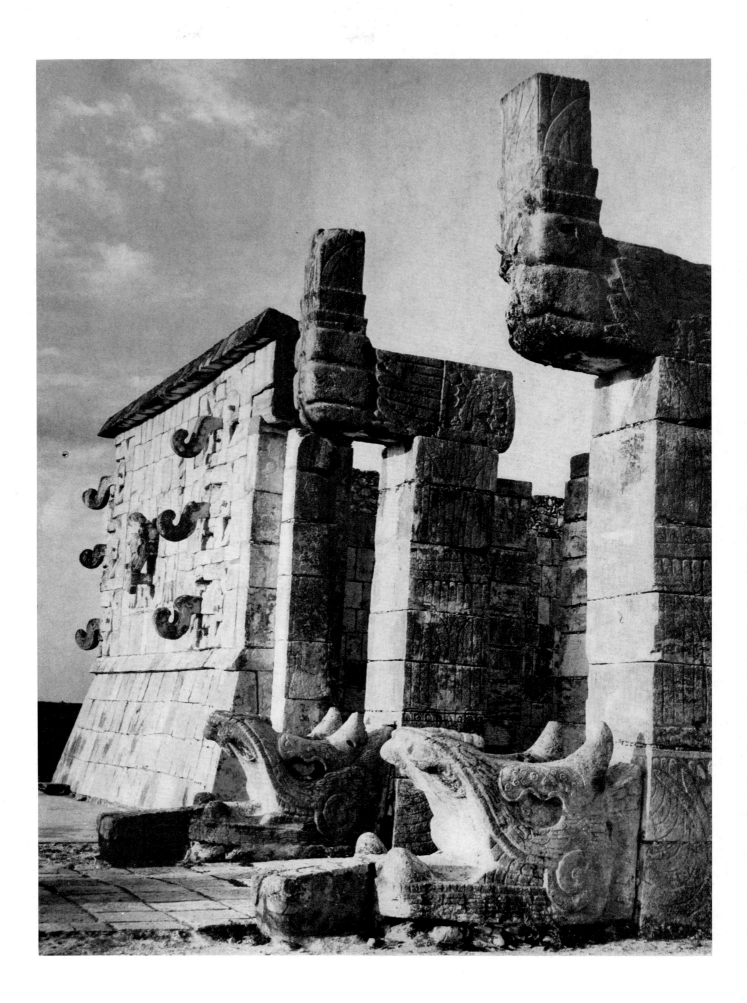

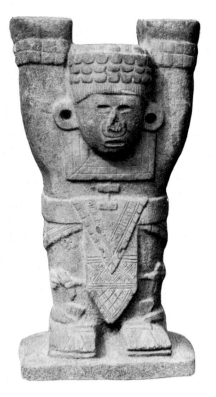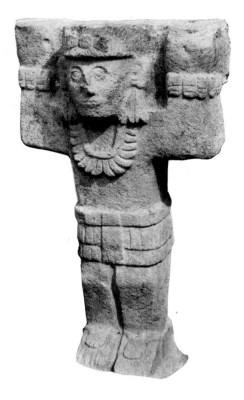

264 Toltec warrior, carved in relief on a pillar in the Temple of the Warriors. Chichén Itzá

261–262 Atlantean figures. Chichén Itzá

263 Large table in the Temple of the Warriors. Chichén Itzá

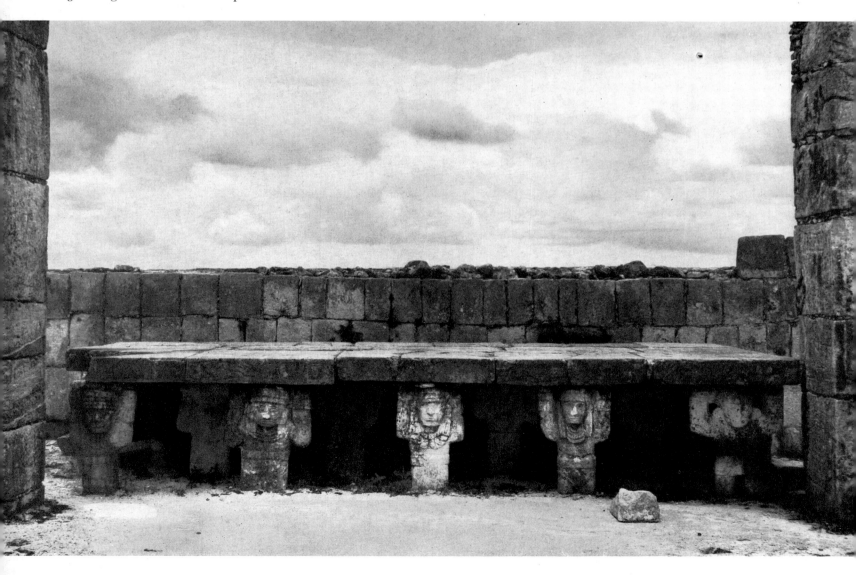

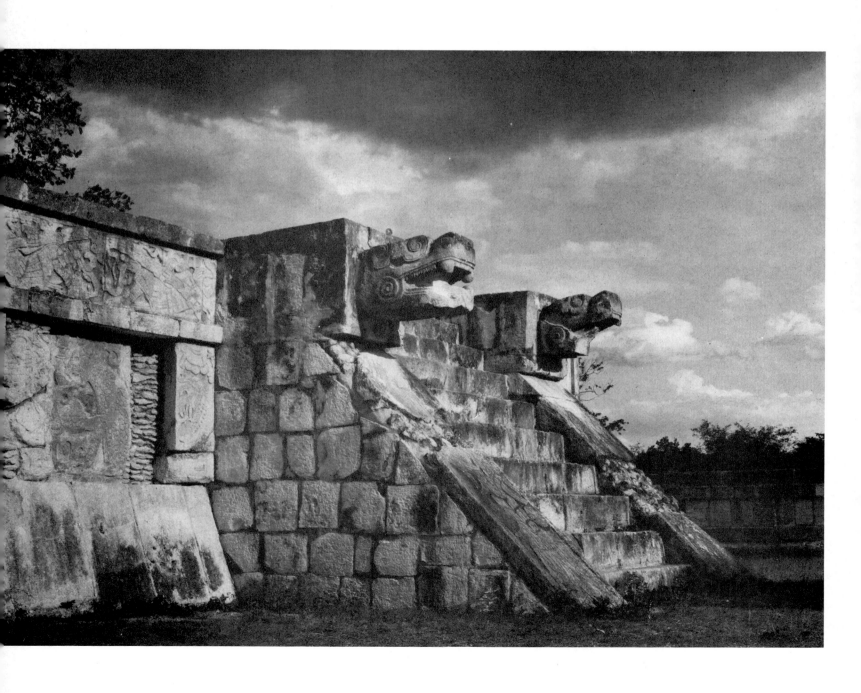

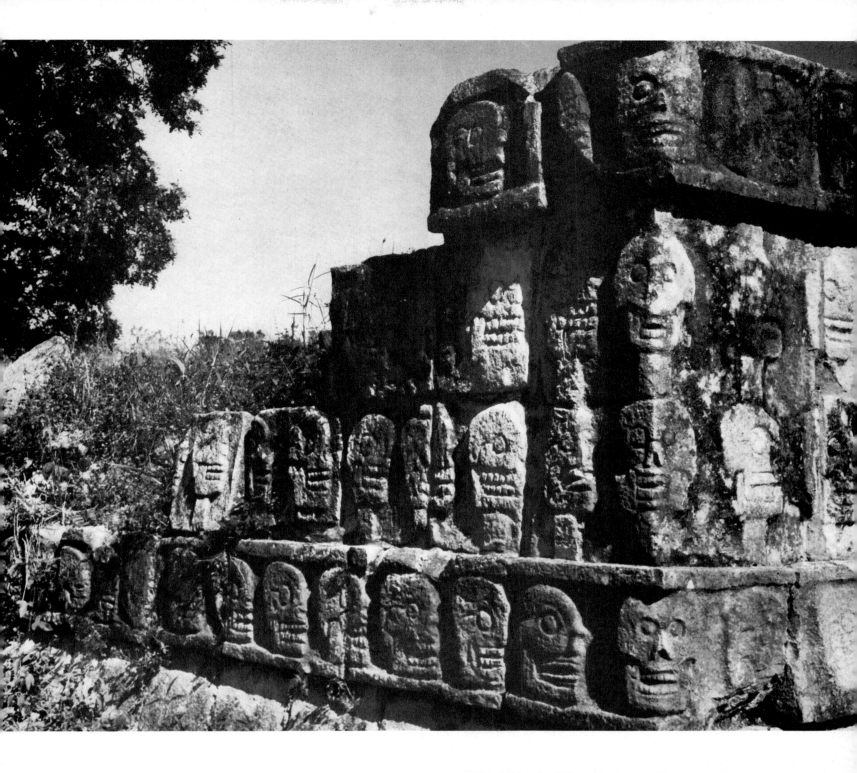

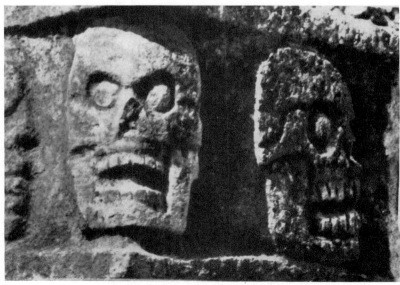

266–267 The Platform of Skulls (Tzompantli).
Chichén Itzá

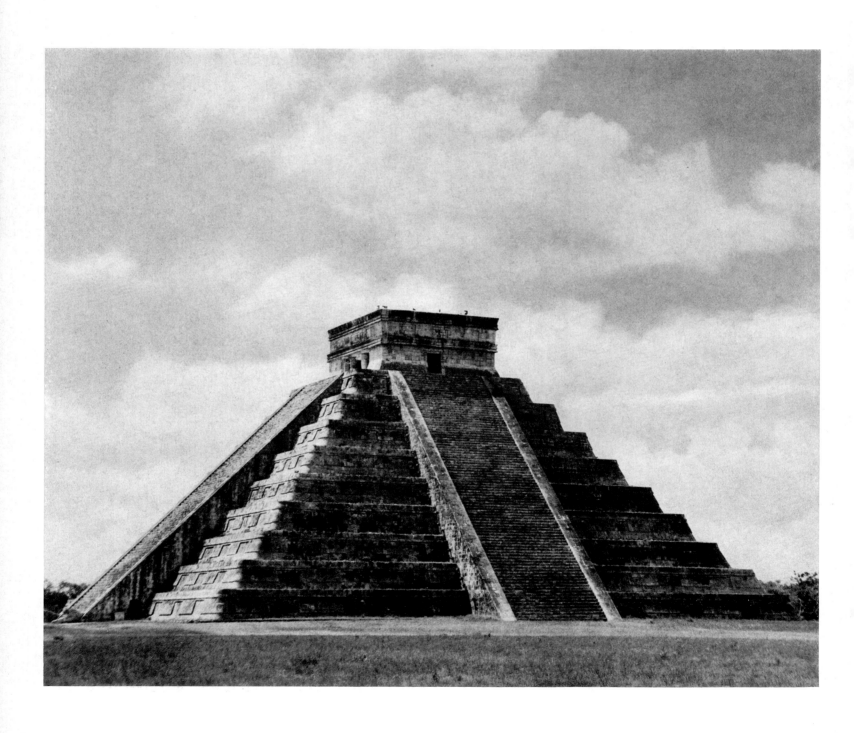

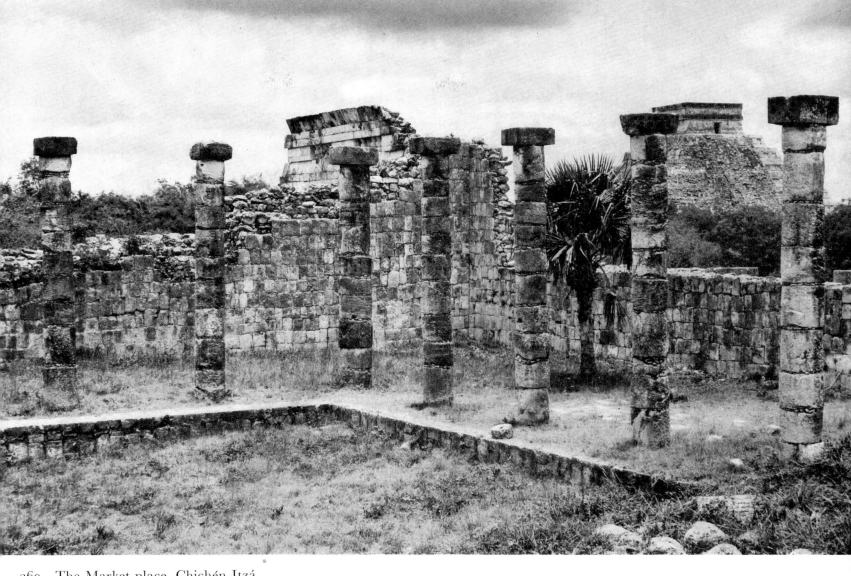

269 The Market-place. Chichén Itzá

270 *Chacmool* in the Castillo. Chichén Itzá

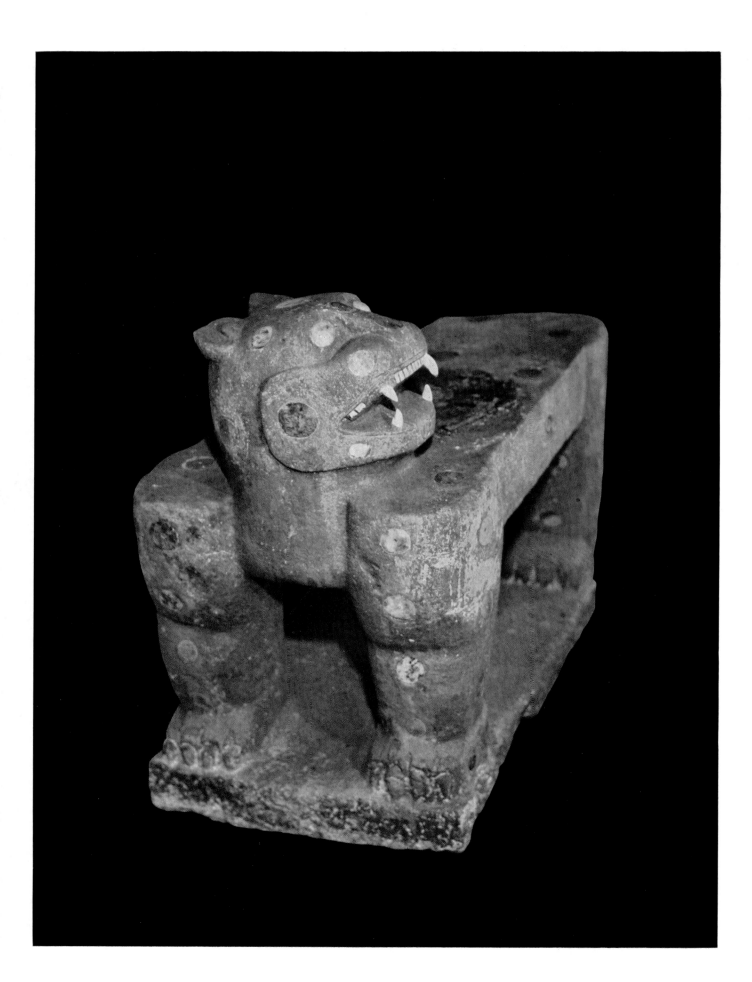

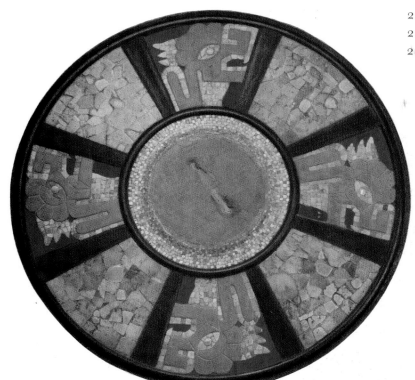

271 The Jaguar Throne in the Castillo. Chichén Itzá
272 Inlaid shield. Chichén Itzá
273 Grave goods found in the stalactite caves. Balancanché

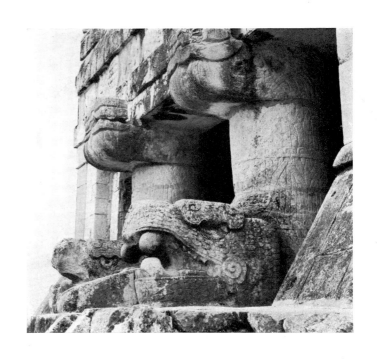

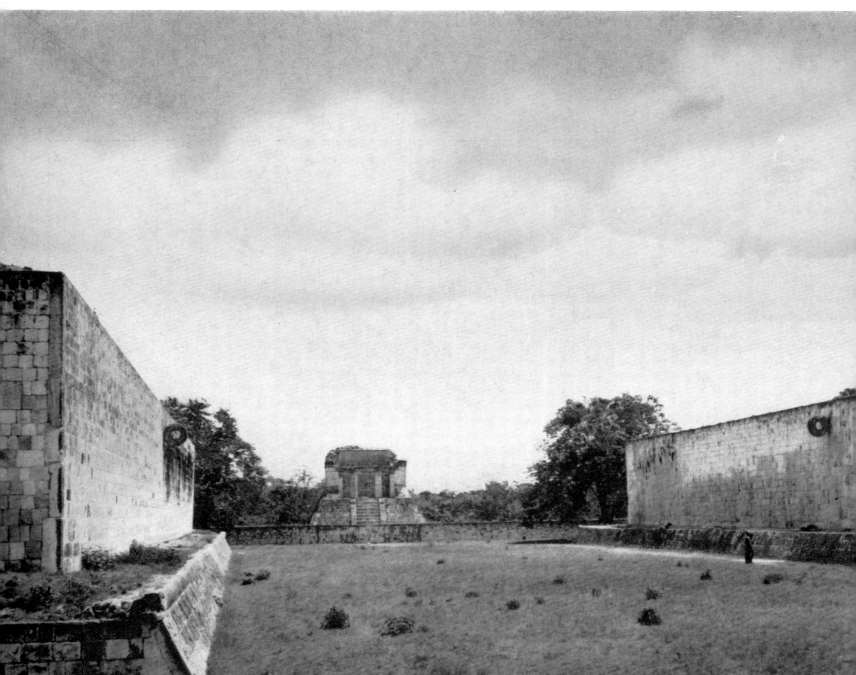

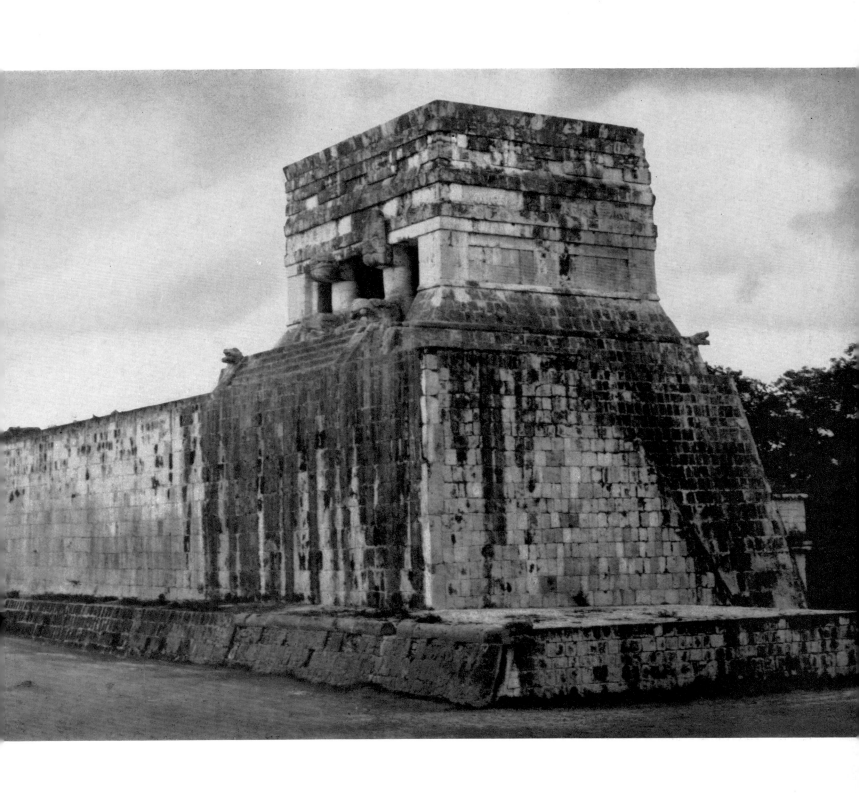

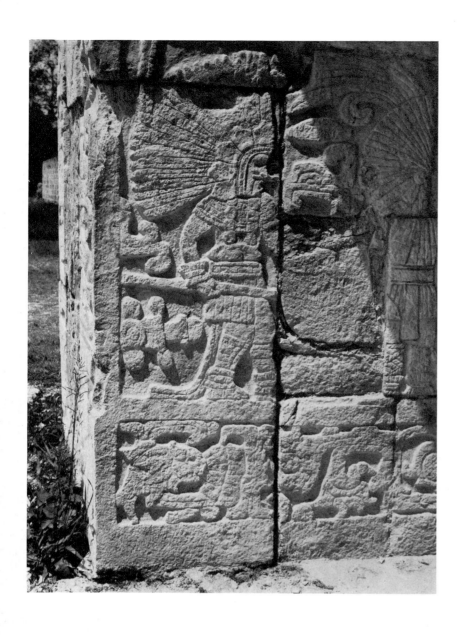

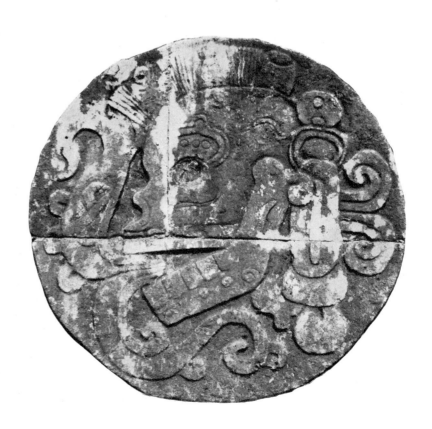

276 Relief carving of a Toltec warrior on the Temple of the Jaguars. Chichén Itzá
277 Skull relief on the balustrade of the ball court. Chichén Itzá
278 Relief of a ball player on the balustrade of the ball court. Chichén Itzá

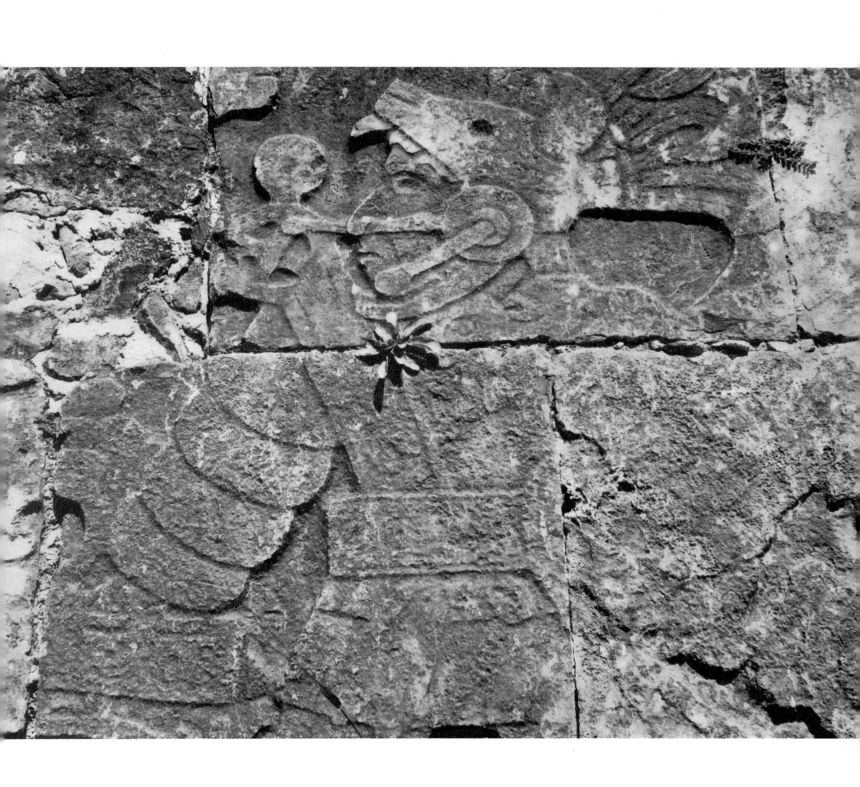

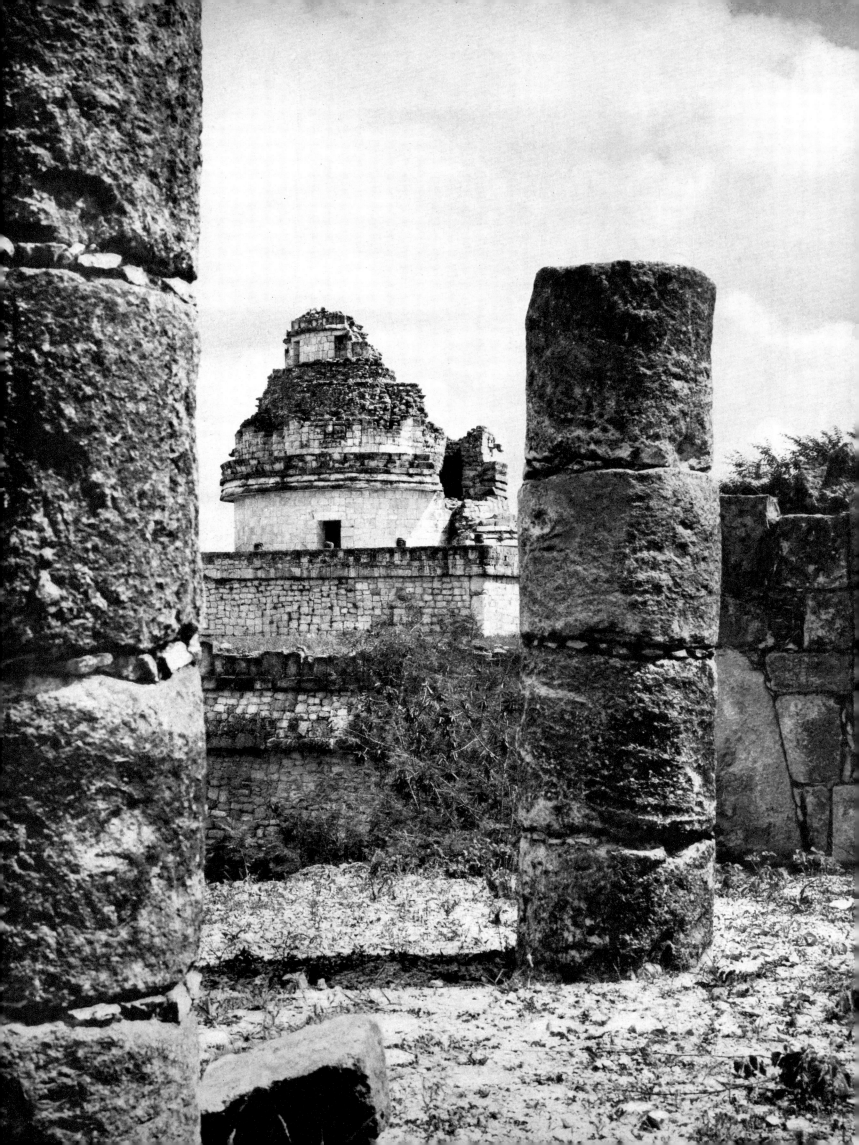

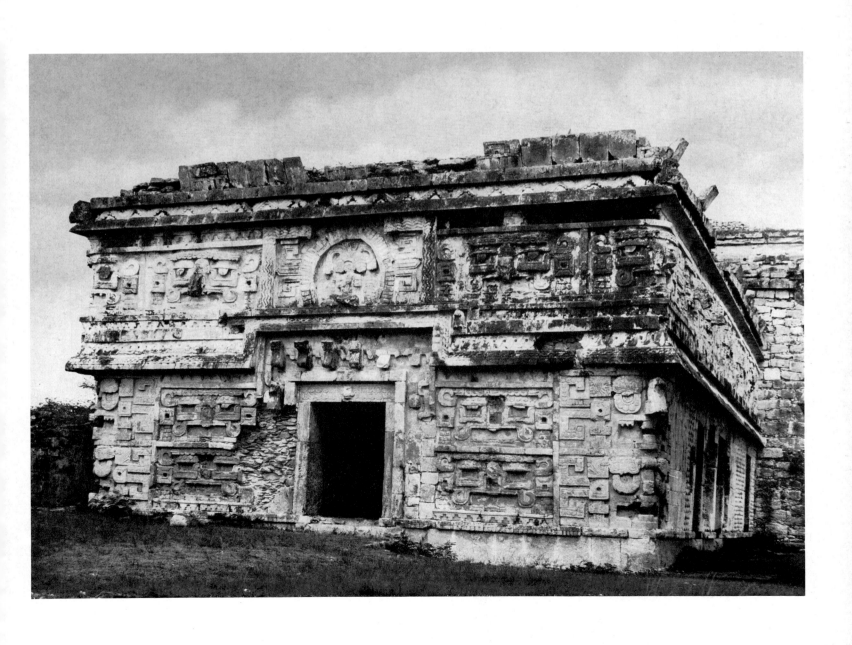

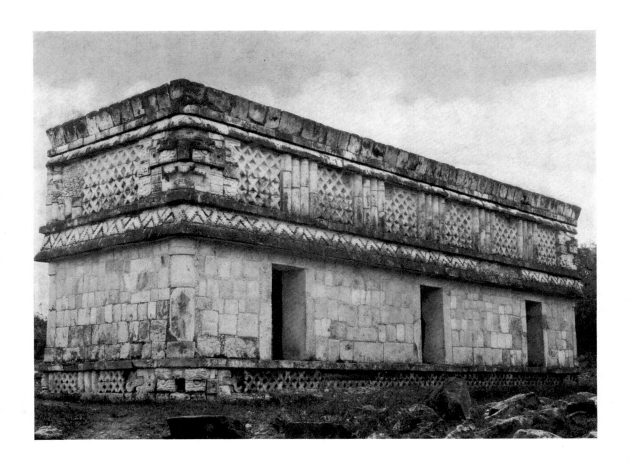

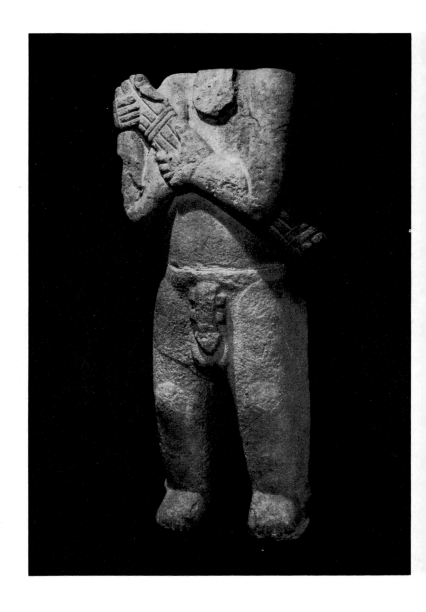

281 The House of the Three Lintels. Chichén Itzá
282 Stone fragment of a figure. Uxmal

283　Vessel with relief decoration. Tecoh
284–285　Clay fragments. Mayapán

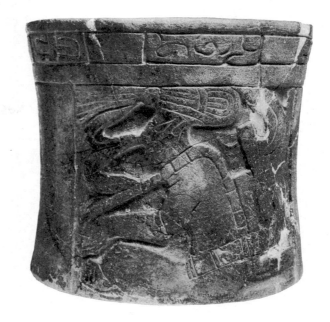

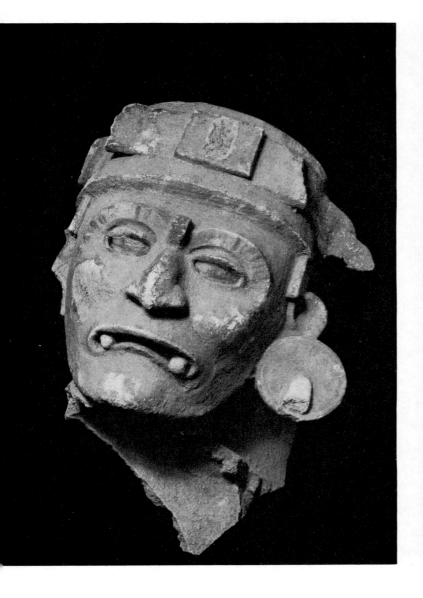

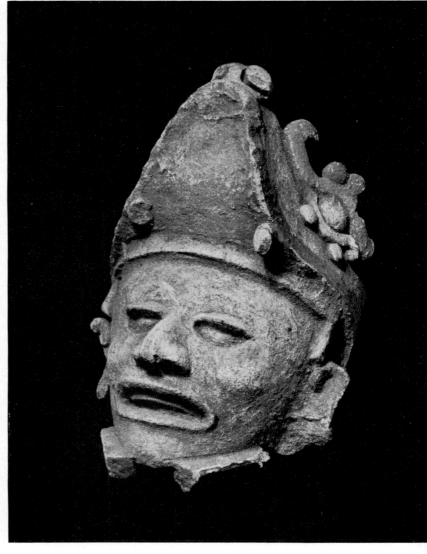

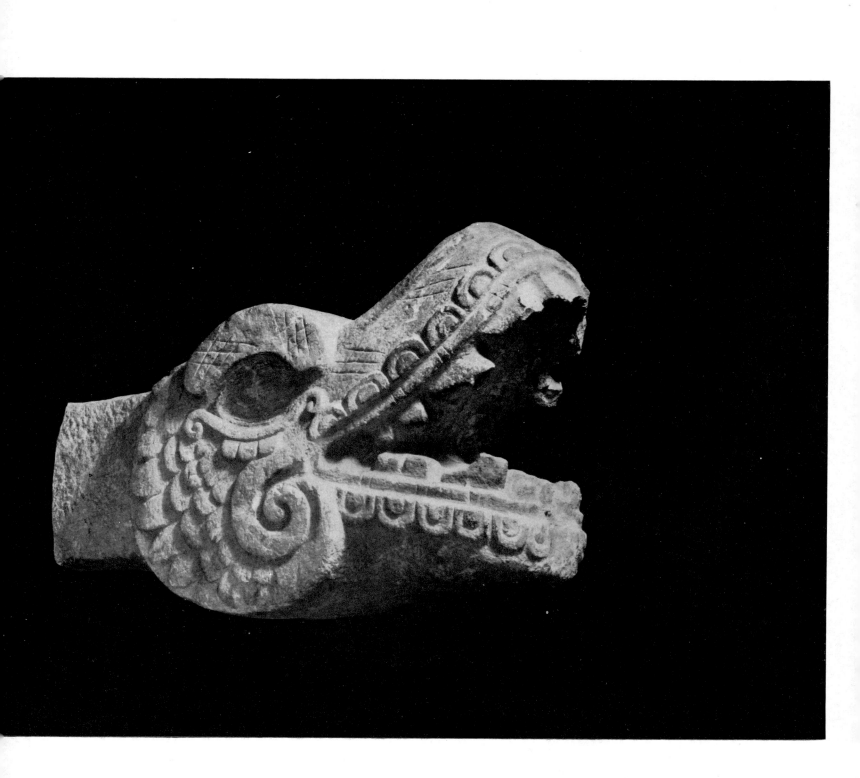

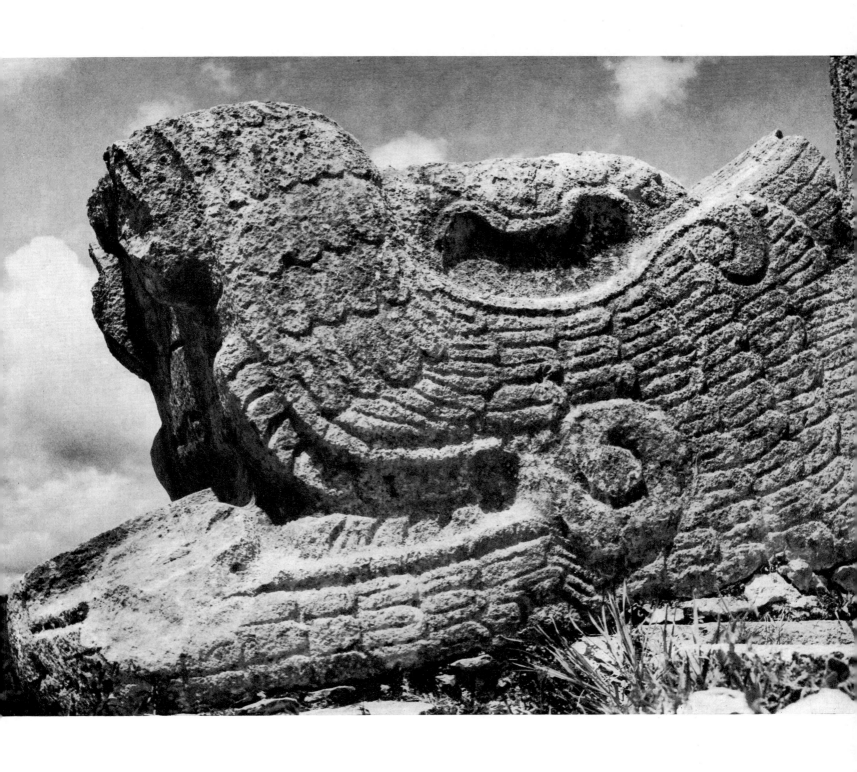

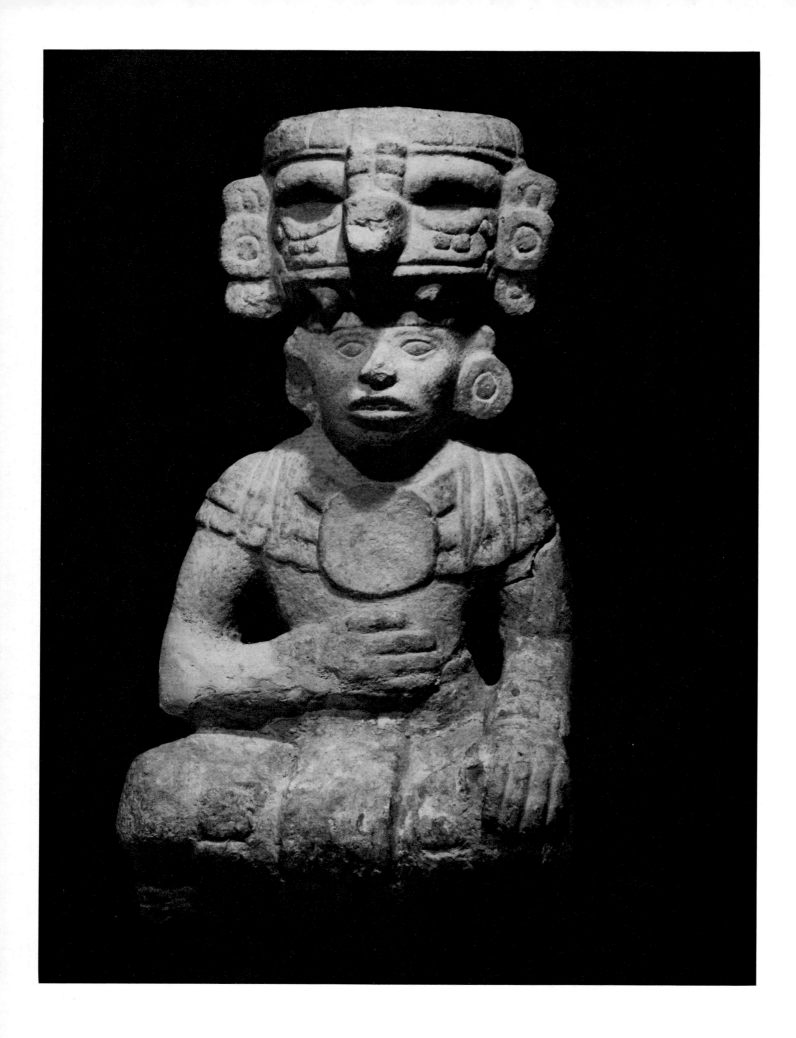

288 Statue of a dignitary. Uxmal

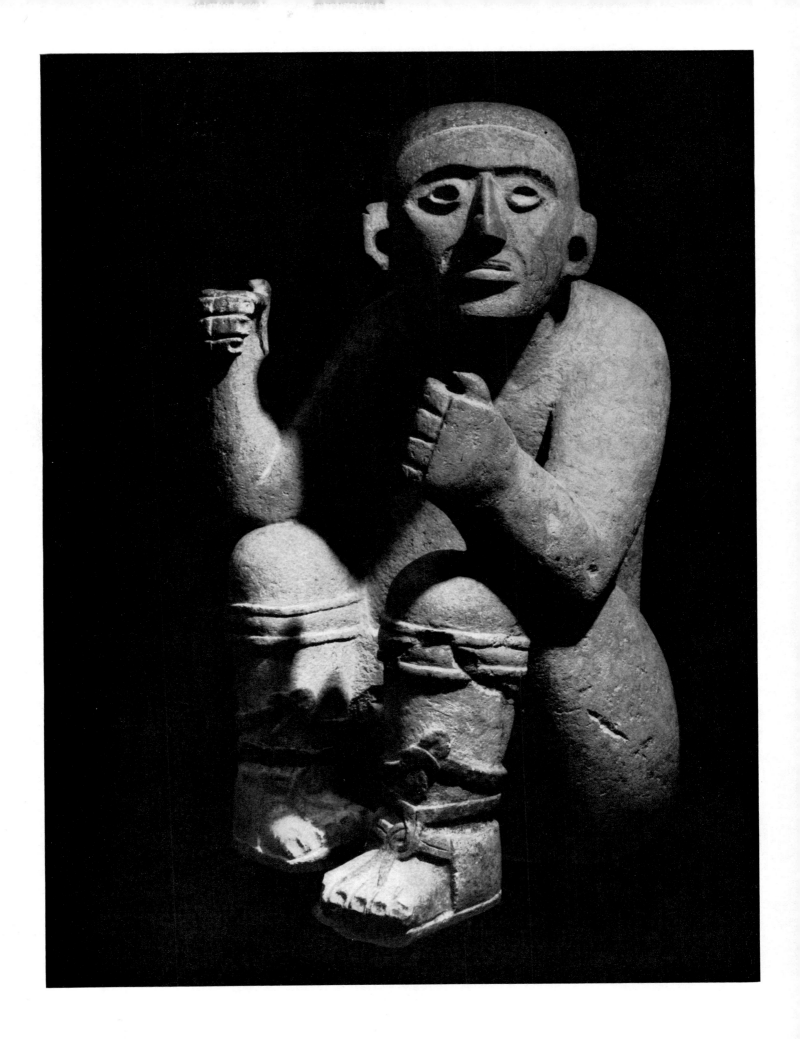

289 Figure of a standard bearer. Chichén Itzá

290 Grave goods in the stalactite caves. Balancanché
291 Bird god. Uxmal
292 Doll. Jaina
293 Bat god. Xúnantun

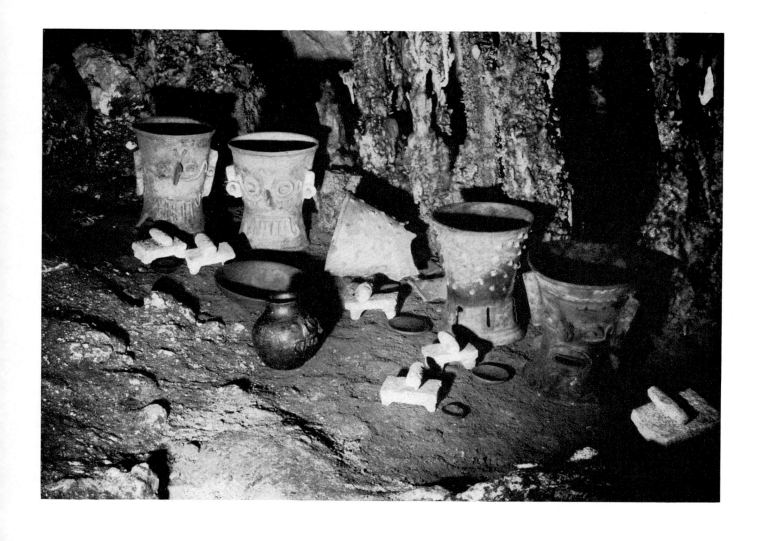

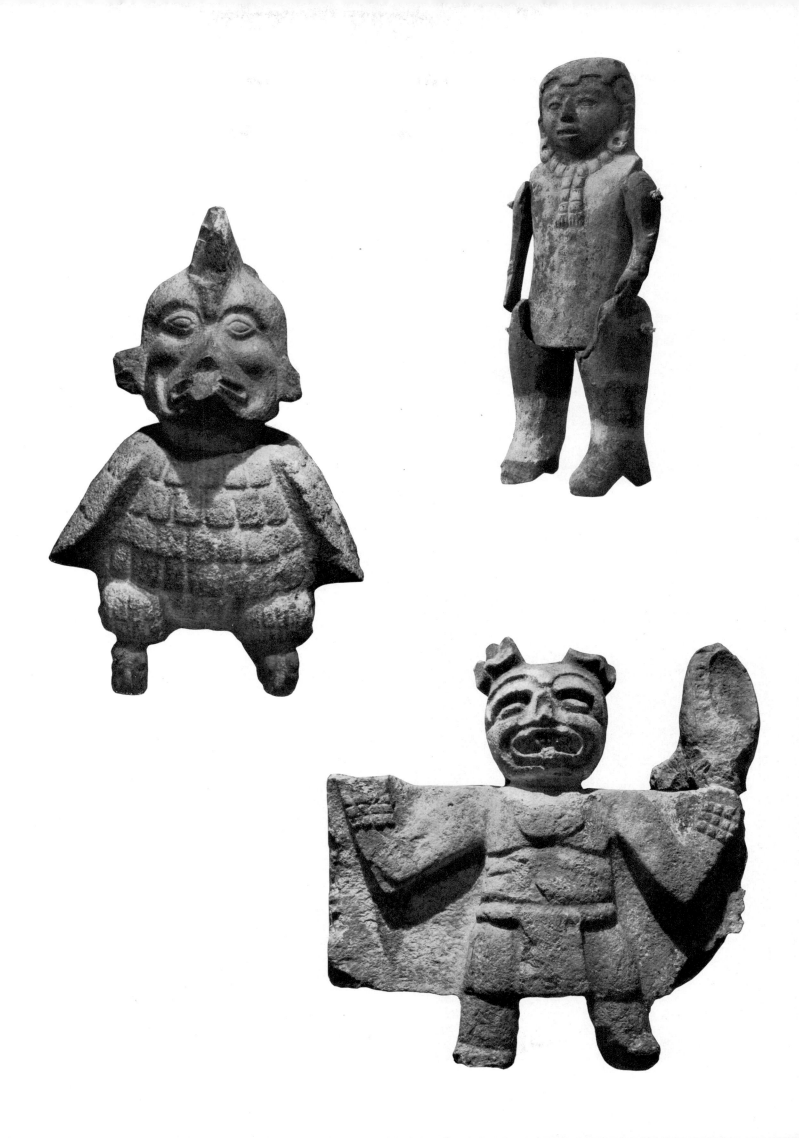

294 Painted dish. Campeche
295 Carved figure of a god. Campeche

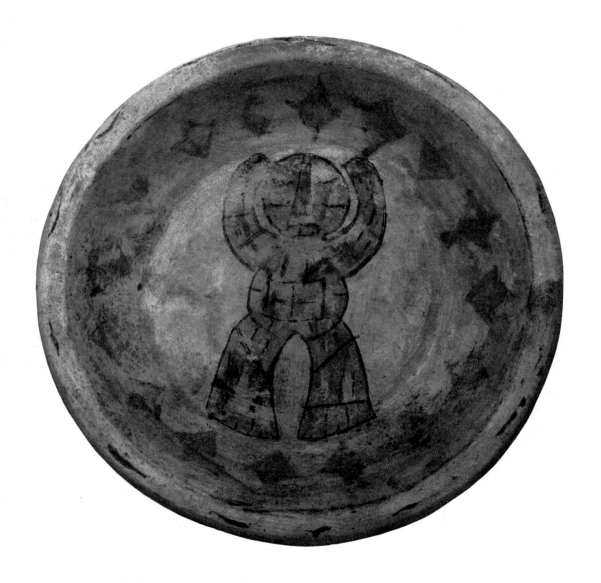

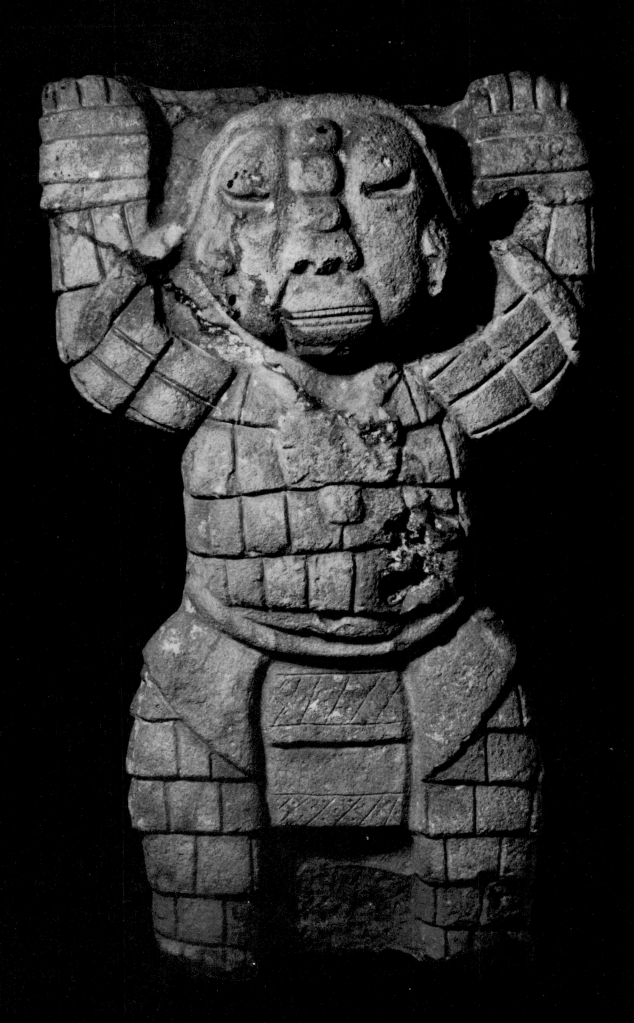

296 Temple rotunda. Mayapán
297 Vessel in the form of the rain god, Chac. Mayapán

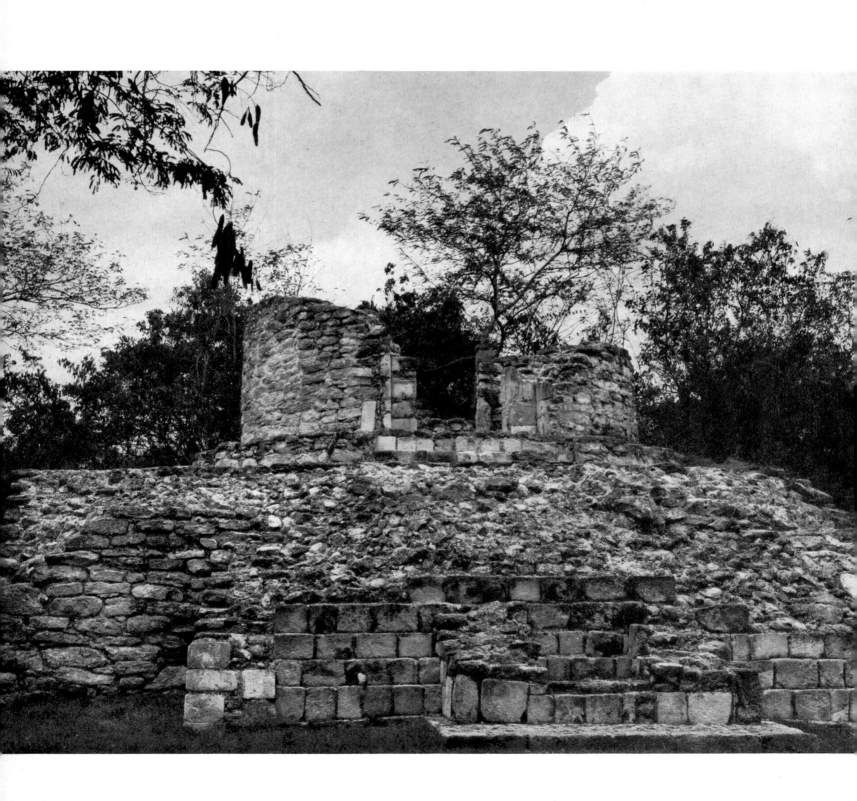

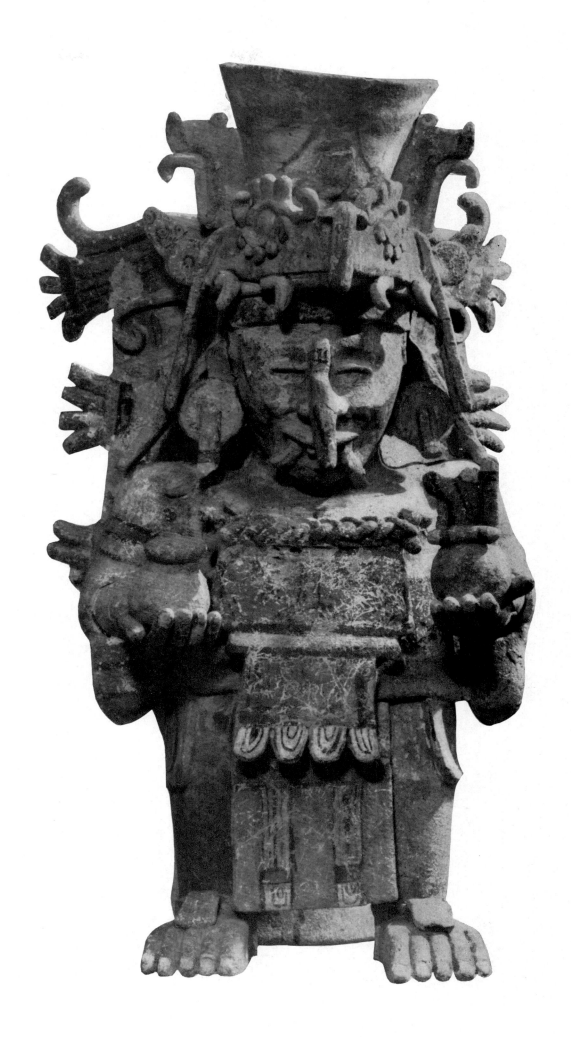

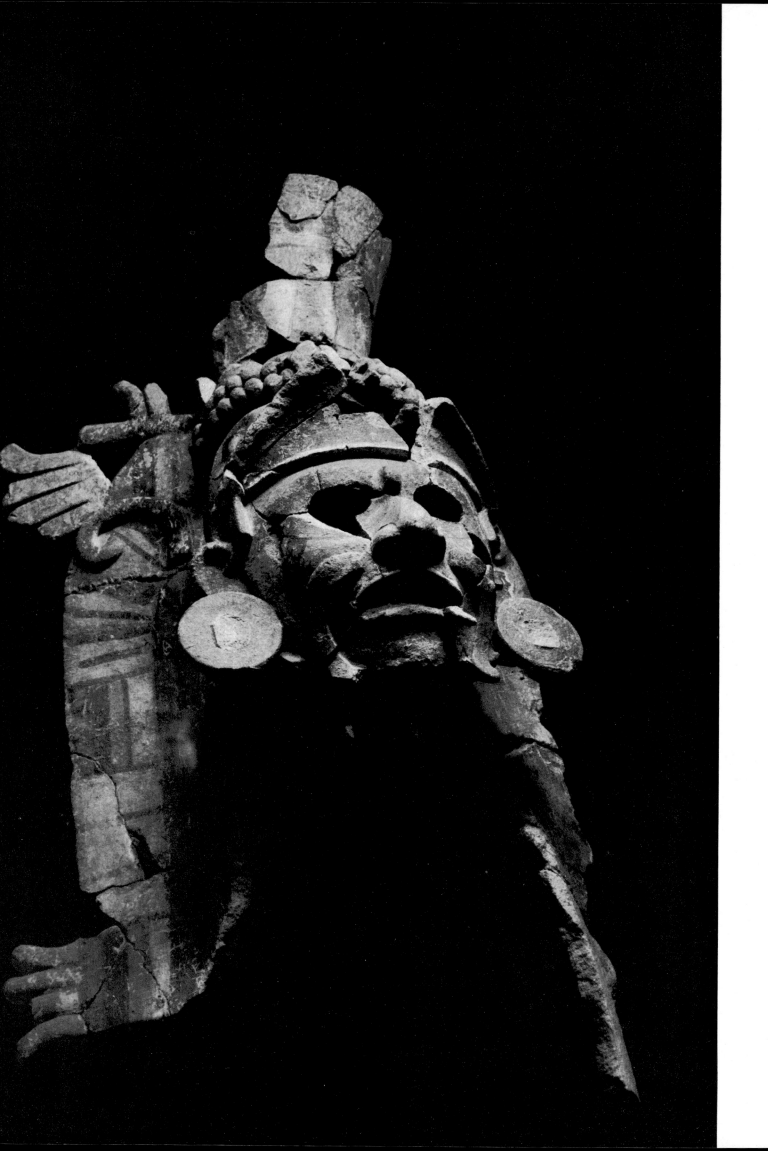

298 Fragment of a cylindrical vessel in the form of a god. Mayapán
299 Model of a skull from the Temple of the Magician. Uxmal

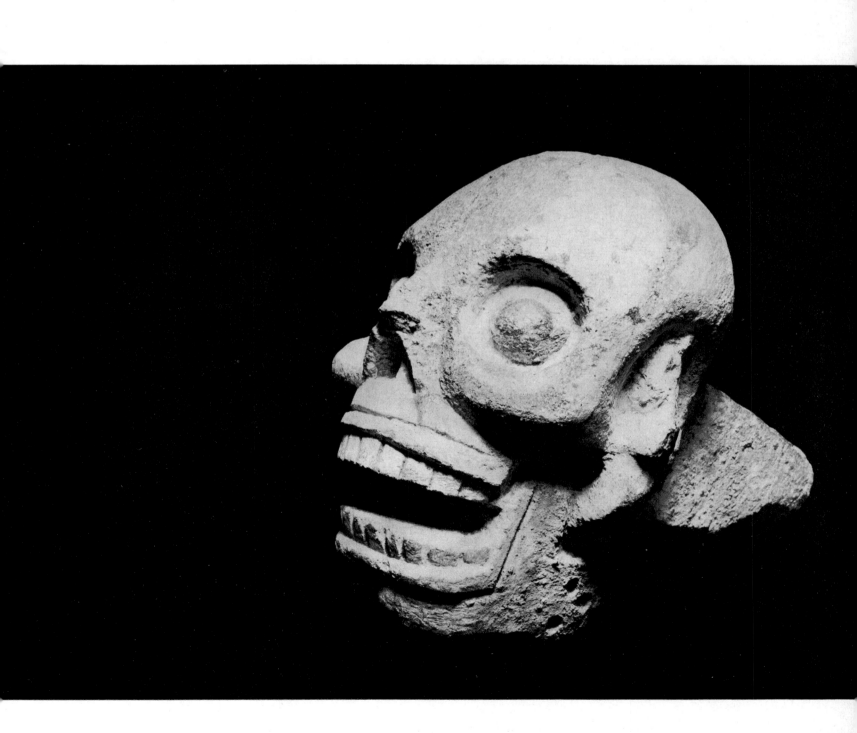

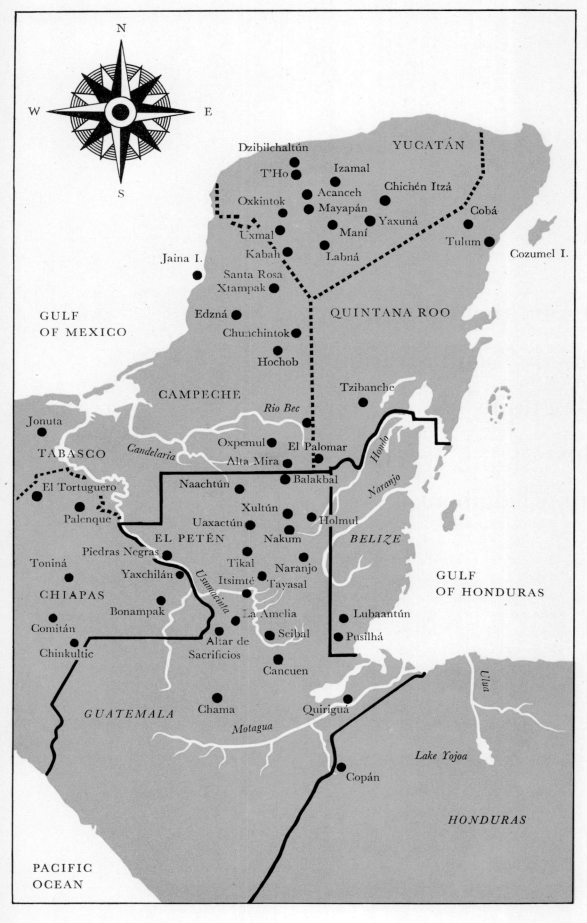

N
W E
S

Dzibilchaltún

T'Ho

Izamal

YUCATÁN

Oxkintok

Acanceh
Mayapán

Chichén Itzá

Uxmal

Maní

Yaxuná

Cobá

Kabah

Labná

Tulum

Jaina I.

Cozumel I.

Santa Rosa
Xtampak

GULF
OF MEXICO

Edzná

QUINTANA ROO

Chunchintok

Hochob

Tzibanche

CAMPECHE

Rio Bec

Oxpemul

El Palomar

Jonuta

Hondo

Candelaria

Alta Mira

TABASCO

Naachtún

Balakbal

Naranjo

El Tortuguero

Xultún

Holmul

BELIZE

Palenque

Uaxactún

Nakum

EL PETÉN

Piedras Negras

Tikal

GULF
OF HONDURAS

Toniná

Yaxchilán

Itsimté

Naranjo

Tayasal

CHIAPAS

Bonampak

Usumacinta

La Amelia

Lubaantún

Comitán

Seibal

Pusilhá

Chinkultic

Altar de
Sacrificios

Cancuen

Ulua

GUATEMALA

Chama

Quiriguá

Lake Yojoa

Motagua

Copán

HONDURAS

PACIFIC
OCEAN

Notes on the text

1 In recent years some groups of Lacandón, in the Nacanjá area and elsewhere, have been baptized. Protestant missionaries have had greater success than Catholics. Nevertheless, one Lacandón, asked what he believed in, returned the laconic answer: 'In the ·33 carbine.'

2 'Tepeu', the equivalent of 'To-Teoteuh' in Nahuatl, the language of central Mexico, means 'Our lord', one of the names of the sun god. 'Gucumatz' is the Quiché translation of the Nahuatl name Quetzalcóatl, literally: 'serpent wrapped in blue and green quetzal feathers'. The name Tepeu Gucumatz is always used in the plural to indicate the female and male principles simultaneously.

3 Huracán means 'one-leg' and is identical with the Mexican god Tezcatlipoca, who is often depicted in manuscripts with only one leg. Caculhá Huracán means 'lightning of one foot' or 'brief flash', Chipi Caculhá means 'small lightning' and Raxa Caculhá 'green lightning'.

4 'Wooden figures'; the literal text is 'wood and stone', i.e. idols of wood and stone.

5 The American Indian had little success with animal husbandry; he domesticated only the dog and the turkey, and (in the Andes) the llama and guanaco. He made up for this by his success as a crop farmer. Nearly half of all the plants consumed in any large measure by human beings today were first cultivated by Indians: maize, potatoes, pimentoes, tomatoes, cocoa, beans, groundnuts, vanilla, tobacco, quinine and many others. So far as we know cotton is the only plant cultivated in both the Old and the New Worlds, but the inhabitants of ancient Peru seem to have been farming it long before the Egyptians. It has been suggested that it may have been imported to Peru from Asia, but there is no conclusive proof of this. The extensive excavations undertaken by Junius Bird at the pre-ceramic site of Huaca Prieta, in the Peruvian state of Chicamatal, in 1946–7 provided a solid basis for future study of that period, but the amount of material Bird gathered was so great and the interpretation of it so complex that he has only recently finished the laboratory stage of his research. Cotton is prominent among the small number of crops at Huaca Prieta; between 2500 and 1200 BC the settlers were already weaving fine cloth.

The most important achievement of the Indian farmers, however, was the cultivation of maize, the second most important food of mankind. The delegates to the thirty-fifth international congress of Americanists in Mexico City in 1962 were astonished to learn that maize was already established in America by 5000 BC, and that it was being harvested in the form in which it is familiar to us today by about 3500 BC. (*XXXV Congreso Internacional de Americanistas*, México D.F., 1962–4, 3 vols.) However the rival claims of Guatemala, Mexico and the central Andes (Peru and Bolivia) to be the place where maize was first cultivated have not been proved, nor is it known whether it was a parallel advance made in two or more places independently. P. C. Mangelsdorff of the United States believes that there were at least two main lines of development, one in Peru and the other in Mesoamerica. Recent excavations at several pre-ceramic sites on the coast of Peru, particularly at Chilca, a few miles south of Lima, by the French archaeologist F. Engel, have produced evidence that rudimentary forms of crop farming already existed in Peru by 4000 BC. Systematic excavation in the Guatemala highlands might well provide evidence of a similar situation.

6 Modern translations of the *Popol Vuh* in European languages include: Schultze-Jena, L: *Popol Vuh, das heilige Buch der Quiché-Indianer von Guatemala*, Stuttgart and Berlin 1944; Recinos, A., D. Goetz and S. G.

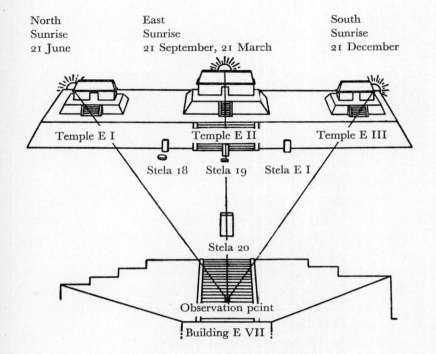

North
Sunrise
21 June

East
Sunrise
21 September, 21 March

South
Sunrise
21 December

Temple E I

Temple E II

Temple E III

Stela 18 Stela 19 Stela E I

Stela 20

Observation point

Building E VII

51 Diagram showing the arrangement of temples
as astronomical markers. Group E, Uaxactún

7 Manik
6 Cimi
5 Chicchan
4 Kan
3 Akbal
2 Ik
1 Imix
13 Ahau
12 Cauac
11 Eznab
10 Caban
9 Cib

5 Pop
4 Pop
3 Pop
2 Pop
1 Pop
0 Pop
4 Uayeb
3 Uayeb
2 Uayeb
1 Uayeb
0 Uayeb
19 Cumhu

A

B

52 Diagram illustrating the intermeshing of the Vague
Year (B), of 365 days, with the 260-day Almanac Year (A)

Morley: *Popol Vuh, the Sacred Book of the Ancient Quiché Maya*, London 1951; Recinos, A.: *Popol Vuh, las antiguas historias del Quiché*, México D.F. 1952.

7 Cf. the report on the excavation of Mound E-III-3 at Kaminaljuyú in Guatemala by Edwin M. Shook and Alfred V. Kidder, published in *Contributions to American Anthropology and History*, Vol. XI, Carnegie Institute of Washington, Washington D.C. 1952.

8 Cf. Anton, F.: *Ancient Mexican Art*, London and New York 1970.

9 All dates quoted in this book are based on the Goodman-Martínez-Thompson correlation, since this corresponds most satisfactorily to the present state of archaeological understanding. Herbert Spinden's correlation would put all dates 260 years earlier.

10 Many scholars nowadays look on the 'Olmecs' as the ancestors of the Maya.

11 A reminder that all dates are based on the Goodman-Martínez-Thompson correlation.

12 Anyone who, like the late Wolfgang Cordan, attempts to reconstruct the language of the ancient Maya, will meet with almost insuperable difficulties, of which the existence of eighteen different, though related, living languages is only one. See: Schlenther, Ursula: *Die geistige Welt der Maya*, Berlin 1965.

13 The situation was quite different in Peru. The off-shore islands are the haunts and nesting-grounds of millions of sea birds, whose droppings create layers of guano yards thick. The ancient Peruvians recognized its fertilizing properties at a very early date.

14 A brief exposition is essential; the system gives a better idea of the formidable intellectual powers of the Maya élite than any other survival of their civilization.

The calendar in everyday use was the 260-day Almanac Year *(tzolkin)*, in which a sequence of twenty day names interlocked with thirteen numbers, so that any given combination of name + number returned once every 260 days. Its principal functions were religious, registering the lucky and unlucky days for embarking on any undertaking. Indians still remember it, and some native communities in Guatemala still use it.

The solar year used in the Julian and Gregorian calendars is approximately $365\frac{1}{4}$ days; in the Maya calendar, the nearest corresponding unit of time was the *haab* of 365 days, sometimes called the

53 Six possible ways to write the digit 0

Vague Year to distinguish it from the true solar year. The Vague Year was divided into 19 periods, 18 named 'months' *(uinal)* of 20 days, and the *uayeb*, the five unlucky days that came together at the end of the year. Any given Almanac Year date (number + day name) would coincide with any given Vague Year date (day number + 'month' name) only once in 18,980 days, fifty-two Vague Years or seventy-three Almanac Years. This fifty-two-year cycle is known as the Calendar Round; it was the only calendar system known to later Mexican civilizations, but it has the obvious drawback that any given date is repeated every fifty-two years. Aztec and Mixtec historians, for instance, had no way of distinguishing the particular year which was known to them (after the Almanac Year date on which it began) as 1 Rabbit, from the year with the same name 52 years earlier or later.

In calendrical computations the Maya combined the Calendar Round with a wholly separate system, the Long Count, in which each day was expressed as a single number, written in a positional notation in which each position represents a factor of twenty: a vigesimal as distinct from a decimal system. (In one case, as can be seen from the following table, the factor happens to be eighteen instead of twenty.)

20 *kin* (days) = 1 *uinal*
18 *uinal* = 1 *tun* (360 days)
20 *tun* = 1 *katun* (7,200 days)
20 *katun* = 1 *baktun* (144,000 days)
20 *baktun* = 1 *pictun* (2,880,000 days)
20 *pictun* = 1 *kalabtun* (57,600,000 days)
20 *kalabtun* = 1 *kinchiltun* (1,152,000,000 days)
20 *kinchiltun* = 1 *alautun* (23,040,000,000 days)

In practice calculations involving the very large units are extremely rare, although one of the stelae at Quiriguá records the Long Count and Calendar Round dates of a day over 90 million years ago. Normally, Long Count dates contain only five numbers, recording the distance in time from an initial date in 3113 BC.

A typical Maya date inscription, giving Long Count and Calendar Round dates together, is conventionally transcribed as follows (from a stela at Naranjó): 9.12.10.5.12 4 Eb 10 Yax. This means that, when 9 *baktun* 12 *katun* 10 *tun* 5 *uinal* 12 *kin* had elapsed since the initial date, the Almanac Year date was 4 Eb and the Vague Year date 10 Yax.

Some Maya dates include a further refinement, the Venus cycle of 584 days (5 Venus cycles = 8 Vague Years), which served as a check on other computations. We know how the Maya corrected the slight inaccuracy in the figure of 584 days (actually the cycle is slightly irregular, and averages 583.92). They did this by deducting 4 days for every 61 cycles and adding 8 days every 300 cycles. Curiously, we do not know how they dealt with the inaccuracy inherent in the solar Vague Year of 365 days.

The Maya had two different kinds of numerals, one consisting of dots and bars and the other of the so-called head-variant numerals (see *fig. 14*). Theirs was the first civilization in human history to use a positional notation based on the zero; they counted not from 1 to 20 but from 0 to 19.

15 Worringer, Wilhelm: *Abstraktion und Einfühlung.* Munich (1908) 1959, p. 87 (*Abstraction and Empathy,* London 1953).

16 Cf. note 21.

17 To gain some impression of the enormous effort that went into building the Maya ceremonial sites, it is only necessary to look at one representative set of figures: six million cubic feet of building materials and rubble were used in the construction of the pyramid of Temple I at Tikal, but the actual temple that stands on it consists of three narrow rooms with a total floor area of 540 square feet.

18 This passage is based on *San Salvador und Honduras. Amtlicher Bericht des Lic. Dr. Diego García de Palacio...*, ed. A. von Frantzius, Berlin 1873.

19 *Palenque, Guía oficial*, Instituto Nacional de Antropología e Historia, México D.F. 1959.

20 The only piece of gold known to date from the Classic period was discovered beneath a stela at Copán. It must have come to Copán in the course of trade with a more southerly part of Mesoamerica. More gold has been found dating from the Postclassic period, but, again, the metal must have been imported; unlike Mexico or Colombia, the regions occupied by the Maya contain no deposits of ore worth mentioning *(figs 31–33)*.

21 In order to understand the crucial significance that this migration had for Mexico as well as for the Maya we must review the position of Tula and the Toltecs at that time.

The Toltecs usher in a period of Mexican history whose records are well authenticated by comparison with earlier times. Veiled in myth, but with a solid core of verifiable historical events, the rise and fall of the Toltec empire were still alive in the memory of the Aztecs at the time of the Spanish conquest. Ruling families among the Aztecs, as among the Maya in Yucatán and in the highlands of Guatemala, were proud to claim descent from the Toltecs.

The migration from Tula was explained in myth as the result of conflict between two gods, the warlike Tezcatlipoca ('Smoking Mirror') and the peace-loving Quetzalcóatl. Tezcatlipoca gained the ascendancy and his adversary had to flee.

In this [year] Topiltzin Acxitl Quetzalcóatl departed with what speed he could, when total disaster overwhelmed the land of Tollan. In this year, 1 Reed, it befell that he took to the great water, to the water of the sky [the sea], and sought the land of the east where, so it is said [and] recounted, he was taken up in smoke, in the red dawn. He said he would come again, he would return and restore his kingdom of Tollan [Tula]. (Based on *Memorial breve acerca de la fundación de la ciudad de Culhuacan por Domingo de San Anton Muñon Chimalpahin Quauhtlehuanitzin. Quellenwerke zur alten Geschichte Amerikas, hrsg. von der Ibero-Amerikanischen Bibliothek Berlin*, Stuttgart 1958.)

Quetzalcóatl's promise to return was to be the downfall of Mexico and, indirectly, of the Maya. The Aztec ruler Moctezuma II mistook Hernán Cortés for Quetzalcóatl and welcomed him with religious awe.

Eric Thompson has warned against the burgeoning fantasies of pseudo-scientific writers who see in the bearded 'White God' Quetzalcóatl of Mexican legend a descendant of the Vikings, or even, as was recently postulated, a dethroned king of Mycenae. The cult of Quetzalcóatl began centuries before the Atlantic voyages of the Vikings, and if the Mycenaeans had ever managed to reach America, they would certainly have introduced implements of fundamental importance such as the wheel, the potter's wheel and the plough, as well as their skills in working metals.

The original Tezcatlipoca and Quetzalcóatl were undoubtedly tribal chieftains, who became gods as the legend was repeated over the years. Further possibility of confusion arises from the fact that generations of Toltec leaders bore the name Quetzalcóatl in addition to their own name, as a title, so that for centuries there were both a god and a succession of chieftains with the same name. About AD 1000, the Toltecs seem to have been divided among themselves between the adherents of the relatively peaceful Quetzalcóatl and those of the warlike Tezcatlipoca, who seems to have prevailed. Quetzalcóatl and his supporters may well have set sail eastward across the Gulf of Mexico; if so, it is tempting to identify them with the outsiders who appeared in Yucatán at much the same period. However, the hypothesis has recently been advanced, on the basis of stylistic comparisons, that the flow of ideas was actually from Chichén Itzá to Tula rather than the reverse.

22 See Tozzer, A. M., ed.: *Landa's Relación de las cosas de Yucatán*. Papers of the Peabody Museum of Archaeology and Ethnology, Harvard University, XVIII. Cambridge, Mass. 1941.

23 This refers to Pedro de Alvarado, who had been in command of a ship in Grijalva's expedition and later played a not inconsiderable part as a captain under Cortés. He was Cortés' deputy in the conquest of Guatemala and acted as chief justice and governor of the province.

24 Because of his thick blond hair, the Mexicans called Pedro de Alvarado 'Tunatiuh' (from the Nahuatl Tonatiuh, 'he goes to shine', one of the names of the sun god). He appears to have concealed a difficult and intransigent character behind friendly behaviour and a charming smile.

25 *Memorial de Solola, Anales de los Cakchiqueles*. Ed. Adrián Recinos. Biblioteca Americana, México-Buenos Aires (Fondo de Cultura Económica), p. 124. The original manuscript, which dates from the colonial period, is now at the University of Pennsylvania, Philadelphia, Pa.

26 Prescott, William H.: *The Conquest of Mexico*. Several editions.

27 *El libro de los libros de Chilám Balám*. Ed de A. Barrera Vázquez. Biblioteca Americana, México; Buenos Aires 1948. *The Book of Chilam Balam of Chumayel*, Washington D.C. 1933. *Anales de los Cakchiqueles*. Ed. Adrián Recinos. Biblioteca Americana, Mexico–Buenos Aires, 1950. *Popol Vuh*. For details of editions see note 6.

28 Bernardino de Sahagún: *Historia general de las cosas de Nueva España*, México D.F. 1938. *Florentine Codex*, Santa Fe, N. Mex., 1950–63.

29 Also the name of a mountain near Chichicastenango in the highlands of Guatemala.

30 Based on the German translation given by Josef Haekel in 'Der "Herr der Tiere" im Glauben der Indianer Meso-Amerikas', *Mitteilungen aus dem Museum für Völkerkunde in Hamburg, XXV. (Festband für Franz Termer)*, Hamburg 1959.

31 At Palenque in the lowlands, and at Kaminaljuyú in the highlands, servants or wives are buried with dignitaries of the highest rank. Since the actual bones are the only surviving evidence of this custom, it is impossible to tell whether these victims were killed beforehand or went into the tomb alive.

32 As told by John Lloyd Stephens in *Incidents of Travel in Central America, Chiapas and Yucatán* (New York 1842). Brunswick, N. J. 1948. As with many old legends, there are various versions.

33 The great fortified castles which were so essential in medieval Europe were not needed by the Maya theocracies of the Classic period: the dense rain forest was protection enough. The only centres with fortifications and walls are Tulum, built in an exposed position on the coast of the Caribbean, and Mayapán, the seat of a militaristic dynasty in the Postclassic period.

Notes on the illustrations

Numbered figures

1 A boat on the Usumacinta, which forms the border between Mexico and Guatemala.

2 Yacum, a Lacandón Maya.

3 The Usumacinta near Yaxchilán.

4 Two Lacandón girls beside the Rio Lacanjá.

5 Maya boy from the village of Zinacatán in the Chiapas highlands.

6 Market day in Chamula, a village in the Chiapas highlands.

7 A Tzeltal Maya woman selling her produce in a village market in the Chiapas highlands.

8 The main street of a village on the Yucatán peninsula.

9 Rubbing from a stela at Kaminaljuyú.

10 Rubbing from a stela at Seibal.

11 Jaguar motif on a vase from the Ulua valley.

12 Rubbing from a lintel at Yaxchilán, depicting two priest-kings in ceremonial dress. Classic period, eighth century.

13 Day glyphs, from the *Codex Dresdensis*.

14 Head-variant numerals from 0 to 19. Numbers above 19 were expressed by multiplication and by displacement of the basic symbols. A simple system of dots and bars was also used, with a dot expressing one, two dots two and so on, and a bar expressing five. Seventeen would look like this: ≝

15 Day glyphs, after T. A. Joyce.

16 Month glyphs, after T. A. Joyce.

17 An 'altar', Copán.

18 Stela 1, Tikal. Although lacking a date inscription, this must be one of the oldest stelae at Tikal.

19 Part of a wooden lintel from Tikal.

20–21 Stelae at Copán.

22 Rubbing from the stone slab covering the sarcophagus in the crypt of the Temple of the Inscriptions, Palenque.

23 Relief in the Temple of the Cross, Palenque.

24–25 Reliefs in the Temple of the Foliated Cross, Palenque.

26 Colossal stone head of the Olmec civilization from Tres Zapotes, now in the marketplace of San Andrés Tuxtla, Vera Cruz.

27 *Chacmool* in front of the Temple of Quetzalcóatl, Tula, Hidalgo. Toltec, *c.* AD 800–1000.

28 Frieze of jaguars, coyotes and eagles on the Temple of Quetzalcóatl, Tula, Hidalgo.

29 Temple of Quetzalcóatl, Tula, Hidalgo, the centre of the Toltec civilization.

30 Relief of a warrior, Tula, Hidalgo. Toltec, *c.* AD 800–1100.

31 Gold disc from the Well of Sacrifice at Chichén Itzá, depicting two Maya warriors fleeing before a Toltec chieftain (after S. K. Lothrop).

32 Gold disc (Disc K) from the Well of Sacrifice at Chichén Itzá, depicting a Toltec general (after S. K. Lothrop).

33 Gold disc (Disc L) from the Well of Sacrifice at Chichén Itzá, depicting a Toltec 'eagle knight' fighting a Maya warrior (after S. K. Lothrop).

Colour and monochrome plates

1 Standing figure of a girl. Solid clay. The original purpose of these primitive, early models can only be guessed at. They were certainly not toys, but they may have played some part in fertility rites. Similar female figures dating from the Preclassic or Formative period have been found throughout Mesoamerica, buried in graves or in cultivated ground. It is only some of the details – differences in the hairstyles, the shaping of the eyes and brows, and the skilfully formed depressions which indicate the pupils and the direction of the gaze – that allow scholars to tell their place of origin. Hairstyles are often very elaborate, but the clothing consists, at most, of a loincloth, a small necklace and large earrings.
El Salvador. Formative period, *c*. 800–200 BC.
Height 18 cm., 7·1 in.
Museo Nacional de El Salvador.

2 Model of a girl. Reddish clay. The skull is compressed between two boards (the back one has been broken off). This was the method by which the skulls of children were deformed to achieve the typical profile seen in Classic Maya art, with the forehead flattened and sloping backwards. This was still the Maya ideal of beauty at the time of the Spanish conquest.
Dep. Sonsonate, El Salvador. Formative period, *c*. 200 BC–AD 100.
Height 31 cm., 12·2 in.
Museo Nacional de El Salvador.

3 Standing figure. Hollow clay. Similar to that reproduced in *pl. 4*. Although the figure is naked, a great deal of care was expended on the styling of the hair, and she is wearing earrings. Little figures of this type are the only source of information we have about the customs and manners of the Formative period. The dating of this period in the highlands of El Salvador is very unsatisfactory, and no systematic programme of excavation has yet been undertaken in the region.
Dep. Usulután (Cordillera de Jucuapa), El Salvador. Formative period, *c*. 200 BC–AD 100.
Height 21·5 cm., 8·4 in.
Museo Nacional de El Salvador.

4 Seated female figure. Hollow clay. Larger figures were less likely to crack in firing if they were hollow. This figure has been badly damaged, but is still impressive. Like those in *pls 2* and *5*, it probably represents a fertility goddess, an earth mother, and would have been buried in a *milpa* (maize field) to ensure a good harvest, or in a grave to assist the dead in the after-life.
Region of Nekepia, El Salvador. Formative period, *c*. 200 BC–AD 100.
Height 18 cm., 7·1 in.
Museo Nacional de El Salvador.

5 Mushroom stone. These curious figures, restricted to a small area in the Guatemala highlands, and none of them later than the Formative period, offer a welcome variation in the otherwise extremely narrow range of archaic forms. They have been found in graves, and may, like ceremonial or votive axes, represent styl ized maize shoots. Some Americanists, however, believe that they reproduce the hallucinogenic mushroom- which priests ate to bring on a state of trance in shamanist rituals. The human figure in this stone could represent one such shaman meditating.
Kaminaljuyú, Guatemala highlands. Formative period, *c*. 200 BC – AD 100.

298

Height 19·5 cm., 7·7 in.

Carlos Nottebohm collection, Guatemala City.

6 Mushroom stone; cf. *pl. 5*. This vital carving represents an acrobat or dancer. Clay figures, of a type known as 'acrobats' or 'serpent men', have been found in Preclassic graves in the Valley of Mexico. Possibly they represent participants in a ritual dance. It is not known where this figure, carved from a volcanic rock, was found, but there can be no doubt that it originated in the Guatemala highlands and dates from the Formative period.

Guatemala highlands. Formative period, *c.* 1500 BC – AD 100.

Height 26·5 cm., 10·4 in.

Carlos Nottebohm collection, Guatemala City.

7 Tall vase. Clay. The crouching human figure, perhaps blind, on the bottom part of the vessel, is very skilfully modelled, partly in relief and partly in the round. The expression of suffering on the face, and the whole shaping of the figure, testify to the confidence and sensitivity which the artists of the late Formative period already possessed. Similar vases, though of less artistic quality, were found in Tomb I at Kaminaljuyú.

Antigua, Guatemala. Formative period, *c.* 500 BC – AD 100.

Height 31 cm., 12·2 in.

Carlos Nottebohm collection, Guatemala City.

8 Vessel in the form of an old man crouching. Clay. The beard, the prominent nose and teeth, are the physical attributes of the Mexican 'old god' of fire, Huehueteotl or Xiuhtecuhtli. The vessel was found in the ruins at Tazumal, which lay on ancient trade routes. As with the cities on the Roman roads in northern Europe, traces of the influences of a number of different cultures have been found there, from Olmec-style stone monuments of the Formative period to Mexican elements in Postclassic buildings. The subject of this figure, the 'old god', could derive from Teotihuacán in Mexico, but the style and the technique are closely related to Formative works from Kaminaljuyú. Until the whole of the highland area has been excavated systematically, so that archaeologists are not obliged to depend on chance finds, it will continue to be difficult to estimate the length of time that elapsed, and the advances that were made, between the various incursions of Mexicans into the regions inhabited by the Maya. Compared to the lowland Maya, the inhabitants of the highlands were generally more receptive to foreign influences.

Tazumal, El Salvador. Early Classic period, *c.* AD 100–500.

Height 19 cm., 7·5 in.

Museo Nacional de El Salvador.

9 Small vase. Grey soapstone with green highlights and traces of reddish paint. The face, that of the rain god (Tlaloc to the Mexicans and Chac to the Maya), is repeated on the other side. The vase was found with more than three hundred other articles in Tomb I at Kaminaljuyú. The structure erected above the tomb, as well as the large number of grave goods, indicate that this was the tomb of an influential priest or a military hero. It was discovered by labourers from a brickworks. After carefully removing over four thousand cubic feet of sun-dried bricks, the archaeologists were dismayed to discover that unskilled hands had already tampered with the tomb and had removed some of its contents. The second tomb in the same pyramid was more informative about burial customs and rites, including evidence of human sacrifice already in the Early Classic period. The chief occupant of the tomb, a man about 5 ft 4 in. tall, was painted all over with cinnabar, the red colour of death, and had been buried wearing rich clothes and an elaborate headdress. He was accompanied on the long journey into the realm of night, voluntarily or involuntarily, by two children between six and eight years old and a youth of eighteen or twenty. Over two hundred grave offerings were carefully laid out on the floor around the body. The custom of burying some of the dead person's possessions with him was common to all American civilizations, and has been the source of much valuable archaeological material. (See note 7.)

Kaminaljuyú, Guatemala. Early Classic period, *c.* AD 100–500.

Height 9·8 cm., 3·9 in.

Museo Nacional de Arqueología, Guatemala City.

10 Fragment of a small dish. Clay. The handle is shaped like a mythological creature, resembling the 'Bat God' who occupies an important position in the art of the Classic period.

Kaminaljuyú, Guatemala, Formative period, c. 500 BC – AD 100.

Height 5 cm., 2 in.

Private collection, Munich.

11 Vessel in two parts. Clay. It takes the form of a squatting woman, apparently pregnant, or perhaps a fertility goddess. A fine mesh pattern was impressed on the moist clay before firing, and after it geometrical ornaments were incised on the scanty garments – bodice, loincloth and neckcloth – and the whole figure rubbed over with cinnabar. The ears are pierced for earrings. Earrings of painted clay, or polished jade for people of high rank, and small necklaces of clay or jade beads were the earliest and most popular forms of personal ornament. It is known that they were worn all over Mesoamerica around 1500 BC, long before clothes were worn. Earrings were still worn, by men as well as women, at the time of the first European landings. The ware of the Early Classic period in the highlands is known as Esperanza; it is almost contemporaneous with the Tzakol phase in the lowlands.

Kaminaljuyú, Guatemala. Early Classic period, c. AD 100–500.

Height 31·5 cm., 12·5 in.

Museo Nacional de Arqueología, Guatemala City.

12 View of part of the Great Plaza at Tikal, looking westwards from the platform of Temple I (height 47 m., 155 ft.) towards Temple II, the Temple of Masks (height 43 m., 142 ft.). In the background, Temple III (54 m., 178 ft.) on the left, and Temple IV (71 m., 234 ft.) can be seen thrusting up out of the dense vegetation. Temple IV is the tallest pre-Columbian building in America. Tikal, probably the largest centre of worship in the lowlands in the Classic period, lies about 190 miles north of Guatemala City in the almost uninhabited region of the Petén. Excavating archaeologists have already mapped buildings spread over an area of 6½ square miles. The site deserves the closest study for at least two reasons: firstly, because it was continuously occupied for a longer period than any other site in the lowlands; secondly, because the most recent research suggests that the site may yield up the reason why the Classic centres were abandoned.

Tikal, Petén, Guatemala. Classic period, c. AD 700–800.

13 Temple I at Tikal, also known as the Temple of the Great Jaguar. The pyramid is built in nine stages, with a steep stairway (now reconstructed) leading up to the temple, which contains only three chambers. The whole structure has been cleared of the luxuriant vegetation which still covers many of the other buildings at Tikal. Even though it is now in a dilapidated condition, the roof comb with its massive sculptures dominates the pyramid. There is hardly one among all the numerous temples of the Classic era which is not crowned with this characteristic architectural element. The temples of the Maya, like those of the Greeks, were painted in bright colours, which the rains have long since washed away. The six tall temples at Tikal were erected in the latter half of the Classic period, around the middle of the eighth century.

Tikal, Petén, Guatemala. Classic period, c. AD 700–800.

14 Stela 2. On one side of this monument, carved of hard stone, there is the figure of a priest-king with a stern, noble bearing, in an ornate costume, and on the other a calendar inscription. The stela was broken at some date, apparently deliberately, and the lower part was found on the Great Plaza, lying in front of a stela of a later date as its 'altar'. The other part, illustrated here, was left in the Acropolis.

Tikal, Petén, Guatemala. Classic period, c. AD 600–800.

Height 120 cm., 47·3 in.

15 Figure of an old god, bearded and almost toothless. Clay, polychrome. The figure holds a human head in his hands, and the bangles he wears on his arms and legs are decorated with human heads. His stool is formed from three thigh bones. The eyebrows, each formed of three flower petals, give this macabre figure a certain air of peacefulness, almost pleasantness. The figure was apparently used as a censer. The smoke of the copal resin burning inside came out through the mouth and must have intensified the figure's already uncanny appearance.

It was found in Tomb 10 at Tikal, in which a prince was buried around AD 400 with seven sacrificed

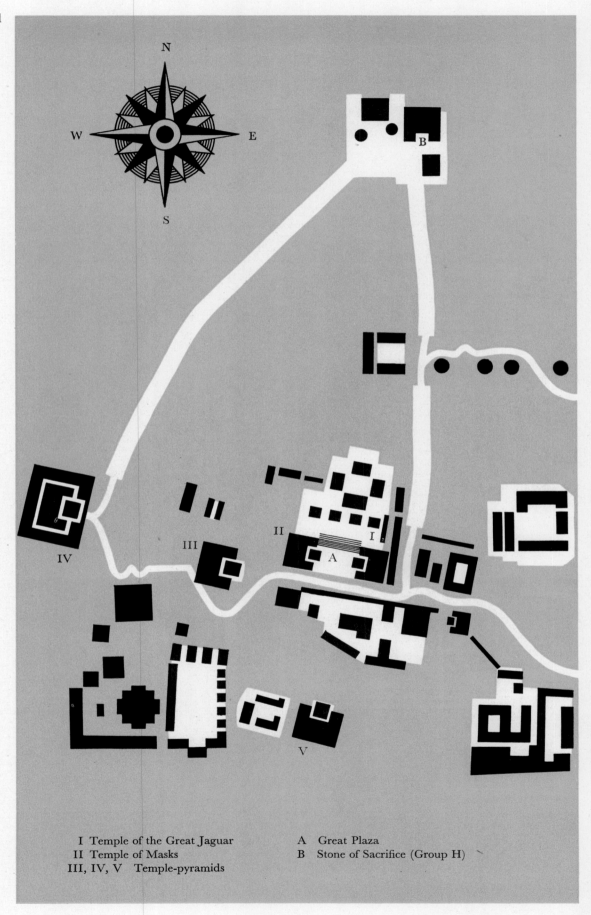

I Temple of the Great Jaguar A Great Plaza
II Temple of Masks B Stone of Sacrifice (Group H)
III, IV, V Temple-pyramids

boys. The dead man wore a headdress inlaid with three thousand pieces of jade, mother-of-pearl and quartz. As well as the usual grave goods, ornaments and ceramic vessels (including the piece illustrated in *pl. 19*), the tomb was also found to contain the skeletons of birds and tortoises, the spine of a crocodile and vestiges of maize flour and honey, which were placed there to make the dead man's journey more agreeable.

Tikal, Petén, Guatemala. Early Classic period, *c.* AD 400.

Height 36 cm., 14·2 in.

Museo Nacional de Arqueología, Guatemala City.

16 Stela 29 at Tikal, the earliest known dated stela. More than a thousand have been found so far on Maya sites in the lowlands, recording dates over a period of 597 years. The date carved on the back of Stela 29 is 8.12.14.8.15 13 Men 3 Zip, which corresponds to 6 July AD 292 (see note 9). The front of this broken column has the carving of a young priest-king, with his body shown frontally and his head in profile, like the figure on Stela 2 (*pl. 14*), but the carving is in a much worse state of deterioration and the outlines are almost erased. The inscription on this stela is already in a perfected form of script, and probably the only explanation why no earlier ones have been found at Tikal is that a change in taste brought about their destruction. It is likely that they were broken up and used as rubble in the bases of pyramids or elsewhere. Stela 29 gives the first date in a series which makes it possible to trace the evolution of style on most of the Maya sites up to AD 889, the date of the last stela, erected at Uaxactún. Dated stelae are found on all but a very small number of Classic sites.

Tikal, Petén, Guatemala. Early Classic period, AD 292.

Height *c.* 80 cm., 32 in.

17 Detail of a lintel in Temple III, Tikal. The fine carving on the wooden lintels of the temple doorways is one of the characteristics of this site. Sapodilla wood is the only one hard enough to have survived the on-slaughts of termites and the damp climate. In view of the fact that the craftsmen had only stone tools to work with, these beams are an astonishing technical feat. Only some minor fragments are left in Tikal itself, from which centuries-old layers of lime encrustation had to be removed before some idea of their original appearance could emerge. Two well-preserved examples of these carved lintels are to be found in the Völkerkunde-Museum in Basle and in the British Museum in London.

Tikal, Petén, Guatemala. Classic period, *c.* AD 600–800.

Dimensions *c.* 140 × 100 cm., 55 × 39 in.

18 The front of Stela 31, depicting a priest-king with a spear-thrower (*atlatl*) and a rectangular shield adorned with the head of the rain god. A warrior as well as a priest, the figure wears a plumed helmet as both adornment and protection.

Inscribed with the date 9.0.10.0.0 (AD 445), Stela 31 was found in a blocked passage in the base of a pyramid. This unusual position, and the defacement of the figures carved on two sides, have not been satisfactorily explained.

Tikal, Petén, Guatemala. Classic period, AD 445.

Height *c.* 120 cm., 47 in.

19 Polychrome vessel, with the knob on the lid modelled in the form of a bird's head. Clay. The decoration, painted in five colours, including a shade of blue-grey unusual in Maya ceramics, represents the rain god wearing a headdress in the form of a bird. This god, who was greatly venerated throughout Mesoamerica, can be identified by the rings round his eyes, resembling spectacles, and the protruding upper teeth. These iconographic conventions are probably of Mexican origin, and changed in Postclassic art. (This vessel, like the old god in *pl. 15*, came from Tomb 10 at Tikal.)

Tikal, Petén, Guatemala. Early Classic period, *c.* AD 400.

Diameter 27·5 cm., 10·8 in.

Museo Nacional de Arqueología, Guatemala City.

20 Altar before Stela M at Copán, in the form of a monster. The serpent's head with a human head in its jaws faces north. The date on Stela M is 9.16.5.0.0 8 Ahau 8 Zotz, which corresponds to AD 756. The main ball court of Copán can be seen in the background of the photograph.

Copán, Honduras. Classic period, AD 756.

Height *c.* 60 cm., 23·6 in.

21 Altar G 1 on the main plaza at Copán, with Stela F in the background. The inscription includes the date 9.18.10.0.0 10 Ahau 8 Zac, corresponding to AD 800, the latest date recorded at Copán. The exact significance of this two-headed serpent is still unknown.

Copán, Honduras. Classic period, AD 800.

Length *c.* 130 cm., 50 in.

22–23 Stela A (right) and Stela B. These both stand on the main plaza at Copán, and both are dated 9.15.0.0.0 4 Ahau 13 Yax (AD 731). A different date is carved on the west face of Stela A, which is one of the most sensitive works of art produced at Copán at its peak. It had fallen down, like most of the others, and was re-erected during the large-scale programme of restoration undertaken at Copán by the Carnegie Institute in 1935. Stelae B, A, F, and H form a square.

Copán, Honduras. Classic period, AD 731.

Height (A) 270 cm., 104·5 in.; (B) 260 cm., 100·6 in.

24 Detail of Stela H, of the same group as Stelae A and B. It is dated 9.17.12.0.0 4 Ahau 14 Muan (AD 782). It appears to be the only one of the many stelae at Copán to depict a female figure. She is dressed in a jaguar skin and decked with magnificent ornaments, and cradles in her arms the ceremonial bar carried by noblemen of the highest rank. Underneath the stela a necklace of jade beads and a small piece of gold leaf, probably from the centre of the necklace, were found. This is the only piece of gold which has been found in conjunction with a dated Maya monument. Analysis reveals that it was mined in Panama or Colombia; it was probably a votive gift on the occasion of the erection of the stela.

Copán, Honduras. Classic period, AD 782.

Height of the stela *c.* 260 cm., 100·6 in.

25 Stela F, another work of the chief period at Copán. It bears two inscriptions. According to Morley the correct date is 9.17.12.13.0 4 Ahau 13 Yax (AD 783). The other inscription gives a date some sixty years earlier.

Copán. Honduras. Classic period, AD 783.

Height *c.* 260 cm., 100·6 in.

26 Stela P, the oldest unbroken stela in the main group, dated 9.9.10.0.0 2 Ahau 13 Pop (AD 623). Compared with later stelae it is a rather unskilled piece of work, and illustrates how much the artists of Copán improved their standards.

Copán, Honduras. Classic period, AD 623.

Height *c.* 240 cm., 94·5 in.

27–28 The Hieroglyphic Stairway at Copán. This structure owes its name to the 2,500 individual glyphs carved on its 63 steps, the largest number of inscriptions on any Maya monument. Sylvanus Morley spent months scrutinizing the glyphs and found about thirty different dates spanning a period of two hundred years, from AD 544 to 744 (9.15.12.10.10 10 Oc 3 Cumhu).

As Gustav Stromsvik of the Carnegie Institute wrote, we can only guess at the purport of this gigantic inscription. It does not appear to be an astronomical table, but if that is to be ruled out, with the long timespan and the many dates, it is tempting to suppose that it could be a historical record of major importance. An inscription on this enormous scale could be rendered legible only in the form of a staircase, which the priest read as he climbed or descended, with the text at eye level.

Copán, Honduras. Classic period, *c.* AD 500–780.

29 Relief of seated god. This figure, from another stairway at Copán, may have been the preamble or an illustration to a text, but we are not likely ever to know for sure.

Copán, Honduras. Classic period, *c.* AD 600–800.

Height *c.* 38 cm., 15 in.

30 The ball court at Copán; in the background, the main plaza with the most important stelae. The ball game was already played by the Olmecs, who were probably the first race in the world to use balls made

of rubber. The importance of the ball game both to the Maya and to later civilizations in Mexico is demonstrated by the numerous courts laid out in the very centre of the ceremonial sites; there are nearly fifty on Maya sites alone. The game, which seems to have been umpired by priests, had its foundations in cosmology. The ball flying through the air represented the sun, while the courts, which were always laid out towards the north-east, represented the heavens and the underworld. In Mixtec and other Mexican pictographic manuscripts the game is played by the gods themselves. The position of the courts in the immediate vicinity of the chief temples on every site leaves no doubt that the game had a purely religious significance. The players were not allowed to touch the ball with their hands but propelled it from the hips.

Copán, Honduras. Classic period, AD 600–800.

31 Marker, one of the three set into the floor of the ball court. Basalt. The carving depicts priests performing a ritual.

Copán, Honduras. Classic period, c. AD 600–800.

Diameter c. 50 cm., 19·7 in.

Now in the museum at Copán.

32–34 The Reviewing Stand, the chief building in the West Court. This is so called by archaeologists because of the four tiers of steps or seats at the front of the building. These steps too have glyphs carved on them, including several dates. The one which is taken to be that of the building's completion corresponds to AD 771. In the centre of this building there stands a life-size figure of a god or daemon, with something resembling a torch in its left hand. The figure's bearing is dignified and its expression noble. A serpent is emerging from the left-hand corner of its mouth. Nothing whatever is known about the meaning and symbolic importance of this figure. The only known sculpture in a similar style is a monkey god found at La Venta, the Olmec centre.

Copán, Honduras. Classic period, AD 771.

Height of the figure c. 150 cm., 59 in.; head 40 cm., 15·75 in.

35 Altar Q, Copán. This is believed to commemorate a congress of astronomers which took place at Copán in AD 776. There are other dates also carved on the top of the stone. Sixteen men are carved in relief on its four sides, each seated cross-legged above a glyph, which probably indicates the religious centre which he represented. Sylvanus Morley believed that the purpose of the congress was to reform the calendar and bring it into line with the solar year. The monument confirms that Copán was one of the centres of learning and science in the Classic period; if the eventual decipherment of the glyphs shows that the delegates came from all over Maya territory, as it may well do, it will be the decisive proof that the site was in fact the intellectual capital of the entire area.

Copán, Honduras. Classic period, AD 776.

Height 70 cm., 27·5 in.; length of each side 112 cm., 44·1 in.

36 Jaguar Stairway on the west side of the East Court, with the so-called Venus Mask. The 'Venus mask' was originally given this name because it is flanked by the Maya symbols for the planet Venus. In my opinion it should be named after the sun god, Kinich Ahau, since the great blind eyes are his most characteristic attribute.

Copán, Honduras. Classic period, c. AD 750.

Height c. 60 cm., 23·5 in.

37–43 Sculptures. The art of Copán was one of detail, in which architecture and sculpture were united. It was not only the free-standing altars and stelae which created this impression, but also the carvings which were an integral factor in the character of every building. During the centuries of neglect, the tropical climate and the forest vegetation destroyed a great deal of this unity, so that the sculptors' works now lie scattered haphazardly among the buildings, and no one can be sure of their original positions.

Copán, Honduras. Classic period, c. AD 600–800.

Height (pl. 37) c. 40 cm., 15·75 in.; (pl. 38) 69 cm., 27 in.; (pl. 39) 33 cm., 13 in.; (pl. 40) 38 cm., 15 in.; (pl. 41) 57 cm., 22·5 in.;(pl. 42) c. 30 cm., 11·8 in.; (pl. 43) c. 80 cm., 31·5 in.

44 Head of a dignitary. Basalt. Sculptures like this were incorporated in the façades of buildings.

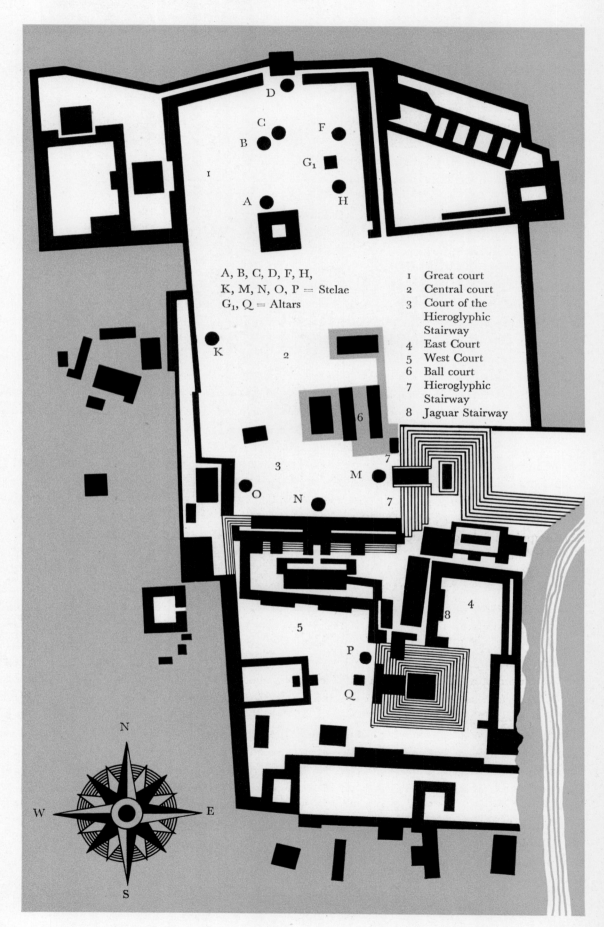

A, B, C, D, F, H,
K, M, N, O, P = Stelae
G₁, Q = Altars

I	Great court
2	Central court
3	Court of the Hieroglyphic Stairway
4	East Court
5	West Court
6	Ball court
7	Hieroglyphic Stairway
8	Jaguar Stairway

N
W E
S

Copán, Honduras. Classic period, *c.* AD 600–800.

Height 26 cm., 10·2 in.

American Museum of Natural History, New York, N.Y.

45 The young maize god. Stone.

Copán, Honduras. Classic period, *c.* AD 600–800.

Height 83 cm., 32·7 in.

Now in the museum at Copán.

46 Head of a dignitary. Light-coloured stone.

Playitas, Petén, Guatemala. Classic period, *c.* AD 600–800.

Height 31 cm., 12·2 in.

Museo Nacional de Arqueología, Guatemala City.

47 Large head from the façade of a building. Basalt.

Style of Copán. Classic period, *c.* AD 600–800.

Height *c.* 35 cm., 13·8 in.

Tulane University Museum, New Orleans, La.

48 Small vase decorated with two gods in relief. Clay. The design on the face not shown is similar. The sides of the vase are decorated with hieroglyphs, which are also interspersed between the reliefs.

El Progreso, Honduras. Classic period, AD 600–800.

Height 7·5 cm., 3 in.

Middle American Research Institute, Tulane University, New Orleans, La.

49 Vessel decorated with a scroll pattern and with handles carved in the form of jaguars. Calcite stone. A typical product of the region of the Rio Ulua, on the eastern extremity of the Maya empire. In the late Classic period, vessels like this were much sought after by merchants.

Ulua valley, Honduras. Late Classic period, *c.* AD 800–1000.

Height 25·5 cm., 10 in.

Middle American Research Institute, Tulane University, New Orleans, La.

50 Figure of a man seated on a low stool. Greenish, highly polished stone. The head is decorated, over the crown and round the ears, with a kind of scale pattern.

Rio Sumpul, El Salvador. Late Classic period, *c.* AD 800–1000.

Height 21·5 cm., 8·4 in.

Museum für Völkerkunde, Berlin.

51 Polychrome vase, decorated with two highly stylized figures. Clay. This style of figural representation, reminiscent in many ways of Art Nouveau, is confined in Maya art to the vicinity of the Rio Ulua in Honduras.

Ulua valley, Honduras. Classic period, *c.* AD 500–800.

Height 14·7 cm., 5·8 in.

Brooklyn Museum, New York, N.Y.

52 Polychrome bowl, decorated with a stylized seated figure. Clay. The fine brush strokes, the cobweb delicacy of the figures, and the intense red colouring are typical of a ceramic ware peculiar to the western part of El Salvador. This region has not yet been properly excavated, and it is not certain whether this ware is actually Maya in origin, or merely produced under the influence of Maya civilization. As yet archaeologists have not discovered any sites in the area covered by the modern republic of El Salvador which show any particular stylistic affinities to the Classic Maya centres. Some degree of influence from the Ulua valley is at least discernible in ceramics. Neither region, on the extreme eastern edge of Maya civilization, appears to have been acquainted with any form of hieroglyphic script; at all events, there is no trace of the use of one. Decoration in both regions is purely ornamental.

San Salvador? Late Classic period, *c.* AD 800–1000.

Height 8·5 cm., 3·4 in.; diameter 23 cm., 9 in.

Museo Nacional de El Salvador.

53 Vase decorated with stylized figures of lovers or dancers. Clay. The scenes are framed by interesting

ornamental patterns: the use of hieroglyphs is unknown on ceramic ware from this region. The influence exerted by the vase painting of the south-east lowlands is unmistakable throughout Maya territory, and doubtless it also extended to decorative art on a small scale in El Salvador. The origins of this sketchy style, almost reminiscent of Art Nouveau, lie in Uaxactún, near Tikal.

Lake Yojoa, Santa Barbara, Honduras. Classic period, *c.* AD 600–800.

Height 18·5 cm., 7·3 in.

Middle American Research Institute, Tulane University, New Orleans, La.

54 Altar L at Quiriguá, carved with the figure of a priest sitting cross-legged. Grey stone. As at Copán, it was customary at Quiriguá to place carved stone blocks, generally known as altars, in front of stelae. Altar L is dated 9.14.13.12.0 12 Ahau 3 Xul.

Quiriguá, Guatemala. Classic period, AD 725.

Diameter 105 cm., 41·4 in.

Museo Nacional de Arqueología, Guatemala City.

55 Stela E at Quiriguá. Red sandstone. This is the largest of all surviving Maya sculptures. Stelae E, F and D on the Plaza at Quiriguá all face east. Another priest or noble of high rank is carved on the back of Stela E, and series of glyphs are carved on both faces. The date, 9.17.0.0.0, marks the end of a *katun* (see note 14).

Quiriguá, Guatemala. Classic period, AD 771.

Height 1,165 cm., 38 ft 2·7 in.

56 Vessel. Clay, coloured dark brown in firing. The handle of the lid is modelled in the form of a small animal. The incised scroll pattern was originally picked out in purple paint.

Uaxactún (Tomb A 31), Petén, Guatemala. Early Classic period, Tzakol phase, *c.* AD 430–630.

Height 21 cm., 8·2 in.

Museo Nacional de Arqueología, Guatemala City.

57 Vase decorated on both sides with the painted figure of a seated priest. Clay.

Nebaj, Guatemala highlands. Late Classic period, Chama 3, *c.* AD 630–900.

Height 13·2 cm., 5·2 in.

Museo Nacional de Arqueología, Guatemala City.

58 Vase decorated with two priests painted in dark brown on an off-white ground. Clay. The delicacy of the strokes suggests that a hair brush was used.

Nebaj, Guatemala highlands. Late Classic period, Esperanza phase, AD 600–1000.

Height 15·3 cm., 6 in.

Museo Nacional de Arqueología, Guatemala City.

59 Vase decorated with mythological figures and a geometrical frieze. Clay.
North Guatemala highlands. Late Classic period, Esperanza phase, AD 600–1000.
Height c. 8 cm., 3·2 in.
Museo Nacional de Arqueología, Guatemala City.

60 Vessel in two parts, in the form of a squatting man. Polished clay, blackened in firing. There are traces
of white paint in the incised decoration.
Uaxactún (Tomb A 22), Petén, Guatemala. Early Classic period, Tzakol phase, c. AD 430–630.
Height 21 cm., 8·2 in.
Museo Nacional de Arqueología, Guatemala City.

61 Figure painted in the centre of a clay tripod vase, decorated in red and black on an orange ground. This
is one of the finest examples of Maya vase painting. The artist has captured the graceful motion of the dancer
with the minimum of strokes. The figure is ringed with a frieze of painted glyphs. The dish was 'killed',
before burial, by drilling a hole through its centre.
Uaxactún (Tomb A 3), Petén, Guatemala. Late Classic period, Tepeu 1, c. AD 600–675.
Diameter of vase 35·5 cm., 14 in.
Museo Nacional de Arqueología, Guatemala City.

62 Cylindrical vase, with sloping base. Clay, partly coated with stucco. The decoration consists of an
over-all herringbone pattern, two square panels containing rudimentary glyphs, and dots and bars, with the
numerical values of 1 and 5 respectively.
Uaxactún (Tomb 11 a), Petén, Guatemala. Late Classic period, Tepeu 2 phase, c. AD 675–750.
Height 17·8 cm., 7 in.
Museo Nacional de Arqueología, Guatemala City.

63 Polychrome dish, painted with the figure of a seated priest. Clay. This type of ware is stylistically akin
to the Ulua ware of Honduras. In some other respects it is rather similar to vase paintings from the northern
lowlands of Guatemala. Precise dating is not possible, since systematic excavations have not yet been carried
out in El Salvador.
El Tronconal, Dep. Ahuachtupán, El Salvador. Probably Classic period, c. AD 600–1000.
Height 7·3 cm., 2·9 in.
Museo Nacional de El Salvador.

64 Tall vase with figures of priests performing a ceremony. Clay. The painted hieroglyphic inscription
includes a date, equivalent to 263 BC. which must be a mistake, and should probably be 137 BC. The vase
itself was made several centuries later, and the scene probably depicts a historical event.
Uaxactún (Tomb A 2), Petén, Guatemala. Classic period, Tepeu 1, c. AD 600–675.
Height 24 cm., 9·4 in.
Museo Nacional de Arqueología, Guatemala City.

65 Vase decorated with two priests (illustrated) and hieroglyphs, incised in relief. Brown clay.
Probably Uaxactún region, Petén, Guatemala. Late Classic period, Tepeu 3, c. AD 750–900.
Height 20 cm., 7·9 in.
Museo Nacional de Arqueología, Guatemala City.

66 Painted vase. Clay. The decoration is typical of the naturalistic style of Chama, where the finest Maya
vase painting was produced. It lies at a point on the northern edge of the highlands, where the transition is
made to the tropical rain forest of Petén. The representation of the priests performing a ceremonial act is
exaggerated almost to the point of caricature. The glyphs interspersed among the figures probably give the
names and history of the people depicted, but have not been deciphered.
Chama, north-eastern Guatemala highlands. Late Classic period, Chama 3, c. AD 750–900.
Height 24·5 cm., 9·6 in.
University Museum, Philadelphia, Pa.

67 Fragment of a tall vase, with a red and orange painted decoration on a cream ground. Clay.
Uaxactún, Petén, Guatemala. Classic period, Tepeu 2, c. AD 675–750.

Height 9 cm., 3·6 in.

Museo Nacional de Arqueología, Guatemala City.

68–69 Painted vase depicting a procession, perhaps a funeral. Clay. A dignitary is being carried in a litter. The dog following him is a symbol of death.

Ratinlixul, north-eastern Guatemala highlands. Late Classic period, Chama 3, c. AD 750–900.

Height 21 cm., 8·2 in.

University Museum, Philadelphia, Pa.

70 Fragment of a dish. Clay. This is one of the very few examples of eroticism in Maya art. It may illustrate a forgotten myth in which a monkey god couples with a woman. The colours are red, black, white and pale blue.

Uaxactún, Petén, Guatemala. Classic period, Tepeu 2, c. AD 675–750.

Height 7 cm., 2·8 in.

Museo Nacional de Arqueología, Guatemala City.

71 Vessel with painted decoration of three priests seated round an altar or an incense-burner, drawn in black and several shades of red on a cream ground. Clay.

Chama, north-eastern Guatemala highlands. Late Classic period, Chama 4, c. AD 900.

Height 18·8 cm., 7·4 in.

University Museum, Philadelphia, Pa.

72 Polychrome vessel, with a picture of a bat god, repeated on the other side, painted in black, orange and brown on a cream ground. Clay.

Chama, north-eastern Guatemala highlands. Late Classic period, Chama 3, c. AD 750–900.

Height 20 cm., 7·9 in.

University Museum, Philadelphia, Pa.

73 Tall vessel, painted in dark brown and several shades of red and yellow. Clay. The main motif is a highly stylized serpent. The pattern of the frieze is taken from basket weaving.

San Salvador? Late Classic period, c. AD 800–1000.

Height 21·5 cm., 8·4 in.

Brooklyn Museum, New York, N.Y.

74 Polychrome vase. Clay. The painted decoration consists of a hieroglyphic frieze and oval fields with stylized mythological figures on both sides of the bowl.

Uaxactún (Tomb A 23), Petén, Guatemala. Classic period, Tepeu 1, c. AD 600–675.

Height 12·5 cm., 5 in.

Museo Nacional de Arqueología, Guatemala City.

75 Vase. Clay. Beneath a hieroglyphic frieze, two highly stylized priests, seated and leaning forwards, alternating with two rectangular fields. The two figures are related stylistically to the 'wasp-waisted' figures of El Salvador. The delicately formed and differentiated hieroglyphs, on the other hand, make it quite certain that the vessel was made in Guatemala.

Northern lowlands or north-eastern highlands of Guatemala. Classic period, c. AD 600–1000.

Height 15·5 cm., 6·1 in.

Museum für Völkerkunde, Berlin.

76 Polychrome vase. Clay. Decorated with a group of travellers – priests on a pilgrimage or merchants. Round the rim, a frieze which imitates plaited raffia.

Probably from the borders of Guatemala and Honduras. Classic period, c., AD 600–1000.

Height 15 cm., 5·9 in.

Brooklyn Museum, New York, N.Y.

77 Decorated vase. Clay. The decoration consists of the body of a monkey painted on the beaker, while its head is modelled in three dimensions.

Probably Honduras. Classic period, c. AD 600–1000.

Height 15·5 cm., 6·1 in.

Brooklyn Museum, New York, N.Y.

78 Large dish. Clay. The painting is of a dancer in a bird mask. Although, like all pre-Columbian ceramic ware, this dish was made without a potter's wheel, the largest variation in its diameter is only 4 millimetres.
Poptun, northern Guatemala. Early Classic period, Tzakol phase, *c.* AD 350–600.
Diameter 26·5 cm., 10·4 in.
Museo Nacional de Arqueología, Guatemala City.

79 Vase. Clay. Painted with two representations of the bat god, and two glyphs on each side between the figures. Clay.
Nebaj, northern Guatemala highlands. Classic period, *c.* AD 600–1000.
Height 14·7 cm., 5·8 in.
Museo Nacional de Arqueología, Guatemala City.

80 Interior of a painted tripod vase. Clay. The decoration shows a priest performing a ritual dance. El Salvador has no large buildings to rival the lowland sites to the north, in Guatemala and Honduras, but its subtle ceramic art is a perfectly adequate compensation. It is still not certain whether the inhabitants of El Salvador at this period were Maya tribes or not; but there can be no doubt of the presence of Maya influences, originating from Uaxactún and from the Ulua valley in Honduras, on both the forms and the style of this ware.
San Salvador? Late Classic period, *c.* AD 600–1000.
Diameter 27 cm., 10·6 in.
Museo Nacional de El Salvador.

81 Tripod vase, similar to that illustrated in *pl. 80.* The head of a mythical animal is modelled in three dimensions on the rim. A design in red and black is painted on the cream ground.
San Salvador? Late Classic period, *c.* AD 600–1000.
Height 13 cm., 5·1 in.
Museo Nacional de El Salvador.

82 Vessel in the form of a crouching woman with a jug on her shoulder. Red clay, vestiges of black and green paint. The woman's hair is parted in the middle and falls to her waist. The artist creates a remarkable expressive force by the fusion of the burden and the bearer, so that although the figure is only five inches high the effect it makes is monumental.
Cobán, Alta Verapaz, Guatemala highlands. Late Classic period, *c.* AD 700–1000.
Height 12·5 cm., 5 in.
Museum für Völkerkunde, Berlin.

83 Figure of a seated woman. Greyish-brown clay. Her dress is simple but she wears rich ornaments: rectangular earrings and a necklace, probably of jade beads. Her hair is elegantly styled. This is probably the likeness of an actual person.
Cobán, Alta Verapaz, Guatemala highlands. Late Classic period, *c.* AD 700–1000.
Height 14·5 cm., 5·7 in.
Carlos Nottebohm collection, Guatemala City.

84 Clay fragment, with the figure of a seated priest in shallow relief.
Probably northern Guatemala. Classic period, *c.* AD 600–1000.
Height 7·5 cm., 3 in.
Museo Nacional de Arqueología, Guatemala City.

85 Whistle in the form of a maize god. Clay. The figure, standing and holding maize cobs in both hands, wears a large number of necklaces and bangles on the wrists and ankles.
Found in a cave at Chicuc, Alta Verapaz, Guatemala. Late Classic period, *c.* AD 700–1000.
Height 23 cm., 9 in.
Museo Nacional de Arqueología, Guatemala City.

86 Figure of the sun god Kinich Ahau. Clay. It was probably a censer in which sacred copal resin was burnt.

Chimuxan, Alta Verapaz, Guatemala. Postclassic period, *c.* 1000–1300.

Height 23 cm., 9 in.

University Museum, Philadelphia, Pa.

87 Two-handled vessel. Clay, showing vestiges of red paint. A human figure is modelled in high relief on the side, with a throwing spear in one hand and traces of tears on the cheeks. It may represent a person chosen for sacrifice, or a god.

Pazún, Guatemala highlands. Late Classic period, *c.* AD 700–1000.

Height 33 cm., 13 in.

Carlos Nottebohm collection, Guatemala City.

88 Tripod censer, with a figure modelled in high relief on the side. Clay, unpolished. The feet of the vessel take the form of small human heads. The disproportionately large nose, tilted slightly upwards, suggests that the figure is a god, probably a rain god. Figures like this, which seems rather comic to us, have been found in La Mixteca Alta in Mexico.

Nebaj, northern highlands of Guatemala. Postclassic period, *c.* AD 1000–1300.

Height 24·5 cm., 9·6 in.

Museo Nacional de Arqueología, Guatemala City.

89 Rectangular, straight-sided vessel. Clay, unpolished. There are highly stylized human figures in relief on two faces, the heads in high relief, and an applied handle and a head in relief on the alternate sides.

Nebaj, northern highlands of Guatemala. Late Classic period, *c.* AD 700–1000.

Height 30·5 cm., 12 in.

Museo Nacional de Arqueología, Guatemala City.

90 Fragment of a large female figure. Clay, with traces of red paint. The figure is holding a bowl and wears earrings, in the form of maize cobs, and a necklace. Her upper arms are scarred with the marks of tattooing. This may not even be Maya work, and it cannot be dated.

Pacific coast of Guatemala. Date unknown.

Height 33 cm., 13 in.

Museo Nacional de Arqueología, Guatemala City.

91 Vessel in the form of a seated, possibly pregnant woman, holding a jug. Polished clay, blackened in firing.

Almost certainly from the Guatemala highlands. Probably Late Classic period, *c.* AD 700–1000.

Height 24 cm., 9·4 in.

University Museum, Philadelphia, Pa.

92 Vessel, perhaps a censer, with a stylized human figure in relief. Clay, traces of white paint. The figure wears a loincloth, a collar, nose and ear plugs, a bead necklace, and bead bracelets and anklets.

Pazún, Guatemala highlands. Probably Late Classic period, *c.* AD 700–1000.

Height 31 cm., 12·2 in.

Carlos Nottebohm collection, Guatemala City.

93 Large pot with a human figure modelled in high relief. Clay. The figure is naked except for necklace and earrings. This type of ware, known as Thin Orange, resulted from the influence of the culture of Teotihuacán, in the Valley of Mexico, which was particularly strong at Kaminaljuyú. The architecture and the ceramics on both sites are so similar that many scholars believe that Kaminaljuyú was actually a colony of the Mexican civilization. Kaminaljuyú, on the outskirts of Guatemala City, is 625 miles as the quetzal flies from the site of Teotihuacán.

Kaminaljuyú, Guatemala highlands. Early Classic period, Esperanza phase, *c.* AD 200–500.

Height *c.* 30 cm., 11·8 in.

Museo Nacional de Arqueología, Guatemala City.

94 Model of a bird, perhaps a turkey. Solid clay, unpainted. Little figures like this are usually pipes, rattles or ocarinas. It is not certain whether this was a toy or made for a grave.

Guatemala highlands. Late Classic period, *c.* AD 800–950.

Height 8 cm., 3·2 in.

Stendahl collection, Los Angeles, Calif.

95 Tall beaker with incised decoration of two dancing monkeys. Dark grey clay.

Guatemala highlands. Classic period, *c.* AD 600–1000.

Height 20·5 cm., 8 in.

University Museum, Philadelphia, Pa.

96 Ocarina in the form of a bird. Clay.

Alta Verapaz, Guatemala highlands. Late Classic period, *c.* AD 800–950.

Height 8·2 cm., 3·3 in.

University Museum, Philadelphia, Pa.

97 Figurine of a dancer in a padded costume. Clay, vestiges of the original paint.

Northern highlands of Guatemala. Late Classic period, *c.* AD 800–950.

Height 11·8 cm., 4·7 in.

University Museum, Philadelphia, Pa.

98 Ocarina in the form of a tapir. Clay.

Northern highlands of Guatemala. Late Classic period, *c.* AD 800–950.

Height 7·8 cm., 3·1 in.

University Museum, Philadelphia, Pa.

99 Pendant, showing a seated dignitary talking to a dwarf. The scroll-type decoration includes seven heads of gods or priests. Jade.

Nebaj (Depot 14), northern highlands of Guatemala. Classic period, *c.* AD 600–1000.

Length 14·5 cm., 5·7 in.; maximum thickness 1·8 cm., 0·7 in.

Museo Nacional de Arqueología, Guatemala City.

100 Seated figure. Greenish-brown fuchsite. The eyes were formerly inlaid with pieces of shell. The fingers and the facial scars are particularly fine incised work. The simplicity and austere perfection betray Olmec influences. This little masterpiece was found in a depot at Uaxactún with flint blades and jade beads.

Uaxactún, Petén, Guatemala. Early Classic period, Tzakol 1, *c.* AD 300–350.

Height 26 cm., 10·2 in.

Museo Nacional de Arqueología, Guatemala City.

101 *Hacha* in the form of a stylized bird's head. Stone. The *hacha* or 'votive axe' is an outsider in Maya art. It probably originated in the central Gulf coast of Mexico, and is the only one of a number of forms typical of that area to have been adopted by the Maya. The objects illustrated were found in graves in the highlands and near the Pacific coast of Guatemala, and were more probably made there by Maya craftsmen rather than imported. Like the ones made on the Gulf coast, the motifs are usually heads of animals or humans. They may represent the emblems of various warrior castes.

Escuintla, Pacific coast of Guatemala. Postclassic period (non-Maya?), *c.* AD 1000–1500.

Height 28 cm., 11 in.

Carlos Nottebohm collection, Guatemala City.

102 *Hacha* in the form of a stylized skull. Grey basalt, semi-polished. See note to *pl. 101*.

Guatemala highlands. Postclassic period (non-Maya?), *c.* AD 1000–1500.

Height 28·5 cm., 11·2 in.

Carlos Nottebohm collection, Guatemala City.

103 *Hacha* in the form of a stylized jaguar's head. Grey polished stone. See note to *pl. 101*.

Antigua, Guatemala highlands. Postclassic period (non-Maya?), *c.* AD 1000–1500.

Height 28 cm., 11 in.

Carlos Nottebohm collection, Guatemala City.

104 Fragment of a *hacha* in the form of a man's head. Grey polished stone. See note to *pl. 101*.

Pacific coast of Guatemala. Postclassic period (non-Maya?), *c.* AD 1000–1500.

Height 18 cm., 7·1 in.

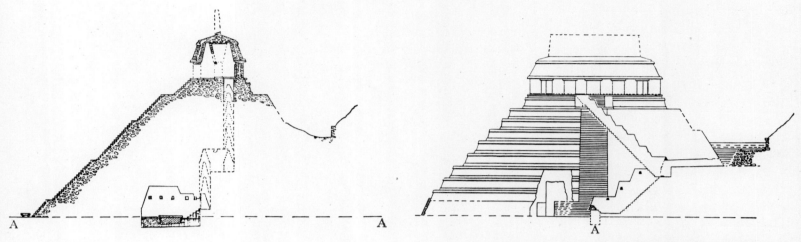

57-58 The Temple of the Inscriptions, Palenque

Carlos Nottebohm collection, Guatemala City.

105 *Hacha* in the form of a warrior's head. Grey semi-polished stone. See note to *pl. 101*. The headdress is in the form of the pelt from the head of a jaguar. (A few years ago the Republic of Guatemala used this exquisite work of art as the model for a postage stamp.)

San José, Pacific coast of Guatemala. Postclassic period (non-Maya?), *c.* AD 1000–1500.

Height 25 cm., 9·8 in.

Carlos Nottebohm collection, Guatemala City.

106 *Hacha* in the form of a stylized bird's head. Green speckled stone. See note to *pl. 101*.

Guatemala highlands. Postclassic period (non-Maya?), *c.* AD 1000–1500.

Height 27·8 cm., 10·9 in.

Carlos Nottebohm collection, Guatemala City.

107 Palenque, seen from the air. The most prominent structures are the Palace and the pyramid of the Temple of the Inscriptions. Like the other lowland centres, Palenque was abandoned at the end of the Classic period, around the second half of the ninth century. The last dated inscription corresponds to AD 785.

Palenque, Chiapas, Mexico. Classic period, *c.* AD 500–900.

108 The Temple of the Inscriptions, Palenque. In 1952 the Mexican archaeologist Alberto Ruz Lhuillier discovered the burial chamber of a dignitary 82 feet below the floor of the temple at the end of a long passage (see *figs 57, 58*).

Palenque, Chiapas, Mexico. Classic period, *c.* AD 692.

109 Figure of the sun god Kinich Ahau, found in the crypt of the Temple of the Inscriptions. Jade.

Palenque, Chiapas, Mexico. Classic period, *c.* AD 692.

Height 9 cm., 3·5 in.

Museo Nacional de Antropología, México D.F.

110 Stone slab, carved in relief, the lid of the sarcophagus in the crypt of the Temple of Inscriptions (see *fig. 22*).

Palenque, Chiapas, Mexico. Classic period, *c.* AD 692.

111 The passage leading down to the crypt of the Temple of the Inscriptions.

Palenque, Chiapas, Mexico. Classic period, *c.* AD 692.

112 Bas-relief of a dignitary from the sarcophagus in the crypt of the Temple of the Inscriptions.

Palenque, Chiapas, Mexico. Classic period, *c.* AD 692.

Approximately life size.

113 Stucco relief on the wall of the crypt of the Temple of the Inscriptions, depicting one of the Nine Lords of the Night.

Palenque, Chiapas, Mexico. Classic period, *c.* AD 692.

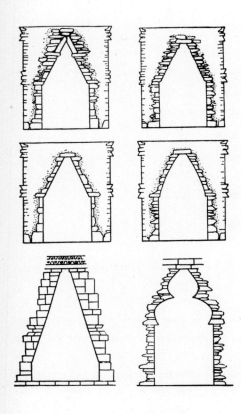

59 Examples of the corbel vault in Maya architecture

114–115 Two human heads. Plaster. These heads, found in the royal tomb beneath the Temple of the Inscriptions, testify to the skill of the artists of Palenque.
Palenque, Chiapas, Mexico. Classic period, *c.* AD 692.
Height (*pl. 114*) 39·5 cm., 15·6 in.; (*pl. 115*) 28 cm., 11 in.
Museo Nacional de Antropología, México D.F.

116 Head of an old man or a god. Made of small pieces of jade (reconstructed by Alberto García M.). This was found among the valuable grave goods in the crypt beneath the Temple of the Inscriptions.
Palenque, Chiapas, Mexico. Classic period, *c.* AD 692.
Height *c.* 10 cm., 3·9 in.
Museo Nacional de Antropología, México D.F.

117 Mosaic mask. Jade; the eyes are made of mother-of-pearl, the pupils of obsidian. More than 200 pieces were used to make this mask, which covered the face of the dignitary buried beneath the Temple of the Inscriptions.
Palenque, Chiapas, Mexico. Classic period, *c.* AD 692.
Height *c.* 30 cm., 11·8 in.
Museo Nacional de Antropología, México D.F.

118 Head of a young priest. Plaster. Like the heads illustrated in *pls 114, 115* and *119* this clearly shows the Maya ideal of beauty. While they were still babes in arms, the heads of children of high birth were squeezed between two boards to flatten the forehead permanently. Later a piece of rubber seems to have been inserted under the skin to raise the apparent height of the bridge of the nose, when possible to the middle of the forehead.
Region of Palenque, Chiapas, Mexico. Classic period, *c.* AD 600–900.
Height *c.* 25 cm., 9·8 in.
Dr Kurt Stavenhagen collection, México D.F.

119 Head of a dignitary. Clay, traces of the original red and blue paint.
Region of Palenque, Chiapas, Mexico. Classic period, *c.* AD 600–900.
Height 21·5 cm., 8·4 in.

Dr Kurt Stavenhagen collection, México D.F.

120 Corridor on the east side of the Palace, Palenque. Rooms were necessarily narrow and passage-like in the Classic period, since the Maya did not know how to construct vaults and it was not possible to construct square rooms with the use of supports. The only exceptions to this rule were the temples in the highlands which had straw roofs, long since decayed.

Palenque, Chiapas, Mexico. Classic period, *c.* AD 600–850.

121 The Temple of the Sun. This is the best preserved of all Classic Maya buildings. It and two similar temples, those of the Cross and the Foliated Cross, enclose a ceremonial plaza. It contains two rectangular, corbel-vaulted chambers, which run parallel to the front of the building. In the inner chamber there is a tablet with an inscribed date corresponding to AD 692. The stucco facing characteristic of Palenque, and the roof comb typical of Classic Maya architecture, have both survived only in a much damaged condition. (See also *fig. 61.*)

Palenque, Chiapas, Mexico. Classic period, *c.* AD 692.

122 The tower of the Palace before restoration, just as it was when Alfred Maudslay first cleared the ruins of the vegetation which covered them at the end of the nineteenth century.

Palenque, Chiapas, Mexico. Classic period, *c.* AD 600–850.

123 The complex of buildings known as the Palace. This stands on a man-made platform measuring approximately 250 by 330 feet. It consists of five courtyards, a large number of rooms and underground chambers. Together with the use of the crypt and the stucco facings, the tower is the third individual characteristic of Palenque. The original function of the three-storied tower may have been as an astronomical observatory. The jungle growth overwhelmed it at a very early stage. Travellers in the eighteenth century, when it was still somewhat nearer to its original state, unfortunately compounded the damage by allowing Catholic stylistic elements to insinuate themselves into their drawings, whose influence is felt in the modern reconstruction. Even a layman cannot fail to be aware that the tower is alien to the rest of the complex.

Palenque, Chiapas, Mexico. Classic period, *c.* AD 600–850.

124 Stucco relief on the west side of the Palace, dating from about one century later than the squat, rustic figures on the stone tablets (*pl. 126*). The rituals performed by young priests and matrons are commemorated with a rococo elegance which has come a long way from the archaic forms. The stucco decoration on the façades at Palenque is unique, but it has suffered much as a result of the frequent burning of the vegetation by farmers, and at the hands of early visitors to the site, and only fragments survive. Frederick Catherwood's drawings of 1840 show a great deal more than now remains.

Palenque, Chiapas, Mexico. Classic period, *c.* AD 650–750.

Height 260 cm., 100·6 in.

125 The north courtyard of the Palace, from the tower. The glyphs carved on the steps on the east side give a date corresponding to AD 603. The stairs on the west side are lined by large stone blocks, carved with squat figures of more than life size. They are notably different from the baroque character of the later reliefs in plaster.

Palenque, Chiapas, Mexico. Classic period, AD 603.

126 Relief from the stairway in the north courtyard of the Palace. It is not certain whether the figures are suppliants, victims destined for sacrifice, or prisoners.

Palenque, Chiapas, Mexico. Classic period, AD 603.

Height of the figures between 200 and 330 cm., 78–130 in.

127 The north group of buildings at Palenque forms an integrated complex on its own. The small, self-contained structures mark the edge of the site, overlooking the plain. Palenque stands on flattened ground on the slope of a range of hills.

Palenque, Chiapas, Mexico. Classic period, AD 600–900.

128 The Temple of the Foliated Cross (*Cruz foliada*). The name derives from a bas-relief in the inner chamber, which has at its centre a cross whose arms terminate in leafy forms.

Palenque, Chiapas, Mexico. Classic period, *c.* AD 650–750.

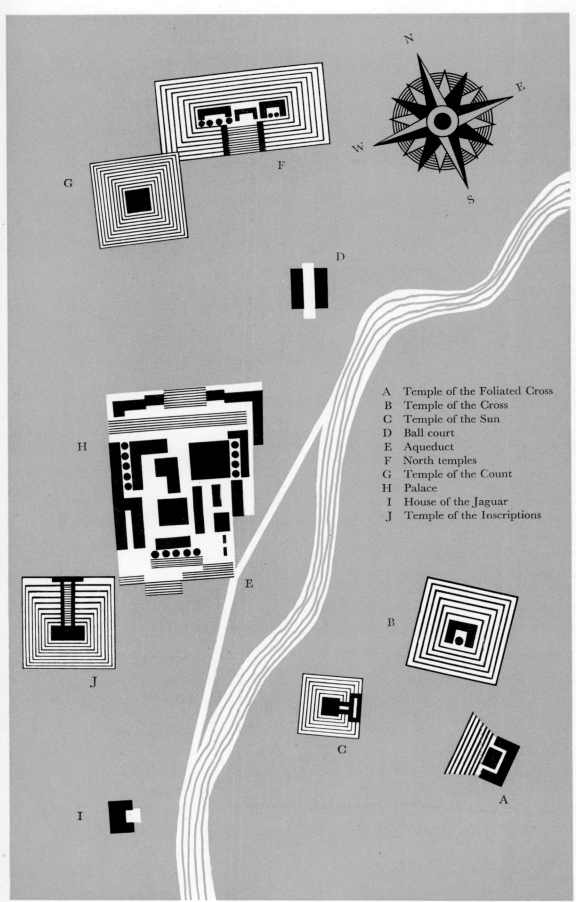

A Temple of the Foliated Cross
B Temple of the Cross
C Temple of the Sun
D Ball court
E Aqueduct
F North temples
G Temple of the Count
H Palace
I House of the Jaguar
J Temple of the Inscriptions

129 Detail of a bas-relief in the Temple of the Foliated Cross, showing a priest performing a ceremony. (Cf. *figs 24–25*.)

Palenque, Chiapas, Mexico. Classic period, *c*. AD 692.

Height of the relief 183 cm., 72 in.; height of the portion reproduced *c*. 140 cm., 55 in.

130 The Tablet from Temple XXI. The object in the hands of the kneeling figure cannot be identified with any certainty. Stylistically, this relief resembles the Tablet of the Writer (*pl. 131*).

Palenque, Chiapas, Mexico. Classic period, *c*. AD 600–800.

Height 132 cm., 52 in.

Museo de las Ruinas, Palenque.

131 The Tablet of the Writer (*Lápida del Escriba*) was found in the Palace, near the base of the tower. It depicts a kneeling figure who holds a scroll in the left hand and an object in the right which is taken to be a writing implement. The hieroglyphs have not yet been deciphered.

Palenque, Chiapas, Mexico. Classic period, *c*. AD 600–800.

Height 131 cm., 51·6 in.

Museo de las Ruinas, Palenque.

132 Four day glyphs from Temple XVIII. Plaster. When this building was excavated, 149 glyphs were found, which had originally been on a plaque set into the wall. Many of them had been broken, so that it was impossible to read the inscription, which may well have been concerned with lunar calculations of some kind. Palenque, Chiapas, Mexico. Classic period, *c*. AD 600–800.

Approximately 12 × 13·4 cm., 4·75 × 5·3 in.

Museo de las Ruinas, Palenque.

133, 135–138 Five figural initial glyphs from a series on the Tablet of the Palace (*Tablero del Palacio*), which was found in 1949 in the northern section of that building. It includes a chronological sequence of fifteen different but related dates, between AD 644 and 720. The figural glyphs, composed of human figures, animals and mythical beings, are rare elements in the Maya script. Apart from Palenque they have been found only at Yaxchilán (Mexico), Quiriguá (Guatemala) and Copán (Honduras).

Palenque, Chiapas, Mexico. Classic period, *c*. AD 720.

Height of the glyphs 24 cm., 9·4 in.

Museo de las Ruinas, Palenque.

134 The Tablet of the Slaves (*Tablero de los Esclavos*). This was found in Complex 4, about 1000 feet to the west of the Temple of the Inscriptions. It depicts a priest and a priestess offering gifts, probably ceremonial regalia, to a prince seated on the backs of two slaves. The inscription gives eleven different dates of the seventh and eighth centuries.

Palenque, Chiapas, Mexico. Classic period, *c*. AD 700–800.

151 × 164 cm., 59·5 × 64·6 in.

Museo de las Ruinas, Palenque.

135–138 See 133.

139 Head of a man. Plaster. Despite the similarity of type displayed by all the heads found so far, there are differences which suggest that they are portraits of individual priests and rulers. Provenance unknown, style of Palenque. Classic period, *c*. AD 600–800.

Height *c*. 15 cm., 5·9 in.

Dr Kurt Stavenhagen collection, México D.F.

140 Detail of cylindrical vessel from the Temple of the Foliated Cross. Clay, traces of the original red, blue and turquoise paint. Several urns like this were found in the same place; they were probably used as receptacles for votive gifts. They are all decorated with the face of the sun god, whose characteristics include the great 'blind' eyes, ringed by wavy lines, the aquiline nose, the T-shaped tooth and the serpentine lines wriggling out of the corners of his mouth.

Palenque, Chiapas, Mexico. Classic period, *c*. AD 700.

Height 116 cm., 45·7 in.

Museo Nacional de Antropología, México D.F.

141 Lintel, carved with the figure of a prostrate warrior or prisoner. Limestone. At both ends, badly damaged glyphs.
Toniná, Chiapas, Mexico. Classic period, *c.* AD 700–800.
Length 96 cm., 37·8 in.
Museo Nacional de Antropología, México D.F.

142 Stela. One of the very few that appear to depict historical events, in this case the victory of one Maya chief over another.
Balam-Kan, Tabasco, Mexico. Classic period, *c.* AD 700–800.
Height *c.* 170 cm., 66·9 in.
Museo Regional de Tabasco, Villa Hermosa.

143 Relief of a priest sacrificing birds in a basin. Limestone. The scene is accompanied by a hieroglyphic inscription.
Jonuta, Tabasco, Mexico. Classic period, *c.* AD 700–800.
Height 103 cm., 40·5 in.
Museo Nacional de Antropología, México D.F.

144 Human head wearing a ceremonial headdress. Plaster. The model is set into a flight of steps leading up to a temple.
Comalcalco, Tabasco, Mexico. Classic period, *c.* AD 700–900.
Height 110 cm., 43·3 in.

145 Comalcalco, a site not far from Palenque. The relationship between the two sites, with Comalcalco, the later, deriving many of its styles and techniques from the earlier, parallels that between Copán and Quiriguá.
Comalcalco, Tabasco, Mexico. Classic period, *c.* AD 600–900.

146 Figure of a seated priest, one of many which decorate the stairway at Comalcalco. Originally the buildings and the carved stairways were painted.
Comalcalco, Tabasco, Mexico. Classic period, *c.* AD 700–900.
Height 64 cm., 25·2 in.

147 Head of a prince. Limestone. The style of this head is unusual in Maya art; a European might find it almost Hellenistic in character.
Comalcalco, Tabasco, Mexico. Classic period, *c.* AD 700–900.
Height 43 cm., 17·9 in.
Museo Nacional de Antropología, México D.F.

148 Fragment of a girl's head. Clay. The Chiapas highlands, on the western edge of Maya civilization, like El Salvador and Honduras (with the exception of Copán) on the eastern edge, experienced only a small measure of the cultural efflorescence of the lowlands, with no great buildings, like those of Palenque or Tikal, and no stelae like those of Yaxchilán and Copán. Hieroglyphic inscriptions, too, are rare and occur only in an old, rudimentary script. The ceramics of the area frequently show the signs of Mexican influences, Olmec in early works, and from the central Gulf Coast in later works.
Chiapas highlands, Mexico. Late Classic period, *c.* AD 700–1100.
Height 13·5 cm., 5·3 in.
Museo Regional de Chiapas, Tuxtla Gutiérrez.

149 Clay fragment, with the head of a man in high relief.
Tabasco, Mexico. Classic period, *c.* AD 800–950.
Height *c.* 32 cm., 12·5 in.
Museo Regional de Tabasco, Villa Hermosa.

150 Censer in the form of the Mexican god Xipe Totec, the Flayed God, wearing an extra, 'new' skin to symbolize the recurrence of spring (cf. F. Anton: *Ancient Mexican Art*, London and New York 1970). This clay vessel was dug up in Antigua in the Guatemala highlands and shows strong signs of Toltec influences. The Toltec tribes who had been driven out of Tula in the Mexican highlands passed through the highlands

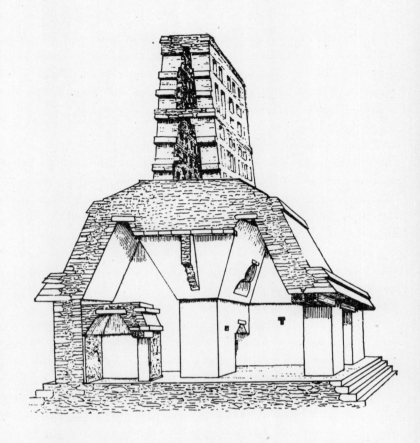

61 Section drawing of
the Temple of the Sun at Palenque

of Guatemala during the twelfth and thirteenth centuries. Their wanderings have been traced as far as Costa Rica. The tribes of Pipil Indians who still live in the highlands of Guatemala and El Salvador are their descendants.

Antigua, Guatemala. Postclassic period, *c*. AD 1200–1500.

Height 27 cm., 10·6 in.

Carlos Nottebohm collection, Guatemala City.

151 Vessel in the form of a man's head. Clay, coloured dark grey in firing. This may have been used to burn offerings of incense, such as copal resin.

Chiapa de Corso, Chiapas, Mexico. Early Classic period, *c*. AD 200–500.

Height 12·5 cm., 5 in.

Museo Regional de Chiapas, Tuxtla Gutiérrez.

152 Ornamental pendant. Green jade. The human head merges directly into the stylized plumes at the back; it probably represents a god.

Guatemala highlands. Classic period, *c*. AD 600–1000.

Height 4·8 cm., 1·9 in.; width 8 cm., 3·2 in.

Cleveland Museum of Art, Cleveland, Ohio.

153 Vessel in the form of a wayfarer carrying a large jug on his back. Clay. The walking-stick is the vessel's spout. Zapotec influence.

Chiapa de Corso, Chiapas, Mexico. Classic period, *c*. AD 500–900.

Height 31 cm., 12·2 in.

Museo Regional de Chiapas, Tuxtla Gutiérrez.

154 Zoomorphic god. Clay. The figure is carrying a large bowl, and has the attributes of a jaguar; it may in fact represent a priest in a jaguar mask.

Rancho los Bordos, Chiapas, Mexico. Date unknown.

Height 32 cm., 12·6 in.

Museo Regional de Chiapas, Tuxtla Gutiérrez.

155 Vessel with relief decoration. Clay. Models like this were frequently placed in caves or in temples as votive gifts. The human figure, modelled in high relief, is seated on a stool in the form of a mask of the Lord of the Underworld, and his headdress, or it may be the canopy of his throne, is in the form of a mask of the rain god. The rest of the baroque decoration is composed of bizarre figures whose heads have been lost.
Teapa, Tabasco, Mexico. Classic period, c. AD 600–900.
Height 60·5 cm., 23·8 in.
Museo Regional de Tabasco, Villa Hermosa.

156 Small head of a priest. Solid clay. The magnificent headdress is composed of a god's mask and the feathers of exotic birds, and testifies to the high rank of the subject of the portrait.
Alta Verapaz, northern Guatemala highlands. Classic period, c. AD 600–1000.
Height 12 cm., 4·7 in.
Museo Nacional de Arqueología, Guatemala City.

157 Man's head. Solid clay; vestiges of red paint are visible round the eyes.
Chiapas highlands, Mexico. Late Classic period, c. AD 800–1100.
Height 11 cm., 4·3 in.
Private collection, Munich.

158, 160 Surviving fragment of Lintel 25, Yaxchilán. It depicts two high priests, one of whom holds the head of a jaguar, a votive gift. The hieroglyphic inscription gives the date 9.14.15.0.0.
Yaxchilán, Chiapas, Mexico. Classic period, AD 726.
Dimensions of the carving 58 × 70 cm., 22·9 × 27·5 in.

159 The Palace of the King (Palacio del Rey), Structure 33, Yaxchilán. This site can only be reached by boat from further up the Usumacinta, the river which forms the border between Mexico and Guatemala for much of its course. Yaxchilán is embraced by a horseshoe curve of the river; it is now so overgrown that even the largest buildings cannot be seen either from the water or from the air.

The stucco reliefs at Palenque, the sculpture at Copán, are far superior to any work in those media anywhere else; Yaxchilán leads the field in bas-relief stone carving, achieving a rhythm and a mastery of the plane surface unequalled at any other Maya site. The earliest dated inscription discovered here corresponds to AD 509, the latest to AD 771. Yaxchilán was explored by Alfred Maudslay at the end of the nineteenth century. The reliefs he brought away with him, with considerable difficulty, are today the pride of the British Museum. These plates (pls 158–167) constitute the first attempt to reproduce the best of these reliefs, both those still on the site and those in the British Museum, side by side.
Yaxchilán, Chiapas, Mexico. Classic period, c. AD 500–800.

161 Fragment of Lintel 25, Yaxchilán.
Yaxchilán, Chiapas, Mexico. Classic period, c. AD 700.
Maudslay Collection, British Museum, London.

162 Lintel in Structure 33, Yaxchilán, depicting the performance of a ritual.
Yaxchilán, Chiapas, Mexico. Classic period, c. AD 700.
88 × 84 cm., 34·5 × 33·1 in.

163 Lintel 24 from Structure 23, Yaxchilán. This depicts a priest pulling a thong through his tongue as a self-mortification. The lintel is dated 9.14.15.0.0 11 Ahau 18 Zac (17 September AD 726).
Yaxchilán, Chiapas, Mexico. Classic period, AD 726.
Maudslay Collection, British Museum, London.

164 Fragment of Lintel 41, from House L, Yaxchilán.
Yaxchilán, Chiapas, Mexico. Classic period, c. AD 700.
Maudslay Collection, British Museum, London.

165 Lintel 16, from House F, Yaxchilán.
Yaxchilán, Chiapas, Mexico. Classic period, c. AD 700.
Maudslay Collection, British Museum, London.

166 Detail of Lintel 45 at Yaxchilán, depicting two priests performing a religious rite.

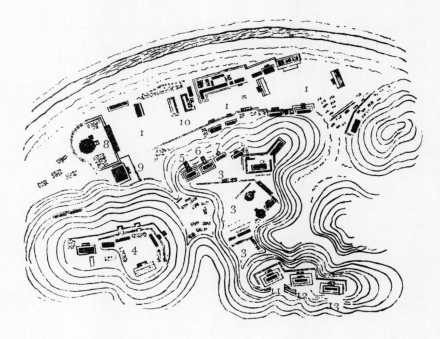

62 Yaxchilán
1 Main plaza
2 Palace
3 Acropolis
4 Capitol
5, 6, 7 Temples
8 Pyramid
9 Labyrinth
10 Ball court
11, 12, 13 Smaller temples

Yaxchilán, Chiapas, Mexico. Classic period, *c.* AD 700.

167 Stela 11 at Yaxchilán, dated 9.16.1.0.0 11 Ahau 8 Zac (AD 752). The upper part of this stela has been broken off. The carving shows a priest wearing the mask of a god, with three suppliants kneeling before him. Two priests in ceremonial vestments are depicted on the back of the stela.
Yaxchilán, Chiapas, Mexico. Classic period, AD 752.
Height *c.* 250 cm., 98·4 in.

168 Detail of a fresco in the Temple of the Mural Paintings, Bonampak. The discovery of these frescoes hit the world's headlines just over twenty years ago, when a photographer who was living among the Lacandón Indians was taken to the temple. He found that they were still taking incense and other offerings to the temples of their ancestors on specific festivals.

The original name of the site has not been recorded. Bonampak means 'painted wall' in Maya, and it is this feature that makes the site so remarkable. The frescoes are the most important anywhere in the two Americas. The artists who painted them knew nothing of perspective or shading, but their draughtsmanship is assured and impressive. As in Egyptian and Etruscan frescoes, bodies are drawn frontally while faces and feet are shown in profile. By this convention even small figures take on a monumental character. The differences of function and rank among the figures are expressed by their dress and ornaments.
Bonampak, Chiapas, Mexico. Classic period, *c.* AD 700.
Height of the figures *c.* 80 cm., 31 in.

169 Fragment of Stela 1, with a dignitary depicted in high relief. Originally over 15 feet high, the stela has collapsed and is broken in several places. The lowest section has a mythological scene carved on it. (Cf. F. Anton: *Altindianische Weisheit und Poesie*, Leipzig 1968).
Bonampak, Chiapas, Mexico. Classic period, *c.* AD 700.
Height of the fragment *c.* 190 cm., 74·8 in.

170 Shallow relief sunk into the ground in front of a stela. Stone. This is the only known example in Classic Maya art (apart from stelae) of a figure shown entirely frontally.
Bonampak, Chiapas, Mexico. Classic period, *c.* AD 700.
Height *c.* 80 cm., 31·5 in.

171 Shallow relief sunk into the ground in front of a stela. Stone. It depicts a prince with two priests, one of whom is offering him the mask of a god. Two rows of glyphs are carved above the figures.
Bonampak, Chiapas, Mexico. Classic period, *c*. AD 700.
Height *c*. 70 cm., 27·5 in.
172 Stela on the stairway leading up to the main temple.
Bonampak, Chiapas, Mexico. Classic period, *c*. AD 700.
Height 250 cm., 98·4 in.
173–174 Details of Stela 12 from Piedras Negras, depicting prisoners of war, probably about to be sacrificed. There are glyphs carved on their thighs or breasts. The stela is dated 9.18.5.0.0 4 Ahau 13 Ceh (15 September 795).
Piedras Negras, Petén, Guatemala. Classic period, AD 795.
Height of the figures *c*. 60 cm., 23·5 in.; height of the stela 313 cm., 123 in.
Museo Nacional de Arqueología, Guatemala City.
175 Stela 14 from Piedras Negras, dated 9.16.6.17.1 (AD 758). It depicts a priest seated in a niche, carved in half relief, with a subordinate in shallow relief at his feet.
Piedras Negras, Petén, Guatemala. Classic period, AD 758.
Height *c*. 220 cm., 86·6 in.
University Museum, Philadelphia, Pa.
176 Vessel. Plumbate ware, dark brown polished clay. The head of a bearded old man is modelled freely, projecting from the side of the vessel. See note to *pl. 178*.
Probably Guatemala highlands. Postclassic period, *c*. AD 1000–1500.
Height 16·2 cm., 6·4 in.
University Museum, Philadelphia, Pa.
177 Vessel. Plumbate ware, dark brown clay. It is in the form of a jaguar with the head modelled freely out of the body of the vessel. See note to *pl. 178*.
Pacific coast of Guatemala. Postclassic period, *c*. AD 1000–1500.
Height 15 cm., 5·9 in.
Museo Nacional de Arqueología, Guatemala City.
178 Head of a bearded man. Plumbate ware. This is perhaps the most widely distributed Mesoamerican ceramic type. It owes its name to its resemblance to lead-glazed Old World ware. This resemblance is partly due to the quartz content of the clay and partly to a particular technique of firing; true glazes are unknown in pre-Columbian ceramics. Plumbate ware has been found over a wide area from Nicaragua to northern Mexico, but the greatest concentration is in the highlands and on the Pacific coasts of El Salvador and Guatemala. The German archaeologist H. D. Disselhoff has spoken of it as a *Leitfossil*, an archaeological trade-mark, of the Toltecs, who were, however, probably responsible for its distribution rather than its manufacture.
Probably the highlands of Guatemala. Postclassic period, *c*. AD 1000–1500.
Height 13 cm., 5·1 in.
University Museum, Philadelphia, Pa.
179 Vase, with the figure of an eagle knight in high relief, holding a round shield and a spear. Plumbate ware.
Northern highlands of Guatemala. Postclassic period, *c*. AD 1000–1500.
Height 18 cm., 7·1 in.
University Museum, Philadelphia, Pa.
180 Effigy vessel with a human body and the head of a coyote or fox. Plumbate ware.
Probably the Guatemala highlands. Postclassic period, *c*. AD 1000–1500.
Height *c*. 18 cm., 7·1 in.
Brooklyn Museum, New York, N.Y.
181 Dish decorated with the figure of a nobleman. Clay. See note to *pl. 184*.
Yucatán, Mexico. Late Classic period, *c*. AD 800.

Diameter *c*. 28 cm., 11 in.

Private collection, Mexico.

182 Shallow bowl, decorated with a geometrical ornament round the rim and with a stylized sea bird, with a long bent neck, in the centre. Clay. See note to *pl. 184*.

Yucatán, Mexico. Late Classic or Early Postclassic period, *c*. AD 850–1100.

Diameter 33·4 cm., 13·2 in.

Museum für Völkerkunde, Berlin.

183 Painted dish, decorated with a figure performing a ritual dance in the centre and a geometrical design round the edge. Clay. See note to *pl. 184*.

Yucatán, Mexico. Late Classic or Early Postclassic period, *c*. AD 850–1100.

Dr Kurt Stavenhagen collection, México D.F.

184 Painted dish, decorated with the figure of a priest in ceremonial dress. Clay. Maya ceramic art experienced a renaissance in Yucatán between the eighth and twelfth centuries. The ware was decorated almost exclusively with figures of priests or related subjects. These religious paintings obviously have a long tradition behind them, which we can only piece together by guesswork. The colouring had a great symbolic significance, denoting whether the priests were wearing ornaments of jade or gold, or from what birds their exotic plumes had been plucked, and also indicating which gods the priests served, by the paint on their faces.

Yucatán, Mexico. Late Classic or Early Postclassic period, *c*. AD 850–1100.

Dr Kurt Stavenhagen collection, México D.F.

185 Standing figure of a man with a hand to one ear. Solid clay, originally painted. This figure and most of the following thirty-eight figures come from the island of Jaina, in the Gulf of Campeche, off the west coast of Yucatán. The Maya used to bury their dead on the island, banishing them to the 'Beyond' by carrying them across the water. The generally rather charming clay figures buried with the dead tell us much about the dress and customs of the living. Unlike the practice in many other regions, Jaina figures were not 'killed', that is, ceremonially broken, before interment.

In recent years the island has been put under military guard to put a halt to the activities of treasure seekers, who have been plundering the graves for decades. Unfortunately the Mexican government has been rather tardy in taking this action, and archaeologists have found hardly one undisturbed cemetery. Such a site could be of immense value for what it would tell us of the Maya burial customs and beliefs. Jaina figurines are collectors' items, and according to quality can fetch prices of up to a thousand dollars in world markets.

Jaina, Campeche, Mexico. Late Classic period, *c*. AD 700–1000.

Height 35·5 cm., 14 in.

Stolper Galerie, Munich.

186–187 Figure of a priest dancing. Solid clay, originally painted. The mask of a god forms the buckle of the belt.

Jaina, Campeche, Mexico. Late Classic period, *c*. AD 700–1000.

Height 13·5 cm., 5·3 in.

Dr Kurt Stavenhagen collection, México D.F.

188 Standing figure of a dignitary, dressed in a blue, short-sleeved coat (a *buc*) and a collar or scarf. Clay, painted. The material of his vast hat is gathered at the top and decorated with flowers or ribbons; the brim is turned up. The unusually high bridge of the nose reproduces the Maya ideal of beauty, achieved in life by inserting a piece of rubber beneath the skin. He wears the earrings worn by all persons of high rank, and a small imperial beard, painted dark brown. In the right hand are the fragments of some object the figure originally held, perhaps a censer or the handles of a bag.

Jaina, Campeche, Mexico. Late Classic period, *c*. AD 700–1000.

Height 17·5 cm., 6·9 in.

Museo Nacional de Antropología, México D.F.

189 Ocarina in the form of a god, or of a priest in ceremonial dress impersonating a god. The figure appears to be standing in front of a throne, if it is not a contraption attached to its back. A small monkey god is seated

on it above the figure's head. The serpents' heads on either side of the god's (or priest's) head carry the heads of gods in their jaws.

Jaina, Campeche, Mexico. Late Classic period, *c.* AD 700–1000.

Height 22 cm., 8·6 in.

Museo Nacional de Antropología, México D.F.

190 Flute in the form of a human figure with a bird's head, perhaps representing a masked priest or an unidentified god. Clay.

Style of Jaina. Late Classic period, *c.* AD 700–1000.

Height 15·5 cm., 6·1 in.

Dr Kurt Stavenhagen collection, México D.F.

191 Rattle in the form of a standing human figure with the head of a frog. Clay, traces of the original paint.

Style of Jaina. Late Classic period, *c.* AD 700–1000.

Height 12·3 cm., 4·9 in.

Dr Kurt Stavenhagen collection, México D.F.

192 Standing man wearing a loincloth. Solid clay, traces of the original paint.

Jaina, Campeche, Mexico. Late Classic period, *c.* AD 700–1000.

Height 18 cm., 7·1 in.

Museo Regional de Tabasco, Villa Hermosa.

193 Ocarina in the form of a seated woman with a jaguar in her lap. Clay, traces of the original paint.

Jaina, Campeche, Mexico. Late Classic period, *c.* AD 700–1000.

Height 18 cm., 7·1 in.

Dr Kurt Stavenhagen collection, México D.F.

194 Seated woman with a child or dwarf. Clay, traces of the original paint. Dwarfs play an important role in Maya mythology, and are frequently represented in art, especially in the company of noblewomen.

Style of Jaina. Late Classic period, *c.* AD 700–1000.

Height 11 cm., 4·5 in.

Dr Kurt Stavenhagen collection, México D.F.

195 Priest-king seated on his throne. Solid clay, made in two parts, with much of its original paint. The incised figure of a priest on the backrest of the throne resembles the decoration of jade tablets or shell pendants of the Classic period. The pattern outlined on the front feet of the throne appears to have been left unfinished.

Style of Jaina. Late Classic period, *c.* AD 700–1000.

Height 10·5 cm., 4·2 in.

Dr Kurt Stavenhagen collection, México D.F.

196 Pair of lovers. Solid clay. Both figures are wearing tall hats, collars and beads. The woman is wearing a skirt fastened with a magnificent clasp, the man a loincloth.

Jaina, Campeche, Mexico. Late Classic period, *c.* AD 700–1000.

Height 18 cm., 7·1 in.

Dr Kurt Stavenhagen collection, México D.F.

197 Whistle in the form of a seated woman with a necklace and pendant. Clay, originally painted.

Style of Jaina. Late Classic period, *c.* AD 700–1000.

Height 12·5 cm., 5 in.

Dr Kurt Stavenhagen collection, México D.F.

198 Ocarina in the form of a seated woman with a child or a dwarf on her lap. Clay, traces of blue and red paint.

Jaina, Campeche, Mexico. Late Classic period, *c.* AD 700–1000.

Height 17 cm., 6·7 in.

Dr Kurt Stavenhagen collection, México D.F.

199 Rattle in the form of a woman with a fat old man on her shoulders. Clay, traces of the original paint.

The group probably relates to a forgotten legend.
Jaina, Campeche, Mexico. Late Classic period, *c.* AD 700–1000.
Height 15·5 cm., 6·1 in.
Museo Regional de Campeche, Campeche.

200 Standing warrior with a round shield and small beard. He wears a bead necklace and the customary loincloth.
Jaina, Campeche, Mexico. Late Classic period, *c.* AD 700–1000.
Height 34 cm., 13·4 in.
Dr Kurt Stavenhagen collection, México D.F.

201 Standing ball player. Solid clay, originally painted. The *yugo* (yoke) and *hacha* (ceremonial axe) girded round his hips are probably emblems of his manhood.
Jaina, Campeche, Mexico. Late Classic period, *c.* AD 700–1000.

202 Standing figure of a young man with arms folded. Solid clay, traces of the original paint. The youth is wearing a loincloth and two necklaces.
Jaina, Campeche, Mexico. Late Classic period, *c.* AD 700–1000.
Height 21 cm., 8·2 in.
Stendahl collection, Los Angeles, Calif.

203 Ocarina in the form of a lecherous old man and a girl. This subject occurs so frequently among the terracottas of Jaina that it must refer to a very old and popular legend, which does not seem to have been confined to the Maya alone.
Style of Jaina. Late Classic period, *c.* AD 700–1000.
Height 9·5 cm., 3·8 in.
Dr Kurt Stavenhagen collection, México D.F.

204 Woman preparing *tortillas*, with her children. Solid clay. This group is exceptional among the Jaina terracottas, which normally depict only priests, high-ranking warriors and fine ladies.
Style of Jaina. Late Classic period, *c.* AD 700–1000.
Height 16·5 cm., 6·5 in.
Dr Kurt Stavenhagen collection, México D.F.

205 Ocarina in the form of an old warrior. Clay, fragments of the original paint. The standing figure wears the quilted cotton costume usually worn by Maya warriors, and a rectangular pendant on his breast.
Style of Jaina. Late Classic period, *c.* AD 700–1000.
Height 14 cm., 5·5 in.
Dr Kurt Stavenhagen collection, México D.F.

206 Standing figure of a young warrior. Solid clay, traces of the original paint. The figure has the scars of tattooing on cheeks and forehead, the fashionable deformed skull and artificially extended nose, and carries a rectangular shield and a sling.
Style of Jaina. Late Classic period, *c.* AD 700–1000.
Height 23 cm., 9 in.
Dr Kurt Stavenhagen collection, México D.F.

207 Woman holding a child by the hand and a puppy under her arm. Reddish clay. This is one of the few clay artifacts in the Jaina style which are known not to have been found on the island itself.
Zona Sala Xupa (five miles from Palenque), Chiapas, Mexico. Classic period, *c.* AD 600–1000.
Height *c.* 12 cm., 4·7 in.
Tulane University Museum, New Orleans, La.

208 Ocarina in the form of a richly dressed noblewoman with raised hands. Clay, traces of blue and red paint. As well as a sumptuous dress, she wears necklaces and large earrings.
Style of Jaina. Late Classic period, *c.* AD 700–1000.
Height 17 cm., 6·7 in.
Dr Kurt Stavenhagen collection, México D.F.

209 Rattle in the form of a woman. Clay, traces of the original paint in several colours. She is carrying a pitcher on her head and a child under her arm. Her blouse (*kub*) is plain, but her skirt (*pic*) is decorated with a key pattern and trimmed with a fringe.
Jaina, Campeche, Mexico. Late Classic period, *c.* AD 700–1000.
Height 16 cm., 6·3 in.
Stendahl collection, Los Angeles, Calif.

210 Ocarina in the form of a noblewoman with tattooed cheeks, wearing ceremonial dress. Clay, with a few traces of paint.
Style of Jaina. Late Classic period, *c.* AD 700–1000.
Height 19·5 cm., 7·7 in.
Dr Kurt Stavenhagen collection, México D.F.

211 Ocarina in the form of a noblewoman accompanied by a man with the head of a coyote, or perhaps a mask. Clay. The group probably refers to an old legend. The creature is hung with jewels and the woman embraces it lovingly, but the pair are overcast with an almost Lenten sorrow.
Style of Jaina. Late Classic period, *c.* AD 700–1000.
Height *c.* 14 cm., 5·5 in.
Dr Kurt Stavenhagen collection, México D.F.

212 Small ocarina in the form of a girl combing her hair. Clay.
Style of Jaina. Late Classic period, *c.* AD 700–1000.
Height 9 cm., 3·5 in.
Dr Kurt Stavenhagen collection, México D.F.

213 Seated figure of an old man or woman hugging a jaguar. Clay.
Jaina, Campeche, Mexico. Late Classic period, *c.* AD 700–1000.
Height 8 cm., 3·2 in.
Museo Nacional de Antropología, México D.F.

214 Rattle in the form of an old man with a young, richly dressed woman. Clay, traces of white paint. The old man wears a plumed helmet and a loincloth, and an embroidered or woven pendant on his chest. Both figures are wearing earrings. The young woman carries a fan in her left hand and is dressed in a blouse (*kub*) and long skirt (*pic*), and a long cloak.
Jaina, Campeche, Mexico. Late Classic period, *c.* AD 700–1000.
Height 16 cm., 6·3 in.
Stendahl collection, Los Angeles, Calif.

215 Whistle in the form of a dwarf. Clay, traces of blue paint. The figure probably represents a court jester. Apart from his huge turban, he wears nothing but a *cache-sexe* and two large beads on his chest. The skull is flattened and the bridge of the nose raised, and the nose is scarred with the marks of tattooing.
Jaina, Campeche, Mexico. Late Classic period, *c.* AD 700–1000.
Height 15·5 cm., 6·1 in.
Stendahl collection, Los Angeles, Calif.

216 Ocarina in the form of a woman and a dwarf. Clay, traces of the original paint. This pair are frequently depicted in Jaina ceramic art, and probably illustrate an old legend which has not been preserved. Dwarfs figure prominently in Maya mythology (as in the legend of the building of the Temple of the Dwarf at Uxmal). As with nearly all the Jaina figures, the skulls are deformed and the noses built up.
Jaina, Campeche, Mexico. Late Classic period, *c.* AD 700–1000.
Height 18·5 cm., 7·3 in.
Dr Kurt Stavenhagen collection, México D.F.

217 Prisoner bound to a post. Solid clay.
Jaina, Campeche, Mexico. Late Classic period, *c.* AD 700–1000.
Height 27 cm., 10·6 in.
Dr. Ludwig-Rautenstrauch-Joest-Museum, Cologne.

218 Priest in ceremonial dress driving two fettered prisoners before him. Clay, traces of the original paint.
Jaina, Campeche, Mexico. Late Classic period, *c.* AD 700–1000.
Height 17·5 cm., 6·9 in.
Stendahl collection, Los Angeles, Calif.

219 Priest wearing a mask of death, in the act of beheading a prisoner. Clay, traces of the original paint.
Jaina, Campeche, Mexico. Late Classic period, *c.* AD 700–1000.
Height 17 cm., 6·7 in.
Dr Kurt Stavenhagen collection, México D.F.

220 High-ranking priest seated on a throne, with subordinate figures. Clay, traces of polychrome paint.
Jaina, Campeche, Mexico. Late Classic period, *c.* AD 700–1000.
Height 18 cm., 7·1 in.
Stendahl collection, Los Angeles, Calif.

221 Seated girl. Clay. The pose suggests a dancer, originally with a fan in the right hand. Although the figure is very small and simple, the artist has captured to perfection the grace of a young girl.
Style of Jaina. Late Classic period, *c.* AD 700–1000.
Height 8 cm., 3·2 in.
Dr Kurt Stavenhagen collection, México D.F.

222 Ocarina in the form of a seated woman. Clay, traces of polychrome paint. The hairstyle is quite different from that usually worn by female figures.
Jaina, Campeche, Mexico. Late Classic period, *c.* AD 700–1000.
Height *c.* 15 cm., 5·9 in.
Stendahl collection, Los Angeles, Calif.

223 Priest in ceremonial dress, seated before a large censer. Clay, traces of blue and white paint. The priest's face is tattooed, and he wears an elaborate headdress and a robe wrapped round rather like a toga.
Style of Jaina. Late Classic period, *c.* AD 700–1000.
Height 25 cm., 9·8 in.
Stendahl collection, Los Angeles, Calif.

224–226 Pages 6, 48–9 and 50 of the *Codex Dresdensis*. Paper with paint on white chalk gesso coating. Of the hundreds of manuscripts which existed prior to the Spanish conquest, only three survived the damp climate, the internecine wars and the Spanish bonfires: the *Codex Tro-Cortesianus*, now in Madrid, the *Codex Peresianus*, now in Paris, and the *Codex Dresdensis*, now in Dresden. The manuscripts are constructed as continuous strips, inscribed on both sides, folded between richly decorated end boards; when fully extended, the Madrid codex is over 23 feet long. They are written on a paper made of the bark of a tree *(Ficus cotonifolia)* which the Maya called *copo*, or of the fibre of the *Agave americana*. After being beaten to a pulp, this material was 'bound' with natural rubber and coated with a thin layer of white chalk gesso. The full length of the *Codex Dresdensis* is over eleven feet; it is folded into 78 pages, divided by red vertical lines at the folds, of which 39 are coloured.

The earliest of the three is the *Dresdensis*, which is far superior to the others in artistic quality. Little is known of how it came to be written, or of the religious ideas it sets forth in its text. The style of the drawings of the gods points to Tikal, Uaxactún, Yaxchilán or Piedras Negras. The mansucript could be a twelfth- or thirteenth-century copy of a version written, probably somewhere in the area bounded by these four sites, at some date in the Classic era. It is not known how it reached Europe; in 1739, after it had lain on the shelves of a Viennese bookshop without finding a buyer for several years, the proprietor got rid of it by presenting it to the Royal Library of Saxony. Alexander Humboldt believed that it was Aztec. In the late nineteenth century it became the pride and joy of the director of the library, Ernst Förstemann. His work on the codex and on the hieroglyphic script of the Maya was the foundation of the speciality of 'backroom' Maya studies, in which many European scholars have participated without ever crossing the Atlantic. When the Third Reich was in need of foreign currency, the ancient manuscript was once again a focus of attention. First of all it was offered to England, where it was refused. Later an attempt was made to find an American purchaser. At the beginning of the Second World War the German Ambassador offered the codex to Tulane University

in New Orleans, overlooking the fact that the principal benefactor of the university's Middle American Research Institute was a Jew. Understandably, the university declined this opportunity of filling Hitler's coffers. (Frans Blom, who was working at Tulane at the time, told me the story while I was in Chiapas.) During the war the manuscript was deposited, with many others of the library's most valuable possessions, in a cellar in Dresden, which became flooded with ground water after the walls cracked under the bombing. Dürer's sketchbook and the *Sachsenspiegel*, a compilation of the laws of medieval Saxony, to name only the most valuable manuscripts, were badly damaged by the water; the *Codex Dresdensis*, which lay on top of the pile, was spared. As the war drew to its close, the staff of the library hid the codex in a farmhouse in Saxony, where it remained until voices were raised in America accusing the Russians of having appropriated the New World's oldest and most precious book. It is now housed in the Sächsische Landesbibliothek, the successor to the royal library. It is kept in a darkened room to protect the colours from fading any more than they already have done.

Pl. 224 shows p. 6, with largely undeciphered glyphs and figures which are presumed to represent gods. It is supposed that the content of the codex is mythological, but this is as much a matter of hypothesis as the names and attributes ascribed to the gods depicted in it. The text does, however, include a number of calendric calculations, the accuracy of which has been checked and testifies to the excellence of the Maya mathematicians.

Pages 48–9 (*pl. 225*, actual size) depict, at the top, two gods holding objects resembling sceptres or rattles, seated on thrones decorated with astronomical glyphs. The god on the left is bad-tempered and old, that on the right handsome and young. The middle figures on both pages are kneeling warriors, each holding two spears or lances and a smaller weapon. The one on the left-hand page has the head of one of the jungle cats, the other shows the Classic Maya profile. The figures at the bottom of both pages appear to be men, lying on the ground, pierced by arrows or spears. The text on pp. 46–50 of the codex is concerned with the correlation of five Venus Years of 584 days (2920 days in all) with eight Vague Years of 365 days (the same total).

Ironically it was Bishop Landa, who consigned so many Maya books to the bonfire, whose notes contained the key to the understanding of the complicated Maya calendar and to the decipherment of the calendar inscriptions.

> The people used certain signs and letters, with which they wrote their past history and their teachings in their books. Through these letters, and through drawings and certain figures, they understand their history and also are able to explain it and teach it to others. We found a great number of these books and since they contained nothing that was not superstition and the devil's lies, we burnt them all, to the great sorrow and distress of the people.

Pl. 226 shows a detail from p. 50 of the codex. Although it is here reproduced at more than three times its actual size, the impact of the original is in no way impaired. The enlargement only draws attention to the skilful brushwork of the artist and the scribe. The fine drawing, the delicate colours, made of animal and mineral dyes, make the *Codex Dresdensis* a unique work of art, even while its content is for the most part unknown. The naked god seated on a throne is the god of death (God A in Paul Schellhas's description of the manuscript, since as with most of the Maya gods the original name is unknown). The young maize god (God E) approaches him in a respectful, almost timid manner, holding in his hands a vessel probably filled with corn. The energetic gesture which the god of death makes with his right hand and the tension in the facial expressions suggest that a quarrel is taking place, or at least that the elder god is administering a sharp reprimand. The faces of both gods are painted like warriors, and they both wear green jade beads round their arms, legs and necks. They symbolize the destructive and the creative forces among the gods, whose rivalry was unceasing.

Provenance unknown, probably Campeche, Mexico. Style of the Classic period, probably *c.* AD 1100–1200.
Total length 3·56 m., 140 in.; height 20·5 cm., 8·1 in.
Sächsische Landesbibliothek, Dresden.

A Cemetery Group
B Nunnery Quadrangle
C Temple of the Magician
D Ball court
E House of the Pigeons
F House of the Governor
G Temple of the Dwarf
H South Group
I Temple of the Old Woman

227 Dish, decorated with the stylized figure of a priest in the centre and with two birds, equally stylized, in the border. Clay. The figures and the decoration are painted in red, brown and black on an orange ground.

Yucatán, Mexico. Postclassic period, c. AD 1100–1400.

Diameter c. 28 cm., 11 in.

Dr Kurt Stavenhagen collection, México D.F.

228 Bowl, decorated with incised design of stylized monkeys. Light brown clay.

Yucatán, Mexico. Postclassic period, c. AD 1200–1500.

Height c. 10 cm., 3·9 in.

Dr Kurt Stavenhagen collection, México D.F.

229 Censer decorated with figure of a god modelled in relief. Grey clay. It probably depicts Quetzalcóatl-Kukulcán, descending from heaven to earth.

Yucatán, Mexico. Postclassic period, c. AD 1200–1500.

Height 29 cm., 11·4 in.

Museo Regional de Yucatán, Mérida.

230 Uxmal, dominated on the right by the Temple of the Magician. (See *fig. 63*.)

Uxmal, Yucatán, Mexico. Postclassic period, Puuc style, c. AD 900–1100.

231 Temple of the Magician. The pyramid is about 100 feet high.

Uxmal, Yucatán, Mexico. Postclassic period, Puuc style, c. AD 900–1100.

232 Masks of the rain god Chac at the corner of the stairway on the east face of the pyramid of the Temple of the Magician.

Uxmal, Yucatán, Mexico. Postclassic period, Puuc style, c. AD 900–1100.

233 Mask of the rain god Chac, originally from the façade of a building at Kabah. Limestone.

Kabah, Yucatán, Mexico. Postclassic period, Puuc style, c. AD 900–1100.

Breadth c. 120 cm., 47·3 in.

Museo Regional de Yucatán, Mérida.

234 View across the overgrown ball court to the so-called Nunnery Quadrangle. Names like this were adopted at an early stage in archaeological investigation, and have, of course, no real relevance to the actual function of the buildings.

Uxmal, Yucatán, Mexico. Postclassic period, Puuc style, c. AD 900–1100.

235 One wing of the Nunnery Quadrangle.

Uxmal, Yucatán, Mexico. Postclassic period, Puuc style, c. AD 900–1100.

236 Detail of the façade of the building on the east side of the Nunnery Quadrangle, showing a human mask on a highly geometrical design of two-headed serpents.

Uxmal, Yucatán, Mexico. Postclassic period, Puuc style, c. AD 900–1100.

237 Corner of the decorated façade of the so-called House of the Governor, showing masks of the rain god Chac.

Uxmal, Yucatán, Mexico. Postclassic period, Puuc style, c. AD 900–1100.

238 The Throne of the Two-headed Jaguar, situated on a small platform in front of the House of the Governor.

Uxmal, Yucatán, Mexico. Postclassic period, Puuc style, c. AD 900–1100.

239 The House of the Governor. The façades are decorated with the masks of the rain god Chac which are typical of the Puuc style. The building is constructed of more than 20,000 finely cut stones.

Uxmal, Yucatán, Mexico. Postclassic period, Puuc style, c. AD 900–1100.

240 Head, probably from the façade of a building in Uxmal. Limestone.

Uxmal (?), Yucatán, Mexico. Postclassic period, Puuc style, c. AD 900–1100.

Height 14 cm., 5·5 in.

Museo Regional de Yucatán, Mérida.

241 The north façade of the House of the Pigeons (El Palomar). The façade is all that still stands of this

group of buildings, which was arranged round a courtyard, like the Nunnery.

Uxmal, Yucatán, Mexico. Postclassic period, Puuc style, *c.* AD 900–1100.

242 Main entrance into the quadrangle of the House of the Pigeons. No attempt has yet been made to restore this complex, which is in a very bad condition.

Uxmal, Yucatán, Mexico. Postclassic period, Puuc style, *c.* AD 900–1100.

243 Mythical creature, from the façade of the Nunnery Quadrangle. Limestone.

Uxmal, Yucatán, Mexico. Postclassic period, Puuc style, *c.* AD 900–1100.

Height *c.* 80 cm., 31·5 in.

Museum of Natural History, New York, N.Y.

244 Man's head from the façade of a building. Stone. One side of the face bears the scars of ornamental tattooing.

Kabah, Yucatán, Mexico. Postclassic period, Puuc style, *c.* AD 900–1100.

Height 49 cm., 19·3 in.

Museo Regional de Yucatán, Mérida.

245 Old man with wings, or feathers on his arms, from the façade of a building. Limestone.

Xunantunich, Campeche, Mexico. Postclassic period, Puuc style, *c.* AD 900–1100.

Height 66 cm., 26 in.

Museo Regional de Campeche, Campeche.

246 The House of Masks (Codz Pop), Kabah. The name derives from the innumerable masks of the rain god which adorn the west front of the building.

Kabah, Yucatán, Mexico. Postclassic period, Puuc style, *c.* AD 900–1100.

247 Detail of the façade of the Codz Pop, showing masks of Chac.

Kabah, Yucatán, Mexico. Postclassic period, Puuc style, *c.* AD 900–1100.

248 . The Plaza, Labná. A stone causeway led from the Palace to the 'watchtower' (**Mirador**).

Labná, Yucatán, Mexico. Postclassic period, Puuc style, *c.* AD 900–1100.

249 The Palace, Labná. Labná is a Maya word meaning 'tumbledown houses' and the name was given to the site by the local Indians after it had been abandoned. It is a Postclassic site and must have reached its zenith at some time between the ninth and twelfth centuries, but a more precise dating is not possible because dated inscriptions, of the kind familiar on Classic sites, are extremely rare in Yucatán. The façade of the Palace is 84 metres, 275 feet, long, and decorated with numerous images of gods. The presence of three different styles indicates that the building was in use over a relatively long period.

Labná, Yucatán, Mexico. Postclassic period, Puuc style, *c.* AD 900–1100.

250 The Arch, Labná. The ancient Maya were not acquainted with the true vault, but used the false, or corbel vault, constructed by allowing each level of stones to project a little further inwards and crowning the angular arch obtained in this way with a large slab. Pillars were introduced into Maya architecture by the Toltecs, and made it possible for the first time to build roofs over wider room spaces. Previously the rooms in Maya buildings were extremely narrow, like passages.

Labná, Yucatán, Mexico. Postclassic period, Puuc style, *c.* AD 900–1100.

251 Human head looking out from the jaws of a serpent, on the façade of the Palace at Labná.

Labná, Yucatán, Mexico. Postclassic period, Puuc style, *c.* AD 900–1100.

252 The Palace, Sayil. The building contains about eighty rooms. When it was restored by archaeologists from the Carnegie Institute, they left half of it as they had found it, while the other half was restored with a thoroughness which has not been matched in any more recent undertaking.

Sayil, Yucatán, Mexico. Postclassic period, Puuc style, *c.* AD 900–1100.

253 Tulum, on the shores of the Caribbean. Tulum is one of the oldest settlements in the northern part of the Yucatán peninsula. The wall which encloses the centre of the site on the three landward sides is an unusual feature; Mayapán is the only other site where fortifications of that kind have been found.

Tulum, Quintana Roo, Mexico. Classic and Postclassic periods, *c.* AD 500–1500.

254 Mural painting in the Temple of the Frescoes at Tulum, depicting a goddess, perhaps Ix Chel. The

N
W E
S

A Temple of the Jaguars
B Castillo
C Temple of the Warriors
a Ball court
b Platform of Skulls (Tzompantli)
c Tomb of the Chacmool
 (Venus Platform)
d Market-place (Mercado)
e Grave of the High Priest
f Red House (Chichan Chob)
g Observatory (Caracol)
h Nunnery
j Church (Iglesia)

style of these frescoes has little affinity with Classic Maya frescoes, and reveals Mixtec influences.

Tulum, Quintana Roo, Mexico. Postclassic period, *c.* AD 1100–1400.

Height of the figure *c.* 80 cm., 31·5 in.

255 Temple at Dzibilchaltún. This site, near the modern town of Mérida, appears to have been occupied over a period of about 1500 years. It seems to have been the most extensive of all the centres of worship on the peninsula.

Dzibilchaltún, Yucatán, Mexico. Preclassic to Postclassic periods, *c.* 100 BC–AD 1500.

256 The largest buildings at Edzná, constructed as a temple pyramid of a rather unusual kind, in that it has no stairways; the priests must have climbed up to the temple on ladders.

Edzná, Campeche, Mexico. Early Postclassic period, Puuc style, *c.* AD 900–1100.

257 The Temple of the Warriors, Chichén Itzá. The pillars decorated with relief carvings of warriors are a foreign innovation in Maya art. The decoration of the façades of the building, and the two feathered serpents which originally supported the roof of the porch, are in the Toltec style.

Chichén Itzá, Yucatán, Mexico. Postclassic period, Maya-Toltec culture, *c.* AD 1000–1300.

258 The main stairway of the Temple of the Warriors. The figure at the top is a warrior carrying a standard.

Chichén Itzá, Yucatán, Mexico. Postclassic period, Maya-Toltec culture, *c.* AD 1000–1300.

259 Detail of the façade of the Temple of the Warriors, probably depicting the Toltec hero Quetzalcóatl, known in Yucatán by the literal Maya translation of his name, Kukulcán ('feathered serpent').

Chichén Itzá, Yucatán, Mexico. Postclassic period, Maya-Toltec culture, *c.* AD 1000–1300.

260 Pillars in the form of feathered serpents which used to support the roof of the porch of the Temple of the Warriors.

Chichén Itzá, Yucatán, Mexico. Postclassic period, Maya-Toltec culture, *c.* AD 1000–1300.

Height *c.* 350 cm., 138 in.

261–262 Two Atlantean figures found at Chichén Itza. Originally they would have supported a stone table top or bench.

Chichén Itzá, Yucatán, Mexico. Postclassic period, Maya-Toltec culture, *c.* AD 1000–1300.

Height *c.* 80–90 cm., 31–35 in.

263 Large table with a ritual function, in the Temple of the Warriors, supported by Atlantean figures.

Chichén Itzá, Yucatán, Mexico. Postclassic period, Maya-Toltec culture, *c.* AD 1000–1300.

264 Square pillar in the Temple of the Warriors, showing relief carving of a Toltec warrior, with traces of yellow, red, blue and green paint.

Chichén Itzá, Yucatán, Mexico. Postclassic period, Maya-Toltec culture, *c.* AD 1000–1300.

265 The Tomb of the Chacmool or Platform of Venus. The platform top of this square structure is approached by steps on every side, the balustrades of which terminate in serpents' heads. The walls are decorated with reliefs in the style of Tula, the Toltec city in central Mexico.

Chichén Itzá, Yucatán, Mexico. Postclassic period, Maya-Toltec culture, *c.* AD 1000–1300.

266–267 The Platform of Skulls (Tzompantli). Its walls are decorated with reliefs of skulls in profile.

Chichén Itzá, Yucatán, Mexico. Postclassic period, Maya-Toltec culture, *c.* AD 1000–1300.

268 The Castillo, the tallest pyramid in Chichén Itzá. Flights of 91 steps each lead up the four sides of the pyramid to the temple; the platform on which it stands makes up a total of 365 steps, the same number as the days in the Vague Year (see note 14).

Chichén Itzá, Yucatán, Mexico. Postclassic period, Maya-Toltec culture, *c.* AD 1000–1300.

269 The Market-place (Mercado) at Chichén Itzá. Originally the complex was covered with a roof of rush and grass.

Chichén Itzá, Yucatán, Mexico. Postclassic period, Maya-Toltec culture, *c.* AD 1000–1300.

270 *Chacmool.* Grey stone. The name *chacmool*, like those given to the Maya temples in general, is quite arbitrary; it is used to denote a reclining figure apparently averting its gaze from a bowl held in its lap. It is a Toltec *Leitfossil*, found wherever Toltec influence is present. Its exact function is unknown: perhaps the bowl was used to contain offerings.

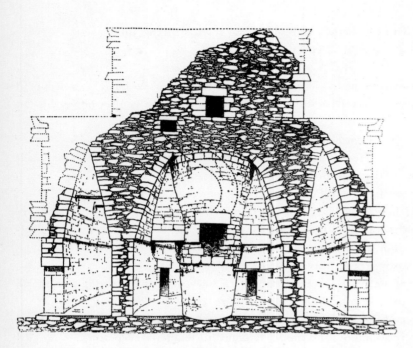

65 Section drawing of the Observatory at Chichén Itzá

66 Ground plan of the Observatory at Chichén Itzá

Castillo, Chichen Itzá, Yucatán, Mexico. Postclassic period, Maya-Toltec culture, *c.* AD 1000–1300.
Height *c.* 120 cm., 47·3 in.

271 The Jaguar Throne, carved from a huge block of stone, painted red. This stands in one of the chambers
inside the Castillo. The eyes and spots are pieces of inlaid jade, the teeth polished bone and shell.
Chichén Itzá, Yucatán, Mexico. Postclassic period, Maya-Toltec culture, *c.* AD 1100–1300.
Height *c.* 70 cm., 27·5 in.

272 Shield. Wood, inlaid with pieces of turquoise, shell and pyrites. Four fiery serpents symbolize the four
quarters of the heavens; unfortunately the decoration of the centre has been lost. The shield was found in
the Castillo, and a similar one, badly damaged, lay on the seat of the Jaguar Throne.
Chichén Itzá, Yucatán, Mexico. Postclassic period, Maya-Toltec culture, *c.* AD 1100–1300.
Museo Nacional de Antropología, México D.F.

273 Grave goods in the stalactite caves at Balancanché, 2¹/₂ miles from Chichén Itzá. The waisted clay
vessels with bumps all over their surface represent the Mexican rain god, Tlaloc. The cave was used as a
cemetery only by the Toltecs, to judge by the style of the objects found in it. The entrance was blocked by
boulders and rubble and was not opened until 1959.
Balancanché, Yucatán, Mexico. Postclassic period, Toltec culture, *c.* AD 1100–1500.

274 Entrance of the Temple of the Jaguars, which dominates the ball court at Chichén Itzá. Like the porch
of the Temple of the Warriors, its roof is supported by two pillars in the form of feathered serpents.
Chichén Itzá, Yucatán, Mexico. Postclassic period, Maya-Toltec culture, *c.* AD 1000–1300.

275 The ball court at Chichén Itzá, the best-preserved of the fifty or so courts that have been discovered
so far on Maya sites. Structurally it differs considerably from Classic ball courts (cf. that at Copán, *pl. 30*),
which must be due to the Toltec influence. The ball game was already of great religious significance in the
Classic period and was maintained as a ritual up to the time of the Spanish conquest.
Chichén Itzá, Yucatán, Mexico. Postclassic period, Maya-Toltec culture, *c.* AD 1000–1300.

276 Relief carving of a Toltec warrior on the wall of the Temple of the Jaguars.
Chichén Itzá, Yucatán, Mexico. Postclassic period, Maya-Toltec culture, *c.* AD 1000–1300.
Height *c.* 120 cm., 47·3 in.

277 Skull relief on the balustrade round the ball court.

Chichén Itzá, Yucatán, Mexico. Postclassic period, Maya-Toltec culture, c. AD 1000–1300.

Height c. 6o cm., 23·6 in.

278 Relief carving of a ball player on the balustrade round the ball court. He wears the typical costume of protective padding round the arms and kidneys and a headdress like a helmet.

Chichén Itzá, Yucatán, Mexico. Postclassic period, Maya-Toltec culture, c. AD 1000–1300.

Height of the figure c. 100 cm., 39·4 in.

279 The Observatory or Caracol ('Snail'), so called because of the appearance of a spiral staircase inside the building. The rays of the sun penetrate into the centre of the buildings twice a year for a few seconds only, through narrow window slits. This was a simple and reliable method of checking the accuracy of the calendar. (See *figs 65 and 66.*)

Chichén Itzá, Yucatán, Mexico. Postclassic period, Maya-Toltec culture, c. AD 1000–1300.

280 The Church (La Iglesia), part of the complex known as the Nunnery, built in the Puuc style before the Toltec invasion. The façades are decorated with masks of the rain god Chac.

Chichén Itzá, Yucatán, Mexico. Early Postclassic period, Puuc style, c. AD 800–1100.

281 The House of the Three Lintels in the old part of Chichén Itzá. This is one of the oldest buildings on the site.

Chichén Itzá, Yucatán, Mexico. Classic period, early Puuc style, c. AD 600–900.

282 Carving of a naked man, lacking the head. Stone. The object in his hands is probably a weapon of some kind.

Uxmal, Yucatán, Mexico. Postclassic period, c. AD 1000–1300.

Height 104 cm., 41 in.

Museo Regional de Yucatán, Mérida.

283 Vessel decorated with an incised frieze and two relief figures of seated priests. Grey clay.

Tecoh, near Acanceh, Yucatán, Mexico. Postclassic period, c. AD 800–1200.

Height 13 cm., 5·1 in.

Private collection, Munich.

284 Fragment in the form of a man's head with prominent canine teeth. Grey clay. It may represent a god.

Mayapán, Yucatán, Mexico. Postclassic period, Maya-Toltec culture, c. AD 1100–1500.

Height 21·5 cm., 8·4 in.

Museo Regional de Yucatán, Mérida.

285 Fragment of a man's head. Grey clay. The headdress is the head of an alligator.

Mayapán, Yucatán, Mexico. Postclassic period, Maya-Toltec culture, c. AD 1100–1500.

Height 19 cm., 7·5 in.

Museo Regional de Yucatán, Mérida.

286 Head of feathered serpent, the emblem of Quetzalcóatl-Kukulcán. Stone. It was originally fixed to the façade of a building by a peg.

Chichén Itzá, Yucatán, México. Postclassic period, Maya-Toltec culture, c. AD 1200–1500.

Length 53 cm., 20·9 in.

Museo Regional de Yucatán, Mérida.

287 Large head of feathered serpent. Grey stone.

Chichén Itzá, Yucatán, Mexico. Postclassic period, Maya-Toltec culture, c. AD 1200–1500.

Height c. 70 cm., 27·5 in.

288 Statue of a dignitary. Stone. The headdress is a stylized jaguar's head. The figure probably originally stood in a niche on the façade of a building.

Uxmal, Yucatán, Mexico. Postclassic period, c. AD 1100–1400.

Height 89 cm., 35 in.

Museo Regional de Yucatán, Mérida.

289 Figure of a standard bearer. Stone. This is not a Maya physical type. It illustrates vividly the cold, brutal appearance of the new warrior caste.

Chichén Itzá, Yucatán, Mexico. Postclassic period, Maya-Toltec culture, *c.* AD 1200–1500.

Height 95 cm., 37·4 in.

Museo Regional de Yucatán, Mérida.

290 Grave goods in a stalactite cave at Balancanché. Clay. All the ceramic vessels in the cave are in the pure Toltec style, known from excavations at Tula. See also *pl. 273*.

Balancanché, Yucatán, Mexico. Postclassic period, Toltec style, *c.* AD 1200–1450.

291 Bird god. Grey stone. Like the bat god in *pl. 293*, this figure originally formed part of the ornamentation on a decorated façade.

Uxmal, Yucatán, Mexico. Postclassic period, *c.* AD 900–1100.

Height 73 cm., 28·7 in.

Museo Regional de Yucatán, Mérida.

292 Doll with movable limbs. Clay, originally painted. Dolls like this one have otherwise been found only on sites of the Teotihuacán civilization of the Valley of Mexico, and in the central part of the Gulf coast. This one may have been imported.

Found on Jaina, Campeche, Mexico. Date unknown.

Height 23 cm., 9 in.

Museo Regional de Campeche, Campeche.

293 Figure of a bat god, from the façade of a building. Stone, traces of paint.

Xúnantun, Campeche, Mexico. Postclassic period, *c.* AD 1000–1500.

Height 62 cm., 24·4 in.

Museo Regional de Campeche, Campeche.

294 Round dish. Clay, painted. The figure with raised hands painted in the centre is a god, but has not been identified. The dress is similar to the garments of quilted cotton typically worn by warriors, and the god could be a patron of that class.

Campeche, Mexico. Postclassic period, *c.* AD 1000–1500.

Diameter 21 cm., 8·2 in.

Museo Regional de Campeche, Campeche.

295 Figure of the same god that decorates the dish in *pl. 294*. Grey stone. It may have supported a table top.

Xeulhoc, Campeche, Mexico. Postclassic period, *c.* AD 1000–1500.

Height 82 cm., 32·3 in.

Museo Regional de Campeche, Campeche.

296 Circular temple. Mayapán is virtually the only site where buildings were deliberately destroyed, presumably in war.

Mayapán, Yucatán, Mexico. Postclassic period, Maya-Toltec culture, *c.* AD 1200–1450.

297 Vessel in the form of the rain god, Chac, recognizable by his snout. Clay, traces of red and blue paint. The figure carries vessels in both hands, from one of which sprout what may be maize plants.

Mayapán, Yucatán, Mexico. Postclassic period, *c.* AD 1200–1450.

Height 55 cm., 21·7 in.

Museo Nacional de Antropología, México D.F.

298 Fragment of a cylindrical vessel in the form of a god. Clay, traces of the original paint.

Mayapán, Yucatán, Mexico. Postclassic period, *c.* AD 1200–1450.

Height 30 cm., 11·8 in.

Museo Regional de Yucatán, Mérida.

299 Model of a skull from the Temple of the Magician in Uxmal. Stone carving. It originally formed part of the decoration of the façade, the peg at the back being inserted into the wall.

Uxmal, Yucatán, Mexico. Postclassic period, *c.* AD 900–1100.

Height 19 cm., 7·5 in.

Museo Regional de Yucatán, Mérida.

Bibliography

Adams, R.: *Archaeological reconnaissance in the Chiapas Highlands*. Sociedad Mexicana de Antropología, Mexico 1961.

Anales del los Xahil (Anales de los Kakchiqueles). Mexico 1946. English tr. Delia Goetz, Oklahoma 1953.

Ancient Maya Paintings of Bonampak, Mexico. Carnegie Institute, Washington, n.d.

Anders, F.: *Das Pantheon der Maya*. Graz 1963.

Andrews, E. W.: *Chronology and astronomy in the Maya area*. New York and London 1940.

Anguiano, R.: *Expedición a Bonampak*. Mexico 1959.

Anton, F.: *Altmexikanische Schriftbilder*. Baden-Baden 1963.

 Maya, Indianerkunst aus Mittelamerika. Munich 1965.

 Ancient Mexican Art. London and New York 1970.

 The Art of Writing. Unesco 1965.

 Altindianische Weisheit und Poesie. Leipzig 1968.

Barrera-Vázquez, A.: *El libro de los libros de Chilam Balam*. Biblioteca Americana, Mexico 1948.

Barthel, Th. S.: *Maya-Astronomie: Lunare Inschriften aus dem Südreich*. Brunswick 1951.

 Die gegenwärtige Situation in der Erforschung der Mayaschrift. Copenhagen 1958.

Beyer, H.: *Zur Konkordanzfrage der Mayadaten mit denen der christlichen Zeitrechnung*. Berlin 1933.

Blom, F.: *La Vida de los Maya*. Bibl. Cult. pop., Guatemala.

Blom, F., and O. La Farge: *Tribes and Temples*. New Orleans 1926/27.

Brainerd, G. W.: *The Maya Civilization*. Los Angeles 1953/54.

Brasseur De Bourbourg, Ch. E.: *Le Livre sacré et les mythes de l'antiquité américaine*. Paris 1861. Diego de Landa, *Relation des choses de Yucatan*. Paris 1864.

Bushnell, G. H. S., and A. Digby: *Ancient American Pottery*. London 1955.

Chinchilla, C. S.: *Aproximación al Arte Maya*. Guatemala 1964.

Codex Dresdensis. Die Maya-Handschrift der Sächsischen Landesbibliothek Dresden. Vollständige Ausgabe, ed. Deckert. Berlin 1962.

 Schrift und Buchmalerei der Maya-Indianer. 24 Tafeln aus dem Codex Dresdensis. ed. R. Krusche. Leipzig 1965.

Coe, M. D.: *The Maya*. London and New York 1966.

Cordan, W.: *Introducción a los glifos mayas. Sistema de Mérida*. Mérida 1963.

 Götter und Göttertiere der Maya. Resultate des Mérida-Systems. Berne and Munich 1963.

Covarrubias, M.: *Indian Art of Mexico and Central America*. New York 1957.

Deckert, H.: *Maya-Handschrift der Sächsischen Landesbibliothek Dresden. Codex Dresdensis. Geschichte und Bibliographie*. Berlin 1962

Dieseldorff, E. P.: *Kunst und Religion der Mayavölker im alten und heutigen Mittelamerika*. Berlin 1926, 1931, 1933.

Digby, A.: *The Maize God and the Crossed Band Glyph*. London 1954.

Disselhoff, H. D.: *Geschichte der altamerikanischen Kulturen*. Munich 1953, 1967.

Dockstader, F.: *Indian Art in Middle America*. Greenwich, Conn. 1964.

Drucker, Ph.: *La Venta, Tabasco; a study of Olmec ceramics and art*. Washington 1952.

 The Cerro de las Mesas offering of jade and other material. Washington 1955.

Duby, G.: *Chiapas indígena*. México 1961.

Emmerich, A.: *Art before Columbus*. New York 1963.

Feuchtwanger, F., and Irmgard Groth: *Art of Ancient Mexico*. London and New York 1953.

Förstemann, E.: *Die Maya-Handschrift der Königl. Bibliothek zu Dresden*. Leipzig 1880.

Gallenkamp, Ch.: *Maya*. New York 1959.

Gann, W. Th.: *Ancient Cities and Modern Tribes. Explorations and Adventures in Maya Lands*. London 1926.

Gates, W. E.: *Commentary upon the Maya-Tzental Perez Codex*. Point Loma, Calif. 1910.

 An Outline Dictionary of the Maya Glyphs. Maya Soc., Pub. 1, Baltimore 1931.

Girard, R.: *Los Chortís ante el problema maya*. 5 vols. Mexico 1949.

 Los Mayas eternos. Mexico 1962.

Gordon, G. B., and J. A. Mason: *Examples of Maya Pottery. The Maya Pottery Collection in the University Museum of Philadelphia*. Philadelphia 1925–43.

Groth Kimball, Irmgard: *Maya Terrakotten*. Tübingen 1960.

Haberland, W.: *Die regionale Verteilung von Schmuckelementen im Bereich der klassischen Maya-Kulturen*. Hamburg 1953.

Holland, W. R.: *Medicina Maya en los altos de Chiapas. Un estudio del cambio socio-cultural*. Mexico 1963.

Holmes, W. H.: *Archaeological studies among the ancient cities of Mexico*. Chicago 1895–97.

 On a nephrite statuette from San Andrés Tuxtla. Lancaster 1907.

Humboldt, A. von: *Vue des Cordillères et monuments des peuples indigènes de l'Amérique*. Paris 1813.

Kelemen, P.: *Medieval American Art*. New York 1956.

Kidder, A. V., and J. E. Thompson: *The Correlation of Maya and Christian chronologies*. Washington 1938.

 The Artifacts of Uaxactun, Guatemala. Washington 1947.

Kidder II, A., and C. S. Chinchilla: *Art of the Ancient Maya*. New York 1959.

Kingsborough, E. K. Lord: *Antiquities of Mexico*. London 1831–48.

Knorozov, J. V.: *Drevnyaya pis'mennost Tsentralnoy Ameriki*. Moscow 1952.

 New Data on the Maya written language. Copenhagen 1958.

Kreichgauer, D.: *Olmeken und Tolteken*. Brunswick 1950. *Altmexikanische Kulturen*. Berlin 1956.

Kubler, G.: The *Art and Architecture of Ancient America*. Harmondsworth 1962.

Landa, Diego de: see Brasseur de Bourbourg.

 J. de Dios de la Rada y Delgado: *Relación de las cosas de Yucatán*. Madrid 1881.

 J. Genet: *Relation des choses de Yucatán*. Paris 1928/29.

 W. Gates: *Yucatán before and after the Conquest by Friar Diego de Landa*. Baltimore 1937.

 A. Barrera-Vásquez: *Relación de las cosas de Yucatán*. Mexico 1938.

 A. M. Tozzer: *Landa's Relación de las cosas de Yucatán*. Cambridge, Mass. 1941.

Lehmann, H.: *Pre-Columbian Ceramics*. London 1961. *Les Civilisations précolombiennes*. Paris 1953.

Lehmann, W.: *Zentral-Amerika. Teil I: Die Sprachen Zentral-Amerikas und ihre Beziehungen zueinander sowie Süd-Amerika und Mexiko*. Berlin 1920.

Lenz, Hans: *Mexican Indian Paper. Its historical background and survival*. Mexico 1961.

Linné, S.: *Treasures of Mexican Art*. Stockholm 1956.

Linné, S., and H. D. Disselhoff: *Ancient America*. London and New York 1961.

Lothrop, S. K.: *Metals from the Cenote of Sacrifice II*. Cambridge 1952.

 Precolumbian Art. New York 1957, London 1958.

Lowe, G. W.: *Excavations at Chiapa de Corzo, Chiapas, Mexico*. 1960.

Maler, T.: *Explorations in the Upper Usumatsintla*. Cambridge 1908–10.

 Researches in the Usumatsintla Valley. Mem. Peabody Mus. Vol. 2, Cambridge, Mass. 1901–03.

Marquina, I.: *Arquitectura Prehispánica*. Mexico 1964.

Mason, J. A.: *The Native Languages of Middle America*. New York and London 1940.

Maudslay, A. P.: *Biologia Centrali-Americana*, 5 vols. London 1889–1902.

Means, Ph. A.: *History of the Spanish Conquest of Yucatan and of the Itzas*. Cambridge, Mass. 1917.

Mengin, E.: *Die wichtigsten Ergebnisse der Mayasprachforschung.* Vienna 1962.

Middle American Research Records. New Orleans 1942–50/1961.

Morley, S. G.: *The Historical Value of the Books of Chilam Balam.* Norwood 1911.

 The Inscriptions at Copán. Carnegie 219. Washington 1920.

 The Inscriptions of Petén. 5 vols. Carnegie 437. Washington 1938. *The Ancient Maya.* Stanford (1946) 1956.

 Guide Book to the Ruins of Quiriguá. Washington 1947.

Nowotny, K. A.: *Die Konkordanz der mesoamerikanischen Chronologie.* Brunswick 1951.

Pavon Abreu, R.: *Bonampak en la escultura.* Mexico 1962.

Peterson, F. A.: *Ancient Mexico.* New York 1959.

Pijoan, J.: *Arte Precolombino, Mexicano y Maya.* Madrid 1954.

Piña Chan, R.: *Bonampak.* Mexico 1962.

Pollock, H. E. D.: *Mayapán, Yucatán, Mexico.* Washington 1962.

Popol Vuh: see Schultze-Jena, L.; Recinos, A.

Powell, J. P.: *Ancient Arts of the Americas.* London and New York 1959.

Proskouriakoff, T.: *An Album of Maya Architecture.* Norman, Okla. 1963.

Rabinal, A.: *Teatro indígena prehispánico.* Mexico 1955.

Recinos, A.: *Crónicas indígenas de Guatemala.* Guatemala 1957.

 Popul Vuh: Las Antiguas Historias del Quiché. Mexico 1947.

Reed, N.: *The Caste War of Yucatan.* Stanford, Calif. 1964.

Rivet, P.: *Cités maya.* Paris 1954.

Robertson, D.: *Pre-Columbian Architecture.* New York 1963.

Roys, R. L.: *The Book of Chilam Balam of Chumayel.* Carnegie 438, Washington 1933.

Ruz Lhuillier, A.: *La Civilización de los antiguos Mayas.* Mexico 1963.

 Exploraciones en Palenque. London 1954.

Satterthwaite, L.: *The Problem of Abnormal Stela Placements at Tikal and elsewhere.* 1958.

Saville, M. H.: *Bibliographical Notes on Palenque.* New York 1928.

Schellhas, P.: *Die Maya-Handschrift der Königl. Bibliothek zu Dresden.* Berlin 1886.

 Representation of Deities in the Maya Manuscripts. Cambridge 1904.

Schlenther, U.: *Über die Auflösung der Theokratien im präkolumbischen Amerika.* Berlin 1961.

 Kritische Bemerkungen zur kybernetischen Entzifferung der Maya-Hieroglyphen. Berlin 1964.

 Die geistige Welt der Maya. Einführung in die Schriftzeugnisse einer indianischen Priesterkultur. Berlin 1965.

Schultze-Jena, L.: *Indiana I: Leben, Glaube und Sprache der Quiché von Guatemala.* Jena 1933.

 Popol Vuh. Das heilige Buch der Quiché-Indianer von Guatemala. Stuttgart and Berlin 1944.

Seler, E.: *Gesammelte Abhandlungen zur amerikanischen Sprach- und Altertumskunde.* (Berlin 1902–23.) Graz 1960/61.

Smith, A. L.: *Uaxactun, Guatemala: Excavations of 1931–1937.* Washington 1950.

Smith, A. L., and A. V. Kidder: *Explorations in the Motagua Valley, Guatemala.* Washington 1943.

Smith, R. E.: *Ceramic Sequence at Uaxactun, Guatemala.* New Orleans 1955.

Sodi, D. M.: *La Literatura de los Mayas.* Mexico 1964.

Soustelle, J. and I. Bernal: *Mexico. Prehispanic Paintings.* New York 1958.

Spinden, J. H.: *A Study of Maya Art.* Mem. Peabody Mus. vol. 6, Cambridge, Mass. 1913.

Stephens, J. L.: *Incidents of Travel in Central America, Chiapas, and Yucatán.* (New York 1841.) Brunswick, N. J. 1948.

Stirling, M. W.: *Stone Monuments of Southern Mexico.* Washington 1943.

Stromsvik, G.: *Guide Book to the Ruins of Copán.* Washington 1947.

Termer, F.: 'Die Maya-Kultur als geographisches Problem', *Phönix,* 121–136. Buenos Aires 1932.

 Durch Urwälder und Sümpfe des nördlichen Amerikas. Hamburg 1941.

 Die Maya-Forschung. Nova Acta Leopoldina der Akademie zu Halle/Saale, Leipzig 1952.

 Die Halbinsel Yucatán. Gotha 1954.

 Etnología y Etnografía de Guatemala. Guatemala 1957.

Thompson, J. E. S.: *Archaeological Researches in Yucatán*. Cambridge 1904.

A correlation of Mayan and European calendars. Chicago 1927.

The Civilization of the Mayas. Field Mus. of Nat. Hist. Anthropol. Leaflet 25, Ist ed., Chicago 1927 (5th ed. 1954).

Ethnology of the Mayas of Southern and Central British Honduras. Field Mus. of Nat. Hist. Anth. Ser. No. 17,2, Chicago 1930.

Maya Hieroglyphic Writing. An Introduction. Carnegie 589, Washington 1950.

'Systems of Hieroglyphic Writing in Middle America and Methods of Deciphering Them', *American Antiquity*, Vol. 24. No. 4. Salt Lake City 1959.

A Catalogue of Maya Hieroglyphs. Norman 1962.

Maya Archaeologist. London 1963.

Tikal Reports. Philadelphia 1958.

Tozzer, A. M.: *Prehistoric Ruins of Tikal, Guatemala*. Cambridge 1911.

Maya Research. New York 1934.

Landa's Relación de las cosas de Yucatán. Papers Peabody Mus. Harvard Univ. XVIII, Cambridge, Mass. 1941.

Chichén Itzá and its Cenote of Sacrifice. Memoirs Peabody Mus. Harvard Univ. XI and XII. Cambridge, Mass. 1957.

The Mayas and their Neighbours. 1962.

Trimborn, H.: *Das Alte Amerika. Grosse Kulturen der Frühzeit*. Stuttgart 1959.

Villacorta, C. A. and J. A.: *Códice de Madrid (Codex Tro-Cortesianus)*. Guatemala.

Villacorta, J. A. and C. A.: *Arqueología Guatemalteca*. Guatemala 1930.

Wadepuhl, W.: *Die alten Maya und ihre Kultur*. Leipzig 1964.

Wagner, H. O.: *Die Bevölkerungsdichte vor 1492. Ursachen des Zusammenbruchs in der Kolonialzeit in Mesoamerika, insbesondere auf Yucatán. Jahrbuch für Ibero-amerikanische Geschichte*. Cologne 1968.

Waldeck, F. de: *Voyage pittoresque et archéologique dans la province de Yucatan (Amérique Centrale) pendant les années 1834-38*. Paris 1938.

Wauchope, R.: *Excavations at Zacualpa, Guatemala*. New Orleans 1948.

Ten Years of Middle American Archaeology. New Orleans 1961.

Lost Tribes and Sunken Continents. Myth and method in the study of American Indians. Chicago 1962.

Westheim, P.: *Arte antiguo de México*. Mexico 1964, 1950.

La Calavera. Mexico 1953.

La Escultura del México Antiguo. Mexico 1956.

Las ideas fundamentales del arte prehispánico en México. Mexico 1957.

La cerámica del México antiguo. Mexico 1962.

The Sculpture of ancient Mexico. Garden City, N. Y. 1963.

Westheim, P., and P. Kelemen: *Die Kunst Alt-Mexikos*. Darmstadt and Berlin 1964.

Willey, G. R.: *The Structure of Ancient Maya society*. 1956.

Wolf, E. R.: *Sons of the Shaking Earth. The People of Mexico and Guatemala*. Chicago 1959.

Zimmermann, G.: *Einige Erleichterungen beim Berechnen von Maya-Daten*. 1935.

Die Hieroglyphen der Mayahandschriften. Hamburg 1956.

Index

Acknowledgments

For their professional help and advice, I should like to thank Gertrude Duby, Jane Powell, Ursula Schlenther, Marjorie Zengel, Ignacio Bernal, Frans Blom, Cottie A. Burland, Alfonso Caso, Carlos Samayoa Chinchilla, Eusebio Dávalos, Helmut Deckert, Frederick J. Dockstader, Sigvald Linné, Frederick Peterson, Antonio Tejeda and Robert Wauchope.

For permission to take photographs of items in private collections, I am indebted to Carlos Nottebohm, Dr Kurt Stavenhagen, the Stendahl Gallery in Los Angeles, and the Stolper Galerie in Munich. I must also express my heartfelt gratitude to the following museums and other institutions: American Museum of Natural History, New York, N.Y.; Brooklyn Museum, New York, N.Y.; Staatliche Museen Berlin, Museum für Völkerkunde; Museo Nacional de Antropología, México D.F.; Museo Nacional de Arqueología, Guatemala City; Museo Nacional de El Salvador (Museo David J. Guzman); Museo Regional de Campeche, Campeche; Museo Regional de Chiapas, Tuxtla Gutiérrez; Museo Regional de Yucatán, Mérida; Museo Regional de Copán, Honduras; British Museum, London; Cleveland Museum of Art, Cleveland, Ohio; Middle American Research Institute, Tulane University, New Orleans, La.; Sächsische Landesbibliothek, Dresden.

Especial acknowledgment is due to the Instituto Nacional de Antropología e Historia in Mexico, and to the Institutos Nacionales de Arqueología in Guatemala and in El Salvador, for the determined efforts made by their staff to preserve the ruins from further deterioration and to render the sites accessible to the general public.

For permission to reproduce some of the figures in the text, I must thank the Peabody Museum of Archaeology and Ethnology at Harvard University, Cambridge, Mass., and the Instituto Nacional de Antropología e Historia, México D.F.

The photographs reproduced as *fig. 4* and *pl. 172* were provided by Foto-Heidemann, Hamburg. The author provided all the rest of the illustration material. The maps were drawn by Sonja Wunderlich.

FERDINAND ANTON

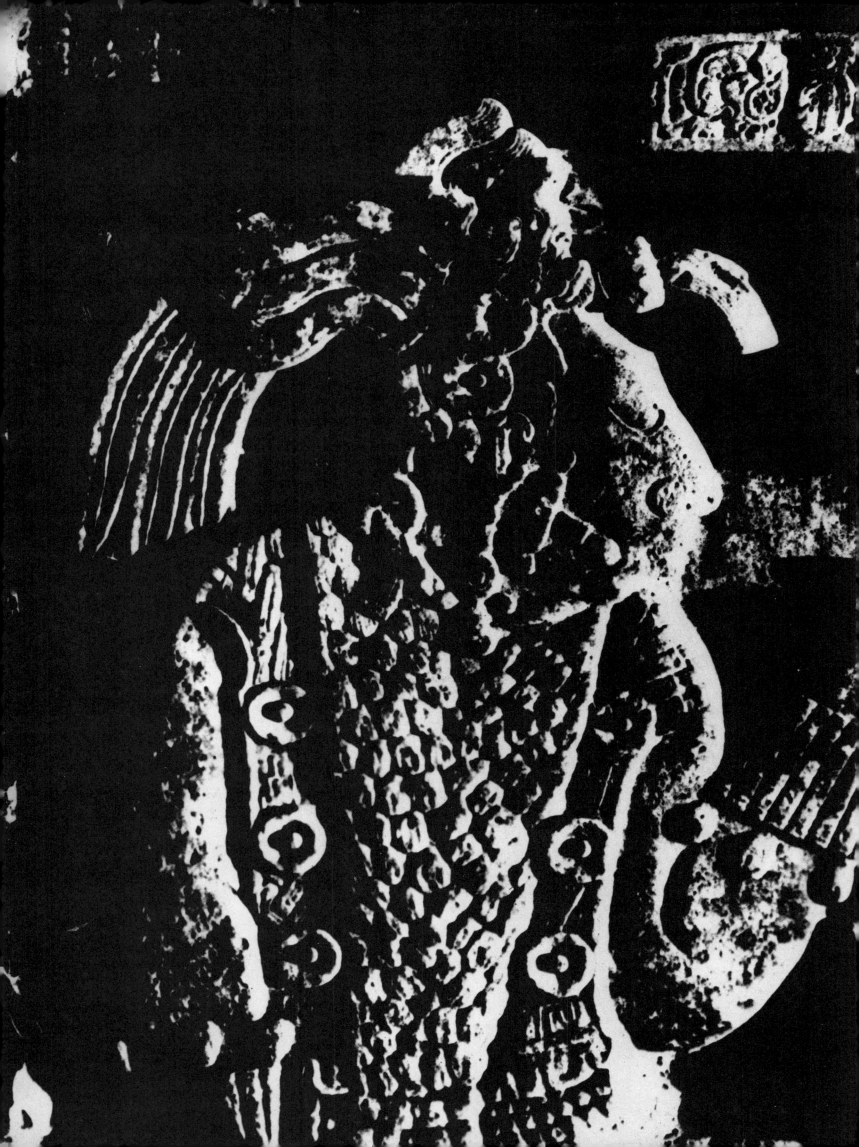